Native American Art in the Twentieth Century

makers, meanings, histories

Native American and First Nation's art has received increasing international recognition in recent years, as Native artists have earned and claimed space for themselves in prestigious galleries and museums. Celebrating the vitality of contemporary Native art, *Native American Art in the Twentieth Century* traces the political context of Native art production from the 1890s to the present, and engages with a range of concepts and issues such as the influence of spirituality in Native art, and the struggle for artistic self-determination.

With contributions from anthropologists, art historians, curators, critics and practising artists, this collection examines pottery, painting, sculpture, printmaking, photography, performance and installation art by some of the most celebrated Native American and Canadian artists of our time. With interests ranging from the Pueblo pottery revival to the invention and marketing of modern Inuit art, contributors offer new interpretative strategies based on Native culture and knowledge, stressing the significance of tradition, mythology and ceremony in the production of Native art, and conceptualising recent art in terms of home, homeland and aboriginal sovereignty. Following the continued resistance of Native artists to dominant orthodoxies of the art market and art history, *Native American Art in the Twentieth Century* argues forcefully for Native art's place in modern art history.

Contributors: Sara Bates, Bruce Bernstein, Colleen Cutschall, Margaret Dubin, Joe Feddersen, Lucy R. Lippard, Gerald R. McMaster, David W. Penney, Ruth B. Phillips, Kristin K. Potter, Lisa A. Roberts, W. Jackson Rushing III, Charlotte Townsend-Gault, Joseph Traugott, Kay WalkingStick, Elizabeth Woody.

Editor: **W. Jackson Rushing III** is Chair of the Department of Art and Art History at the University of Missouri-St. Louis, where he is also Fellow at the Center for International Studies.

Native American Art in the Twentieth Century

makers, meanings, histories

Edited by W. Jackson Rushing III

London and New York

First published 1999
by Routledge
11 New Fetter Lane, London EC4P 4EE

Simultaneously published in the USA and Canada
by Routledge
29 West 35th Street, New York, NY 10001

Typeset in Perpetua and Bell Gothic by Keystroke
Printed and bound in Great Britain by Butler and Tanner Ltd, Frome and London

British Library Cataloguing in Publication Data
A catalogue record for this book is available from the British Library

Library of Congress Cataloging in Publication Data
Native American art in the twentieth century / [edited by] W. Jackson Rushing III
 p. cm.
 Includes bibliographical references and index.
 1. Indian art—North America—History—20th century. 2. Indian
art—Collectors and collecting—North America—History—20th
century. 3. Indian art—North America—Themes, motives. I. Title.
E98.A7R89 1999
704.03'97'00904.—dc21 98–48803

ISBN 0–415–13747–0 (hbk)
ISBN 0–415–13748–9 (pbk)

Contents

Illustrations

Colour plates

Black and white plates

Acknowledgments for illustrations

Photographs of works are by the author of the chapter concerned, with the exceptions listed below. We are indebted to the people and archives below for permission to reproduce photographs. Every effort has been made to trace copyright holders, but in a few cases this has not been possible. Any omissions brought to our attention will be remedied in future editions.

Color illustrations

Plate A Dan Namingha, *Passages*. Courtesy of Niman Fine Art and the Wheelwright Museum of the American Indian, Sante Fe, New Mexico. Photo by Lynn Lown.

B Les Namingha, *Initiation*. Photo courtesy of Les Namingha and Gallery 10, Sante Fe, New Mexico.

C Kenojuak Ashevak, *Together with Ravens*, print. Printed by Lukta Qiatsuk. Copyright and image courtesy of The West Baffin Island Eskimo Co-operative.

D Teresa Marshall, *Elitekey*. Photography courtesy of the National Gallery of Canada, Ottawa.

E Robert Houle, *Kanata*, National Gallery of Canada, Ottawa.

F Robert Houle, *The Place Where God Lives*, National Gallery of Canada, Ottawa.

G Carl Beam, *The North American Iceberg*, National Gallery of Canada, Ottawa.

H Colleen Cutschall, *Sons of the Wind* from "House Made of Stars," Winnipeg Art Gallery. Courtesy of Colleen Cutschall.

I Lawrence Paul Yuxweluptun, *Scorched Earth, Clear-cut Logging on Native Sovereign Lands, Shaman Coming to Fix*. Courtesy of the National Gallery of Canada, Ottawa.

J James Luna, *Artifact Piece*. Courtesy of James A. Luna. Photo by Robin Holland.

K Carm Little Turtle, *Earthman won't dance except with other women*. Courtesy of the artist.

L Jolene Rickard, *I See Red in '92*. Courtesy of the artist.

M Shelley Niro, *This Land in Mine Land: 500 Year Itch*. Courtesy of the artist.

N Rosalie Favell, *All I knew about my Indian blood*. Courtesy of the artist.

O Emmi Whitehorse, *Forest Floor*. Courtesy of the artist.

P Rick Bartow, *Nickwitch*. Courtesy of the artist and the Froelick Adelhart Gallery, Portland, Oregon.

Q Colleen Cutschall, *The Second Time: The Courtship of the Sun and the Moon*, Kennerdine Gallery, University of Saskatchewan. By permission of the artist.

R Kay WalkingStick, *Danaë in Arizona*. Courtesy of the artist.

S Colleen Cutschall, *Garden of the Evening Star*, Winnipeg Art Gallery, Winnipeg. Courtesy of the artist.

T Sara Bates, *Honoring*. Courtesy of the artist.

U Sara Bates, *Honoring Gawexsky*. Courtesy of the artist.

Black and white plates

Plate 1 Nampeyo and pottery, postcard based on a photograph by Adam Clarke Vroman and published by Detroit Photographic Co., *c*. 1903.

2 Bowl with snout, plate XLVIII from J. Walter Fewkes, "Preliminary Account of an Expedition to the Cliff Villages of the Red Rock Country, and the Tusayan Ruins of Sikyatki and Awatobi, Arizona, in 1895," in *Annual Report of the Regents of the Smithsonian Institution Showing the Operations, Expenditures, and Condition of the Institution to July, 1895* (Washington, DC: Government Printing Office, 1897).

3 Nampeyo's snout-nose bowl collected by Walter Hough. Drawing by Robert Turner.

4 Nampeyo's bowl with bird design. Drawing by Robert Turner.

5 Bird design on a vessel from Old Cuñopavi, plate XLVII in J. Walter Fewkes, "Preliminary Account of an Expedition to the Cliff Villages of the Red Rock Country, and the Tusayan Ruins of Sikyatki and Awatobi, Arizona, in 1895," *Annual Report of the Regents of the Smithsonian Institution Showing the Operations, Expenditures, and Condition of the Institution to July, 1895* (Washington, DC: Government Printing Office, 1897).

6 Nampeyo's 1896 bowl with design derived from Old Cuñopavi vessel. Drawing by Robert Turner.

7 Nampeyo, Sikyatki Revival bowl, Colorado Springs Pioneer Museum, gift of Horace S. Poley. Drawing by Daryl Grene.

8 Tonita Peña, *Buffalo Dance*. © The Detroit Institute of Arts. Gift of Miss Amelia Elizabeth White.

9 Otis Polelonema, *Mask Dance*. © The Detroit Institute of Arts. Gift of Lillian Henkel Haass and Constance Haass McMath.

10 Velino Shije Herrera, *Crow Dance*. © The Detroit Institute of Arts. Gift of Lillian Henkel Haass and Constance Haass McMath.

11 Photo of James Houston, *c*. 1995. Courtesy of James Houston.

12 Map of the Northern Territories. Courtesy of Her Majesty the Queen in Right of Canada, Natural Resources Canada, © 1997.

13 Opening pages of article in *Design Magazine* 55, no. 4 (March 1959), pp. 152–3.

14 Illustration and caption of bear carving, from James Houston, "In Search of Contemporary Eskimo Art," *Canadian Art Magazine* 9 (1952), p. 102.

15 Kenojuak Ashevak, *Together with Ravens*, drawing © Courtesy of The West Baffin Island Co-operative, image courtesy of the McMichael Canadian Art Collection.

16 Edgar Heap of Birds, *Building Minnesota*. By permission of the artist.

17 Edgar Heap of Birds, *Building Minnesota*, detail. By permission of the artist.

18 Diego Romero, ceramic bowls (1997–98). Photography courtesy of Diego Romero and Gallery 10, Sante Fe, New Mexico.

Notes on the Contributors

Sara Bates is a Cherokee inter-media artist who works with natural materials. She earned her MFA at the University of California, Santa Barbara and was summer Artist-in-Residence (1987–9) for the Cherokee Nation, where she taught art-making through traditional Cherokee mythology. From 1990 to 1995 Bates was Director of Exhibitions and Programs at the American Indian Contemporary Arts in San Francisco, California, where she curated more than thirty exhibitions, including "The Spirit of Native America" (1992), which traveled to eleven Latin American countries. She has also edited catalogues of the exhibitions she curated for AICA, including *Indian Humor* (1992) and *Dancing Across Time: Images of the Southwest* (1995). Bates was Artist-in-Residence at the Headlands Center for the Arts (1992) in Sausalito, California. Works from her "Honoring" series have been exhibited widely in the United States and in solo shows in France, Italy, and in New Zealand at the World Celebration of Indigenous Art and Culture (1993).

Bruce Bernstein is Assistant Director of Cultural Resources at the National Museum of the American Indian, Smithsonian Institution in Washington, D.C. He received his Ph.D. in anthropology at the University of New Mexico and was formerly Associate Director of the Museum of Indian Arts and Culture in Santa Fe, New Mexico. Principal organizer of a major traveling exhibition, "With a View to the Southwest: Dorothy Dunn and a Story of Native American Painting" (Museum of New Mexico, 1995), he is co-author with W. Jackson Rushing of *Modern by Tradition: American Indian Painting in the Studio Style* (Museum of New Mexico Press, 1995), which won the Southwest Book Award for 1996. Bernstein previously held positions at the Wheelwright Museum of the American Indian in Santa Fe and the Maxwell Museum of Anthropology in Albuquerque. He has written on the marketing and patronage of modern Southwestern Indian art for *American Indian Art Magazine*.

Colleen Cutschall, a Lakota artist, is Associate Professor and Coordinator of Visual Art at Brandon University in Brandon, Manitoba. Formerly a student of the noted Lakota painter Oscar

Howe, she is a graduate of Barat College in Illinois and Black Hills State College in South Dakota. Her paintings and installations have been seen in numerous solo exhibitions, including "Voice in the Blood" (1990), "Sister Wolf and her Moon" (1993), and "House Made of Stars" (1996). Her essays have been published in numerous journals, including the *Canadian Journal of Native Studies*, and her artist's statement, "The Seen and Unseen form the Narrative," was featured in *Plains Indian Drawings 1865–1935: Pages from a Visual History* (Harry N. Abrams, 1996). She is President of the Native American Art Studies Association.

Margaret Dubin earned her Ph.D. in social anthropology at the University of California at Berkeley in 1998. Her dissertation, "Collecting Native America: The Culture of an Art World," explores the circulation and consumption of Native American art and was supported by a grant from the Phoebe Hearst Bannister Fund. Her essays on Native American artists and the anthropology of art have appeared in *Native North American Artists* (St James Press, 1997), *Visual Anthropology Review*, and *Museum Anthropology*. Dubin's film, *Doors Facing East* (1994), examines the interplay of memory, architecture, and spirituality in one extended Navajo family. She has been a high-school teacher at Zuni Pueblo and has contributed to *Indian Country Today*, *Native Peoples Magazine*, and *News from Native California*. In addition to teaching at San Francisco State University she is Lecturer in Anthropology at Stanford University.

Joe Feddersen is an artist and educator who teaches at Evergreen State College in Olympia, Washington. He is a member of the Colville Federated Tribes. Feddersen earned his MFA in printmaking at the University of Wisconsin in Madison in 1989 and has had numerous solo exhibitions: at Sacred Circle Gallery in Seattle (1984, 1985); C. N. Gorman Museum, University of California at Davis (1986); Elizabeth Leach Gallery, Portland, Oregon (1987, 1990, 1993); and the Evergreen Galleries, Evergreen State College (1993). He has shown in dozens of group exhibitions, including "New Directions/Northwest" (Portland Art Museum, 1986), "Visions" (American Indian Contemporary Arts, San Francisco, 1994), and "Native Paper" (Gallery 210, University of Missouri-St. Louis, 1996). His work is in several important public collections, including those of the Portland, Seattle, and Tacoma Art Museums in the Pacific Northwest; the Heard Museum, Phoenix, Arizona; and the Eiteljorg Museum in Indianapolis, Indiana. He has collaborated with Elizabeth Woody on five projects, including *Archives*, a major installation at the Tula Foundation in Atlanta, Georgia (1994).

Lucy R. Lippard is one of America's most distinguished and influential critics. A columnist for the *Village Voice*, *In These Times*, and *Z Magazine*, she is the author of seventeen books, including *Mixed Blessings* (Pantheon Books, 1990), *The Pink Swan* (The New Press, 1995), and *The Lure of the Local* (The New Press, 1997). Her edited volume, *Partial Recall: Photographs of Native North Americans* (The New Press, 1992), included Gerald McMaster's essay, "Colonial alchemy: Reading the Boarding School Experience." A noted activist, Lippard is co-founder of numerous artists' organizations, including Printed Matter, the Heresies Collective, Political Art Documentation/Distribution, and Artists Call Against U.S. Intervention in Central America. Curator of more than fifty exhibitions, she has written extensively about contemporary Native art: "Double Vision," in *Women of Sweetgrass, Cedar, and Sage* (Gallery of the American Indian Community House, 1985); "Shimá: The Paintings of Emmi Whitehorse," in *Neeznáá: Emmi Whitehorse, Ten Years* (Wheelwright Museum of the American Indian, 1991); "Jimmie Durham: Postmodernist Savage," *Art in America* 81 (1993); "Lost meanings,

Kept Secrets: Lance Belanger's *Neo Lithic Tango*", in *Tango: Lance Belanger* (Ottawa Art Gallery, 1995); and "In the Open, Under the Surface," in *Sola: Emmi Whitehorse* (Tucson Museum of Art, 1997).

Gerald R. McMaster (Plains Cree) is a Ph.D. candidate at the Amsterdam School of Cultural Analysis (Amsterdam, Holland) and Curator of Contemporary Indian Art at the Canadian Museum of Civilization in Hull, Quebec. He has curated or co-curated the following exhibitions: "Challenges," de Meervaart Cultural Center (Amsterdam, 1985); "In the Shadow of the Sun," CMC (Hull, 1988); "Public/Private Gatherings," CMC (Hull, 1991); "Indigena: Contemporary Native Perspectives," CMC (Hull, 1992); "Edward Poitras Canada XLVI Biennale di Venezia" (Venice, Italy, 1995); "Plains Indian Drawings 1865–1935: Pages from a Visual History," The Drawing Center (New York, 1996) and "Reservation X," CMC (Hull, 1998). His one-person exhibitions include: "Riel Remembered," Thunder Bay Art Gallery (Ontario, 1985); "The Cowboy/Indian show," McMichael Canadian Art Collection (Kleinburg, Ontario, 1991); and "Savage Graces," Museum of Anthropology at the University of British Columbia (Vancouver, 1992). He has contributed essays and chapters to numerous exhibition catalogues and to *Art Journal* and the *Canadian Journal of Native Studies*.

David W. Penney was awarded a Ph.D. in art history at Columbia University in New York City and is Chief Curator at the Detroit Institute of Arts. He is also an adjunct Professor at Wayne State University in Detroit, where he teaches African, Native American, and Precolumbian art history. Penney is the editor of *Ancient Art of the American Woodland Indians* (Harry N. Abrams, 1985), principal author of *Art of the American Indian Frontier: The Chandler–Pohrt Collection* (University of Washington Press, 1992), and co-author of *Images of Identity: American Indians and Photography* (1992), all of which accompanied exhibitions he organized for the DIA. He was President of the Native American Art Studies Association in 1989–93 and is now researching recent Native American art.

Ruth B. Phillips is Professor of Fine Arts and Anthropology and Director of the Museum of Anthropology at the University of British Columbia in Vancouver. Her publications on African and First Nations art include *Representing Woman: Sande Masquerades of the Mende of Sierra Leone* (Fowler Museum of Cultural History, Los Angeles, 1995) and *Patterns of Power: The Jasper Grant Collection and Great Lakes Indian Art of the Early Nineteenth Century* (McMichael Canadian Collection, Kleinburg, Ontario, 1984). Her most recent books are *Trading Identities: The Souvenir in Native North American Art from the Northeast, 1700–1900* (University of Washington Press, 1998) and, with Janet Catherine Berlo, *Native North American Art* (Oxford University Press, 1998). Phillips is a a founding board member of the Otsego Institute for Native American Art History.

Kristin K. Potter is enrolled in the School of Law at the University of New Mexico in Albuquerque, where she earned her MA in Native American art history. She contributed essays on the contemporary Native artists Rick Bartow, Suzie Bevins, Dempsey Bob, Joe Feddersen, Teresa Marshall, and James Schoppert to *Native North American Artists* (St James Press, 1997). Her essay "Frederick H. Evans and G. Bernard Shaw: The United House of Faith and Reason" was published in *History of Photography* (Summer 1995). Her essay in this volume is derived from her thesis and a paper she presented to the biannual meeting of the Native American Art Studies Association in Tulsa, Oklahoma (1995).

Lisa A. Roberts earned her MA in art history at Wayne State University in Detroit, Michigan and she is a Ph.D. candidate at the University of Illinois. Previously she was a curatorial assistant at the Detroit Institute of Arts, where she co-authored *Images of Identity: American Indians and Photography* (1992). She published essays on Jaune Quick-to-See Smith, Kay WalkingStick, and seven other contemporary indigenous artists in *Native North American Artists* (St. James Press, 1997).

W. Jackson Rushing III is Chair, Department of Art and Art History at the University of Missouri-St. Louis, where he is also a Fellow at the Center for International Studies. He is author of *Native American Art and the New York Avant-Garde: A History of Cultural Primitivism* (University of Texas Press, 1995) and co-author of *Modern by Tradition: American Indian Painting in the Studio Style* (Museum of New Mexico Press, 1995). He has curated four exhibitions, including "Native Paper" at Gallery 210 (University of Missouri-St. Louis, 1996), and written catalogue essays on Edgar Heap of Birds, Joe Herrera, Allan Houser, Teresa Marshall, and Fritz Scholder. His art criticism has appeared in *Akwe:kon Journal, Artspace, New Art Examiner*, and *Third Text* and he was guest editor of *Art Journal* (Fall, 1992). Rushing was Vice President of the Native American Art Studies Association in 1995–97 and is a founding board member of the Otsego Institute for Native American Art History.

Charlotte Townsend-Gault received her Ph.D. in social anthropology at University College London and teaches in the Department of Art History, Art and Theory at the University of British Columbia in Vancouver. She curated "Yuxweluptun: Born to Live and Die on Your Colonialist Reservations" for the Belkin Gallery at UBC in 1995 and, in 1992, was a co-curator of "Land Spirit, Power: First Nations at the National Gallery of Canada." The chapters "Art, Argument and Anger on the Northwest Coast," in *Contesting Art: Politics and Identity in the Modern World*, edited by Jeremy MacClancey (Berg, 1997) and "Let X = Audience," in the catalogue for *Reservation X*, edited by Gerald McMaster for the Canadian Museum of Civilization (1998), are preliminary stages in work for a book on contemporary extensions of First Nations visual culture in urban British Columbia. She is editing an anthology of texts, historical and contemporary, which have contributed to the construction of Northwest Coast art.

Joseph Traugott earned his MFA in printmaking and his Ph.D. in American Studies at the University of New Mexico in Albuquerque. He is Curator of Twentieth-century Art at the Museum of Fine Arts in Santa Fe, New Mexico. Traugott is the author of *O'Keeffe's New Mexico* (Museum of New Mexico, 1997), the catalogue of a traveling exhibition he organized. He is co-author of *La Terra Incantata Dei Pueblo: Fotografie Di Charles F. Lummis, 1888–1905* (Vianelo Libri, 1991) and author of *Pueblo Architecture and Modern Adobes* (Museum of New Mexico, 1998), which documents his exhibition on the residential architecture of William Lumpkins. Traugott's essays and art criticism have appeared in *Art Journal* and *Artspace*. He has curated dozens of exhibitions of contemporary art and maintains a fleet of Ramblers.

Kay WalkingStick, whose parents were Cherokee and Scottish-American, is an internationally-exhibited artist, whose paintings are in the permanent collections of the Albright-Knox Gallery in Buffalo, New York, the Heard Museum in Phoenix, Arizona, the Israeli Museum in Jerusalem, the Metropolitan Museum of Art in New York City, the National Gallery of Canada in Ottawa, and the San Diego Museum of Fine Arts in San Diego, California. Her work is in fifteen distinguished corporate collections and she has received a Joan Mitchell Foundation Award in Painting. She was

guest editor of *Art Journal* (Fall 1992) published by the College Art Association of America, and has contributed essays to *Artforum* and to the *Northeast Indian Quarterly*. In great demand as a lecturer, consultant, and juror, WalkingStick is Professor of Fine Art at Cornell University in Ithaca, New York.

Elizabeth Woody (Navajo/Warm Springs/Wasco/Yakama) is a writer, visual artist, community activist, and Program Associate at Ecotrust, a non-profit environmental organization in Portland, Oregon. From 1994 to 1996 she was a professor of creative writing at the Institute of American Indian Arts in Santa Fe, New Mexico. Her first collection of poetry, *Hand Into Stone* (Contact II, 1989) received the American Book Award. She is also the author of *Luminaries of the Humble* (University of Arizona Press, 1994) and *Seven Hands, Seven Hearts, Prose and Poetry* (Eighth Mountain Press, 1994). Her numerous awards include the William Stafford Memorial Award for Poetry (1995) and an Americans for Indian Opportunity Ambassadors Fellowship (1993). In 1997 she was an Artist-in-Residence at Intersection for the Arts in San Francisco, California. Woody has given lectures, presentations and workshops at schools and conferences all across the United States, including the Telluride Native Writer's Program. She was a founding member of the Northwest Native American Writers Association. Her visual art has been exhibited regionally and nationally in the traveling exhibition "The Submuloc Show/Columbus Wohs" (1992) and in "For the Seventh Generation: Native American Artists Counter the Quincentenary" (1992), organized by the distinguished Cherokee artist Phil Young.

Editor's Foreword

The state of the art, May 1998 A few weeks ago the Canadian Museum of Civilization in Hull, Quebec, opened "Reservation X," which featured eight contemporary indigenous artists from Canada and the United States. Curated by Gerald McMaster (a contributor to this volume) and described as "eight commissioned inquiries into aboriginal identity," this exhibition is the most recent in a series of critically important shows held in the museum's Indian and Inuit Art Gallery since 1989.[1] The Heard Museum in Phoenix, Arizona, is currently showing its Seventh Native American Fine Art Invitational, which also includes both Native American and First Nations artists working in a variety of media. According to Margaret Archuleta, Curator of Fine Art, "The Heard Museum's Invitational continues to be the only fine art invitational exclusive to Native artists that is not thematic and does not follow categories as defining distinctions."[2] Running simultaneously with these two exhibitions is the Oakland Museum of California's "The Discovery of Gold in California: Paintings by Harry Fonseca," which features richly tactile images that are paradoxically gorgeous (as art) and violent (as history). In 1997 the Tucson Museum of Art in Tucson, Arizona, presented "Sola: Emmi Whitehorse," the twelfth in a series of exhibitions focused on contemporary Southwest images funded by the Stonewall Foundation. "Gifts of the Spirit: Works by Nineteenth-Century and Contemporary Native American Artists" was a stunning exhibition held at the Peabody Essex Museum in Salem, Massachusetts in 1996–7, whose list of accomplished artists included Truman Lowe, George Morrison, Shelley Niro, and the brothers Diego and Mateo Romero, among numerous others. Also on view in 1996 was "Between Two Worlds: Sculpture By David Ruben Piqtoukun" (Winnipeg Art Gallery, Manitoba): sixty-two provocative objects made with materials such as African wonderstone, Greek alabaster, limestone, marble, and welded steel, by an artist whose work is in several public collections, including the Art Gallery of Ontario and the Staatliche Museum für Volkerkunde in Munich, Germany. The Aperture Foundation published a sumptuous portfolio of contemporary indigenous photography (and texts) in 1995: "Strong Hearts: Native American Visions and Voices," which constitutes a fine introduction and overview. And by the time our edited volume reaches libraries and bookstores, Teresa Marshall will have had a solo exhibition, "A Bed to

the Bones," at the Contemporary Art Gallery in Vancouver, British Columbia, and the Winnipeg Art Gallery in Manitoba will be on the verge of its Robert Houle retrospective.[3] A more comprehensive overview of recent exhibitions in galleries and museums is prohibited in this context, but this précis hints, at least, at the widespread vitality of, and growing public interest in, twentieth-century Native American and First Nations art.

Why is it then that such art is frequently missing from the curricula of major research universities and art schools in Canada and the United States? A partial explanation lies in the fact that instructors trained in the history of "traditional" Indian art are not always conversant with the issues and paradigms of modern and contemporary art. Similarly, scholars of "mainstream" modernism and its various offspring who might be interested in democratizing, pluralizing, and indigenizing their survey courses, often do not have the requisite familiarity with Native art in the twentieth century, which is decidedly underpublished. Both groups, I believe, will find this book an especially useful addition to their reading lists, as will artists, anthropologists, and scholars of (Native) American and Canadian Studies. Written by artists, art historians, anthropologists, curators, and critics, the essays in this collection are theoretically informed and highly conscious of the moral, taxonomic, and epistemological obstacles inhering in a "post-colonial" history or criticism of Native American and First Nations art since 1900.[4]

Although it would be extremely difficult, I think, to produce a collection of essays on this subject that was both truly comprehensive and reasonably affordable – and this fact underscores the strength and tenacity of aboriginal American artists in this century – this book does examine a remarkable array of topics ranging from the 1890s to the present. In addition to chronological breadth, this anthology also casts a wide net over geography (from Pueblo country to the Arctic), methodology, and a plurality of artistic paradigms, including revival styles, genre painting and abstraction, and "postmodern" performance and installation.[5] And the issues considered in these essays are impressively diverse as well: the patronage and marketing of Indian art; institutional authority and indigenous intentionality; Native (dis)engagement with modernism; the politics of representation; aesthetic and cultural identity; and ecology, feminism, and spirituality in contemporary Native art.

Many of the writers represented here are operating in what I have described previously as the fertile interstitial zone that critical theory and cultural studies have created between art history and anthropology.[6] And the Native American and First Nations contributors to this volume are writing both out of and into the space of sovereignty and self-determination. I am pleased and honored to be the coordinator and editor of such a pre-eminent group of practitioners. Indeed, many of the contributors to this book have taken an active role in shaping and defining the emergent new discourse on twentieth-century Native American visual culture(s). This interdisciplinary volume will help satisfy an urgent need for poststructural texts that forge new methodologies for the study of global indigenous art in the twentieth century.

Despite the fact that the historical, intellectual, and aesthetic terrain mapped by these essays is vast, the subtitle – makers, meanings, histories – indicates a unifying structure. The intentions and motivations of specific makers, such as the early modern Hopi potter Nampeyo and the contemporary Cowichan-Okanagan artist Yuxweluptun (aka Lawrence Paul), are articulated with respectful sensitivity. The multiple meanings of Native art in various contexts is also a ubiquitous theme, as is the recognition of, and commitment to, *histories* (as opposed to a hegemonic HISTORY) of twentieth-century Indian art that value the emic authority of Native voices.

W. Jackson Rushing III
University of Missouri-St. Louis

Notes

1 Gerald McMaster (ed.) *Reservation X: The Power of Place in Aboriginal Contemporary Art* (Ottawa: Canadian Museum of Civilization, 1998). On the Canadian Museum of Civilization, see Gerald R. McMaster and Lee-Ann Martin, "The Contemporary Indian Art Collection at the Canadian Museum of Civilization," *American Indian Art* 15 (Autumn 1990): 50–5, and W. Jackson Rushing, "Contingent Histories, Aesthetic Politics," *New Art Examiner* 20 (March 1993): 14–15. Following recent Native discourse, in this text the terms Native American, Indian, indigenous, aboriginal, and First Nations are used interchangeably; see Lee-Ann Martin, *The Art of Alex Janvier: His First Thirty Years, 1960–1990* (Thunder Bay, Ontario: Thunder Bay Art Gallery, 1993), p. 44.

2 Margaret Archuleta, "Curator Statement," in *Seventh Native American Fine Art Invitational* (Phoenix, AZ: Heard Museum, 1997), p. 2.

3 Robert Yassin, Tisa Rodríguez Sherman, and Lucy Lippard, *Sola: Emmi Whitehorse* (Tucson, AZ: Tucson Museum of Art, 1997); Dan L. Monroe *et al.*, *Gifts of the Spirit: Works by Nineteenth-Century and Contemporary Native American Artists* (Salem, MA: Peabody Essex Museum, 1996); Darlene Coward Wright, *Between Two Worlds: Sculpture By David Ruben Piqtoukun* (Winnipeg, Ontario: Winnipeg Art Gallery, 1996); and W. Jackson Rushing, *Teresa Mashall: A Bed to The Bones* (Vancouver: Contemporary Art Gallery, 1998).

4 I have made the term "post-colonial" contingent, even though it is in use in reference to Native art and its history, because I believe that we are still working *toward* the post-colonial era in North America.

5 The applicability of the term "postmodern" to recent Native artistic practice is debatable. See, for example, Joseph Traugott, "Native American Artists and the Postmodern Divide," *Art Journal* 51 (Fall 1992): 36–43 and Loretta Todd, "What More Do They Want," in Gerald McMaster and Lee-Ann Martin (eds) *Indigena: Contemporary Native Perspectives* (Vancouver: Douglas and McIntyre, 1992), pp. 71–9.

6 See W. Jackson Rushing, "Critical Issues in Native American Art," *Art Journal* 51 (Fall 1992): 13.

Acknowledgments

I am grateful first and foremost to the Native American and First Nations artists whose work is discussed in these pages – without their courage and dedication there would be nothing to say – and to the contributors for their diligence and patience. Rebecca Barden, Senior Editor at Routledge, has been exemplary in her commitment to this project and I thank her for her encouragement and guidance. During the three years I researched, compiled, and edited this volume, I had the good fortune to be supported by fellowships from the National Endowment for the Humanities, the George A. and Eliza Gardner Howard Foundation at Brown University in Providence, Rhode Island, and the Center for International Studies at the University of Missouri-St. Louis. I am pleased to acknowledge the generosity of these patrons. On behalf of the contributors I wish to thank all those who lent slides and photographs for publication. For picture support in Santa Fe, New Mexico I am especially grateful to Frances Namingha at Niman Fine Art, Maggie Ohnesorgen at Gallery 10, and Jonathan Batkin at the Wheelwright Museum of the American Indian. Thanks also to France Duhamel at the National Gallery of Canada in Ottawa. Susan Hiller's edited volume, *The Myth of Primitivism* (Routledge, 1991) provided me with a fine model; I congratulate her and her colleagues on the quality of their work. I enjoyed pleasant and productive conversations with all of the authors collected here, but in particular I must thank Sara Bates and Joseph Traugott for helping me to clarify certain issues. My colleagues at the Otsego Institute for Native American Art History aided me by their outstanding integrity and authenticity in scholarship and art criticism. At the University of Missouri-St. Louis I am indebted to Dr. Douglas Wartzok, Dean of the Graduate School, and Dr. Joel Glassman, Director of the Center for International Studies. Thanks, as always, to the R. W. King Estate in Lott, Texas for its continued support of my work.

Although I have quoted the contributing authors in my editor's introduction to each section, my comments should be read only as my understanding of the various essays. The individual authors bear no responsibility for any interpretative errors I might have made.

Part I

Editor's Introduction to Part I

The essays in this section, by Joseph Traugott, David W. Penney and Lisa A. Roberts, Kristin K. Potter, and Bruce Bernstein touch on the social and economic history of selected Native American art forms from the late nineteenth century through the 1970s, noting, in the case of Penney, Roberts, and Bernstein, the legacy of that history in the present. Although their subject matters are diverse – the Sikyatki Pottery Revival at Hopi in the 1890s, modern Pueblo painting in the 1920s and 1930s, the marketing of Inuit sculptures and prints in the 1950s and 1960s, and the reception of historic and contemporary Indian art in the 1960s and 1970s – these essays do have some important points of intersection. They all further our understanding, for example, of how extra-aesthetic forces and ideas located in Euro-American culture created and then appropriated the category "Indian art." Patronage, both public and private, is therefore central to the collective content of this first section. Common also to this first group of essays is an investigation of the nexus between anthropological discourse on an originary purity supposedly manifest in aboriginal art and a desire for market shares for such art. Thus, to borrow from Potter's essay, "James Houston, Armchair Tourism, and the Marketing of Contemporary Inuit Art," this section examines the link between economic independence and efforts to preserve the "cultural integrity" of Native peoples. Much of the work done by the authors is historiographical: reading closely, analyzing, and historicizing a variety of anthropological and art historical texts that we have inherited from our predecessors.

Joseph Traugott's "Fewkes and Nampeyo: Clarifying a Myth-Understanding" makes for an appropriate and auspicious beginning for this volume. The Tewa-Hopi potter Nampeyo and the Smithsonian Institution anthropologist Jesse Walter Fewkes are "canonical" figures in the history of twentieth-century Native American art. Not only were Nampeyo and her husband Lesou the roots, so to speak, of a still-blossoming family tree of remarkable artistic accomplishment that includes the artists Dan and Les Namingha (uncle and nephew, respectively: Plates A and B), but Nampeyo's innovative ceramic wares marked the beginning of the ever-growing market for contemporary Native art. No introductory lecture or text on Amerindian art, modern or otherwise, is complete

without an acknowledgment of her achievement and its still powerful influence. The elegant shapes of her vessels and their complex decorative iconography (which opens a window on to ancient American knowledge) still inspire contemporary artists and eager collectors. So it is instructive to begin with Traugott's clear-eyed historiographical interrogation of the "conventional wisdom" about her creative impulses and the agendas of her patrons. A century after the fact, a formidable body of literature exists on Nampeyo's art and Traugott sifts through it delicately, searching for inconsistencies and subjecting what has passed for "common sense" to the physical facts of her pots and the archival information associated with them. One of Traugott's several *coups* is to unveil the relationship between Fewkes's "camouflage" and the emergence of the popular legend about Nampeyo and her sources. In so doing, he revisits the process by which anthropological research is distilled into a "photographic icon," and explains how the circulation of commercialized images of art and artists both constructs ethnicity and serves as the proof for competing stories about the meaning of Nampeyo's work. The revival instigated by Nampeyo's artistry, Traugott reveals, was not strictly the result of what the noted anthropologist Ruth Bunzel described as a "sudden mutation in style." Moreover, Traugott argues that the commercial history of Hopi pottery at the turn of the century might well be linked to Fewkes's determination to make his research support his presumptions about Hopi migration patterns.

Less than a generation separated Nampeyo's pottery experiments at Hopi and the emergence of modern Pueblo watercolors in and around Santa Fe about 1915. In their essay, "America's Pueblo Artists: Encounters on the Borderlands," David W. Penney and Lisa A. Roberts return to a subject that has fascinated collectors, academics, and subsequent generations of Native American artists for decades. Created by self-taught artists such as Crescencio Martinez and Tonita Peña, whose numerous patrons included the Museum of New Mexico and the School of American Research, the syncretic style of modern Pueblo painting dominated Indian art in the United States for more than fifty years. This paradigmatic dominance was due in no small measure to the indefatigable art teacher Dorothy Dunn, who codified and institutionalized the style of the first generation of twentieth-century Pueblo painters at The Studio she founded in 1932 at the Santa Fe Indian School.[1] Refining what they see as the over reductive thesis offered by J. J. Brody in his pioneering book *Indian Painters and White Patrons* (1971), Penney and Roberts seek to explicate the "dialogic and collaborative" nature of the relationship between the artists and their supporters. They write about the "strategic agendas" of both Indians and non-Indians alike, agendas that impinged on the production and circulation of watercolors made in the "contact zone." Employing Mary Louise Pratt's concept of autoethnography, Penney and Roberts describe modern Pueblo watercolors as an "antidote to the assimilationists' misrepresentations" of Native culture in the American Southwest. On the other side, they reveal patronage as a process by which an enlightened bourgeoisie sought to secure "innocence" for themselves *vis-à-vis* the destruction of aboriginal cultures. And, like Traugott, they are interested in capitalism and anthropology as instruments for converting authenticity into commodity. Penney and Roberts also share with Traugott two other concerns: (1) to show how ethnographic representations of Native artistic practice were considered superior to "local knowledge"; and (2) to evaluate how the imposing of external standards of connoisseurship tended to efface the substantial difference between ancient and modern Indian art.

Just as Dorothy Dunn is inextricably associated with the widespread dissemination of the so-called traditional style of Native painting in the United States, the Canadian entrepreneur James Houston almost single-handedly established the post-World War II market for Inuit sculptures and prints. Given the way Houston's ideas and energies loom over the history of these highly collectable

forms of indigenous culture, the absence of sufficient critical investigation of his role as a culture broker is a major lacuna; one which Kristin Potter's essay seeks to remedy. Potter, who examines archival documents and a plethora of Houston's promotional texts, builds her argument around "armchair tourism," an "ideal exploratory narrative," and a troubling circular reasoning she identifies in the discourse on Inuit art. She notes in particular the process by which Houston's articles transform the armchair souvenir into a "miniature masterpiece of primitive art." Too often, histories of aboriginal American art are insular, never making connections with other visual traditions or other colonial histories. So it is admirable that Potter situates Houston's activities in northern Canada in an international context by comparing and contrasting Inuit art history with the Brazilian government's efforts to market Mamaindé cultural artifacts in the 1960s. Impressive also is her recognition of the paradoxical power of intimate distance created by reading armchair tourist texts such as Houston's. Like Penney and Roberts, Potter refuses to isolate indigenous values in art from either their subsequent commodification or their appropriation as emblems of (Canadian) national identity. Her discussion of Houston's "control of information" is likewise not dissimilar to Traugott's awareness of the "conflation of fact and fiction" in the history of early modern Hopi art. Furthermore, Traugott's term "myth-understanding" (as a sign for a willful manipulation of history) is applicable, perhaps, to Potter's revelation of Houston's *factitious* account of Inuit art and culture. She demonstrates, for example, how it was necessary for Houston to demystify the printmaking technologies used by Inuit artists even as he mystified their alleged archaism.

One of the most important lessons of Bruce Bernstein's essay, "Contexts for the Growth and Development of the Indian Art World in the 1960s and 1970s," is that *plus ça change, plus c'est la même chose*. The "dialectic of curio and art" is central not only to his discussion of the 1960s and 1970s, but to all the other essays in this section as well. And like the other contributors, Bernstein also sees Native American art as the reification of an authenticity which is in fact a discursive fiction (or what I am calling factitious). No less than his colleagues, Bernstein also identifies a Euro-American "need to control the production of Indian art" in the period he is considering. After reviewing private and institutional patronage, he too, recognizes even well meaning efforts as (patriarchical) intervention. The archaism and romanticism articulated in the other essays is present here in the primitivism of the counter-culture of the sixties. He also discusses, to good effect, the progressive (Native) "Americanization" in the 1950s of the international market for "primitive" art. Kachina cult objects, Mimbres pottery, and Northwest Coast Indian objects, he notes, had higher visibility in galleries and at auction houses because they more closely conformed to Euro-American notions of fine art than, say, Plains Indian beadwork. Useful also is Bernstein's account of the way the Whitney Museum of American Art in New York, the Walker Art Center in Minneapolis, and The Nelson-Atkins Museum of Art in Kansas City furthered in the 1970s the legitimization of "Indian artifacts as art" that was initiated by the "Exposition of Indian Tribal Arts" (1931) and continued by "Indian Art of the United States" (1941).[2] Documenting the expansion of galleries of Native American art out of the Southwest to Los Angeles, San Francisco, and New York, he cites the conflation in commercial spaces of old and new works of art. Thus, one of his conclusions – which may be contested in some quarters – is that this admixture of "classical traditions" that signify a "romanticized and idealized past" and "today's most popular contemporary artists" has had a salutary effect. However, no one, I suspect, will deny him his anxiety about the dual power that consumer expectations and the "hermetic world of scholarship" exert over the direction of Native American art.

In this section, then, the authors identify and explore a series of contexts – including scientific research, nationalist narratives, market maneuvers, and aboriginal resistance or accommodation to

Euro-American intrusions – in and through which Native American art was created, distributed, and institutionalized from 1900 through the 1970s. They continue a positive tendency in recent scholarship that seeks to break down the distinctions between folk/craft and fine art and to see artistic practice as enmeshed in a fluid network of social relations.

Notes

1 On modern Pueblo watercolors, see Dorothy Dunn, *American Indian Painting* (Albuquerque, NM: University of New Mexico Press, 1968) and Bruce Bernstein and W. Jackson Rushing, *Modern By Tradition: American Indian Painting in the Studio Style* (Santa Fe, NM: Museum of New Mexico Press, 1995).

2 For the "Exposition of Indian Tribal Arts" (1931), see W. Jackson Rushing, *Native American Art and the New York Avant-Garde* (Austin, TX: University of Texas Press, 1995), 97–103 and Molly H. Mullin, "The Patronage of Difference: Making Indian Art 'Art, not Ethnology,'" in George E. Marcus and Fred R. Myers (eds) *The Traffic In Culture* (Berkeley, CA: University of California Press, 1995), pp. 166–95. For "Indian Art of the United States" (1941), see W. Jackson Rushing, "Marketing the Affinity of the Primitive and the Modern: René d'Harnoncourt and *Indian Art of the United States*," in Janet Catherine Berlo (ed.) *The Early Years of Native American Art History* (Seattle, WA: University of Washington Press, 1992), 191–236.

Joseph Traugott

Fewkes and Nampeyo
Clarifying a Myth-Understanding

According to popular Southwestern legend, archaeologist J. Walter Fewkes aided the Hopi-Tewa potter Nampeyo (*c.* 1860–1942) with her efforts to revitalize the ceramic arts of the Hopi Pueblos in Arizona at the end of the nineteenth century. J. J. Brody summarized the generic history of Nampeyo's pottery in his book *Indian Painters and White Patrons*, when he observed,

> About 1895 a conscious Revival of quality wares was begun at the First Mesa Hopi villages. Anthropologist J. Walter Fewkes had been working at Sikyatki, and his excavations provided the stimulus for Hano potter Nampeyo, who first imitated and then modified the design forms of Sikyatki ware uncovered in the Jeddito Valley. Nampeyo was an exceptionally talented potter, and her Revival pieces found a ready market. Other Hano potters soon began to copy the ancient Jeddito Valley wares, and the Revival spread quickly and has continued to the present.[1]

For more than a century scholars have argued about the "Sikyatki Revival" and debated its meaning. A "conventional wisdom" developed which implied scholarly agreement over the details of the Revival. This paper continues the debate and concludes that Fewkes incorporated inaccuracies into the legend to camouflage the shortcomings of his own research.

Four versions of the legend

Fewkes's assistant Walter Hough initiated the popular version of the Nampeyo tale through his tourist guide *The Moki Snake Dance*, published by the Passenger Department of the Santa Fe Railway in 1898. At a time when the names of virtually all Indian artists were unknown, Hough told readers

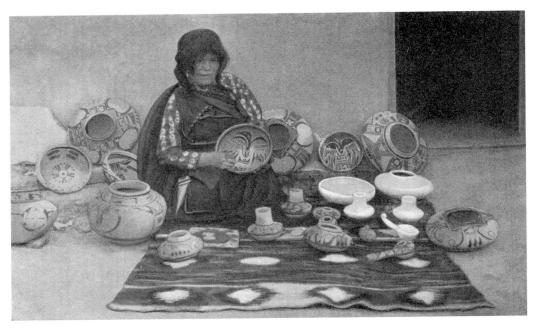

Plate 1 Nampeyo and pottery, photochrom postcard based on a photograph taken in 1901 by Adam Clark Vroman

to seek out Nampeyo, "the best potter in all Moki-land."[2] Aided by the sale of more than 42,000 copies of the Hough's booklet from Fred Harvey Company museums and gift shops, by 1902 Nampeyo's work had become synonymous with Hopi pottery.

Dealers in Native arts emphasized aspects of the story that promoted the quality of Nampeyo's pottery and served to increase sales of her work. Tourists repeated the trader versions of the tale which tended to emphasize Nampeyo as a superior artist and creator of the revival. Adam Clark Vroman's 1901 photograph, "Nampeyo, Hopi Pottery Maker" (Plate 1) was often reproduced as an illustration and on postcards. The Detroit Photographic Company transformed Vroman's black and white print into a full-color photochrom postcard that circulated widely. Soon the popular version of the legend was little more than a photographic icon on a postcard.

Fewkes developed a second version of the Revival: an anthropological interpretation of Nampeyo's work based on his assessment that contemporary Hopi pottery was mediocre. Fewkes generalized that "certainly the entire Pueblo culture . . . judged by the character of their pottery manufacture, has greatly deteriorated since the middle of the sixteenth century."[3] This judgment placed Fewkes's archaeological activities in the position of rediscovering true "Hopi-ness" from the period before Spanish colonization. He concluded, in the *Annual Report* of the Smithsonian Institution for the Year 1895, that his Sikyatki excavation brought a measure of historic enlightenment to the Hopi. Fewkes stated that:

> The best potter from the East mesa . . . an intelligent woman named Nampio, acknowledged that her productions were far inferior to those of the women of Sikyatki, and she begged permission to copy some of the decorations for future inspiration.[4]

According to Fewkes, without the intervention of archaeologists, the inhabitants of First Mesa had only meager knowledge of their cultural past. Fewkes used his version of the Nampeyo legend to enhance the scientific importance of his discoveries at Sikyatki.[5]

Fewkes also alleged that contemporary Pueblo pottery was sometimes sold as antiquities. He stated with great indignity that "it has come to be a custom for the Hopi potters to dispose of, as Sikyatki ware, to unsuspecting white visitors, some of their modern objects of pottery."[6] Fewkes assumed intellectual ownership of the designs from his discoveries and apparently expected that the Hopi would also treat the designs in an academic, noncommercial manner, hence the need for Nampeyo to beg permission to make drawings of prehistoric Hopi design elements. Thus acceptable behavior to Fewkes included removing ritual objects from Hopi graves for scholarly purposes, but not allowing the Hopi to capitalize on their past.

A third variation of the popular myth, the aesthetic explanation, lauded Nampeyo's artistic presence and diminished the role of both anthropologists and traders. In 1929 Ruth Bunzel developed the prototype for this revisionist explanation when she stated that "there is no doubt that it was Nampeyo and not the traders and ethnologists who was responsible for the Revival of the Sikyatki style." She interpreted the Nampeyo legend in terms of artistic genius which produced "those sudden mutations in style that mark the history of the arts among all peoples." Bunzel believed that "the original stimulus came from outside," but argued that it was "Nampeyo's unerring discrimination and lively perception that vitalized what would otherwise have been so much dead wood."[7] While this model strived to empower the artistic sensibilities of Native peoples, it offered a simplistic explanation of a complex cross-cultural phenomenon.

A fourth explanation of the Revival, an economic argument, correlated the development of a market economy at Hopi with the changes in Hopi pottery. Fewkes had noted the role of commercial markets in the beginnings of the Revival.

Archaeologists Alfred E. Dittert, Jr. and Fred Plog emphasized the economic interpretation of the Sikyatki Revival in their 1980 book *Generations in Clay*. Following the popularity of materialist anthropological explanations after the 1960s, they noted that Nampeyo "responded to the new commercial stimulus and not only reproduced good pottery but continued to improve it." They based their explanation on the assumption that historic period Hopi ceramics were "somewhat decadent" when compared with past products. They observed that First Mesa became an important market for pottery only after Thomas Keam established his trading post in 1875 and encouraged the development of quality wares.[8]

Over the years a conventional wisdom developed which implied scholarly agreement that the Revival began with Fewkes's Sikyatki excavation in 1895. This superficial agreement over the "facts" served to minimize the conflict between analyses, commentaries, and conclusions. Nonetheless, by the 1960s it became clear that the four versions of the Nampeyo story contradicted each other.

The process of reassessing the Nampeyo legend to resolve these contradictions began with Theodore R. Frisbie's 1973 essay "The influence of J. Walter Fewkes on Nampeyo: Fact or Fancy?" After summarizing the bibliographic data, he carefully analyzed the published descriptions of Nampeyo and her activities. Frisbie correctly associated Nampeyo's pre-Revival pottery with painted Kachina designs, suggested that the Revival began before Fewkes's 1895 excavations at Sikyatki, and noted that Fewkes's associate Walter Hough collected examples of the new Revival pottery in 1896. Frisbie suggested that Fewkes began with an "aloof but permissive" attitude which deteriorated to "distrust," and finally degenerated into warnings about "potential dangers of Revival pieces." He concluded that Fewkes did little to assist Nampeyo and argued that their relationship was so contradictory that it remained "a topic worthy of further study."[9]

In 1980, Edwin Wade and Lea S. McChesney confirmed some of Frisbie's conclusions in *America's Great Lost Expedition: The Thomas Keam Collection of Hopi Pottery from the Second Hemenway Expedition, 1890–1894*. The exhibition catalogue presented a sizable collection of historic and prehistoric Hopi pottery, which trader Thomas Keam sold to philanthropist Mary Hemenway in April 1892. After Hemenway's death in 1894, the Keam material was given to the Peabody Museum at Harvard University, where it languished for decades until Wade and McChesney began to organize it in the 1970s.

Wade and McChesney refuted Fewkes's contention that the Sikyatki Revival originated with his 1895 expedition. Their research demonstrated that Keam had commissioned the production of replicas from the vessels that he had excavated from nearby ruins. Keam included these replicas along with the corresponding prehistoric models in the selection from the collection sold to Hemenway. They also noted that Keam did not record the name of the potter, or potters, who worked on his replication project and speculated that it was possibly Nampeyo.[10] They also believed that the variety of the replicas indicated that more than one potter was involved with the replica project.

In 1996, Barbara Kramer published a detailed biography of Nampeyo which sought to identify the inaccurate details of the artist's life that had become part of the "common knowledge."[11] The resulting biography presented a fascinating portrayal that clarified the complexities of Nampeyo's life. Kramer noted ten inconsistencies between the Nampeyo legend, published biographical notes, and the art history of Nampeyo's pottery. For example, she accurately contended that the origin of the Revival predated Fewkes's Sikyatki excavation. On the other hand, Kramer underestimated Keam's role and argued against Wade and McChesney's conviction that Keam played "a major role in the Revival of ancient pottery styles."[12]

Nonetheless, critical questions still remain. Did Nampeyo make the replicas in the Hemenway Collection? Did she really copy the forms and designs from Sikyatki excavations? Were her works sold as antiquities? Why did Fewkes seem to support Nampeyo's efforts in the beginning, but then turn against her? By carefully comparing the legend with documentary evidence it is possible to answer these these questions.

Did Nampeyo make the Keam replicas?

Written evidence associated with the Nampeyo pottery collected by Hough in 1896, now in the National Anthropological Archives, supports the conclusion that Nampeyo participated in Keam's replication project. The catalogue card for object 158,143 states "written on base by Dr. Hough: 'copy of ancient jar in Hemenway coll. by Nampeo.' "[13] This notation confirms that Nampeyo participated in Keam's project and verifies that Fewkes and Hough knew that Nampeyo worked from the prehistoric designs in the Keam Collection. However, this conclusion does not rule out the possibility that other potters were involved.

Did Nampeyo copy the designs from Sikyatki ruins?

In 1896 Fewkes and his assistant Hough excavated a series of sites to prove that the designs on prehistoric Hopi pottery would confirm the migration myths of the Hopi clans. In the preliminary report on his activities from 1896, Fewkes stated that he continued "the lines of investigation inaugurated in the summer of 1895" into the claim of the Patki family "that their ancestors lived near

Winslow and at Chaves Pass."[14] Fewkes concluded that his research demonstrated that "the Patki or some other Moki family once lived at Homolobi."[15]

During the summer of 1896, Nampeyo created a second group of modern works based on prehistoric designs. The models for several of these pieces can be found in the collections that Fewkes and Hough made at Old Cuñopavi, on Second Mesa, in 1896. In some cases Nampeyo replicated the physical form of an unusual piece; other times she painted designs derived from these prehistoric vessels on her own low bowl forms. Fewkes published drawings of two vessels from the Old Cuñopavi excavation in his preliminary site report, vessels which Nampeyo replicated during the summer of 1896. One unusual vessel had a stump "snout" and was painted with an anthropomorphic bird figure and gambling reeds (Plate 2). Nampeyo copied the form of the shallow snout bowl, but slipped it with a crackly Polacca slip and painted the vessel with a pre-Sikyatki-Revival Kachina mask image (Plate 3). For another bowl she adapted the anthropomorphic bird from the prehistoric snout bowl on one of her vessels, but added a face with headdress when she painted this figure on a Revival-style bowl with a hanging lug (Plate 4). This low bowl featured an upturned rim and a polished kaolin slip that fired a smooth, shiny white. Nampeyo also copied a bird design from a vessel that Fewkes later published in the preliminary report on his activities in 1896 (Plate 5). This figure was reproduced exactly, on the inside of another low Revival bowl, which was finished with a polished, smooth, shiny kaolin slip (Plate 6). The painting on the outside of this piece presented two feather and line designs that were taken from a bowl excavated in 1895 at the Sikyatki ruin. Hough collected these three bowls as part of his research activities in 1896.

These vessels express a high degree of experimentation. They include three different slips, four discernible shapes, as well as a variety of designs including anthropomorphic figures, Kachina masks, and abstract feather motifs. However, the most important aspect of Nampeyo's vessels in the Hough Collection is their close relationship to specific pieces of prehistoric pottery excavated during the two-day dig at Old Cuñopavi in 1896. Their close similarity demonstrates that Nampeyo worked directly from the ancient vessels. She quoted their designs and forms as if from a cultural menu.

Occasionally Nampeyo used minor elements that may be traced to vessels from Fewkes's 1895 excavations at Sikyatki. However the excavation at Old Cuñopavi appears to have been the more important influence on Nampeyo's development.

Did Nampeyo promote her work as ancient?

Fewkes worried that Nampeyo's modern works could be mis-identified as ancient and sold by deceitful individuals as prehistoric pottery. "There is a danger," he wrote, "that in a few years some of Nampeo's imitations will be regarded as ancient Hopi ware" of the second epoch.[16] It is unlikely that Nampeyo, who did not speak English, actually promoted her work as prehistoric. However, the traders did.

Horace S. Poley donated a bowl to the Colorado Springs Pioneer Museum (Plate 7) that appears to be an example of what Fewkes feared: a modern piece that had been sold as an antiquity. Although an informant from the Hopi village of Walpi told Poley that the bowl was from the Tokonabi region of the Navajo National Monument and had been used in the Snake Dance rituals, close inspection indicates that Nampeyo probably made this piece. The bowl, which Poley collected in 1908, bears a strong resemblance to a modern bowl made by Nampeyo and collected by Hough in 1896 (National Museum of Natural History 158, 146) and to a prehistoric bowl sold by Keam as part of the Hemenway Collection (Peabody Museum 44–13–10/27101). The Poley bowl appears to have been

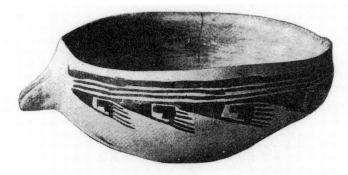

BOWL WITH SNOUT.
(Cuñopavi, No. 157817.)

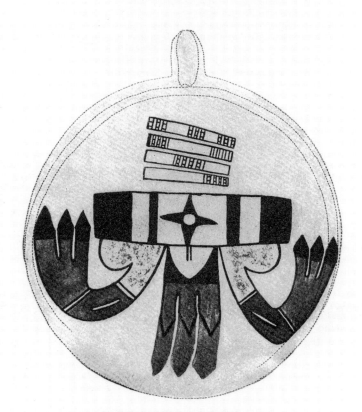

GAMBLING REEDS, AND BIRD.
(Cuñopavi, No. 157735.)

Plate 2 Bowl with snout, painted with gambling reeds and bird, plate XLVIII from Fewkes's "Preliminary account of an expedition to the cliff villages of the Red Rock Country, and the Tusayan ruins of Sikyatki and Awatobi, Arizona, in 1895" (1897)

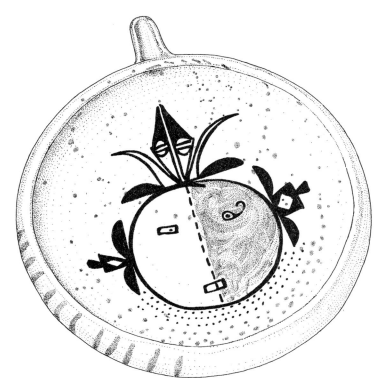

Plate 3 Nampeyo's snout-
nose bowl with Kachina
mask image, collected by
Walter Hough in 1896.
Drawing by Robert Turner

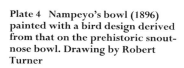

Plate 4 Nampeyo's bowl (1896)
painted with a bird design derived
from that on the prehistoric snout-
nose bowl. Drawing by Robert
Turner

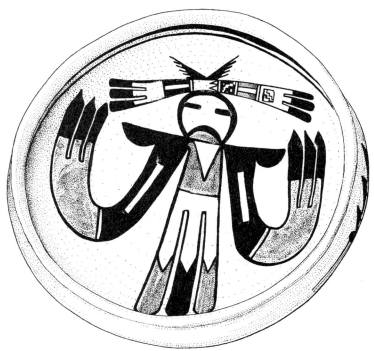

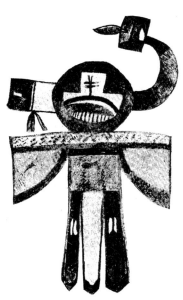

Plate 5 Bird design on a vessel excavated at Old Cuñopavi, plate XLVII in Fewkes's report of 1897

BIRD DESIGN.
(Cuñopavi, No. 157795.)

Plate 6 Nampeyo's bowl (1896) painted with a figurative design derived from the prehistoric bowl from Old Cuñopavi. Drawing by Robert Turner

intentionally antiqued with dirt and abrasions to disguise its modern origins; the crackly white slip on it clearly identified it as a turn-of-the-century production.

Outsiders not accustomed to Pueblo pottery had difficulty distinguishing between ancient and modern productions. The catalogue card for Nampeyo's vessel 158,155 at the National Museum of Natural History notes that it was "originally in archaeology collections as 'Prehistoric, Wolpi, Arizona'" and was "transferred" to the Bureau of Ethnology when it was shown to be modern. Obviously, Nampeyo's Revival wares were so similar to prehistoric pieces that they even fooled the museum staff, demonstrating how easily modern works could be sold as antiquities to naive buyers.

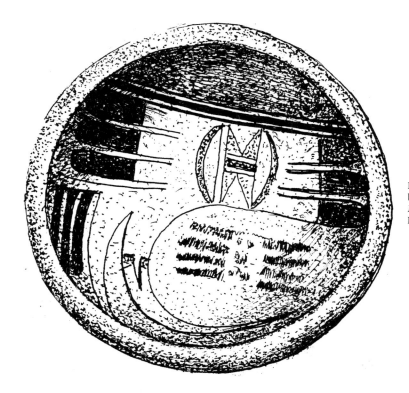

Plate 7 Nampeyo, Sikyatki Revival bowl, n.d., Colorado Springs Museum. Gift of Horace S. Poley. Drawing by Daryl Grene

Did Fewkes understand the history of Hopi ceramics?

The complex relationship between Fewkes and Nampeyo was undoubtedly tied to Fewkes's assumption that prehistoric pottery designs were clan specific and were handed down from mother to daughter. The theoretical source for correlating clan symbols with pottery designs came from Alexander Stephen's catalogue of Keam's pottery collection. Fewkes copied this catalogue in 1890 and was obviously influenced by the detail of Stephen's ethnographic research. However, working backward into prehistory was not as simple as identifying contemporary symbols from the 1890s.

As a young scientist he went to the Hopi region to prove that the oral histories of clan migrations could be confirmed by the archaeological record. According to the legends that Alexander M. Stephen collected during the 1880s and early 1890s, the Hopi villages developed from aggregations of clan groups that came from many parts of the Southwest. Fewkes believed that he could trace clan symbols on painted pottery from various prehistoric sites.

According to Fewkes's chronology, which separated Hopi history in into three stages, the first epoch was a pre-Hopi period of migrations when clans moved throughout the Southwest. The second period was the Keresan epoch which began with the founding of the Hopi villages. The Keresan epoch ended with the destruction of Sikyatki before Spanish contact, and the abandonment of Awatobi in 1702. The third period began after the Pueblo revolt in 1680 when Tewa clans from the northern Rio Grande Valley in New Mexico settled at First Mesa and founded the village of Hano. The Tanoan epoch lasted until the middle 1890s, when the Sikyatki Revival marked the beginning of the fourth epoch.

Migrations in the early eighteenth century brought Tewa pottery and design elements to Hopi. These forms completely supplanted the Sikyatki bird and animal motifs associated with the previous Keresan epoch. Fewkes concluded that the development of Kachina representations on ceramic objects was a visual manifestation of the influence of these new Tewa clans at Hopi. He tied this historic development to Nampeyo's work by stating that "the most common figure on the third epoc of Hopi pottery . . . and manufactured up to 1895 by Nampeo, a Hano potter, is a representation of the Corn Maid, Shalako mana."[17]

By the time that Fewkes arrived at the Hopi mesas in 1891, the painting of mask imagery on bowls, canteens, and tiles was considered to be part of the visual idiom. He misinterpreted the duration of the production of painted Kachina designs on pottery and viewed these pieces as diagnostic symbols of what he called the Tanoan epoch. It seems that the Kachina representations on pottery only occurred after the establishment of Keam's trading post, but Fewkes did not interpret their appearance as a commercial development. Instead, he viewed mask imagery in terms of cultural epochs and corresponding design elements. While conclusive information is lacking, circumstantial evidence points to Keam as the popularizer and promoter of mask paintings. Fewkes overlooked this possibility. Instead, he was so convinced of his anthropological assumptions about Hopi history that he blindly forced his data to fit his theoretical model.

Why did Fewkes mis-state the history of the Revival?

Each of the explanations of the Sikyatki Revival centered on differing forms of authenticity, sought contrasting definitions of cultural purity, and rejected indigenous objects that had been tainted by non-native cultural interaction. The popular culture tale promoted the belief that the Revival designs were "authentic" Hopi designs because the source vessels for the Revival had not been altered by interaction with Hispanic or European-American designs. This nineteenth-century belief made Nampeyo's modern work "genuine," and thus highly collectable. Simultaneously, the idea of "copying" diminished the value of the resulting artworks.

The anthropological version prioritized ancient designs over modern adaptations and affirmed Victorian-era aesthetic judgments about Pueblo pottery. The economic interpretations of the Sikyatki Revival emphasized the power of the market over Native aesthetics, and defined ethical behavior for the use of prehistoric designs based on capitalist values. Meanwhile, the artistic version of the Revival legend contradicted the economic assessments and confirmed the ability of Native artists to transcend the social context of external financial pressures.

The actual history of the Sikyatki Revival contradicted both popular and academic versions of the Nampeyo legend. The origins began with Keam, not Fewkes; Nampeyo worked on the replication project that Keam organized; she copied objects excavated from Old Cuñopavi in 1896; traders did sell Nampeyo's works as antiquities, but even musuem catalogers had difficulty differentiating between old and new pieces. Fewkes and his assistant Hough knew these details and chose not to reveal them. They consciously withheld details that could have prevented a century of misconceptions. Fewkes knowingly constructed an incomplete explanation of Nampeyo's activities for the Smithsonian's annual report for 1895, repeated his biased description of Nampeyo in the Sikyatki site report, and reconfirmed his interpretation of the Revival in his 1919 essay about Hopi pottery designs.

That Nampeyo worked in 1896 from two vessels that were published in 1898 indicates that Fewkes was not a passive participant in this process. Did Nampeyo work from these pieces because

they were important to Fewkes, or did they become important to Fewkes because a Native potter found them interesting? Or dld Fewkes, like Keam, commission the fabrication of replicas from these two vessels? How did Nampeyo, who lived on First Mesa, get access to artifacts that were excavated on Second Mesa? It is impossible to answer these questions at this time, but it seems plausible that Fewkes or Hough commissioned the production of some of Nampeyo's works that were collected during that summer.

Now that these details are known, the question is why a respected scholar would consciously mislead readers. Wade argued that Fewkes altered the tale to protect his anthropological reputation. He noted the popularity of Nampeyo's wares, which "swept away the 'valid' ceramic tradition" that Fewkes was studying.[18] Wade implied that if Fewkes were directly connected with the promotion of Nampeyo's pottery, then he could be accused of meddling with Native culture and abandoning his scientific objectivity. While maintenance of scientific reputation is a plausible explanation, it does not explain why Fewkes did not tell the truth and blame Keam. Instead, Fewkes repeatedly emphasized in print that he allowed Nampeyo to sketch from his discoveries. Nor did Wade's conclusion explain why Fewkes allowed his assistant Hough to purchase Nampeyo's work in 1896, and to accession these pieces into the collection of the National Museum of Natural History.

A more fundamental explanation for Fewkes's descriptions of the Revival is that Nampeyo's work with prehistoric designs refuted assumptions underpinning Fewkes's research into Pueblo pottery, Hopi origin myths, and Tusayan prehistory. As stated previously, Fewkes based his research on the belief that pottery designs were clan-based, passed from mother to daughter, culturally diagnostic, and indicative of clan migrations. Nampeyo, however, was born to a Hopi father and a Tewa mother who was related to immigrants from the northern Rio Grande valley in New Mexico. According to Fewkes's schema, Nampeyo should have been denied the use of Hopi designs because she was Tewa. Thus a Tewa potter was responsible for reviving Hopi designs that had been taken from Hopi graves at Old Cuñopavi. This would not have happened if Fewkes's ethnographic assumptions were correct.

In short, Nampeyo's actions compromised the validity of Fewkes's archaeological research. If Nampeyo could copy Hopi clan symbols, why couldn't other non-Hopi potters also replicate their ceramic styles and designs? Similarly, if Fewkes blamed Keam for the Revival, that would indicate that Hopi pottery designs were commodities, which also invalidated Fewkes's research assumptions. It was not until after the 1896 field season, when Nampeyo copied directly from exotic vessels excavated at Old Cuñopavi, that Fewkes realized the frailty of his ethnographic assumptions. Fewkes never returned to his promising research into Hopi migrations after the 1896 season. Over a decade later he presented his theory and a catalog of pottery design elements in his essay "Designs on prehistoric Hopi pottery," but did not address the theoretical problems in his research.

The versions of the Nampeyo legend use aspects of western academic thought to validate facets of Hopi pottery and its social context. At the same time, these permutations of a popular story blend endorsement and criticism into a legend which ultimately affirms the intellectual dominance of western scholars over Native potters and their wares. The relationship between Fewkes and Nampeyo raises important issues of academic distance, cultural interference, and scholarly ethics. It is not useful to hold Fewkes's nineteenth-century research to twentieth-century values, but it is valuable to investigate how anthropologists and art historians have wrestled with these issues. After a century of confusion it is still possible to correct some of the myth-understandings promoted by Fewkes about Nampeyo and the Sikyatki Revival.

Notes

1 J. J. Brody, *Indian Painters and White Patrons* (Albuquerque, NM: University of New Mexico Press, 1971), p. 67.

2 Walter Hough, *The Moki Snake Dance* (Chicago: Passenger Department, The Santa Fe Railway, 1898), p. 48.

3 J. Walter Fewkes, "Archaeological Expedition to Arizona in 1895," *Seventeenth Annual Report of the Bureau of American Ethnology to the Secretary of the Smithsonian Institution, 1895–96* (Washington, DC: Government Printing Office, 1898), p. 651.

4 J. Walter Fewkes, "Preliminary Account of an Expedition to the Cliff Villages of the Red Rock Country, and the Tusayan Ruins of Sikyatki and Awatobi, Arizona, in 1895," *Annual Report of the Board of Regents of the Smithsonian Institution showing the Operations, Expenditures, and Condition of the Institution to July 1895* (Washington, DC: Government Printing Office, 1897), p. 577.

5 Fewkes's derogatory comments about Hopi pottery and culture expressed the influence of Lewis Henry Morgan's evolutionary theories. Morgan had postulated three stages of human evolution and used the trait of pottery-making as one of the criteria for differentiating savagery and barbarism from civilization. Fewkes's assessment that the quality of Hopi pottery had declined also implied that Hopi culture had declined during the recent centuries of the Spanish colonial period.

6 Fewkes, "Archaeological Expedition to Arizona," p. 632.

7 Ruth Bunzel, *The Pueblo Pottery: A Study of Creative Imagination in Primitive Art*. (New York: Dover Publications, 1972), pp. 83, 88.

8 Alfred E. Dittert, Jr. and Fred Plog, *Generations in Clay: Pueblo Pottery of the American Southwest* (Flagstaff, AZ: Northland Press), pp. 30–31. Dittert and Plog's materialist explanation implied that Hopi potters responded when they correctly assessed the commercial potential of prehistoric shapes, surfaces, colors, and design elements. During the 1880s, archaeologists, curators, and middlemen purchased literally thousands of pieces of Hopi pottery for museum collections around the world. These collectors often sought "authentic" Hopi pieces – those works made before the influences of Spanish forms and Zuni designs. Nonetheless, it was the traders who often provided the ancient pottery sought by the anthropologists. Lorenzo Hubbell's 1905 mail order catalogue from his trading post at Ganado, Arizona, underscored this point. He priced his collections of prehistoric pottery at $2.50 to $10.00, but sold Nampeyo's work for only $0.50 to $10.00. Pottery by other Hopi went for only $0.25 to $5.00 (J. L. Hubbell, *Navajo Blankets & Indian Curios* (Ganado: Hubbell Trading Post, 1905 repr. US Park Service, no date), unpaginated.

The search for heirloom and prehistoric pieces, combined with the aesthetic assessment that 1880s Hopi crackle wares were inferior, created the antiquities market that affected both dealers and potters. Keam's excavations at prehistoric ruins increased the supply of antiquities after the heirloom pieces were no longer available at the Hopi villages. However, Dittert and Plog's economic explanation missed an opportunity to analyze how the traders met the demand for prehistoric wares, a market that the anthropologists created through their collecting policies.

9 Theodore R. Frisbie, "The Influence of J. Walter Fewkes on Nampeyo: Fact or Fancy?", in Albert Schroeder (ed.) *The Changing Ways of Southwestern Indians* (Glorieta, NM: Rio Grande Press, 1973), p. 238.

10 Edwin L. Wade and Lea S. McChesney, *Historic Hopi Ceramics: The Thomas V. Keam Collection of the Peabody Museum of Archaeology and Ethnology, Harvard University* (Cambridge, MA: Peabody Museum Press, 1981), p. 455.

11 Barbara Kramer, *Nampeyo and Her Pottery* (Albuquerque, NM: University of New Mexico Press, 1996), p. x.

12 Kramer, *Nampeyo and Her Pottery*, p. 190.

13 Unfortunately this object could not be located when I visited the archive in 1990. Is it possible that this piece was renumbered and is in fact bowl 158,146 collected by Hough in 1896, which does appear to be a copy of bowl 43–39–10/25101 from the Keam Collection at the Peabody Museum?

14 J. Walter Fewkes, "Preliminary Account of an Expedition to the Pueblo Ruins Near Winslow, Arizona in 1896," *Annual Report of the Regents of the Smithsonian Institution Showing the Operations, Expenditures and Condition of the Institution to July, 1896* (Washington, DC: Government Printing Office, 1898), p. 519.

15 Fewkes, "Preliminary Account of an Expedition to the Pueblo Ruins Near Winslow, Arizona in 1896," p. 520.

16 J. Walter Fewkes, "Designs on Prehistoric Hopi Pottery," *Thirty-third Annual Report of the Bureau of American Ethnology to the Secretary of the Smithsonian Institution, 1911–1912* (Washington, Government Printing Office, 1919), pp. 207–84 (repr. in *Designs on Prehistoric Hopi Pottery* (New York: Dover Publications, 1973), p. 218).

17 J. Walter Fewkes, "Designs on Prehistoric Hopi Pottery," *Thirty-third Annual Report of the Bureau of American Ethnology to the Secretary of the Smithsonian Institution, 1911–1912* (Washington: Government Printing Office, 1919), pp. 207–84 (repr. in *Designs on Prehistoric Hopi Pottery* (New York: Dover Publications, 1973), p. 275).

18 Edwin L. Wade, "The Ethnic Art Market in the American Southwest, 1880–1980," in George W. Stocking, Jr. (ed.) *Objects and Others: Essays on Museums and Material Culture* (Madison, WI: University of Wisconsin Press, 1985), p. 174.

Bibliography

Ashton, Robert, Jr. (1976) "Nampeyo and Lesou," *American Indian Art* 1/3 (Summer): 24–33.

Brody, J. J. (1971) *Indian Painters and White Patrons*, Albuquerque, NM: University of New Mexico Press.

Bunzel, Ruth (1929) *The Pueblo Potter: A Study of Creative Imagination in Primitive Art*, New York: Columbia University Press (repr., New York: Dover Publications, 1972).

Casagrande, Louis B. and Phillips Bourns (1983) *Side Trips: The Photography of Sumner W. Matteson, 1898–1908*, Milwaukee, WI and Minneapolis, MN: Milwaukee Public Museum and the Science Museum of Minnesota.

Dittert, Alfred E., Jr. and Plog, Fred, (1980) *Generations in Clay: Pueblo Pottery of the American Souhwest*, Flagstaff, AZ: Northland Press.

Dorsey, George A. (1903) *Indians of the Southwest*, Chicago, IL: Passenger Department, Atchison, Topika & Santa Fe Railway System.

Fewkes, J. Walter (1897) "Preliminary Account of an Expedition to the Cliff Villages of the Red Rock Country, and the Tusayan Ruins of Sikyatki and Awatobi, Arizona, in 1895," *Annual Report of the Regents of the Smithsonian Institution showing the Operations, Expenditures, and Condition of the Institution to July, 1895*, Washington, DC: Government Printing Office, pp. 557–88.

—— (1898) "Archaeological Expedition to Arizona in 1895," *Seventeenth Annual Report of the Bureau of American Ethnology to the Secretary of the Smithsonian Institution, 1895–96*, Washington, DC: Government Printing Office, pp. 631–728 (repr. in *Designs on Prehistoric Hopi Pottery*, New York: Dover Publications, 1973).

—— (1898) "Preliminary Account of an Expedition to the Pueblo Ruins Near Winslow, Arizona, in

1896," *Annual Report of the Regents of the Smithsonian Institution showing the Operations, Expenditures, and Condition of the Institution to July, 1896*, Washington, DC: Government Printing Office, pp. 517–40.

—— (1919) "Designs on Prehistoric Hopi Pottery," *Thirty-third Annual Report of the Bureau of American Ethnology to the Secretary of the Smithsonian Institution, 1911–1912*, Washington: Government Printing Office, pp. 207–84 (repr. in *Designs on Prehistoric Hopi Pottery*, New York: Dover Publications, 1973).

Frisbie, Theodore R. (1973) "The Influence of J. Walter Fewkes on Nampeyo: Fact or Fancy?" in Albert Schroeder (ed.) *The Changing Ways of Southwestern Indians*, Glorieta, NM: Rio Grande Press.

Hough, Walter (1898) *The Moki Snake Dance*, Chicago: Passenger Department, The Santa Fe Railway (reprint, with an introduction by Joseph Traugott, Albuquerque, NM: Avanyu Publishing, 1992).

—— (1915) *The Hopi Indians*, Cedar Rapids, IA: The Torch Press.

Hubbell, J. L. (1905) *Navajo Blankets & Indian Curios*, Ganado: Hubbell Trading Post, unpaginated, (repr. by US Park Service, no date).

James, George Wharton (1901) "Indian Pottery," *The House Beautiful* 9/5 (April), pp. 235–43.

Kramer, Barbara (1996) *Nampeyo and Her Pottery*, Albuquerque, NM: University of New Mexico Press.

Patterson, Alex (1994) *Hopi Pottery Symbols*, Boulder, CO: Johnson Books.

Wade, Edwin L. (1981) *Historic Hopi Ceramics: The Thomas V. Keam Collection of the Peabody Museum of Archaeology and Ethnology, Harvard University*, Cambridge, MA: Peabody Museum Press.

—— (1985) "The Ethnic Art Market in the American Southwest, 1880–1980," in George W. Stocking, Jr. (ed.) *Objects and Others: Essays on Museums and Material Culture*, Madison, WI: University of Wisconsin Press.

Wade, Edwin L. and McChesney, Lea S. (1980) *American Great Lost Expedition: The Thomas Keam Collection of Hopi Pottery from the Second Hemenway Expedition 1890–1894*, Phoenix, AZ: Heard Museum.

Webb, William and Weinstein, Robert A. (1973) *Dwellers At the Source: Southwestern Indian Photographs of A. C. Vroman, 1895–1904*, New York: Grossman Publishers.

Chapter two
David W. Penney and Lisa Roberts

America's Pueblo Artists
Encounters on the Borderlands

The young watercolor painters of the southwest Pueblos who began to paint images of traditional dances shortly after World War I are often thought of as the "first," "modern" American Indian artists. They were not the first Native people to produce pictures with watercolors on paper; Plains ledger book artists had already been doing so for decades. They were not the first Native Americans self-consciously to model themselves as "artists" in the traditional, Euro American sense of the word. They were the first, however, to operate within the mainstream art world of early modernism in America, so in that sense the appellation, "first modern American Indian artists" is correct. The work was widely exhibited throughout the 1920s and 1930s in New York City and elsewhere. Critics and writers discussed Pueblo paintings and constructed a discursive framework for evaluating and understanding them. Without question, the style and content of the paintings and the words that were written about them had a profound, formative influence on succeeding generations of artists of Native American ancestry, one that is still felt by many even today.

When the works of these young painters entered into the art world of mainstream America, they stepped into the "frontier," or "contact zone" between Pueblo communities and the outside world. Mary Louise Pratt uses this term to describe "the space of colonial encounters, the space in which peoples geographically and historically separated come into contact with each other and establish ongoing relations, usually involving conditions of coercion, radical inequality, and intractable conflict."[1] Although Pueblo people had contended with the problems of the contact zone ever since Spanish settlement during the 1500s, their relations with the outside world entered a new phase when they were confronted with the increasing pace of American (or "Anglo") penetration and settlement of their traditional environment. Prominent historical events in this process would include the construction of the Santa Fe railroad system of the 1880s and the moment when the territory of New Mexico was admitted to the Union in 1912. The encounters between Anglo and

Pueblo transformed both and, interestingly enough, it is possible to see how the mutual fashioning of a modern Pueblo "art" played a mediating role in a difficult, contentious, and for Pueblo people, often threatening and dangerous, relationship between them. Anglo supporters of Pueblo sovereignty, such as it could be conceived by them, promoted Pueblo art as a strategy in support of Pueblo cultural survival. Talented members of Pueblo communities refashioned themselves, as much as possible or desirable, into "artists" in the Anglo understanding of the term.[2] Anglo enthusiasts of Pueblo "art" saw a potential for transforming American art by establishing an indigenous, autochthonic foundation for an American tradition of subject matter and content independent of Europe.[3] These strategic agendas helped shape the circumstances by which Pueblo watercolors could be produced and how they were seen and understood.

The matter is not as simple as the title of J. J. Brody's book about these artists, *Indian Painters and White Patrons*, might suggest, since the relationships between the producers, promoters, and consumers of Pueblo watercolors were dialogic and collaborative, as most "border" encounters tend to be. Although Pueblo artists created the work, many others contributed incentives and pressures to help shape it. From the beginning, critical discussion of the paintings was about a polarity of values that contrasted an indigenous/authentic identity with an assimilated/inauthentic one, a ploy that we will argue here was consciously intended to obscure the collaborative interactions between Pueblo artists and their Anglo patrons. We believe a more accurate understanding of their dialogic relations can be gained by scrutinizing more carefully the processes of encounter, reflection, and expression, what Pratt has described as the "mirror dance" of the contact zone.

Who were the producers, promoters, and consumers of the "first modern Native American art"? The artists, by and large, were products of the border world. The more senior, early, watercolor artists such as Crescencio Martinez and Julian Martinez had participated in the frontier commerce of tourist art. These male painters began by collaborating with their wives to produce painted pottery for sale. The younger artists, including Tonita Peña, Roybal, and Fred Kabotie, by and large, began painting as teenagers when students in day schools and boarding schools, where they received encouragement and support from teachers. The government policies that established the schools had been designed to indoctrinate Pueblo children with American "civilization" and convert them into citizens. The schools were part of the institutional policies set in motion by the Dawes Act of 1887, also known as the Allotment Act, which was intended to impose acculturating education, discourage traditional religious ceremonialism, and eliminate tribal principles of land tenure to replace them with the laws of private ownership, a policy which in practice resulted in white confiscation or purchase of reservation lands. Government Indian policy of the period between 1887 and the early 1920s was designed to break up the "great tribal mass," as Teddy Roosevelt called it, and speed the assimilation and absorption of Native societies into the American mainstream. One might argue that this episode was conceived by its designers as the last phase of the "conquest" of North America, although few at that time may have thought to use that word.

The female teachers who worked with the earliest generation of artists, Esther B. Hoyt at the San Ildefonso day school and Elizabeth DeHuff, wife of the superintendent at the Santa Fe Indian School, are better understood as part of the "anti-conquest," as Pratt calls it, "the strategies . . . whereby European bourgeois subjects seek to secure their innocence in the same moment they assert European hegemony."[4] Their encouraging attitude toward their students' art was in direct conflict with institutional policy of the government schools. The teachers were part of a larger community of Anglo authors, artists, arts patrons, and social activists, who arrived in the Santa Fe and Taos area

after World War I and took a confrontational stance against the aggressive interventions into Pueblo community life stemming from government policy. Through their political activism, they secured their innocence from the more overt acts of conquest. They fought to "preserve" Pueblo culture, however, because of a perception of its value to America, as a uniquely American "contribution" to the world. Their hegemonic prerogative to claim colonized cultures as national possessions for "mankind," for "science," and for the sake of "knowledge" characterizes the anti-conquest. Of additional significance for us here was their hegemonic perception of the possibility of a Pueblo "art," in the European sense of the term, both as a cultural endeavor and as an economic activity.

This possibility grew from long-standing commerce between Pueblo artisans and the outside world, which after 1880 began more and more to meet the market demand for touristic commodities. The intermediaries in this commerce, the traders, vacillated between economic exploitation and genuine assistance and support, the conquest and anti-conquest, all in the name of good business. The career of Thomas Keams, who in 1873 established a trading post at Keams Canyon twelve miles from Walpi, amply illustrates the ambiguities of the trader relationship. It is conceded, generally, that Keams felt warmly toward the Hopi and genuinely believed he worked on their behalf. He supplied the Hopi villages with manufactured supplies and bought Hopi pottery and other crafts to sell to the tourists who came by railway to Flagstaff (after 1882). His trading post was also the initial foothold for the intrusion of government policy among the Hopi: the first agency building was constructed there in 1874 and Keams Canyon eventually became the seat for the administration of the Hopi reservation (established in 1882 but not posted until 1887). Keams also played an active role in the creation of a Hopi boarding school at the agency, working closely with Protestant missionaries who opened the school, and he assisted government agents in enforcing the attendance of Hopi children. He did this as a proponent of the "progressive" movement of the Hopi into the modern world, which to his understanding, meant urging Hopi participation in capitalist economy as wage earners. He employed graduates of the school at Keams Canyon and worked with the Protestant mission to find female graduates jobs as maids. His efforts with Hopi potters show parallel strategies to engage them with the marketplace. By the early 1880s Keams had single-handedly converted First Mesa domestic pottery production to decorated, commercial wares. He also commissioned replicas of archaeologically recovered Sikyatki polychrome and San Bernardo polychrome vessels, thereby spawning the "Revival style" made famous by the Tewa-Hopi potter Nampeyo and others.[5]

Keams was one of many traders in the Southwest who worked directly with artisans to fashion successful tourist commodities. Above all, the tourist demands authentic experiences and Keams worked to satisfy that desire by legitimizing contemporary Hopi pottery craft with more "authentic," historical models. The potters who engaged in these acts of touristic self-representation created what Pratt calls, "autoethnography," those "instances in which colonized subjects undertake to represent themselves in ways that engage with the colonizer's own terms."[6] The "terms" here were determined by tourist demand for authentic experiences during their travels and "authentic" commodities as material representations of experience to take home with them. Here, then, is where authenticity is converted into commodity value. The objects in and of themselves, their materials, workmanship, and design, represent but a fraction of the value as tourist art. The rest of their value comes from their success as a "model," as Dean McCannel uses the term, for the authentic experience the tourist desires.[7]

Anthropologists, ethnographers, and archaeologists who arrived in the Southwest in increasing numbers after 1880 played a dominant role in validating the "authenticity" of Pueblo art, by

redirecting the efforts of the artists, purchasing "authentic" products for museums, and by convincing potential buyers to do the same. Early anthropology of the Southwest also vacillated between conquest and anti-conquest, ranging from the self-consciously intrusive military officer John Gregory Bourke, who steadfastly refused to leave a Hopi kiva during an 1881 snake ceremony, arguing to his journal, "how important it was that some memoranda of this curious rite be preserved,"[8] to Frank Hamilton Cushing who was initiated into the Zuni Bow Priest Society during the same year after two years of residency at Zuni.[9] Whether inquisitor or more passive participant–spectator, the anthropologists of this period did not doubt for a moment the hegemonic ambition of their enterprise, which was to make visible and comprehensible to "science" the local practices they witnessed and described. Their work acknowledged the "natural" inevitability of the conquest, as progress (see Edgar J. Hewett's statement below), and they were motivated by the belief that their ethnographic representations of local realities would eventually become all that remained of them. With their scientific, comparative, and classificatory method, the scope of their representations expanded beyond local knowledge and were believed therefore to be superior to it. The anthropological representation, or ethnography, thereby becomes more "authentic" than local experience itself. No wonder, then, that sympathetic anthropologists were willing to help Pueblo artists "correct" their work to reflect more closely the hegemonic conception of what an "authentic" Pueblo reality should be.

Pueblo painters

Sometime around the year 1900 the ethnographer Jesse Walter Fewkes asked four Hopi men to produce a series of paintings representing Hopi Kachinas, providing them with paper, pencils, pigments, and brushes. Fewkes went to some trouble, he claimed, to find men whose works would be "little affected by white teachers with whom these people have come into more intimate contact than ever before," with the intention that these paintings would be "a valuable means of studying the symbolism of the tribe." Fewkes wanted the Hopi to create authentic "artifacts" albeit with novel media and intent.[10]

Of the four Hopi artists, Fewkes rejected the work of a former student of the government school at Lawrence, Kansas, because his drawings showed "influence of instruction." Here Fewkes initiated the kind of intervention and critical language that would shape the future of Pueblo painting and Native American art, more generally speaking, during the following decades. Fewkes simultaneously acknowledged and negated the syncretic character of the paintings produced by the Hopi men at his behest: "their character has been somewhat influenced by foreign art [but] the pictures here described and reproduced may be regarded as pure Hopi."[11] Ironically, the contradiction of this statement leaves to Fewkes (and the critics and patrons to follow) the judgment with regard to what is "foreign" and what is "pure." Fewkes's concern, here expressed in 1903, was echoed nearly thirty years later when the Eastern Association of Indian Affairs (a group of well-meaning and wealthy social activists and professional ethnographers; see below) published in its *Bulletin* a proposal for a school of applied arts in Santa Fe. The "curriculum of Native arts in schools should be handled with extreme care," they cautioned, to preserve, "the uncorrupted spirit of Indian art."[12]

As it turns out, many Native people around the turn of the century were engaged in making a pictorial record of their cultural life, and not only at the behest of anthropologists. The practice was particularly common among the Plains tribes where an indigenous tradition of drawing personal

histories, or war records, on paper in bound books (ledger books, notebooks, autograph books) had existed since at least the 1860s. During the reservation era, the 1880s and thereafter, dozens of collections of drawings were produced by informal "ledger book artists," filled with images not so much of personal histories, but of drawings illustrating tribal life, ceremonies, and dances. Many of these collections of drawings were commissioned by traders, agents, or simply the curious, as original documents of Plains Indian life. These acts of "autoethnography" in pictorial form present a reflexive consciousness of the self in terms of the other. They attempt to illustrate, in a fashion organized for didactic purposes, what is normally only enacted. Some were produced by young men who had not experienced Plains warfare and therefore had no personal exploits to illustrate. The young artists seem to have been motivated to record and preserve histories and traditional practices they felt were threatened by the outside world. Their work focused upon the special and unique attributes of their culture that were sometimes gleaned from the accounts of elders, or were closely observed and rendered with great clarity.[13] All these works stress making *visible* the unique attributes of their culture in explicit detail, a trait shared by Pueblo watercolors. Early experience with boarding schools and day schools where traditional customs were discouraged and contrasted with the "civilization" of whites apparently impressed many young Indian people with the distinctive and endangered qualities of their ancestral culture, and contributed, perhaps, to a kind of anthropological awareness, or at least some sympathy with the salvage paradigm of turn-of-the-century anthropology. Fred Kabotie, perhaps the most famous of the Pueblo watercolorists, put it very simply: "When you're so remote from your own people, you get lonesome. You don't paint what's around you, you paint what you have in mind. Loneliness moves to you express something of your home, your background."[14] Several young, talented Pueblo artists took up paints and paper while forming relationships with teachers, anthropologists, patrons, and each other. Their paintings illustrated the ceremonial life of their Pueblos. They worked in a pictorial style showing in explicit detail the costumes and postures of ceremonial dancers. Their work is at once didactic and documentary. Its "ethnographic" character paralleled the objectives of anthropologists who actively supported, encouraged, and "authenticated" it.

The Pueblo community of San Ildefonso, located just north of Santa Fe, was home to several early watercolor painters. At least two, Julian Martinez and Crescencio Martinez, painted pottery designs in a collaboration with their wives, Maria and Maximiliana, who fabricated the pots. Both couples formed close relationships with Edgar J. Hewett, an anthropologist who supervised the excavations at Frijoles Canyon, now Bandolier National Monument, for the School of American Research beginning in 1907. The site is just south of San Ildefonso and Hewett employed many San Ildefonso residents at the dig. Some time around 1910 Hewett began to encourage Crescencio Martinez's painting when he saw his crayon drawings of dancers on odd pieces of cardboard. Later, in 1917, Hewett commissioned a set of paintings from Martinez illustrating traditional San Ildefonso dances for the newly opened Museum of New Mexico.

Tonita Peña, who had attended the San Ildefonso Day School between 1889 and 1906, recalled that Hewett had noticed the paintings and crayon drawings that she and other students had made at the behest of their teacher, Esther B. Hoyt. Peña's aunt and uncle, Martina Vigil and Florentino Montoya, with whom she lived after the death of her mother in 1905, were also a pottery-making team with Florentino doing the painting. Peña made and painted pottery and continued to produce watercolors representing ceremonies and dancers (see Plate 8). Sometime after Peña's move to Cochiti to live with her aunt and uncle, Hewett began to purchase paintings from her for the museum, supplying her with "Winston brand watercolors" from England and good art paper.

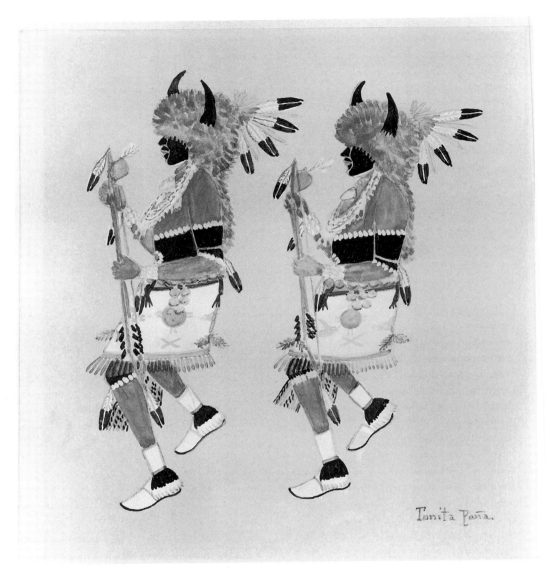

Plate 8 Tonita Peña, *Buffalo Dance* (1920s), watercolor, 7⅛" x 5", copyright Detroit Institute of Arts. **Gift of Miss Amelia Elizabeth White**

Hewett worked closely with all these San Ildefonso "self-taught" artists at the beginning of their careers, helping them refine and develop their autoethnographic expressions.[15]

On one afternoon during the summer of 1917 when the poet and author Alice Corbin Henderson toured the Frijoles Canyon ruins with Ananda Coomaraswamy, "the Hindu art critic" (as she called him), she was offered two watercolor paintings by the "custodians" of the site, Colonel and Mrs A. J. Abbott. Henderson had recently arrived as a resident of the Santa Fe community and she was already well known. The paintings depicted the deer dance and the buffalo dance of San

Ildefonso Pueblo against the white, featureless background of the paper. They had been painted by Alfonso Roybal (also known as Awa-Tsireh), the nephew of Crescencio Martinez. Alfonso had been helping his uncle with the Hewett commission but had left these works with the Abbotts to sell. Writing later, however, Henderson would overlook Hewett's involvement with San Ildefonso artists and miss entirely any intent on the part of Pueblo artists to simply document and illustrate dances. She envisioned a very different heritage for the paintings.

"These young artists," she wrote in 1925 in the *New York Times*,

> had simply, with a fine consistency, carried their distinctive Indian vision into a new field of expression. This new development represented no 'break,' but was merely an extension of the centuries old tradition of the Pueblos. The transition, that is from the incised hieroglyphs and deer hunts on the walls of cliff dwellings [indeed, Hewett and the workers from San Ildefonso had discovered wall paintings in the ruins at Frijoles Canyon], through the symbolic use of pottery designs, to these more realistic but still highly conventionalized drawings of human forms, was a purely natural progression and sequence.[16]

There is no question that these kinds of sources played a role in the minds of San Ildefonso artists, but certainly not in the way Henderson described it. Henderson posited an evolutionary ("natural") progression through stages of art making (citing "Altimira," "primitive artists," and "Orientals") and implied that Roybal accessed these sources through some kind of cultural or racial memory (not through his experiences with the excavations at Frijoles Canyon, nor his work with uncle Crescencio, nor his involvement with Hewett). As for the pictorial, illustrative technique, Henderson referred to an "unspoiled purity of vision . . . uncorrupted by any false canon of art-shop talk or commercial end."[17]

Henderson resisted the interpretation of Roybal's watercolors as expressions of auto-ethnography, as self-conscious self-representations for the benefit of others. Instead, she preferred to see the pictures as "authentic" artifacts of an artistic evolution, albeit an accelerated one. In so doing, she preserved her innocence as a passive spectator who simply calls our (the reader's) attention to what she has observed. She thereby avoids acknowledging her complicity in the fact that the pictures were intended for her. She mistakes the clarity of Roybal's autoethnographic representation, his desire to clearly describe and illustrate, for a kind of "primitive" purity. Or does she? In her *New York Times* essay of 1925, who is she trying to convince of Roybal's purity and her own innocence? Presumably the potential buyers of Roybal's paintings available for purchase at Amelia Elizabeth White's gallery on Madison Avenue. But more about that later.

Another group of young artists came from the Santa Fe Indian School. The Hopi students who were sent there were considered uneducatable at the Hopi day schools, owing to discipline and truancy problems. One of them, Fred Kabotie, recalled that when he arrived in 1915 the school was run by a strict, authoritarian superintendent whom the students referred to as "tight pants." Kabotie's first years of education were fairly typical for many Indian young people of the time: separation from family and community, strict discipline, and largely vocational training. The superintendent was replaced in 1918 by John D. DeHuff, whose wife Elizabeth recruited Kabotie and five other students from the school to paint with watercolors at a make-shift studio in her living room. Elizabeth claimed that she had been inspired to encourage students to paint images of dances after attending a Corn Dance at San Felipe Pueblo in 1918. Kabotie recalled much later that DeHuff

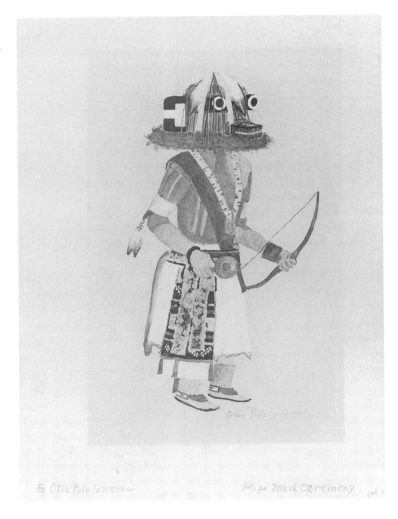

Plate 9 Otis Polelonema, *Mask Dance* (1920s), watercolor, 14¼" × 22¼", copyright Detroit Institute of Arts. Gift of Lillian Henkel Haass and Constance Haass McMath

had simply permitted him to paint what he wanted and that he depicted Kachinas because he missed the traditional ways of home. Alice Corbin Henderson made the case in 1925 that Elizabeth DeHuff had been inspired by the paintings produced by Roybal and other students at the day school at San Ildefonso. In any case, Mrs DeHuff arranged for Fred Kabotie, Otis Polelonema, also a Hopi (see Plate 9), Velino Shije Herrera from Zia, and a few others, to be excused from carpentry class in the afternoons, and assembled them all at her house to make pictures (see Plate 10).

It is not surprising to learn that Mrs DeHuff took the results of her afternoon studio sessions to Hewett, by then the Director of the Museum of New Mexico, established in 1917, who arranged an exhibition of the work in an "alcove" of the museum.[18] Hewett had been acquiring the paintings of Crescencio Martinez for the museum since 1917 and very probably paintings by Tonita Peña as well. The museum had been created to respond to the growth of artistic and cultural activity of the Santa Fe and Taos region. "During the last year [1915]," Paul A. F. Walter wrote breathlessly, "eighteen art exhibits have been held. . . . Who can say that the Santa Fe-Taos school of art may not

Plate 10 Velino Shije Herrera, *Crow Dance* (early 1930s), watercolor, copyright Detroit Institute of Arts. Gift of Lillian Henkel Haass and Constance Haass McMath

in the near future mean to American art what the Barbizon school meant to France?"[19] The "new museum," Walter hoped, would be the "most American of American art museums."[20] American artists had been working in the Santa Fe–Taos area since Joseph Sharp and Oscar Blumenschein set up studios in the 1890s. During the years after the war, the pace picked up, with artists from many of America's urban centers establishing summer studios there. Notable among them was a large contingent from New York led by Robert Henri, who interestingly enough first visited the region in 1914 after an invitation by none other than Hewett. Henri's enthusiasm brought George Bellows, John Marin, Leon Kroll, George L. K. Morris, and, most significantly for the future of Pueblo watercolorists, Henri's former student and close friend, John Sloan, who spent his first summer in Santa Fe in 1919.[21]

They came, wrote Walter,

> to establish a new and virile American school of art which will make a lasting impress on the world. It is in the historic background, the atmosphere, the environment, the sunshine, the sky, the climate, the people, the mingling of nations and races, and above all, the American Indian, who in this region embodies in himself a long lineage of artistic aspiration, of poetic culture, of that intangible attribute which is known as character.[22]

Were Mrs DeHuff's students expected to fulfill these heavily loaded expectations as source material for the colony of expatriate artists? Evidently so, as the published notice of the Museum of New Mexico exhibition in *El Placio* concluded, "The entire exhibit seems to prove that with the Pueblo Indian art is racial, rather than individual, and that beautiful results are obtained if the Indian is given free reign to express himself."[23] The watercolorists, whom their teachers had given "free reign" of expression, represented the kind of cultural "authenticity" that outsiders came to Santa Fe to seek. Their "racial" art was understood as the latest of that "long line of artistic aspiration" of "the American Indian."

Pueblo painters come to New York

In the years following World War I, the colony of artists, writers, social activists, and intellectuals who gathered in Santa Fe and Taos initiated a new direction in a distinctive, North American *criollisimo*, as American cultural elites attempted to define for themselves a distinctly "Native" identity in contrast to and separate from Europe. While the land of North America, with its "wild," "boundless," and "untamed" character, had provided the foundation for the development of a uniquely American identity among earlier generations of American-born thinkers of European descent, that land had been considered primordial, without history, and largely uninhabited, save for the "savage" who stood in the way of progress. Europe, in contrast, had history, to which some thought America was too dependent and indebted. The Pueblo peoples suggested an alternative notion to those who had assembled in Santa Fe and Taos. Archaeologists had excavated their ancient habitations in nearby ruins. Their history had weathered the Spanish conquistadors and colonization. They provided America with a cultural, historical legacy that urban intellectuals of the Santa Fe and Taos colonies wished to appropriate as the foundation for a uniquely American identity in a world they feared was dominated by Europe.

During the early decades of the twentieth century, however, Pueblo people faced what seemed to be their last, fatal challenge. Even Hewett had to concede, "[Pueblo] destiny would seem to be absorption into the aggressive and efficient race that broke into its continental isolation," to which he added, in characteristic, anthropological fashion, "[t]he task now is to investigate and understand the Indian culture in all its phases."[24] From this investigation some concluded that Pueblo culture had powerful lessons for America. When John Collier, the progressive social activist who later became the Commissioner for the Bureau of Indian Affairs under F. D. Roosevelt, visited Taos in 1920, the circle of Mabel Dodge Luhan drew him into discussions of Pueblo communalism and its application to the modern world of America.[25] Marsden Hartley wrote at some length, that same year, about the lessons of American Indian aesthetics for American art in terms that can be understood more broadly to refer to the value of Pueblo culture to American civilization.

> In the aesthetic sense alone, then, we have the redman as a gift. As Americans we should accept the one American genius we possess, with genuine alacrity. We have upon our own soil something to show the world as our own, while it lives.[26]

In this passage Hartley reveals the contradictions of the creole dilemma. He claims the "redman's gift" as "American," his and America's to "possess," without acknowledging that this claim of possession is in fact the threat to "it[s]" life. Instead, he implies that proper stewardship of the "gift" would insure its survival. The matter of Pueblo survival, in terms Hartley and others

envisioned as useful to their America, would occupy this increasingly influential group for the next two decades.

During the 1920s, the urban elite who had gathered in Santa Fe and Taos took up the Pueblo watercolorists nurtured by Hewett and enlisted them in their Americanist cause. First and foremost, they believed that the watercolorists, and American Indian art more generally speaking, represented an autochthonous foundation for a uniquely American aesthetic. For this reason, they stressed a unity of tradition between the watercolors and the pottery, wall paintings, and ceremonial arts of current and earlier generations. The broader Americanist objective of the group led them to political activism on behalf of the beleaguered Pueblos, but here too, the Pueblo painters could help. Their illustrations of dances demystified and aestheticized Pueblo ceremonialism at a time when government policy worked to abolish it. Ultimately, the high-minded objectives of the Americanist agenda would devolve into economic issues, with lasting effects for the Pueblos. First, social activism aside, success in saving Pueblo ceremonies from government policy was assisted immeasurably by their increasing value through the 1920s as tourist attractions. Second, the expanding tourism of the Southwest during the 1920s suggested to some the potential of arts and crafts for Indian cash economies, expanding on the economic agenda of traders long active in the area. To some of the Santa Fe and Taos elite, tourism was an unfortunate consequence of their promotion of Pueblo culture's value to America. On the other hand, their promotion of American Indian art as an American Indian business eventually reversed government policy and led directly to the creation of the Indian Arts and Crafts Board in 1935 and other initiatives to support and encourage arts production.

If Pueblo watercolors were to have any effect in influencing American art, they had to be seen in the great urban centers where the American aesthetic was forged and promulgated. When Mabel Dodge Luhan saw the exhibition of Pueblo watercolors at the Museum of New Mexico in 1919, she purchased the entire collection and sent the pictures east with a collection of Santos. They appear to have circulated among several galleries. John Sloan, newly arrived in Santa Fe in 1919, arranged to have Luhan's collection supplemented by additional pictures from Hewett and shown in the Society of Independent Artists exhibition of 1920 at the Waldorf Astoria Hotel in New York. Walter Pach, the notable art critic for the *New York Times*, took a keen interest. He wrote that the "young artists . . . expressed their own ideas and the things seen by them in almost the primitive manner of their ancestors, certainly without any reference to the technique of the modern painter. The result shows the strength that lies in direct expression."[27] For Pach, the "primitive manner" of the pictures was evidence of the artists' seamless connection to the past. Later in the review he compared Fred Kabotie's "Snake Dance" with Egyptian reliefs and ancient Greek vase painting. As these ancient Mediterranean sources had laid the foundation for European art, Pueblo watercolors, in Pach's view, were an ancient well-spring for Americanists.[28]

In the program that accompanied the 1920 show, Hewett wrote, "It must be borne upon the consciousness of the people of this country that we have a priceless inheritance of genuinely American culture which we have been blindly destroying instead of fostering." If they did not know already, the art public of New York would soon learn what Hewett was talking about. The government threat to the Pueblos had heretofore only a local forum in the Southwest. The contentious situation between the Pueblos and local authorities had deteriorated to the extent that, during the summer of 1919, the *Santa Fe New Mexican* reported frequent police harassment of Pueblo dances. The newly arrived Sloans were swept into the controversy by their artist friends, who apparently prompted Sloan to arrange send Pueblo watercolors to New York to dramatize the

beauty and harmlessness of the dances.[29] The urban intellectuals at Santa Fe and Taos began to organize around two issues: saving Pueblo ceremonies and fighting the Bursum bill which threatened Pueblo land grants. Their strategy was to promote their causes at the centers of urban power.

Government action against dances had grown out of the 1887 Dawes Act. Mandatory education drew young people away from the Pueblos where they were deprived of the traditional and ceremonial education that would make them viable members of Pueblo society. It had been customary for the communities to call children back from school so that they could take part in their ceremonial responsibilities. Government officials, teachers, and missionaries attacked this practice by condemning the ceremonies themselves. Complaints about the dances from teachers and missionaries, including a scathing report about reputed sexual excesses attendant on the Hopi Snake ceremony, prompted Commissioner Charles H. Burke to issue a resolution in 1920 recommending close supervision of dances and ceremonies and suggesting that the Bureau put a stop to all those activities that interfered with "industrial pursuits."[30] More strident measures and threats followed over the next few years. The assimilationist position was summarized by the superintendent of the Pueblos as follows, "Until the old customs and Indian practices are broken up among this people we cannot hope for a great amount of progress. The secret dance is perhaps one of the greatest evils. What goes on I will not attempt to say, but I firmly believe that it is little less than a ribald system of debauchery."[31]

The Bursum bill was sponsored by Secretary of the Interior, Albert Bacon Fall, in 1921 and introduced in modified form by New Mexico Senator Holm Olaf Bursum in 1922. The bill would have conferred on recent settlers the title to former Pueblo lands. The titles in dispute, for some Pueblos, included most of their irrigated agricultural land. John Collier, as a paid field worker of the Indian Welfare Committee of the General Federation of Women's Clubs, led opposition to the bill and recruited many of the Santa Fe and Taos intellectuals into the Indian Defense Fund to raise money. By 1922, the New Mexican Association of Indian Affairs in Santa Fe and the Eastern Association of Indian Affairs (EAIA) in New York city had been organized to "save the Pueblos." Members of these organizations deluged the national press with articles, wrote letters to the *New York Times* and politicked endlessly with the wealthy and influential. Collier brought thirteen Pueblo officials to New York in early 1924 and presented them to New York society at a Cosmopolitan Club reception. The Pueblo visitors danced and Collier spoke. Collier organized his presentation around a question planted in the audience, "is there any experience that would lead us to believe that ancestral ceremonies and modes of existence of the Indians could be preserved?"[32]

While the fight to save Pueblo dances and land titles hung in the balance, exhibitions of Pueblo watercolors appeared regularly in New York and elsewhere. Mary Austin lent the paintings by Alfonso Roybal that she had purchased from Alice Corbin Henderson to the American Museum of Natural History in 1920. Henderson sent the paintings she still had to the Arts Club of Chicago that same year. Sloan continued to assemble collections of paintings for the annual Independent Artists exhibition at the Waldorf Astoria. In October of 1922 Amelia Elizabeth White opened an American Indian art gallery on Madison Avenue called Ishauu, a name that soundly vaguely like an Indian word but was based actually on the childhood pronunciation of her own name, "Elizabeth." The gallery was linked to the EAIA and it was not intended for profit but to encourage a market for American Indian art. White, a newspaper heiress and one of the organizing officers of the EAIA, had first traveled to Santa Fe in 1913 where she met F. W. Hodge and other anthropologists, and began to collect Pueblo pottery, Navajo silver and textiles. She and her sister purchased property in Santa

Fe (now the School for American Research) in 1923 and moved regularly back and forth between New York and the Southwest where she continued collecting, becoming in the process a steady patron of the watercolorists. A society column in the New York Evening Post of 1926 described "Miss White" as "a generous patron of the arts of Santa Fe and [the agent] for Indian productions here in New York."[33]

White organized a number of exhibitions of American Indian art featuring watercolors, in New York and abroad, throughout the 1920s. In 1926, under the auspices of the EAIA, she presented a group of Pueblo watercolors at the New York Art Center. In 1928, she organized a large exhibition of her collection (or inventory, which apparently was the same thing) for the Consular Building at the Iberian American Exposition, Seville, Spain. White donated the items she sent to Seville to the Department of the Interior and arranged to have them sent for display at the Pavilion Etats-Unis, Exposition Coloniale Internationale, Paris, in late 1930 and early 1931. In 1930 the Brooklyn Museum exhibited a large number of Pueblo paintings from her collection along side the "Codex Hopiensis," or the early group of Hopi Kachina pictures commissioned by Fewkes in 1900. Her efforts culminated in the "Exposition of Indian Tribal Arts" of 1931, which thereafter traveled to a number of American cities. Through White's efforts, in close collaboration with John and Dolly Sloan and largely by means of her collection, American Indian art and the Pueblo watercolorists with their illustrations of Pueblo ceremonialism entered into the art world and America's urban centers.

On the occasion of the Society of Independent Artists exhibition of 1922, E. H. Cahill wrote for the prestigious periodical *International Studio* that the watercolors "mark the birth of a new Art in America." Cahill emphasized as well the value of the paintings as a documentary record of endangered Pueblo ceremonialism, saying that "their pictures record the emotional quality and color and movement of the astounding Pueblo ceremonies."[34] Marsden Hartley published his first of several epistles to the aesthetics of Pueblo dances that year (quoted above). For Hewett, the watercolors illustrated

> wisdom from birds, beasts, flowers, skies, waters, clouds and hills. All this is voiced in his prayers and dramatized in his dances – rhythm of movement and color summoned to express in the utmost brilliancy the vibrant faith of a people in the deific order of the world and in the way the 'ancients' devised for keeping man in harmony with his universe."[35]

How could reports of "sexual excess" and "debauchery" be reconciled with these images of "color and movement" and "utmost brilliancy"? The watercolors and printed words like these were powerful antidotes to the assimilationists' misrepresentations. They succeeded in making visible the "secrets" of Pueblo ceremonies that heretofore only visitors to the Pueblos had witnessed. By revealing their secrets, the watercolors had rendered the ceremonies harmless and innocent.

Entrepreneurial and corporate interests in the Southwest, namely traders and the Santa Fe Railroad, also worked to cast Pueblo ceremonialism and art as exotic, aesthetic, and ultimately enticing enough to see and purchase for one's self. The Santa Fe Railroad and the Fred Harvey Company, a restaurant and hotel chain, had been aggressively promoting tourism in the Southwest since the 1880s. Harvey opened hotels in Albuquerque, the Grand Canyon, Winslow and Gallup, Arizona, and spas at Las Vegas, New Mexico. By 1926, the Fred Harvey Company had initiated its extensive program of "Indian Detours" which provided bus and automobile transportation for

tourists to distant Pueblos.[36] Now, visitors by rail could easily access the Pueblo communities. Not all the Santa Fe and Taos intellectuals were happy with this development, although they were accustomed to visiting Pueblo ceremonies themselves. But when the Santa Fe and Taos community had argued that the Pueblos were of value to America, America claimed that value for its own. Its innocence was at once revealed and lost.

The American Indian and art as commodity

The protest from the Pueblos over land rights and religious freedom laid the groundwork for reform of the Bureau of Indian Affairs and its policies. To some considerable extent, however, the Pueblos were "saved," because their supporters made a case for their value to America, as part of its history, its legacy, as a foundation for a unique national identity. As an American possession in a quickly growing consumer society, the Pueblos began to be evaluated for their commodity value, as tourist destinations or as sources for commodity arts and crafts. The 1920s saw the formulation of the modern touristic identity for the Pueblos, an identity and commodity role still very much active today. As a uniquely American cultural and arts tradition, the Pueblos defined a kind of root foundation for the burgeoning need for an American cultural identity independent and apart from Europe. These then, would be the central themes to expanded efforts to develop and market Southwest Indian art in the 1920s and 1930s: the requirement to preserve its authenticity while broadening critical and consumer appreciation of its value as a uniquely American artistic tradition.[37]

In Santa Fe, schemes to control the quality and authenticity of Pueblo productions for tourist consumption took shape during the early 1920s. Hewett initiated the annual Southwestern Indian Arts and Crafts Exhibition of Santa Fe in 1921 (the precursor to the Indian Market of today) offering prizes to exhibitors. First prize that year went to Kabotie. The fair eventually imposed prescriptions for the exhibitors that disallowed inappropriate borrowings of tribal motifs or exotic (i.e. non-Indian) forms. The Indian Arts Fund, initiated in 1923 among the Santa Fe group (the Sloans, Austin, Henderson, Hewett, etc.) sought to collect significant works of Indian art (mostly pottery) so that "notable art works should not be carried away by tourists and random collectors."[38] Their selection process was intended to establish standards of connoisseurship.

Amelia Elizabeth White clearly saw her social activism as a way of preserving Pueblo society and of providing a means of economic development. The EAIA, with White as Secretary, urged the Bureau of Indian Affairs to develop a policy to "(1) encourage Indians to continue pottery making, basketry, beading, painting, etc., (2) revive arts in danger of disappearing; (3) encourage a standard of excellence; [and] (4) devise a method for expanding the market."[39] The study published by the association in 1930 claimed that the combined Pueblos already earned $50,000 annually for arts production. The study proposed establishing a commission in Washington and field schools throughout the country. The first three initiatives were addressed the next year (March 1931) when the EAIA announced plans to create a "School for Applied Arts" at the Santa Fe Indian School, which Fred Kabotie, Otis Polelonema, and Velino Shije Herrera had attended. The plan warned, however, against the potential dangers of *teaching* American Indian art, "since teaching, unless properly supervised, is capable of destroying native arts more quickly than any other agency." For example, "instruction to girls of all Pueblos by a teacher from one Pueblo would soon blur the present clear cut lines of demarcation between various types, and would destroy a large part of the beauty and significance of each type, thereby reducing its value."[40] The EAIA feared that improper instruction

threatened its *authenticity*. The value of American Indian applied arts for the non-Indian consumer lay in their link to the touristic and Americanist image of "the Indian" that so many had laboriously constructed over the previous decade. Once Indians had been "saved," their value existed only to the extent that this "image" could be preserved. The plans promoted by the EAIA were realized when Dorothy Dunn began in the fall of 1932 as Teacher of Fine and Applied Arts at the Santa Fe Indian School. Her program, known as "The Studio" would train the next generation of American Indian watercolorists in the style pioneered by Kabotie, Peña, Julian Martinez, Roybal, Polelonema, and Velino Shije Herrera.[41]

If Dorothy Dunn's Studio was intended to guide artists in creating authentic American Indian art (or "traditional" as the style has become known today), the "Exposition of Indian Tribal Arts" showed the greater American public how to see and comprehend it. Under the auspices of the EAIA, with Amelia Elizabeth White's sponsorship and John Sloan as director, the Exposition of Indian Tribal Arts, Inc. was incorporated in late 1930 with the purpose: (1) to win the aesthetic appraisal of Indian art; (2) to awaken public appreciation so as to encourage the Indians to continue to create and develop their art."[42] On December 1, 1931, the Exposition opened an enormous exhibition of 615 American Indian art objects at the Grand Central Galleries in New York. Many of the objects came from White's collection but these were supplemented by loans from the Museum of the American Indian, Heye Foundation, the Brooklyn Museum, the Peabody Museum, Harvard, and the American Museum of Natural History. The exhibition drew together a vast array of objects, archaeological pieces from "the Moundbuilders and Cliff-Dwellers," pottery, weavings, baskets, silver jewelry, beadwork, Northwest coast carvings, and watercolor paintings produced by Pueblo and Kiowa artists. In so doing, it offered a pan-optical conflation of Native history and tribal diversity. By this means, the modern watercolors were "grounded essentially in the traditions of their race," as one reviewer put it.[43] As the Exposition transformed "artifacts" borrowed from anthropology museums into "art," so the art of the watercolorists were contextualized firmly as "artifacts" rooted in the "traditions of their own people." Critical reviews and promotional literature argued the importance of seeing the equivalence of ancient and modern expressions of American Indian art and attempted to efface any difference between them.[44]

Underlying this effort, and explicit in the literature of the time, was the positioning of American Indian art as an indigenous foundation for a distinctive American aesthetic and artistic movement. Sloan wrote characteristically in the introduction of a 1931 pamphlet for the Exposition, that "spreading the consciousness of Indian Art in America affords another means by which American artists and patrons of art can contribute toward the culture of their own continent to enrich the product and keep it American."[45] Christian Brinton, president of the College Art Association (sponsor of the Exposition tour to over a dozen American cities) addressed the New York radio audience with a similar theme. He complained that America had never evolved an "aesthetic declaration of independence," but now proclaimed that "the battle for American aesthetic expression had been won. But it has not been won by our typical, foreign trained man with his ill-digested Parisian artist *table-d'hôte*."This was possible, he declared because "we possess an artistic treasury not only older, but fresher and purer than anything Europe has to offer."[46] Walter Pach, art critic for the *New York Times*, made a further point:

> this soil has affected the character of the American people. *Our* environment, *our* air, *our* waters and forests [emphasis mine] are what make Americans different from their

cousins in England, Germany, France, and the rest of the Old World. . . . The art of the Indians, so eloquent of this land, is American art, and of the most important kind.[47]

European American claims to the continent had been settled by earlier generations; it was time, Pach argued, to claim the continent's indigenous people and art as well.

The paintings produced by the Pueblo watercolorists during the 1920s came to represent the image of American Indian culture that America wished to "preserve": visible, accessible, aestheticized, and available for commodity consumption, yet concealing through the relentlessly applied image of "authenticity" its accommodation to the colonizing culture that wished to claim it for its own. The supporters, patrons, and teachers of these modern American Indian artists enforced their resistance to any "Americanizing or Europeanizing tendencies" by means of shows, prizes, schools, and most importantly, their purchasing dollars. The artists themselves continued to pioneer the implications of their success and new-found visibility, becoming teachers themselves, nurturing art economies among their own communities, producing public commissions, and continuing their role as ambassadors and representatives. On the other hand, white American artists and European expatriate artists during the 1930s and 1940s responded to Sloan's call to claim the American Indian as the foundation for a uniquely American "primitivism." These artists, like John Graham, Adolph Gottlieb, and Jackson Pollock, successfully merged the lessons of European modernism with their own, often eccentric perceptions of American Indian art, mythology, and ideology, and laid the groundwork for claims of an American hegemony over "world art" at mid-century.[48] Kabotie, Peña, Herrera, and the others, successfully fulfilled the objectives they themselves and their patrons had conceived and pursued. They developed an art that mediated between the "radical inequality" of power and "intractable conflict" customary of colonial encounters and helped ease their communities into the complexities of twentieth-century consumer society. This observation is not intended to diminish in the slightest their considerable accomplishments. We wish to point out in conclusion, however, that the kinds of constraints, perceptions, and relationships described here with their roots in America's colonial enterprise are still very active in the lives of living artists of Native American ancestry working today. One need only visit Santa Fe to witness first hand the commodity value of "authenticity" at work at full force in the marketplace.

Notes

1 Mary Louise Pratt, *Imperial Eyes: Travel Writing and Transculturation* (London: Routledge, 1992), p. 6.

2 Edwin L. Wade, "Straddling the Cultural Fence: The Conflict of Ethnic Artists Within Pueblo Societies," in *The Arts of the North American Indian: Native Traditions in Evolution*, E. L. Wade (ed.), (New York: Hudson Hills Press, 1986), pp. 243–54.

3 This point is the focus of W. Jackson Rushing, *Native American Art and the New York Avant-Garde* (Austin, TX: University of Texas Press, 1995).

4 Pratt, *Imperial Eyes*, p. 7.

5 This discussion of Keams is drawn from Harry C. James, *Pages from Hopi History* (Tucson, AZ: University of Arizona Press, 1974), *passim*, and Lydia L. Wyckoff, *Designs and Factions: Politics, Religion and Ceramics on the Hopi Third Mesa* (Albuquerque, NM: University of New Mexico Press, 1985), pp. 40–4, 71–84.

6 Pratt, *Imperial Eyes*, p. 7.

7 Dean McCannell, *The Tourist: A New Theory of the Leisure Class* (New York: Schocken, 1976), pp. 32–3.

8 James C. Porter, *Paper Medicine Man: John Gregory Bourke and His American West* (Norman, OK: University of Oklahoma Press, 1986), p. 102.

9 Jesse Green (ed.) *Cushing at Zuni: The Correspondence and Journals of Frank Hamilton Cushing 1879–1884* (Albuquerque, NM: University of New Mexico Press, 1990), pp. 178–82.

10 Jesse Walter Fewkes, "Hopi Kachinas Drawn by Native Artists," *Bureau of American Ethnology Report* 21 (Washington, D.C.: Government Printing Office, 1903), p. 14.

11 ibid.

12 Eastern Association of Indian Affairs, *Bulletin* no. 22 (1931), unpaginated.

13 cf. Janet Berlo (ed.) *Plains Indian Drawings 1865–1935: Pages from a Visual History* (New York: Harry N. Abrams, 1996).

14 Fred Kabotie and Bill Belknap, *Fred Kabotie: Hopi Indian Artist* (Flagstaff, AZ: Museum of Northern Arizona Press, 1977), p. 8.

15 See Marilee Jantzer-White, "Tonita Peña (Quah Ah), Pueblo painter: asserting identity through continuity and change," *The American Indian Quarterly* 18 3 (Summer 1994): 369–82; and Samuel L. Gray, *Tonita Peña* (Albuquerque, NM: Avanyu Press, 1990).

16 Alice Corbin Henderson, "The World of Art: A Boy Painter Among the Pueblo Indians and Unspoiled Native Work," *New York Times Magazine* (September 6, 1923): 18–19.

17 ibid.

18 Tryntje Van Ness, Seymour *When the Rainbow Touches Down* (Albuquerque, NM: University of New Mexico Press, 1988), pp. 20–1.

19 Paul A. F. Walter, "The Santa Fe–Taos Art Movement," *Art and Archaeology* 4 2 (July/December, 1916): 333.

20 ibid.

21 John Loughery, *John Sloan: Painter and Rebel* (New York: Henry Holt 1995), p. 225.

22 Walter, "The Santa Fe–Taos Art Movement," p. 333.

23 Anonymous, "Exhibit by Indian Pupils," *El Palacio* 6 (1919): 143.

24 Edgar L. Hewett, "America in the Evolution of Human Society," *Art and Archaeology* 9 1 (January, 1920): 6.

25 Kenneth R. Philp, *John Collier's Crusade for Indian Reform 1920–1954* (Tucson, AZ: University of Arizona Press, 1977), p. 24.

26 Marsden Hartley, "Red Man Ceremonials: An American Plea for American Esthetics," *Art and Archaeology* 9 1 (January, 1920): 13.

27 Walter Pach, "Indian Paintings in the Exhibition of Independents," *New York Times*, March 14, 1920.

28 cf. Rushing, *Native American Art and the New York Avant-Garde*, p. 33.

29 Loughery, *John Sloan*, pp. 255–6.

30 Philp, *John Collier's Crusade*, p. 56.

31 *New York Times*, June 13, 1924.

32 Philp, *John Collier's Crusade*, pp. 26–70; a description of the reception is found in the letter from Roberts Walker to Alice Corbin Henderson, January 30, 1924, Amelia Elizabeth White Papers, School for American Research, Santa Fe.

33 Sarah D. Lowrie, *New York Evening Post*, January 28, 1926.

34 E. H. Cahill, "America Has its 'Primitives,'" *International Studio* 75 299, (March, 1922): 81.

35 Edgar L. Hewett, "Native American Artists," *Art and Archaeology* 13 3 (March, 1922): 103.

36 Kathleen L. Howard and Diana F. Pardue, *Inventing the Southwest: The Fred Harvey Company and Native American Art* (Flagstaff, AZ: Northland Publishing, 1996).

37 cf. Rushing, *Native American Art and the New York Avant-Garde*, pp. 97, 103–4.

38 Winona Garmhausen, *History of Indian Arts Education in Santa Fe* (Santa Fe: Sunstone, 1988), p. 32.

39 Eastern Association of Indian Affairs, *Bulletin* no. 20 (1930), unpaginated.

40 Eastern Association of Indian Affairs, *Bulletin* no. 22 (1931), unpaginated.

41 cf. Dorthy Dunn, *American Indian Painting of the Southwest and Plains Areas* (Albuquerque, NM: University of New Mexico Press, 1968); Bruce Bernstein and W. Jackson Rushing, *Modern By Tradition: American Indian Painting in the Studio Style* (Santa Fe, NM: Museum of New Mexico Press, 1995).

42 Certificate of incorporation for *The Exposition of Indian Tribal Arts*, Amelia Elizabeth White Papers, School for American Research, Santa Fe.

43 Royal Cortissoz, quoted in, "Indian Tribal Arts Exhibition Starts on Long Tour of Nation," *Art Digest* 6 (December 15, 1931): 32.

44 cf. Rushing, *Native American Art and the New York Avant-Garde*, pp. 97–103.

45 John Sloan, quoted in *Exposition of Tribal Indian Arts* (New York: Exposition of Tribal Indian Arts, Inc., 1931), unpaginated.

46 Christian Brinton, "My Idea of American Indian Art," broadcast by WOR in New York, December 15, 1931, transcript in the Amelia Elizabeth White Papers, School for American Research, Santa Fe.

47 Walter Pach, "A Critic's View of the Significance and Value of a Unique American Asset," *New York Times*, November 22, 1931.

48 Rushing, *Native American Art and the New York Avant-Garde*, pp. 121–68.

Chapter three
Kristin K. Potter

James Houston, Armchair Tourism, and the Marketing of Inuit Art

I

During the late 1940s and early 1950s it became increasingly difficult for the Canadian government to ignore the extreme poverty and cultural displacement suffered by the Inuit of the Northern Territories. Throughout the early twentieth century increased contact with the southern world had introduced new needs, diseases and dilemmas for the Inuit, yet complementary services such as employment opportunities, health care, and education had not been forthcoming. The Canadian government experimented with several social programs in an attempt to establish a higher degree of economic independence for the Inuit, while simultaneously trying to preserve their cultural integrity.

The most successful of these programs was created by James Houston (Plate 11). With the support of the Canadian Handicrafts Guild, the Canadian government, and the Hudson Bay Company, Houston and his wife Alma lived at Cape Dorset on Baffin Island during the 1950s and developed an economically viable Native arts program which became known as the West Baffin Island Co-operative[1] (see Plate 12). Initially Houston encouraged the Inuit to carve soapstone into small sculptures for sale to outsiders. Later, in 1957, in response to a seemingly trivial question regarding how cigarette package labels are duplicated, Houston expanded his program to include printmaking. The subsequent influence of these two artistic traditions, which sprang from Houston's tenure in the north, has been enormous.

Addressing questions such as "Why James Houston?", "Why the late 1940s?", Nelson Graburn argued that the Canadian search for a sense of national identity after the Second World War and the current international interest in indigenous peoples were the two main reasons for the successful reception of contemporary Inuit sculptures and prints.[2] In a related discussion, Graburn mentioned

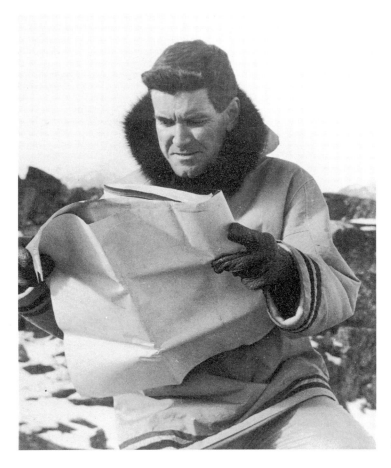

**Plate 11 James Houston, *c.* 1955.
Courtesy of James Houston**

that Houston's writings on contemporary Inuit art, published throughout the 1950s and 1960s, were extremely well received:

> Houston wrote so well and told such a good story, with the best of photographic illustrations, about these interesting new arts, that his articles were enthusiastically embraced.
>
> Soon other Canadians followed Houston's lead, recounting the story of his discovery. . . . These articles appear to have been based almost exclusively on Houston's control of the information. . . . The same information was taken up and reprinted almost without question by many scholars, some of them far removed from the Canadian scene.[3]

Most of Houston's early articles on contemporary Inuit art are a variation on a single core of ideas; these ideas reached a far-ranging and eclectic audience because they appeared in a variety of magazines, including *Craft Horizons, Canadian Art*, and *The Beaver*. The popularity of his 1967 book *Eskimo Prints* lead to its reissue just four years later, in 1971. Owing to these factors, Houston's

writings are arguably the primary means by which the greater public (Canadians and others) learned about contemporary Inuit art at the time.

A conflation of fact and fiction, advertisement and short story, Houston's essays are engaging and easily readable. One of the keys to his success resided in his ability to encourage his readers to experience the Arctic for themselves by providing a rich playground for their visual and emotional imaginations. Houston typically began with, or soon entered into, vague philosophical ponderings about the origin of the Canadian Eskimo, and the main body of these essays consisted of brief, genre-based dialogues that provided anecdotal accounts of daily life in the North.

While some scholars have offered correctives to Houston's blatant disregard for historical accuracy and penchant for inspirational prose, Graburn's brief historical contextualization is typical of the way in which Houston's early writings have been addressed. Yet these approaches do not adequately consider the importance of Houston's articles in the successful promotion of contemporary Inuit arts at mid century and after. In this essay my analysis of Houston's writings will reveal not only that he was keenly aware of the interest in primitive arts at mid century but will also show how he adopted and adapted preconceptions about primitive peoples at the time in order to access the greater non-Western art market. Moreover, by successfully utilizing his reader's desire to interact with an exotic cultural other as a means of promoting Inuit art, Houston's writings facilitated an indirect form of touristic interaction, which is treated in this essay as part of a case study in armchair tourism.

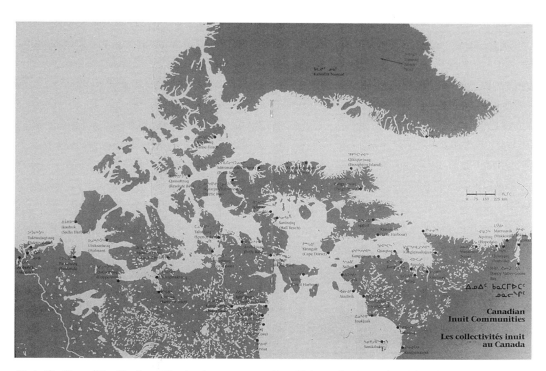

Plate 12 Map of the Northern Territories, courtesy of her Majesty the Queen in Right of Canada, Natural Resources, Canada, copyright 1997

II

Because his readers did not venture into the Canadian Arctic to meet the artists in their homes, a discussion involving tourism may seem irrelevant. But neither travel to a designated area nor direct contact with one's host is necessary to the formation of a touristic relationship. In a unique essay Paul Aspelin identified "indirect tourism" as a phenomenon "in which two cultures may come into contact and affect each other without their human representatives . . . themselves necessarily coming into direct contact."[4] Aspelin began his discussion by distinguishing between direct and indirect forms of tourism in what he terms "linkages":

> Indirect tourism does not involve simply the elimination of direct linkages, of direct social or personal contact. More importantly, it involves the elimination of many or most of the cultural linkages which are themselves brought about through the direct contact of people from one culture with people of another. Indirect tourism does not involve the total elimination of all contacts, however, for then there would be no contact situation left, by definition, nor any interaction between tourist and host worthy of being called tourism.[5]

Having defined his terminology and established a theoretical framework, Aspelin discussed the historical context of the Mamainde of Brazil. During the 1960s, missionaries brought Mamainde goods to sell in cities frequented by tourists, such as Rio de Janeiro. With the proceeds the missionaries bought fabricated goods, such as metal tools, which they distributed to the Mamainde upon their return. It was not long before the Brazilian government became involved in this venture, assigning accountability for it to the Indian Protection Service.[6]

Despite the lack of immediate contact, this interaction had economic and cultural effects on both groups. While "the tourists could show they 'visited the Indians' without directly bothering them at all, simply by purchasing Mamainde artifacts from Indian agencies located in the provincial capitals,"[7] for the Mamainde, the sale of cultural products far from their home was the economic option that was least disruptive of their social and cultural livelihood. Rather than be transformed into live curiosities to be watched and photographed, this indirect relationship maintained privacy and fostered cultural pride among the Mamainde. However, although the interaction was indirect, market demands concerning style, quality and the kind of objects made by – and, in turn, associated with – the Mamainde were influential. Consequently, Aspelin noted that the lack of immediate interaction potentially perpetuated stereotypes of the Mamainde.[8]

The historical parallels between the Mamainde during the 1960s and the Inuit during the 1950s are apparent. For example, being Fourth-World cultures surrounded by the political boundaries of another group, both the Mamainde and the Inuit were ambivalent about their relationship with the dominant culture. At the time, both peoples were reliant upon specific outside goods, yet neither were fully integrated into a cash economy. Concerning the "linkages," neither the consumers of the Mamainde goods nor the patrons of Inuit art actually met the producers in person. In both cases the objects were purchased in retail settings far from their place of creation, and the revenue (or its tangible result) was channeled back to the producers. I would argue, consequently, that the success of contemporary Inuit art is also an indirect form of tourism.

However, the two cases are not entirely similar. While the consumers of the Mamainde goods presumably were not Brazilians but tourists on vacation, Houston was (at least initially) targeting

Canadians within their own national boundaries. Also, while the sale of Mamainde products were successful through "word of mouth" knowledge passed on informally among tourists and promoters,[9] knowledge of Inuit art was primarily based on the widespread circulation of Houston's promotional writings. These differences – the relative lack of travel on the part of the tourist and the literary source – are the key to identifying Houston's articles as armchair tourism, which can be considered a subgroup and one of the most extreme manifestations of indirect tourism.[10]

While armchair tourism requires a great degree of suspended disbelief on the part of the tourist, who is essentially an individual who seeks out a souvenir related to a textually-based experience, as Eric Cohen stated, "(t)he further one moves down the scale of modes of touristic experiences, the less strict the criteria of authenticity employed by the tourist will tend to become."[11] However, it is important to note that these "criteria of authenticity" are not merely diminished but displaced from the experience to the object and then, at least in part, recovered by the manner in which the object serves to authenticate the experience.[12] Moreover, in this case, the souvenir is not merely a tourist trinket, but a miniature masterpiece of primitive art (as conceived by Houston).

In comparison to other, more immediate, kinds of tourism, armchair tourism accommodates the greatest number of tourists, yet the degree of adaptation for the host culture is comparatively small, for there is none of the adaptation necessary to meet guests' daily needs. Rather, accommodation occurs in the form of the construction or utilization of a pre-existing space (such as the West Baffin Island Co-operative) for the creation and exportation of cultural products. In this case local interaction with visitors is extremely limited because relatively few individuals (such as Houston) come into contact with the host population.[13]

Armchair tourism also allows one to resolve or bypass altogether many of the potential dilemmas inherent in touristic interaction. For example, while most tourists are in search of an "authentic" experience with a cultural other and often anticipate getting to know their hosts personally, they can find this form of interaction painfully awkward.[14] Situations in which a benign act is misconstrued as an insult or a generous gesture as a serious threat are possible, if not common. Not knowing how to interact, or not understanding different social codes, keeps many tourists from traveling to places too culturally different from their own.[15] There is also the issue of "white guilt," which is associated with ethnic tourism.[16] But armchair tourists conveniently avoid these predicaments while getting to know their hosts on an individual basis. For example, in "Eskimo Sculptors" (1951), Houston began with Syoolie and Amidilak, two Inuit huntsmen who, having arrived at the trading post, discuss a discouraging day of hunting. Having concluded the trade of their seal and fox furs, the conversation between the men then turns to their carvings. As Syoolie talks enthusiastically about his next carving project, Amidilak's son Koonie surprises the group with an exquisitely carved human figure.[17] In a later article, Houston recounts a time in which he awaited the passing of a storm with Munamee, another Inuit carver who was so engrossed in the magical powers of the amulet he was carving, he scarcely acknowledged Houston's presence.[18] In addition to these men, Houston also introduced his readers to the ideal, composite, anonymous Eskimo, who is a skilled hunter, humble man, clever joker, and sincere artist – whose anatomical knowledge of the animals he hunts is evident in his carvings. Consequently, one comes away from Houston's articles having gotten to know both the ideal and individual Inuit as they overcome adversities and express the concerns of their daily lives.

Utilizing this highly distanced yet, paradoxically, intimate form of cultural interaction to its fullest, Houston also accommodated those who want to be "the lone explorer." A primary reason

why tourists dislike the presence of their own kind is because they can heighten each others' self-consciousness as cultural voyeurs and give probable cause for their hosts to "stage," and consequently "spoil" their cultural practices by catering to an outside audience.[19] But the one-on-one engagement between the reader and the primitive culture revealed in Houston's articles allows one to engage in the story knowing that one is not spoiling it for others, and vice versa. Because reading is an essentially private act, readers remain secure, innocent, unimplicated, and unburdened by the intrusive presence of their own kind. While Houston's presence in the articles is undeniable, strategically he remains only a catalyst who facilitates an ideal, hence all the more memorable, encounter with the Inuit.

III

Despite the fact that Houston's essays discuss Inuit sculptures and prints at length, he never specifically mentions how to obtain one. By promoting the knowledge of, rather than access to, contemporary Inuit art, Houston established it as a prestige item. Consequently, just as the ideal tourist returns home with objects that are recognizably valuable, which results in part from the difficulty of their acquisition, those who seek out Inuit art are held in high esteem by their collector peers.[20] Initially this strategy created a great deal of confusion, which is evident in the numerous letters written to the Canadian government at the time. Many people who had read Houston's texts (or one of the copycat articles) wrote to the government about their desire to purchase contemporary Inuit art. Although Houston's articles stressed the uniqueness and originality of the soapstone sculptures, people wrote in search of their desired favorites.[21] A similar situation occurred with Inuit prints, in which art dealers requested permission to reproduce Inuit prints in smaller, more easily accessible and affordable forms.[22] Despite these misunderstandings, however, once it became commonly understood that Inuit art was not easily acquired, the desire for it became an even more culturally sanctioned quest – a quest which continues to drive the Inuit art market today.

IV

Distance is a key element in the conception of primitive people and their art, creating both difference and desire. In a conceptual sense, distance provides a context in which to establish the binary category us/other, which is followed by all of the other normative binaries of primitivism, such as light/dark, civilized/uncivilized, and history/myth. The consumer of non-western art, then, requires that the origin of production be distanced from the here and now in order to maintain the classic distinction between us and them: our art and their artifacts. Consequently, common to the marketing of non-Western art are spatial and temporal perversions which allow the free play of conjecture necessary properly to exaggerate and hone the idea of primitive peoples and their cultural products.[23]

In order to promote contemporary Inuit soapstone sculptures as the kind of objects that adventurous tourists, such as his readers, dream of finding on their journey into a foreign land, Houston did two things. First, he instructed the Inuit to make sculptures that differed stylistically and iconographically from historic work.[24] At the same time, in his writings Houston allowed, if not prompted, his readers to associate the Inuit with their precontact past. By encouraging the creation of sculptures that contrast with historic work, Houston sought to disassociate contemporary

carvings from the derogatory attitudes held about Inuit art at the time.[25] By fostering the cognitive association between the Inuit of the distant past and the present Houston was better able to ensure the purity and rarity – thus value – of contemporary Inuit sculptures.

It is well known that Houston used both placards and the brief text *Eskimo Handicrafts / Susunusuk* (1951) to instruct Inuit artists. This pamphlet contained illustrations and instructions in English and Inuit that encouraged the creation of art that is high in quality (according to Western standards) yet devoid of Western subject matter. For example, the caption that accompanies an image of a man, his dog, and a walrus reads: "Man throwing harpoon, or spearing through ice, dog, walrus or seal. If they are carefully carved and polished the kaloona [white man] will buy them."[26] Although these visual aids were presented as optional, as J. Douglas Leechman noted:

> [the Eskimo] is being encouraged to use better materials and to work as skillfully as he can. This is not done by direct suggestion, but by the more subtle and more effective method of paying the most for the best work. The Eskimo is quick to learn . . . Hudson's Bay post managers, who have been coached on values, buy the carvings direct from the Eskimos.[27]

These "values" mentioned above are outlined in a lesser known publication of Houston's entitled, "Eskimo Handicrafts: A Private Guide for the Hudson Bay Company Manager 1953," in which he stated:

> Generally speaking, we have found that functional objects such as ash trays, pen holders, match holders and cribbage boards have been our poorest selling items.
>
> This is because our Agents and customers are looking for primative [*sic*] work by a primitive people. This term primitive does not mean that the work is crude since many primitive people have made extremely delicate crafts, but it is true that the ash tray, pen holder and cribbage board do not represent the Eskimo culture and as a result there is little interest in buying that type of work.[28]

Although this is, to my knowledge, the only direct reference made by Houston to historic Inuit art in print during the 1950s, this passage attests to both his awareness of the public's negative perception of historic Inuit objects, as well as to his insight into the current market for primitive art.

As evident in government records, both Houston and others recognized the significance of marketing strategies to the long-term success of contemporary Inuit art. The first collection of sculptures amassed by Houston were exhibited in association with the Canadian Handicraft Guild. Thereafter, fine art venues, rather than tourist shops and trading posts (where historic carvings were typically sold), were chosen for the display and sale of Inuit sculptures. As R. A. J. Phillips, who was at the time the Assistant Director of the Department of Northern Affairs and Natural Resources, explained in a previously unpublished letter, " the long range preservation of Eskimo art depends in part upon the auspices under which it is sold. . . . The image of Canadian Eskimo art can easily be spoiled through its sale in improper circumstances."[29] In fact, this concern about marketing led those involved to discourage the sale of Inuit art outside of Canada:

> the Department [of Northern Affairs and Natural Resources] has long discouraged substantial sales of carvings to the U.S. Apart from the many other dangers in

American selling, there is virtually no control over the type of outlet or promotion use [*sic*] and consequently, no control over the image which the art creates in the public mind.[30]

Having tailored Inuit sculptures to fit the public's perception of "fine" (gallery quality) primitive art, in his articles Houston compensated for the contemporary existence of the Inuit themselves. Throughout his writings Houston repeatedly manufactured distance by dramatically grounding the Inuit in the past, but not within the complex realm of Arctic history or archaeology. Instead, Houston created his own version of Inuit history, which is thick with wonder and mystery. For instance, in "Eskimo Artists" (1962) Houston skillfully capitalized on the lack of agriculture in the Arctic to associate the Inuit, not simply with pre-contact peoples, but with the pre-agricultural peoples of the North American continent – the Paleo-Eskimo: "(F)or the Eskimo in his geographically remote isolation is an energetic and highly perceptive man, drawing his fresh, often unique ideas directly from the forgotten well of thoughts that existed before agriculture or animal husbandry."[31]

To obscure spatial immediacy, in the opening paragraph to "Eskimo Graphic Art" (1960) Houston traced the pre-contact migration route of the Thule, the predecessors of the Inuit: "The Eskimo people are one of the most widely distributed races on earth. Their prehistoric nomadic wanderings have scattered them halfway around the globe, from northeast Asia across Arctic America to Greenland."[32] In one grand sweep of the imagination, Houston encompassed the entire far northern

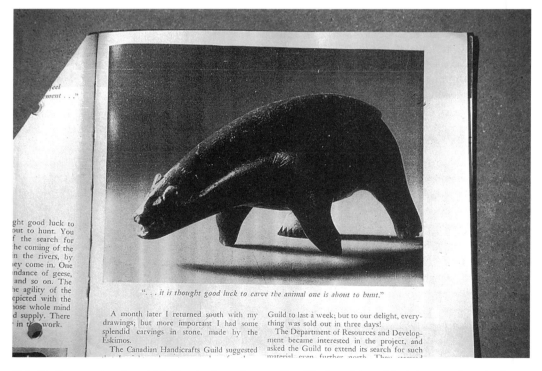

"*. . . it is thought good luck to carve the animal one is about to hunt.*"

Plate 13 Bear carving, for which Houston's caption was ". . . it is thought good luck to carve the animal one is about to hunt" (from his paper "In Search of Contemporary Eskimo Art," *Canadian Art Magazine* 9 (1952))

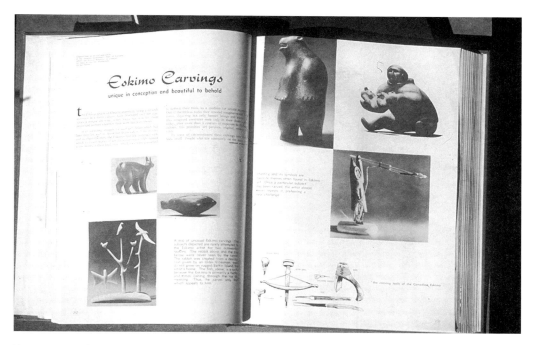

Plate 14 Pages from *Design Magazine* **55 (March 1959)**

hemisphere in which the Inuit become conceivably closer to the people and terrain of ancient Siberia than the modern-day cities of Quebec or Ottawa.

Although he openly acknowledged that the Inuit were happy to sell their work, Houston also distanced contemporary Inuit sculpture from vulgarities such as exchange value by stressing that they saw no direct connection between art-making and monetary compensation. Regarding the artist Kopeekolik, Houston stated: "As far as he was concerned, there was no connection between carving and commercial gain – he had proved himself a carver of walrus, and that was enough."[33] In concert with this, Houston also associated Inuit sculptures with indigenous spiritual practices, because it is commonly known that primitive art is worth more if it is was created exclusively for internal-religious (rather than external-commercial) use. To do this, Houston made vague, yet strategically placed statements, such as "(p)erhaps the Eskimo hunter still attaches magical significance to the little models of the game he hopes to kill;"[34] or, "it is thought good luck to carve the animal one is about to hunt"[35] (Plates 13, 14).

In his articles Houston also employed theories propounded by Herbert Spencer, a nineteenth-century anthropologist, who believed that primitive peoples' keen awareness of the environment precluded them from functioning at a higher conceptual level.[36] In "Contemporary Art of the Eskimo" (1954) Houston stated: "In his art we see life through the eyes of a hunter as he perfectly portrays the moving things around him with the keen, trained senses of one whose very life depends upon observation."[37] Again, in *Canadian Eskimo Art* (1954), Houston pondered, "It is impossible to know the objectives of the ancient Eskimo carvers since no written record accompanies their work. It is not easy either to analyze the motives of living Eskimo artists, because they seldom give utterance to abstract thought."[38]

In fact, according to Houston, art-making is not an intellectual activity for the Inuit but a purely natural and intuitive one. Comparing them to Arctic wildflowers in the springtime Houston stated of Inuit artists, "Where nature allows, their art flourishes."[39] Furthermore, because their carvings were an expression of pure, unalienated labor, the Inuit were oblivious to any kind of art historical or critical burden: "Because he has not been exposed to any formal training, or been overwhelmed by the great works of any especially talented people, the Eskimo has no troublesome yardstick of good art or bad art or formalized carving techniques to inhibit him."[40]

While defining the Inuit as the medium through which the primeval creative urges of humanity flow and who consequently do not possess a "troublesome yardstick" with which to gauge the quality of their work, Houston enacted a conceptual *coup d'état*. Houston promoted Inuit artists as Savage Savants – learned yet untaught – who have a quasi-religious obsession with craftsmanship and are so well versed in their aesthetic standards that they make judgments in absolute unison.[41] Houston also emphasized that Inuit artists are highly innovative and, although they respect each other's carvings, they have strict sanctions against copying one another and simply cannot comprehend the reason for carving the same form twice.[42] Houston puts this to the test in an article written in 1952 by asking Kopeekolik if he would make another carving of a walrus. Kopeekolik's response is both incredulous and confused: "He looked at me for a moment and then asked 'Why?' He said, 'I have carved a perfect likeness of a walrus. Why would you want me to make another one?' "[43] This conversation ended happily with Houston suggesting that Kopeekolik carve a caribou, an animal Kopeekolik had never tried before.

By finding that the Inuit are predisposed to creating original works of art according to aesthetic standards that are remarkably high and in alignment with the standards of their purchasing public, Houston confidently implied that intervention is neither necessary nor desirable. Moreover, his essays allowed him to promote this mirage of cultural purity in which the Inuit survive in full bloom relatively unaffected by their patrons. Fortunately, however, this interaction did profoundly affect the Inuit in that it provided economic relief and facilitated cultural and artistic recognition.

V

Printmaking in the Canadian Arctic began in 1957. Because the initial experiments appeared to have great potential as a supplement to soapstone carving, Houston used his accumulated leave in 1958 to go to Japan for four months for an intensive course in the "direct hand transfer" method, the knowledge of which he shared with Inuit artists upon his return to the Arctic. After the first two years, in which questions regarding materials, images, and the division of labor were settled, the printmaking project quickly materialized. This was due in large part to Terrence Ryan, another artistically inclined non-Native Canadian, who settled on Baffin Island in 1958 and became a full-time artistic advisor to the Inuit. With Ryan's assistance, the standards and policies of the Cape Dorset printshop were modeled on those of printshops in the south, resulting in the release of the first annual Inuit print collection in 1959.[44] Although Houston left the Arctic permanently three years later, in 1962, his conception of Inuit printmaking and the legacy of his influence on this tradition stem in part from his 1960 article in *Canadian Art* and his 1967 book *Eskimo Prints*, in which he adapted his previous strategies in order to publicize this art form.

In order to understand the relative success of Inuit printmaking it is necessary to address briefly the problems that arose with the creation and marketing of the sculptures. The popularity of Inuit soapstone sculpture was both great and unanticipated, yet, besides the danger of becoming

dependent on a single export for economic livelihood, there were other limitations to working with this material. Although soapstone is comparatively soft, the carving of it requires specific tools that were hard to obtain in the Arctic, particularly during the early 1950s. Although the artists quickly learned that they could earn more money for bigger sculptures,[45] larger and substantially heavier pieces had to be carved outdoors, which is a difficult undertaking for the elderly, the sick, or those living a semi-nomadic lifestyle. Even the acquisition of soapstone was a problem because the areas easily accessible were quickly mined out. Although the Hudson Bay Company started a program in which stone was redistributed to carvers in different districts, this was contrary to the market, which developed in accord with the recognition of regional styles based on indigenous stone types.[46] Moreover, the primary motivation for purchasing soapstone carvings was not a concern for quality, but the desire to support Inuit carvers economically and, in his later articles and speeches, Houston jokingly alluded to how he threw inferior work into the ocean after he purchased them.[47]

In addition, overproduction was also a problematic issue. Unable to conceptualize the greater market within which their products moved, the Inuit saw a direct relationship between production and revenue without anticipating the consequences of flooding the market. By 1951, owing to the quantity of unsaleable work and speculation about the future of the market, the Hudson Bay Company Stores temporarily stopped buying Inuit sculptures. Despite the concern voiced about exporting to the United States, in the same year Eugene Powers (a personal friend of Houston's) became the United States wholesaler, who partially alleviated the surplus by expanding the market base.

In contrast, for printmaking both quality and overproduction were entirely different issues. The surplus of drawings and the uneven quality of those drawings was not only anticipated but encouraged because not all drawings were printed; rather a pool of possibilities was created. This meant that Houston and others involved could buy unprintable drawings knowingly without creating the same economic dilemma, because they were not purchasing a finished product. In fact, only a tiny fraction of the drawings created were translated into prints. According to Jean Blodgett, since the late 1950s out of almost one hundred thousand drawings, only one thousand have been translated into prints.[48] This 1:100 ratio reflects a rigorous system of acceptance and rejection. For example, although Ryan and the Inuit printers might have selected and printed a drawing, this did not necessarily guarantee its inclusion in an annual collection since the final print had to be endorsed by the Canadian Eskimo Art Council. An outside regulatory body, this council was formed in 1961 to "approve the annual editions . . . to foment publicity, arrange exhibits and channel money into Inuit art ventures."[49] Manifesting aesthetic and economic inclusionism on the one hand, and aesthetic and economic elitism on the other, the West Baffin Island Eskimo Co-operative supported a broad base of artists with a wide range of abilities. Simultaneously it appealed to a discriminating public, and income from the prints offset the money paid to all of the co-operative members for both printed and unprinted drawings.[50] (See Plate 15 for an example of later work by the Co-operative.)

For all the great marketing advantage of printmaking, there had been nothing comparable to it in the Arctic prior to its introduction. So for Houston, who had previously marketed soapstone sculptures as an extension of an age-old tradition, there was a great marketing dilemma with Inuit prints because printmaking is conceivably one of the least "primitive" of all artistic media. Printmaking and printing generally are associated with technology, which is one of the most important causes of, or consequences of, the development of an industrialized, hence civilized, society; the absence of this medium of communication has long been part of the very definition of primitive peoples.[51]

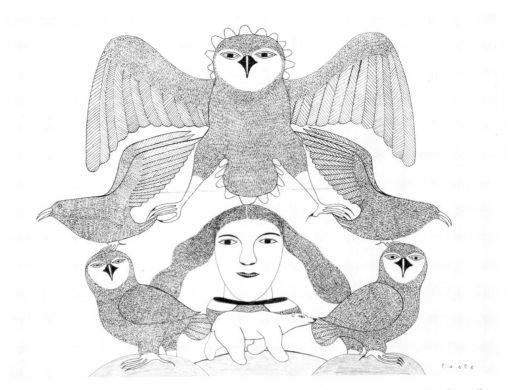

Plate 15 Kenojuak Ashevak, *Together with Ravens* (1979), drawing in felt-tip pen and colored pencil, copyright the West Baffin Island Co-operative. Photograph courtesy the McMichael Canadian Art Collection

The specialization of labor associated with printmaking, which traditionally involves the co-operation of the artist, carver, and printer, was also problematic. In relation to non-Western artists, the breakdown of artistic production into separate steps done by different people is generally, and derogatorily, associated with factory-produced tourist art. Although Houston had capitalized on the tourist desire for Inuit sculptures, he was adamant about it not being perceived as tourist art. Yet the "assembly line" associations of printmaking create the potential for just such a negative perception.

Furthermore, there was the issue of intention. Jungian-based theories, popular at mid-century, supported the idea that non-Western peoples were exemplars of humanity's collective unconscious. According to Jungian models, both their spontaneity and lack of intent allowed "primitive" peoples to encounter more easily the metaphysical substratum of human existence than those burdened by self-consciousness. Yet printmaking requires a high degree of cognitive awareness. Premeditation, for example, is involved in connection with both color schemes and stencil arrangement. Printmaking also demands that one anticipate just how the original image will translate, not only from drawing to stone block, but also from stone block to print. Consequently, it would seem virtually impossible to promote Inuit prints as anything other than an acculturated art form.

In order to maintain the facade of cultural purity that he established in his earlier writings Houston presented the Inuit as predisposed to develop printmaking. Even though he expressed the desire to experiment with printmaking in a government memo dated December 1955, in one of his

most well-known stories (included in *Eskimo Prints*) Houston credits the Inuit (specifically, a carver named Oshaweetok) with this decision in 1957.[52] To further compensate for the apparent paradox between "primitive" culture and modern medium, in his writings Houston employed "the comparative method." An organizational strategy associated with the early years of anthropological study, the comparative method is a means of neatly accounting for and illustrating the varied degrees of cultural development by hierarchically ordering different cultures from least to most developed in terms of tools and technology. In his discussion of the division of the artist, block-cutter and printer Houston stated that the Inuit manner of printmaking "parallels the early concepts of printmaking in both Europe and the Far East."[53] By placing the Inuit within the grand continuum of cultural evolution, offering in the process a window into civilization's past, he suggested that the occurrence of this medium is not the result of outside encroachment but is the result of a "natural" internal development.

Houston also promoted the Inuit as a people, not simply in the process of development, but on the threshold of cultural metamorphosis, both civilized and "primitive." This not only provided dramatic tension but, more importantly, allowed Houston to assure his readers that while the Inuit are beginning to utilize technology in their creation of art, they remain firmly grounded in their "primitive" background. This tactic is evident in how Houston addressed the technology used by the Inuit, for he often described in detail the actual process followed by the Inuit, concluding that "(s)tencil is perhaps the most immediate graphic art form ever developed. It is a simple medium and one can achieve direct results in a few minutes."[54] This expository mode not only demystified the technological side of printmaking, but also allowed the continued mystification of the Inuit in regard to their archaic mode of artistic expression. Moreover, it is important to note that, since the beginning of printmaking in the North, the printers maintained a great concern for veracity in relation to the translation of a drawing to a print. While this is commonly done out of respect for the individual's artistic vision, it also is a means by which to once again assure the buyers of Inuit prints that they are purchasing art that is an immediate expression of a "primitive" mind.

In fact, even the most common alteration that occurs from drawing to print could be understood in terms of making the print appear even more "primitive." In her detailed analysis of Inuit printmaking, Jean Blodgett regularly finds the inclusion or enlargement of a white border in the prints.[55] Although this, and other alterations, are ascribed to practical constraints such as composition, or size of paper or stone, they are also potentially indicative of another underlying assumption utilized by Houston. At mid century it was commonly believed that "primitive" peoples did not depict "landscape" because they had no conception of such or the rules of perspective that call for such visual conventions. Aware of this, Houston wrote in 1956: "Certainly it is important to note that few, if any, primitive groups portray backgrounds . . . "[56] If ground lines are a simple indication of landscape, the removal of them is yet another subtle, if unintended, means of adapting Inuit prints to people's preconceptions of non-Western art.

Concerning the specialization of labor, the printshop adopted the Japanese method of attribution in which the shop, artist, and printer are all acknowledged. Although "primitive" art is typically known by culture and not by individual artist, in this case such careful attribution ensures that Inuit prints are not perceived as mass-produced tourist art. Simultaneously it encourages the development of an interest in individuals, such as Kenojuak and Pitseolak, who are the most widely known Inuit women artists from this period (Plate C).

While fabricating and exploiting this transitory state between "primitive" and modern, Houston did not seek to imply that the Inuit will remain there indefinitely. Rather he cleverly suggested that

there was very little time in which to act, boldly linking printmaking with gradual disappearance of Inuit religion:

> Eskimo art must surely owe its original debt to the religion of Shamanism . . . Today more than half the prints, like the amulets, still draw their inspiration directly from the sources of Shamanism. The printed images we see are reflections of these old traditions that slowly fade before them. Christian intrusions and standardized education on every side will undoubtedly see the death of this ancient religion.[57]

Another concern on the part of his patrons that Houston both anticipated and assuaged in his writings is that of the change in subsistence patterns brought on by the introduction of printmaking in the North. Presumably, the more time the Inuit devoted to depicting their daily lives for outsiders, the less time they had for actually doing those "traditional" things. However, according to Houston, printmaking was conducive to just the opposite. As with the production of sculptures, Houston stated that printmaking allowed the Inuit to continue living their "traditional" semi-nomadic lifestyle. Because he only solicited the Inuit to make drawings (and, at first, stencils)[58] their seasonal movements were not at all restricted by his requests: "As the dog teams arrived from the winter camps, we received from the people drawings . . . "[59] Regarding the Inuit printers, Houston described their schedule as such: "From the beginning . . . work habits were determined by climate. On good hunting days the printmakers simply disappeared, but during the bad months and stormy periods they accomplished a prodigious amount of work."[60]

In tune with the seasonal rhythms of nature, the printers' work patterns again coincided with general perceptions of "primitive" peoples. This arrangement, of course, has added value, because if printmaking enables the Inuit to continue living off the land, it simultaneously helps lift the burden of government welfare (which was the primary reason the Canadian government became involved in the arts program). As Houston stated emphatically in his "Private Guide" (1953) regarding the careful selection of Inuit handicrafts: "In this way we can *all help the Eskimos help themselves*."[61]

VI

Disenchanted with the blatant discrepancies between Houston's widely published tales and the lesser known historical facts, in the closing remark of his review of Houston's *Confessions of an Igloo Dweller*, John Ayre called for a "well-rounded history based on established fact."[62] More than four decades since Houston's arrival in the North, scholarship dedicated to assessing such an important figure in the history of Inuit art is conspicuously absent. However, this is not an isolated instance, for middle-men such as Houston have been routinely overlooked in scholarly investigations. As Christopher Steiner observed about African traders, those who function as the liaison between the supply and demand are difficult to address because they operate within the least stable, most unpredictable position.[63]

At mid century Houston was essentially a free agent – an explorer – and has been described variously as an artist, lecturer, writer, adventurer, and Canadian national hero. Not responsible to, and not the responsibility of, any one specific academic field or institution, Houston has long managed to elude critique. Yet as Steiner noted, those who are the pivotal link between creation and consumption are not simply invisible catalysts in the exchange, but profoundly affect what is

exchanged and why: "the traders are not only moving a set of objects through the world economic system, they are also exchanging information – mediating, modifying, and commenting on a broad spectrum of cultural knowledge."[64] For these reasons, cultural brokers such as Houston must be carefully considered.

In a unique article that does just this, R. W. Dunning discusses "marginal men" who are "non-ethnic external representatives of powerful outside organizations" that enter into and profoundly affect Native communities.[65] Having studied the effects of these individuals in five remote northern indigenous communities at the time of Houston's presence in the North, Dunning concluded: "The nature of the social and cultural change would appear to be directly related to paternalistic leadership which in the isolated northern communities is often capricious, authoritarian, and discriminatory."[66] This characterization is, of course, antithetical to the general public's perception of James Houston who as both an author and authority, has been a master at soliciting sympathy and capturing the imagination of his audience.[67] While he may have exploited the ambiguity of his position, his amicable and well-humored autobiographical writings have long served to protect him from an objective evaluation as a "marginal man." However, as I have shown here, by utilizing an ideal exploratory narrative in his early writings, Houston facilitated the development of an economic relationship based on indirect cultural interaction, which led to the sale of "authentic" cultural "artifacts." This self-validating, circular mode, in which the object generates the narrative and the narrative authenticates the object, continues to shape the supply of and stimulate the demand for Inuit art today.

Notes

1 This organization was incorporated in 1959 as the West Baffin Sports Fishing Co-operative and renamed in 1961 as the West Baffin Island Eskimo Co-operative.

2 Nelson H. H. Graburn, "Inuit Art and Canadian Nationalism: Why Eskimos? Why Canada? *Inuit Art Quarterly* 1 (Fall 1986): 5–7.

3 Nelson H. H. Graburn, "The Discovery of Inuit Art: James A. Houston – Animateur," *Inuit Art Quarterly* 2 (Spring 1987): 4.

4 Paul L. Aspelin, "The Anthropological Analysis of Tourism: Indirect Tourism and Political Economy in the Case of the Mamainde of Mato Grosso, Brazil," *Annals of Tourism Research* 4 (January/February 1977): 137.

5 ibid., pp. 144–5.

6 ibid., pp. 150–1.

7 ibid., p. 135.

8 ibid., pp. 151–3.

9 ibid., p. 151.

10 With the developments in computer technology it is not difficult to envision *virtual* tourism in the near future.

11 Eric Cohen, "Authenticity and Commoditization in Tourism," *Annals of Tourism Research* 15 (1988): 377.

12 For a discussion of the relationship between object and souvenir, and between experience and narrative see Susan Stewart, *On Longing: Narratives of the Miniature, the Gigantic, the Souvenir, the Collection* (Durham, NC: Duke University Press, 1993), pp. 132–50.

13 For a discussion of the different kinds of tourism and relative degree of contact associated with each see the Introduction to Valene L. Smith (ed.) *Hosts and Guests: The Anthropology of Tourism*, (Philadelphia: University of Pennsylvania Press, 1989), pp. 1–17.

14 Dean MacCannell, *The Tourist: A New Theory of the Leisure Class* (New York: Shocken, 1976; repr. 1989), pp. 91–108.

15 As Elery Hamilton-Smith aptly asserts: "For Them the Effort is not Worth the Pleasures" ("Four kinds of tourism?" *Annals of Tourism Research* 14 (1987): 339).

16 See Joan Laxson, "How 'We' See 'Them': Tourism and Native Americans," *Annals of Tourism Research* 18 (1991): 365–91.

17 James Houston, "Eskimo Sculptors," *The Beaver* (June 1951): 35.

18 James Houston, "Eskimo Carvings," *Royal Architectural Journal of Canada* 31 (April 1954): 118.

19 See MacCannell, *The Tourist*, pp. 91–108.

20 See Nelson H. H. Graburn's discussion of the "hierarchy of prestige" in "Tourism: The Sacred Journey," *Hosts and Guests*, p. 34.

21 Public Archives of Canada; Record Group (RG) 85, vol. 431 File 255 – 2 – 4 – 1 pt. 3: Orders and Enquiries re: Eskimo Prints; and RG 85, vol. 1416 File 255 –1 pt. 10: Development of Eskimo Arts and Crafts Policy.

22 ibid.

23 See Johannes Fabian, *Time and the Other: How Anthropology Makes its Object* (New York: Columbia University Press, 1983.)p. 71–104; James Clifford, "Histories of the Tribal and Modern," in *The Predicament of Culture: Twentieth Century Ethnography, Literature, and Art* (Cambridge, MA: Harvard University Press, 1988), pp. 189–214.

24 Many historic carvings (post-contact to pre-Houston) are complex, open forms that consist of more than one piece or material, and reflect cultural contact, while contemporary sculptures almost exclusively consist of closed, bulky, and fairly unified forms that supposedly do not reflect cultural contact.

25 See Jean Blodgett, "The Historic Period in Canadian Eskimo Art," in *Inuit Art: An Anthology*, ed. Alma Houston (Winnipeg, Man: Watson and Dwyer, 1988), pp. 17–26.

26 James Houston, *Eskimo Handicrafts/Sunuyusuk* (Ottawa: Canadian Handicrafts Guild with approval of the Department of Resources and Development Northwest Territory Branch; translated by Sam Ford and Frederica Woodrow, 1951), p. 14.

27 J. Douglas Leechman, quoted by Charles Martjin in "Canadian Eskimo Carving in Historical Perspective," *Anthropos* 59 (1964): 562.

28 Houston, "Eskimo Handicrafts: A Private Guide for the Hudson's Bay Company Manager 1953," 3. Indian Affairs and Northern Development: Inuit Art Information Center, Record 2497.

29 Unpublished letter from R. A. J. Phillips to A. H. FitzGerald March 8, 1962. Public Archives of Canada RG 85, vol. 453 File 255 – 1 – 2 pt. 4: Development of Eskimo Arts and Crafts Policy: General Correspondences.

30 ibid.

31 James Houston, "Eskimo Artists," *Geographical Magazine* 34 (1962): 640.

32 James Houston, "Eskimo Graphic Art," *Canadian Art* 67 (1960): 6.

33 James Houston, "Contemporary Art of the Eskimo," *The Studio* 147 (February 1954): 44. In a later essay Houston asserts: "(S)uddenly, without explanation, he will start again. Such inspired and uninspired periods are shared by true artists everywhere. This is hardly a commercial approach to carving." See his essay, "To find life in stone," in *Sculpture/Inuit: Masterworks of the Canadian Arctic* (Toronto: University of Toronto Press, 1971), p. 55.

34 James Houston, *Canadian Eskimo Art* (Department of Northern Affairs and Natural Resources, Ottawa: Queen's Printer, 1954), n.p.

35 James Houston, "In Search of Contemporary Eskimo Art," *Canadian Art* 9 (1952): 102.

36 According to George Stocking, Spencer believed that, "(t)he sensory perceptions of the savage were

notoriously acute, but as a result of an antagonism between 'perceptive' and 'reflexive' activity, his mental processes rarely rose above the level of sensation," in Stocking, *Race, Culture and Evolution* (Chicago: University of Chicago Press, 1968; repr. 1982), p. 117.

37 Houston, "Contemporary Art of the Eskimo," p. 43.

38 Houston, *Canadian Eskimo Art*, n.p.; and (repeated verbatim) in "Eskimo Carvings," *Design* 55 (March 1959): 167.

39 Houston, *Canadian Eskimo Art*, n.p.

40 Houston, "Contemporary Art of the Eskimo," 44. The use of the third person is a form of objectification and a means of establishing distance, hence, authority. See Fabian, *Time and the Other*, pp. 85–6.

41 Houston, "Eskimo Carvings," p. 13.

42 Despite minor variations, owing to the limited iconographic range as suggested by Houston, Inuit carvers could not help but repeat themselves.

43 Houston, "In Search of Contemporary Eskimo Art," pp. 99–100.

44 Prior to this, a set of thirteen uncatalogued experimental prints were exhibited at the Hudson Bay Company store in Winnipeg in the winter of 1958.

45 Nelson H. H. Graburn, "Inuit Art," in Martina Magenau Jacobs and James B. Richardson III (eds) *Arctic Life: A Challenge to Survive* (Pittsburgh, PA: Carnegie Institute, 1983), p. 181.

46 ibid., p. 182.

47 James Houston, "The Inuit Intuit," *Craft International* (Summer 1981): 18.

48 Jean Blodgett, *In Cape Dorset We Do It This Way: Three Decades of Inuit Printmaking* (Kleinburg, Ont.: McMichael Canadian Art Collection, 1991), pp. 23, 65, 60.

49 Graburn, "Inuit Art and Canadian Nationalism," p. 6.

50 Initially, everyone was paid equally for their drawings regardless of whether they were printed or not. See Dorothy Harley Eber, "Looking for the artists of Dorset," *The Canadian Forum* 54 (July/August, 1972): 14.

51 William M. Ivins Jr., *Prints and Visual Communication* (Cambridge, MA: Harvard University Press, 1953; repr. Cambridge: MIT Press, 1985), p. 1.

52 Public Archives of Canada Documents 318: 255–5/166 cited in Helga Goetz, "Inuit Art: A History of Government Involvement," in *In The Shadow of the Sun: Perspectives on Contemporary Native Art*, ed. Canadian Museum of Civilization (Hull and Quebec: Canadian Ethnology Service, Mercury Series Paper 124), p. 367.

53 James Houston, *Eskimo Prints* (Barre, MA: Barre Publishers, 1967; repr. 1971), p. 22.

54 ibid., p. 16.

55 See Blodgett, *Three Decades*, pp. 32, 56, 63, 66.

56 James Houston, "My Friend Angotiawak," *Canadian Art* 13 (1956): 224.

57 Houston, *Eskimo Prints*, p. 31.

58 Although many of the artists took notice of which drawings were being chosen for prints and adapted their work accordingly, they were not originally solicited in this fashion.

59 Houston, *Eskimo Prints*, p. 21.

60 ibid., pp. 18, 21.

61 Houston, "Eskimo Handicrafts," p. 3 (emphasis original).

62 John Ayre, Review of "Confessions of an Igloo Dweller," *Inuit Art Quarterly* 11 (Spring 1996): 43.

63 Christopher Steiner, *African Art in Transit* (Cambridge: Cambridge University Press, 1994), pp. 1–15.

64 ibid., p. 2.

65 R. W. Dunning, "Ethnic Relations and the Marginal Man in Canada," *Human Organization* 18 (Spring 1959): 117.

66 ibid., p. 122.

67 What uncritical evaluations of Houston's writings do exist corroborate Mary Louise Pratt's assessment of the state of criticism on travel and exploratory literature. See her *Imperial Eyes: Travel Writing and Transculturation* (London: Routledge, 1992), p. 10.

Bruce Bernstein

Contexts for the Growth and Development of the Indian Art World in the 1960s and 1970s

Throughout this century ethnographic museums and art museums have developed fundamentally different modes of classification and exhibition. Objects collected from non-European societies have been classified in two major categories: as (scientific) cultural artifacts or as (aesthetic) works of art. Since the 1970s museum curators, anthropologists, art historians, collectors, and artists have created a dialogue which allowed for a single object to be either art or ethnology, or both simultaneously. The criteria for determining art or cultural object incorporate a discourse determining the object's – and therefore the maker's – level of authenticity. The notion of authenticity is generally an imposed one as will be demonstrated in the following: it is a discursive element which now permeates all parties associated with the Indian art world. During the 1960s and 1970s, the divergent viewpoints increasingly began to intersect, particularly as nineteenth-century and earlier Indian art was objectified. Nonetheless, twentieth-century pieces are still judged against a dialectic of material culture, art and authenticity.

There have been attempts throughout the century to move American Indian arts from ethnography to art; examples are the 1931 "Exposition of Indian Tribal Arts" (LaFarge and Sloan 1931), and the 1941 exhibition at the Museum of Modern Art curated by René d'Harnoncourt. Both of these were publicized as exhibitions of "Indian art as art, *not* ethnology" (ibid.: 15); nonetheless, these exhibitions were not able to achieve their supposed purpose until the 1970s. There were also earlier efforts to transform curio to art, including the establishment of the Santa Fe Indian Fair (Bernstein 1993, 1994a, 1994b; Dietrich 1936; Otis 1931) to help develop markets for new forms of Pueblo art pottery and the development of museum collections (see Dauber 1990, 1993; Stocking 1982), as well as exhibitions of the traditional Studio style of Indian painting in Chicago, New York, and Santa Fe (Bernstein and Rushing 1995; Brody 1997; Rushing 1995). But none of these would have the lasting effects of the late 1960s and 1970s art market developments

because it is only since then that the national context has been properly situated to accept the notion that Indian art was equal in stature to other world art traditions.

The organizers of these shows did not want Indian artists to be subjected to low-brow Indian traders' influence, but rather, wanted to help them produce "articles of real worth, not Indian curios" (Dietrich 1936: 26). Concurrently, Santa Fe's artistic community wanted to protect Pueblo people from being drawn into the ranks of the masses. These exhibitions were in fact more directed at replacing with art the mass-consumerism of curios and souvenirs that traders had been promoting since the 1880s. Indeed, Santa Fe's artistic and museum communities believed they knew what was best for Indian people, which justified their desire to control the production of Indian art. Through their brokering of Indian art, Santa Fe's curators and art patrons believed they would be able to control popular opinion about Indian art in particular, and, in general, about the value of American Indian culture for modern America.

The 1930s exhibitions aimed to combat the curio by emphasizing aesthetics. Mentors such as Edgar Hewett, Kenneth Chapman, and Dorothy Dunn sought to "re-teach" Pueblo people an authentic aesthetic, which had been identified and juried by the Museum of New Mexico's curators and found to be free of all European influences. Museum Director Edgar Hewett's principal concern had been for authenticity, for the reconstruction of Pueblo culture – a revival of Pueblo pottery and dance, built upon hereditary talents. Hewett, as well as Chapman, Dunn, and others, wanted to build a re-created past as revealed through archaeology.

The Santa Fe arts community believed that the trader, motivated by money, did not seek an authentic art, but rather a curio that would sell quickly. The Santa Fe arts community believed, for example, that traders degraded the Navajo textile tradition by encouraging artists to weave floor rugs with patterns inspired by Persian carpets. In retrospect, the Santa Fe community did not comprehend the weavers' need to make money from their weaving, nor Navajo people's transformation of an adopted style into something as uniquely Navajo as any previous or subsequent weaving period or style.

Through the development of the Indian Fair in 1922 and the Indian Arts Fund collection (Dauber 1993), the Sante Fe community tried to influence these artists to return to their own aboriginal traditions in order to locate a genuine art form. Ironically, the art forms most promoted were developed in the twentieth century, such as Navajo floor rugs. Black-on-black pottery, promoted since the first Indian Fair in 1922 as the archetypal style of Pueblo art-pottery, was an invention of Maria and Julian Martinez of San Ildefonso Pueblo in the winter of 1919–20. The watercolor painting tradition was a development of three San Ildefonso painters working with the patronage of the Museum of New Mexico in 1913–20. While the promoters insisted that the paintings and pottery they encouraged were infused with the high principles of art, they were nonetheless an invention and were another means by which the non-Pueblo world appropriated Pueblo culture.

The shift in attitude toward Indian art in the 1960s and 1970s was the result of a broader international context that created a resurgence of interest in American Indian cultures, resulting in books, movies, and a new market for Indian-made and Indian style jewelry, pots, and other art forms. Native American art history became an academic discipline in the 1970s. As Indian art scholar Ralph T. Coe recalls, "The art had always been there, it was only a manner of calling attention to it." Exhibitions and new galleries opened in order to feature Indian artists and to present their work as "art."

The national context

An intense period of nationalism followed the United States' victory in World War II. And while the 1950s were reflexive, celebratory years dominated by the American dream, the 1960s began a turbulent era in which the American ideal of equality and representation for all Americans was severely tested through civil unrest and the Vietnam war.

One reaction to this disillusionment was the 1960s counterculture typified by the hippies who began searching for alternative modes of thought and living. Increased American affluence and leisure supplied the youth with the means and confidence to renounce high technology and disembodied intellectuality as expressed by shabby and ethnic derived clothing, long hair, sexual promiscuity, use of drugs for pleasure and insight, esoteric and eclectic religious activity, and rebellious politics (Brand 1988: 570). Many discovered the religions of American Indians and interpreted them in terms of a highly ecological consciousness. As Kenneth Lincoln (1983: 64) has observed, "Native peoples lived at home in the American frontier. The pilgrims, homesteaders, pioneers, ranchers, [and] city-builders all watched at a distance, in awe, fear and envy."

Theodore Rozack, in his *The Making of a Counterculture* (1969; see also Brand 1988) points out how, during the 1960s many people, particularly the young, reacted against poverty, racism, the war in Vietnam, the exploitation of the environment, the military-industrial complex, capitalism, and a personal sense of alienation by actively rebelling against their own society and consciously seeking alternative lifestyles. The hippie, immersed in drugs, mysticism and the occult, was actually a revolutionary displaying his or her opposition to "technocratic society."

As Robert F. Berkhofer, Jr. (1978: 108–11) says, one result of the counterculture movement was an elevation of the Indian in the eyes of many Anglos. The Indian's connection to the land, tradition, and community was romantically appealing to the alienated and to the ecology-minded.

> American Indians, ever the object of romantic interest . . . from a distance . . . looked perfect: ecologically aware, spiritual, tribal, anarchistic, drug-using, exotic, native, and wronged, the lone genuine holdouts against American conformity and success.
>
> (Brand 1988: 570)

The intellectual and social climate in the United States was ripe for "discovering" and embracing Indian cultures. Social service organizations, books and television focused on their health and economic plight, but despite poverty and inadequate healthcare, American Indians retained a semblance of their traditional lifestyles. American society looked to Indian cultures for a means of recapturing a genuine American heritage.

The primitive arts market

In the art world, European influence on American art waned after World War II. To replace it, Americans turned inward and rediscovered their own art traditions, such as the Hudson River School, and American furniture. American house interiors of the 1960s and 1970s emphasized nature through the use of plants, macrame wall hangings, and natural-finish wood furniture. Nothing complemented these interiors better than handcrafted Indian pots, rugs, and baskets. In the

words of long-time pottery aficionado and dealer Al Packard, "Pottery got to be a decorator item because they were knowable, being bright and colorful – they could live anywhere."[1]

The primitive art market gravitated toward American Indian arts during the 1950s. A single primitive arts dealer in Los Angeles (Robert Altman) and a handful in New York city (Julius Carlebach, Marge Simpson, and George Terasaki) included primarily Northwest Coast Indian art along with their stock of Oceanic and African art – long the subject of European connoisseurship. African and Oceanic were two of the very few primitive art traditions that were acknowledged to be more than assemblages of artifacts or crafts. Kachina dolls and masks, Mimbres pots, and Northwest Coast objects may have been the first Indian-made items to be included as art in the ethnic arts world because they conformed to the European art historians' definitions of fine art: they were paintings and sculpture. American Indian material was affordable compared to other types of ethnic art, and herein lay part of its appeal.

In 1971, the Green collection of American Indian Art was auctioned at the Sotheby Parke-Bernet Galleries in New York city. As curator and collector Ted Coe remembers, many pieces sold for "four figures – low by today's standards, but for then, unheard of sums of money." After the Green sale "American Indian art became a commodity, beginning a long descent of monetary appreciation and value over aesthetic appreciation."[2]

Art museum exhibitions of American Indian art

Three art museum exhibitions followed, helping to legitimize Indian artifacts as art. The museum shows engendered an Indian art history or scholarship to certify and establish Indian art's merit, distinguishing excellent or poor examples on aesthetic grounds. Pottery, for example, had been the subject of collecting, scholarship, and commerce. However, until the early 1970s the contexts were quite distinct from those of fine art. Exhibitions at the Whitney Museum in New York City, the Walker Art Center in Minneapolis, and The Nelson-Atkins Museum of Art in Kansas City permanently altered the long-standing status of American Indian-made objects as anthropology.

The Whitney Museum's 1971 "Two Hundred Years of American Indian Art," curated by Norman Feder, who also wrote an exhibition catalog (Feder 1971), emphasized religious and ceremonial art because he believed objects made for esoteric purposes exacted the most from the maker. In an earlier catalog he wrote:

> Technical excellence does not necessarily mean artistic excellence. . . . Although we can appreciate this skill and admire its results it is only those works which have an emotional impact on the viewer are included here [as art]. Usually, but not always, they were intended for use in some religious capacity.
>
> (Feder 1969: 23–4)

At the Walker Art Center in 1972, "American Indian Art: Form and Tradition" utilized modern art exhibition techniques, and thus helped solidify the Native American arts presentation as part of the modern art milieu. In addition, the accompanying catalogue (Walker Art Center 1972) included an essay by Ojibway writer Gerald Vizenor. This was one of the first publications to include a Native writer along with non-Native authors in the main body of a book instead of in an addendum.

The Walker show was remarkably direct in expressing its intention:

At last it's the Indian's turn! After 70 years of fascination with the powerful art of the far away cultures of black Africa and the South Pacific, today's art public has also become aware of the depth and expressiveness of the original American's aesthetic legacy. . . . The spiritual content of Indian objects eludes the white man, and the specialist's interest in them has been primarily historical and ethnographic.

<div align="right">(Friedman 1972: 23)</div>

The "Sacred Circles" exhibition, organized and curated by Coe of The Nelson-Atkins Museum of Art in Kansas City, was originally conceived to open only in London, as part of the 1976 bicentennial celebration. It sought to demonstrate the "viability of Native American arts" as well as to include a "sociological message that there was an America unseen and unknown" – in other words, "In the bicentennial year there was more than George Washington" (Coe, personal communication, 1994).

The advent of American Indian Art galleries

The marketplace was deeply divided between historic (or antique) and contemporary Indian art. The explosion in interest and monetary value outside of Santa Fe was almost exclusively reserved for the antique or historic sector of the market. In the ethnic art markets there is a strong tendency for pieces in the classical traditions, or rare, or antique art objects to command the highest prices because they can, for the buyer, represent a romanticized and idealized past. Antique pottery as contrasted with modern pottery, for instance, evokes a time of "traditional" societies when Indians made pots for "service rather than the tourist market" (Frank and Harlow 1974: caption, plate IV). Predictably, modern pottery prices lagged behind historic pottery prices. In fact, modern pottery prices remained almost exactly where they had been in the early 1960s. But by the early 1970s, modern pottery prices were on the rise. Throughout the 1980s and 1990s the best potters have consistently been able to receive increasing sums for their best work. Nonetheless, the price for historic pottery also continues to escalate, and modern pottery continues to lag behind historic pottery in price.

Indian art galleries were Anglo-controlled and had their origins in the Tuscon–Phoenix–Scottsdale areas of Arizona. With the expansion of the Indian art market, galleries spread to Los Angeles, San Francisco, and New York. Urban centers had the advantage of a larger population from which to draw a steady stream of customers, as well as access to airports. The Arizona galleries were strong because the dealers could remain close to their clientele and potential sources of southwestern material in the villages and homes of long-time residents.

A direct outgrowth of the Indian art market was the creation of *American Indian Art* magazine in 1975, "to give credit to an art form which has been, for so long, ignored" (*American Indian Art* 1975: 4). The editorial continued, "*American Indian Art* is an art magazine and not an anthropological journal"; it would discuss Indian-made objects as art, not as curios and souvenirs, which is what "Euro-Americans have often thought of American Indian objects" (p. 4). Books on pottery were published in the 1970s as well. Many of these used "environmental photography" which depicted pots in natural settings, for example, an olla under a cactus or on a sun-baked mud surface (see Arizona Highways 1974; Jacka 1976; Spivey 1979). Pots were illustrated as part of the timeless landscape of the Southwest and its first peoples.

Historic pottery was finite in quantity, so to satisfy the demand for Indian pottery and other types of Indian arts, galleries expanded their inventories to include works by contemporary artists. These shops attempted to establish Indian art as a fine art tradition by selectively dealing in the superb old pieces, promoting them as rare, antique treasures of the past, while at the same time marketing today's most popular contemporary artists. The situating of the old and new together in galleries had a positive effect for contemporary artists.

The Sante Fe context

The artistic formulas that brought financial success to potters in the 1930s remained essentially unchanged through the 1970s; polished blackwares and matte on black at San Ildefonso, polished and carved blackwares at Santa Clara, incised redwares at San Juan, and pieces poster-painted after firing at Tesuque. Although there was a general trend toward small pots, most pottery looked much the same as it did in the 1930s and 1940s. There was no distinction made between the types and uses of pottery – making pots for home use or for sale was part of the larger continuum of being a potter. Pots, as an extension of "everyday living in the old Pueblo world, were spontaneous acts of creation to meet functional and ceremonial needs." The generations of potters through the mid-1960s "made pottery for the act of making it as well as for income."[3]

In contrast, today's potters are more concerned with personal self-expression: the pot is one's own distinct product. Individuality is encouraged through signatures on the bottoms of pots, competitive judging at events such as Santa Fe's Indian Market, magazine and newspaper articles, and gallery shows. Competition is a by-product of individualization and a market economy. The Southwestern Association for Indian Arts[4] (SWAIA) encourages competition through judging and promotion, with Pueblo potters being told whose pots are better, and, further, by holding up monetary incentives including cash prizes for "best work." Individual artists compete for gallery shows and the increased sales which follow. These shows emphasize individual achievement and reward the more personable and outgoing artists – people with whom buyers are more likely to want to be associated. Since the 1970s, there has been a dramatic increase in the number of potters who work as individual artists outside of their communities, competing for sales and artistic fame.

Changes in pottery-making reflect cultural changes in the Pueblo world after World War II, when wage labor became increasingly important. Subsistence farming among Pueblo people decreased, and indeed, Pueblo people were advised not to farm. Instead they would be compensated for their idle lands under the federal soil bank program. "Many returning veterans had learned new trades in the service, or took advantage of the GI Bill to become skilled workmen and professional people" (Sando 1992: 148). As a result of their experiences in a broader American society, veterans began demanding the same economic opportunities and products that were available to others. The dominance of a cash economy obliged people to find employment, which they did in Santa Fe, Albuquerque, and Los Alamos, as well as in California.

As relocation programs had moved Tewa Pueblo people to Phoenix, Los Angeles, and San Francisco, government-sponsored economic opportunity plans brought people home in the late 1960s and 1970s by creating job opportunities in the Pueblos. The growth in village population, in turn, initiated a revitalized interest in Pueblo culture and traditions. This was exemplified in the vitality and numbers of dance participants as well as the number of potters working in the 1990s.

In 1968, just before the Indian art market became a phenomenal success, there was a relatively small and tightly knit group of traders and Indian suppliers. Santo Domingo traders brought Navajo-made rugs and jewelry from the reservation, while potters and jewelers continued decades-old relationships of maker and buyer. Modern pottery generally sat on "dusty shelves along with a few historic pots."[5] Furthermore, there were no special sections for better known potters such as Maria Martinez, rather, it was all sold under the name of "Indian pottery."

Indian art *dealers*, as they are known today, did not exist in Santa Fe before the early seventies. In 1970, Santa Fe had fifteen or so curio stores and trading posts; there were no Indian art galleries and sales were low key. These were "old-time" curio dealers and traders who purchased pottery in quantity with little – if any – attention to quality. Mass-produced pottery continued to be sold by the laundry basket load, replacing the wagon load, to traders and curio shops. Potters "laid it out on the floor" in shops and the trader quoted a price on the basis of the number and size of the pieces.

> Potters didn't want to peddle it all over town. I had to take the good with the bad, that was part of the deal. You have to eat the mistakes so to speak – the bad could always be traded or even thrown away.

Potters needed the traders to sell their pottery since their best retail alternative was to sit under the portal during the hot summer months or, at Fiesta Indian Market, where hoards of visitors carelessly stepped on potters and their wares. Nonetheless, a few visitors would purchase pottery in the villages. Prices remained low; a bowl with an eight inch diameter was about $12 retail, which meant that the potter received $6 wholesale for the piece. A comparable size bowl made by Maria Martinez in the early 1960s sold for $25 to $35.

The Indian jewelry boom

The massive expansion in Indian arts was largely due to the "jewelry explosion,"[6] a national craze for Indian-made and Indian-style jewelry that had strong reverberations for Pueblo people and Santa Fe's Indian traders. The jewelry explosion created an unprecedented situation, with jewelers and traders struggling to meet the demand fomented by the national interest in and desire for jewelry and, later, "all things Indian."

The boom was the first manifestation of renewed interest amongst the American public in Native American cultures. There was an overnight surge of interest in Indian jewelry. "Anything put in the case would be sold immediately." It was a new mass-consumerism for which "jewelry was being stereotyped, the same piece being made over and over." The demand – and prices – "went crazy." Suddenly there was not enough jewelry to meet the demand. Indian and non-Indian people became instant smiths, producing hundreds of the big and ugly pieces which sold better than anything else. Santo Domingo traders also stopped coming to Santa Fe because they could go to California and Phoenix, where they could do better.

The boom in Indian jewelry was related to high fashion. A national advertisement in 1968 for Estée Lauder perfume featured a woman wearing a concha belt: "It was the talk of the traders; we were amazed because no one wore it [Indian jewelry]," yet by the end of 1960s Navajo silver was standard fashion. The allure of Indian jewelry lay in its boldness, exoticism, and ethnic connotations. Jewelry represented everything that the alternative culture desired and longed to belong to; it stood for tribalism, ethnicity, and deep philosophical meanings. The short-term result was the over

production and manufacturing of Indian-style jewelry, much of it made by unskilled smiths, some even by non-Indians, who, once the demand fell off, returned to other types of wage labor. After the fad subsided the less-skilled Native smiths abandoned jewelry-making. Many jewelers continued, making pieces for a smaller, but now consistent market. Interest in Pueblo pottery followed the emerging national interest in American Indian cultures, and it too was an overnight sensation. Traders and potters do not remember the boom's beginning, only finding themselves in the middle of it.

The Pueblo Pottery Boom

When Bob Ward purchased Candelario's Original Trading Post about 1970, the price included the remainder of the store's inventory of pottery from 1890. Ward proceeded to double the accepted retail prices for all of these items – and sold every pot. In 1964 an historic San Ildefonso olla cost $35 while in 1968 the price was $75 (Wade 1976: 116).

Ward was following the model provided by art dealer Larry Frank. In 1966 trader C. G. Wallace sold a collection of five hundred pots for $10,000 to the Vander Wagens, another long-time trading family at Zuni. In turn, Frank purchased the collection in 1969 for $45,000 from the Vander Wagens. This was an unheard-of sum at the time. Although he paid an average of $90 per pot, over the course of the next ten years he did not sell one for less than $200, and many for substantially more. Frank recalls that "I had the lion's share of pottery so I sold it slowly."

Frank had been collecting pottery since the early 1960s and describes this price shift as part of "the time of pottery." He continues, "the motion was set when I went into it [buying and selling pottery]." His astute role in the shift of the historic pottery market may have been due to his awareness of the primitive art market in Paris, New York, and Los Angeles.

To help market Pueblo pottery, Frank wrote, together with Francis Harlow, *Historic Pottery of the Pueblo Indians: 1600–1880* (1974). There were few pottery books available (see Mera 1939 as well as Chapman 1978, much of which was written long before its publication), other than those written by historians and anthropologists. According to Frank, he "wanted to break through the anthropology of pots in order that people could appreciate a pot's beauty." The work was intended "to be the definitive book on dating and identification of styles."[7]

Pueblo concepts of pottery stand in strong contrast to the notions of art history and connoisseurship as exemplified in Frank and Harlow's book. Pueblo philosophy favors the process over the product, a potter's skill is never "sold," it is not a commodity. Books such as *Historic Pottery of the Pueblo Indians* value the object over the creative knowledge of potting.

Historic Pottery of the Pueblo Indians continues to provide illustrations of older pots for contemporary potters as well as the most coherent description of scholars' concepts of the singular and linear manner in which Anglo scholarly traditions conceptualize Pueblo potting history. For collectors, the book serves as a guide to pottery types as well as a standard of aesthetic quality for historic pottery. It is still the single most influential tool in marketing historic pottery.

In the 1970s pottery production generated a profound dislocation in the Pueblo economy as well as in gender roles. For centuries pottery-making was primarily done by women, with the exchange of pottery controlled by men (Snow 1973). As Babcock (1993: 224) observed, "cultural expressions such as potteries [sic] are not only a way of seeing the world but also a way of changing it, and that is perforce political." As the status of the individual potter grew in the marketplace, Pueblo women, once muted and discouraged from putting themselves forward, now found themselves as

representatives and spokespeople for their communities and Pueblo culture in general to the outside world.

Financial gain from pottery-making in all the Pueblos has helped invigorate religious practices through the financing of new and remodeled dance practice houses, kivas,[8] and dance regalia. In addition, potting allows people to stay home and have flexible work schedules, making participation in religious ceremonies easier. But while potters enjoy financial success, the related problems of greed and materialism are also visible. Material wealth is apparent everywhere in clothing, vehicles, homes, furniture, and dance regalia. The most successful potters are loath to report their earnings, and indeed some of the most successful Santa Clara potters live away from the Pueblo in order not to be under scrutiny from other community members.

The "Seven Families in Pueblo Pottery" exhibition

In the spring of 1974, the Maxwell Museum of Anthropology at the University of New Mexico in Albuquerque opened an exhibition featuring seven families of Pueblo pottery (the Martinez and Gonzales families of San Ildefonso, the Tafoya and Gutierrez families of Santa Clara, the Nampeyo family of Hopi, and the Lewis and Chino families of Acoma). This exhibition had a strong, direct effect on the sale of Santa Fe's pottery. The show was designed to trace the development in style and technique in pottery-making from generation to generation. The exhibition and catalog

> represent a nearly completed chronological sequence of the potter's art within each family. Examples of contemporary pottery show the diversity of current Pueblo ceramics within the fundamental traditions of the craft. The text traces the history of each family as far back in time as the oldest living member can recall. Statements by each potter about the work of his or her family enable the reader to see the development of the craft through the eyes of the artists themselves.
>
> (Maxwell Museum 1974: 114)

Previous books on pottery were largely anthropological, treating the pottery and people as objects, and they were often dehumanizing. *Seven Families* (the catalog) combined the best of anthropology and art by demonstrating how artistic traditions are family based and passed on through successive generations. The exhibition and catalog marked what Rick Dillingham recalled as the "beginning of people searching out particular potters." *Seven Families* gave people information about potters and potting, "putting things into perspective . . . about the continuity of families and traditions." This was the first time this kind of information was made broadly accessible.

The *Seven Families* catalog consolidated understanding of contemporary potters as artists. Potters were no longer mute craftspeople, but rather had faces, names, and voices as demonstrated in the photography and quotations that constituted the catalog. As a result, customers sought out pottery by artist and family instead of village style. People used the show and catalog as a guide to collecting pottery. Dillingham lamented that it was just "a checklist of collectable pottery" but conceded that "at least people knew potters' names and faces and where to find them."[9]

At the time, there were no other books on contemporary pottery available and since 1974, over 80,000 copies have been printed. During that time, picture book biographies and museum exhibitions have become commonplace ways to promote Pueblo potters (e.g. Blair and Blair 1986;

Peterson 1977; Spivey 1979; Trimble 1987). In 1995 Dillingham completed the long anticipated sequel, *Fourteen Families of Pueblo Pottery*.

The Institute of American Indian Arts

The establishment in Santa Fe in 1962 of the Institute of American Indian Arts (IAIA) also had profound effect on Indian arts by training new artists, bringing together an esteemed faculty of Indian art instructors, and providing new media and venues for making, selling, and displaying their work. "The school represented the first attempt in the history of U.S. Indian education to make the arts the central element of the curriculum" (Gritton 1991: 22; see also Brody 1971: 187–206; Garmhausen 1988: 62–86). The IAIA offered a college preparatory curriculum with vocational training in the arts. Its primary goal was to retain cultural pride while preparing students for college and bettering their academic performance.

"Traditional" art instructors, such as Geronima Montoya were removed from their teaching posts, since it was widely believed that the style of painting that had been taught at the Santa Fe Indian School Studio, since its inception by Dorothy Dunn in 1932, was creatively drained. The Indian School Studio's arbitrary traditional ideal had been created by Dunn. Allan Houser, a Dorothy Dunn student and a new faculty member at the IAIA remembered Dunn as a teacher:

> You had to pretty much focus in on what she had in mind. . . . She should have given me the chance to study anatomy for instance. But she said; "No, Indians have a natural feeling for action and rhythm." Now its a good idea, this belief that being Indian is something that you're born into. But it didn't help me learn anything about anatomy.
>
> My only objection to Dorothy Dunn was this: she trained us all the same way. "You either paint like this, Mr. Houser, or it's not Indian art."
>
> (quoted in Highwater 1980: 149)

In reaction to long-held perceptions about "Indian art" and in order to break from the Santa Fe painting tradition and move into a modern era, the IAIA's teaching emphasis was on *all* types of arts, rooting its training in the broader contexts of world art history. The students were taught mainstream trends with the goal of "producing artists with a high degree of recognized national reputation" (Garmhausen 1988: 73). The faculty included artists such as the painter Fritz Scholder, the sculptor Allan Houser, the jeweler Charles Loloma, and, as Art Director, Lloyd New, a designer and art educator.

New was outspoken about the importance of this new approach, suggesting "Let's stop looking backward for our standards of Indian art production. We must admit that the heyday of Indian life is past, or passing" (New quoted in Gritton 1991: 24). Since students shared in the larger society as well as their own cultures, they were encouraged to use all media, techniques, and non-Indian art forms. Again, New spoke forcefully for the creation of a new Indian art teaching institution since it was not possible "for anyone to live realistically while shut in by outmoded tradition." Moreover, he believed the new generation should not resort to a "hopeless prospect of mere remanipulation of the past" (ibid., 23).

Individualism was an important aspect of the Institute's training, in direct contrast to the communal nature of many Native American societies. The IAIA did not expect homogeneity on the

part of the predominantly Indian student body, but rather encouraged students to find themselves as artists of the world on a purely personal basis (Garmhausen 1988: 78).

"Providing a non-native, modern context for Indian arts was not a new concept" (Gritton 1991: 24). Rather, it was an approach championed by Santa Fe's artists' community in the 1920s, at the 1931 "Exposition of Indian Tribal Arts", and through René d'Harnoncourt's work with the Indian Arts and Crafts Board (Schrader 1983). But all of these efforts had little, if any, long-lasting national impact because they were still more concerned with a display of anonymous, primitive, or tribal work rather than with that of individual artists' works.

These exhibits may have included superb pieces of modern art; however, they were generally displayed by tribe or technique (i.e. as beadwork, basketry, pottery, or painting), and included a wide variety of dates and media. In contrast, contemporary Anglo artists' exhibits usually presented a single artistic genre and represented a single period of art history. In addition, Indian art exhibitions, such as the 1931 "Exposition of Indian Tribal Arts" and d'Harnoncourt's 1939 San Francisco World's Fair and "Golden Gate Exposition" included demonstrations by artists and other cultural performances such as dancing; Anglo artists were not asked to demonstrate their painting techniques, or other cultural traditions, at their exhibitions.

At the IAIA, following Fritz Scholder's and T. C. Cannon's lead, students were encouraged to use their creativity to respond to life experiences. These were often young artists "who knew that they were neither enfranchised as members of American society nor were they living the historic reality of their ancestors" (New as quoted in Rushing 1991: 17). "Realizing their marginality, relative to 'mainstream' culture, and experiencing simultaneously a sense that they were not leading *authentic* Indian lives, they portrayed themselves in a liminal identity" (Rushing 1991: 17). These works began to represent a pan-Indianism and, subsequently, an expression of the modern conditions of American Indian lives.

The IAIA began to impact the Santa Fe Indian Market in the 1970s. While none of the IAIA faculty entered pieces in Indian Market, many did serve as judges. Moreover, the IAIA's nurturing of individualism may have influenced Market's artists, but there were other national factors at work as well.

Allan Houser trained many sculpture students, and by the mid-1970s their work required the rewriting of the judging category, from clay figurines and Kachina dolls to wood, stone, and metal sculptures. In 1971, Bob Haozous was the first of the new generation of American artists of Indian descent to win at Indian Market. Changes in the sculpture category reinforced the feelings of many members of SWAIA's board that Market was for *traditional* arts. But nonetheless, new styles or non-traditional art forms such as oil or acrylic paintings with backgrounds, silver jewelry set with stones other than turquoise, and stone sculpture all began to be included in Indian Market during the 1970s.

In 1975 and again in 1976 Fritz Scholder offered a $1,000 award to the winner of a new contemporary painting category that would be specially created, of which Scholder wanted to be the sole judge of the entrants. SWAIA's Board of Directors rejected his offer. In addition, "a number of the Indian artists felt so strongly about Fritz Scholder judging their work, that they were planning to protest by a written and signed petition."[10] Artist and SWAIA Board member Geronima Montoya expressed her displeasure as well, saying, "Fritz Scholder had no regard for the traditional Indian artists and had publicly ridiculed their work."[11]

The emotional outpouring directed at Scholder, and by extension at the IAIA, was a result of the long relationship of the SWAIA to the local Pueblo communities and, in particular, to its fostering of the flat "traditional" style of painting. The Indian Fairs and Markets had always included a special

category for students' work from the Santa Fe Indian School. When contemporary painter Harry Fonseca won the award for best painting in 1980, the tacit constraints were shown finally to have been lifted, allowing participation of all types of artists.

Going forward while pedaling backward: the landscape today

This was the climate in which the Indian art market began to flourish in the 1970s. In the 1970s Indian material culture became art. Although the debate continues (Clifford 1988: 189–214), the confluence of art and ethnology was illustrated by the "'Primitivism' in 20th Century Art" exhibition of 1985 (see Rubin 1984) which brought together a major body of African, Oceanic, and American Indian artifacts from ethnographic museums to be shown alongside works by Pablo Picasso, Henry Moore, Henri Matisse, André Derain, and others to illustrate the powerful aesthetic qualities of tribal art and its influence on and so-called affinity to modern art. Further, as prices have climbed for contemporary and antique Indian art so has Indian art's legitimacy as art.

As people's interest increased they sought out artists. Beginning in the late 1960s, when buyers wanted to meet artists and buy directly from them, Santa Fe Indian Market was the place to go. At the same time the Gallup Intertribal Ceremonial continued to market Indian arts under the older formula of a trader's display. The authority to determine authenticity shifted to the Native artists, who to some degree (particularly the younger generation) capitulated to the Romantic sentimentality of non-Indians and began echoing these ideas to sell their work.

The notions of "less-expensive souvenir" and "more-expensive art piece" have persisted since the 1930s, and both concepts have been equally embraced by Indian people. While the idea of producing souvenirs might be met with disdain by some Indian people, and by buyers, traders, curators, and gallery owners, craftspeople continue to manufacture the majority of their output for the tourist market. Indeed the continued concern about the ghettoized nature of Indian arts is a direct outgrowth of the majority of pieces being made to reify a sentimentalized culture. Contemporary Chirichua Apache Artist Bob Haozous refers to this phenomenon as "self-censorship" of Indian people's true selves.

Regardless of the remarkable changes during this century, quality American Indian art does not change depending on whether its objects are displayed in an art gallery or anthropological exhibition. An object is as beautiful in the anthropology museum as in the art gallery. It remains a fallacy of the post-1970s period of American Indian art studies that objects in art galleries will be automatically transformed into art.

For the non-Indian or outsider looking in, the term "art" is a convenient classification to make sense of a dynamic and integral component of the Native American worldview, to make the Indian world intelligible in terms of Euro-American experience. Indian art is the sense of motion and creation expressed symbolically in objects and is to be understood as a way of living. Indian arts have always been dynamic, challenging conventions and adapting, reinterpreting, and improvising. Indian art reflects a particular community's aesthetic that is firmly rooted within the daily lives of the people and their religion, along with cars, fast food, and mass media. A new generation of Indian artists continues the intimate and vital dialogue between life experience and artistic expression. Tradition is constantly changing and it needs creativity in order to remain alive because creativity breaks apart old thoughts in order to reassemble the parts into new thoughts. But we must ask ourselves what happens when art is controlled by a hermetic world of scholarship and art markets and the artists themselves begin to fall victim to the chimera of a Romanticized past.

Notes

1 Personal communication with Al Packard. See note 5 below for further details.

2 The top price at the November auction was "$6,100, for a superb Washo basket made in 1905 by Datsolalee (the same basket was recently appraised at $350,000). The audience applauded as the item was knocked down at that figure – whereupon Harmer Johnson, who was conducting the sale, remarked 'I thought that was reserved for famous paintings'" (Sturtevant 1973: 50, n. 4).

3 Personal communication with Dr Alfonso Ortiz (San Juan), 1939–97, eminent scholar and teacher who taught anthropology at Claremont Colleges, Princeton, and the University of New Mexico.

4 The Southwestern Association for Indian Arts was first established as the New Mexico Association on Indian Affairs in 1922, a political advocacy organization. The organization successfully won many political battles for Indian rights as well as supplying the first reservation-based nursing to the Pueblos and the Navajo Reservation in the late 1920s. The group became sponsor of Indian Market in 1936 because of its commitment to the betterment of the economic condition of Pueblo people. In the late 1950s it changed its name to the Southwestern Association for Indian Affairs, and in 1993 changed it again, to the present name, to better reflect its emphasis on the arts.

5 Personal communication with Al Packard, a long-time trader and collector of Indian art whose father was also a trader. For decades Packard owned a shop on the Santa Fe Plaza, which still bears his name although he sold it in about 1982. All of the quotations in this section are through the courtesy of Al Packard.

6 The quotes in this section are also from interviews with Al Packard.

7 Personal communication with Larry Frank, 1993.

8 The religious chambers found in all Pueblo villages.

9 Personal communication with Rick Dillingham (1953–95) who was an important American ceramic artist. He spent all of his adult life working with Pueblo potters, making pottery with them, writing about pottery, and buying and selling Pueblo pottery. He was instrumental in the organization of the "Seven Families" exhibition at the Maxwell Museum. In 1994 he revisited the subject and published *Fourteen Families in Pueblo Pottery*.

10 August 7, 1975, SWAIA Board Meeting minutes, Offices of SWAIA, Sante Fe.

11 Personal communication with Genonima Montoya, 1992.

References

American Indian Art (1975) "Outlook 1975." *American Indian Art* 1(1): 4.

Arizona Highways (1974) *Southwest Pottery Today* (special edition) 50(5), May.

Babcock, Barbara (1993) "Shaping Selves, Reshaping Lives: The Art and Experience of Helen Cordero," in D. and N. Whitten (eds) *Imagery and Creativity: Ethnoaesthetics and Art Worlds in the Americas*, Tucson, AZ: University of Arizona Press, 205–34.

Berkhofer, Robert (1978) *The White Man's Indian: Images of the American Indian from Columbus to the Present*, New York: Alfred Knopf.

Bernstein, Bruce (1993) "The Marketing of Culture: Pottery and Santa Fe's Indian Market," Ph.D. diss., University of New Mexico.

—— (1994a) "Pueblo Potters, Museum Curators, and Santa Fe's Indian Market," *Expedition* 36(1): 14–23.

—— (1994b) "Potters and Patrons: The Creation of Pueblo Art Pottery," *American Indian Art* 20(1): 70–80.

Bernstein, Bruce and Rushing, W. Jackson (1995) *Modern By Tradition: The Studio Style of American Indian Painting*. Santa Fe, NM: Museum of New Mexico.

Blair, Mary Ellen and Blair, Laurence (1986) *Margaret Tafoya: A Tewa Potter's Heritage and Legacy*, West Chester, PA: Schiffer Publishing.

Brand, Stewart (1988) "Indian and the Counter-Culture, 1960s–1970s," in William Washburn (ed.) *Handbook of North American Indians: Volume 4, History of Indian–White Relations*, Washington, DC: Smithsonian Institution Press, pp. 570–2.

Brody, J. J. (1971) *Indian Painters and White Patrons*, Albuquerque, NM: University of New Mexico Press.

—— (1997) *Pueblo Indian Painters*, Santa Fe, NM: School of American Research.

Chapman, Kenneth (1978) *The Pottery of San Ildefonso Pueblo*, Albuquerque, NM: University of New Mexico Press.

Coe, Ralph T. (1976) *Sacred Circles: Two Thousand Years of North American Indian Art*, Kansas City: Nelson Gallery of Art.

Dauber, Kenneth (1990) "Pueblo Pottery and the Politics of Regional Identity," *Journal of the Southwest*, 32(4): 576–96.

—— (1993) "Shaping the Clay: Pueblo Pottery, Cultural Sponsorship and Regional Identity in New Mexico," Ph.D. Diss., University of Arizona.

Dietrich, Margretta (1936) "Old Art in New Forms," *New Mexico Magazine* 14(9) (September): 26–7, 56.

Dillingham, Rick (1995) *Fourteen Families of Pueblo Pottery*, Albuquerque, NM: University of New Mexico Press.

Feder, Norman (1969) *American Indian Art*, New York: Henry N. Abrams.

—— (1971) *Two Hundred Years of North American Indian Art*, New York: Praeger Publishers.

Frank, Larry and Harlow, Francis (1974) *Historic Pottery of the Pueblo Indians 1600–1880*, New York: New York Graphic Society.

Friedman, Martin (1972) "Of Traditions and Aesthetics," in *American Indian Art: Form and Tradition*, New York: E. P. Dutton, 23–33.

Garmhausen, Winona (1982) "The Institute of American Indian Arts 1962 to 1978: with historical background 1890–1962," Ph.D. diss., University of New Mexico.

—— (1988) *History of Indian Arts Education in Santa Fe*, Santa Fe, NM: Sunstone Press.

Gratz, Kathleen (1976) "Origins of the Tesuque Raingod," *El Palacio* 82(3): 3–8.

Gritton, Joy (1991) "The Institute of American Indian Arts: A Convergence of Ideologies," in *Shared Visions: Native American Painters and Sculptors in the Twentieth Century*, Phoenix, AZ: Heard Museum, 22–9.

Highwater, Jamake (1980) *Song from the Earth: American Indian Painting*, Boston, MA: New York Graphic Society.

Jacka, Jerry (1976) *Pottery Treasures: The Splendor of Southwest Indian Art*, Portland, OR: Graphic Arts Center Publishing Company.

LaFarge, Oliver and Sloan, John (1931) *Introduction to American Indian Art*. [Reprinted in 1971 by Rio Grande Press: Glorieta, NM.]

Maxwell Museum of Anthropology (1974) *Seven Families in Pueblo Pottery*, Albuquerque, NM: University of New Mexico Press.

Mera, H.P. (1939) "Style Trends of Pueblo Pottery: In the Rio Grande and Little Colorado Cultural Areas from the Sixteenth to the Nineteenth Century," *Laboratory of Anthropology Memoirs* 3.

Otis, Raymond (1931) *Indian Art of the Southwest: An Exposition of Methods and Practices*, Santa Fe, NM: New Mexico Association for Indian Affairs.

Peterson, Susan (1977) *The Living Tradition of Maria Martinez*, Tokyo: Kodansha International.

Rozack, Theodore (1969) *The Making of a Counterculture: Reflections on the Technocractic Society and its Youthful Opposition*, Garden City, NY: Doubleday.

Rubin, William (ed.) (1984) *Primitivism in Modern Art: Affinity of the Tribal and Modern*, 2 volumes, New York: Museum of Modern Art.

Rushing, W. Jackson (1991) "Authenticity and Subjectivity in Post-War Painting: Concerning Herrera, Scholder, and Cannon," in *Shared Visions: Native American Painters and Sculptures in the Twentieth Century*, Phoenix, AZ: Heard Museum, 12–21.

—— (1995) *Native American Art and the New York Avant-Garde*, Austin, TX: University of Texas.

Sando, Joe (1992) Pueblo Nations: Eight Centuries of Pueblo Indian History, Santa Fe, NM: Clearlight Publications.

Schrader, Robert (1983) *The Indian Arts and Crafts Board: An Aspect of the New Deal Indian Policy*, Albuquerque, NM: University of New Mexico Press.

Snow, David (1973) "Some Economic Considerations of Historic Rio Grande Pueblo Pottery," in A. Schroeder (ed.) *The Changing Ways of Southwestern Indians: A Historic Perspective*, Glorieta, NM: Rio Grande Press, 55–72.

Spivey, Richard (1979) *Maria*, Flagstaff, AZ: Northland Press.

Stocking, George (1982) "The Santa Fe Style in American Anthropology: Regional Interest, Academic Initiative, and Philanthropic Policy in the First Two Decades of the Laboratory of Anthropology, Inc," *Journal of the History of the Behaviour Sciences* 18: 3–19.

Sturtevant, William (1973) "Museums as Anthropological Data Banks," in A. Redfield (ed.) *Anthropology Beyond the University*, Proceedings of the Southern Anthropological Society, no. 7: 40–55.

Trimble, Stephen (1987) *Talking with the Clay: The Art of Pueblo Pottery*, Sante Fe, NM: School of American Research.

Walker Art Center (1972) *American Indian Art: Form and Tradition*, New York: E. P. Dutton.

Plate A Dan Namingha, *Passages* (front view), (1997), mixed media on wood, 32" × 26" × 17". Courtesy of Niman Fine Art and the Wheelwright Museum of the American Indian, Santa Fe. Photo by Lyn Lown

Plate B Les Namingha, *Initiation* (1997), acrylic on canvas, 24" × 36". Courtesy of Les Namingha and Gallery 10, Santa Fe

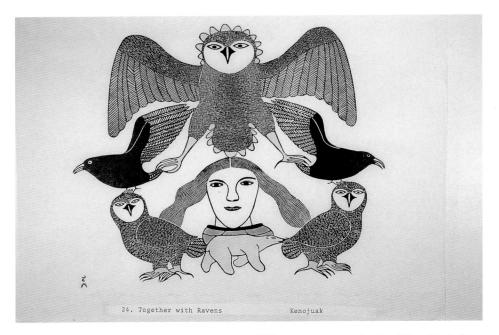

Plate C Kenojuak Ashevak, *Together with Ravens* (1979), stone and stencil print. Printed by Lukta Qiatsuk. Copyright and image courtesy of the West Baffin Eskimo Co-operative

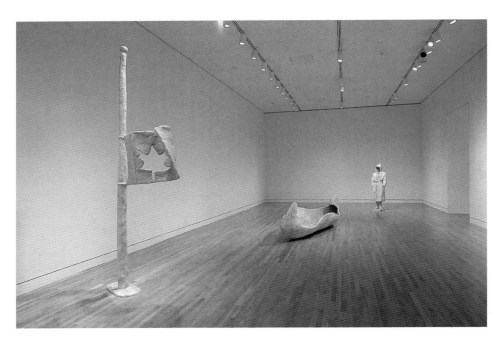

Plate D Teresa Marshall, *Elitekey* (1990) as exhibited at the National Gallery of Canada, Ottawa. An installation in cement of three elements: Micmac canoe (35" × 39" × 148"), Eta Joe (Micmac figure) (72" × 25" × 24"), Canadian flag (128" × 44" × 10"). Photograph courtesy of the National Gallery of Canada, Ottawa

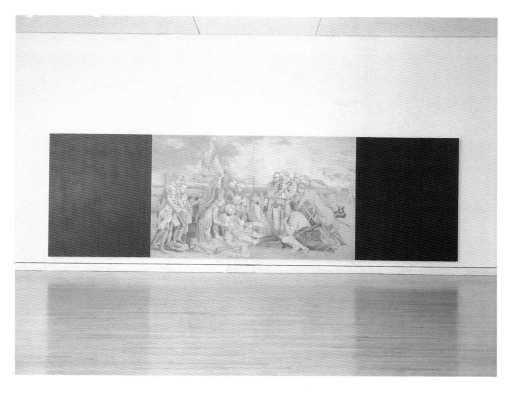

Plate E Robert Houle, *Kanata* **(1992), acrylic and conté crayon on canvas, 7' 6" × 24', National Gallery of Canada, Ottawa**

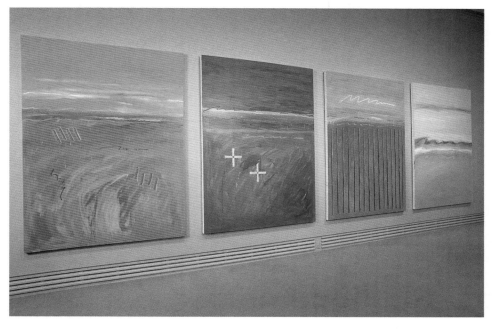

Plate F Robert Houle, *The Place Where God Lives* **(1989), oil on canvas, four panels, each 8' × 6', National Gallery of Canada, Ottawa**

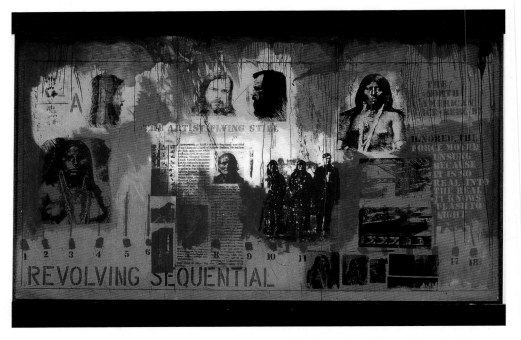

Plate G Carl Beam, *The North American Iceberg* **(1985), acrylic, photoserigraph, pencil, on plexiglass, 7' × 12'3", National Gallery of Canada, Ottawa**

Plate H Colleen Cutschall, *Sons of the Wind,* **1992, from "House Made of Stars" (1996), a mixed media installation, Winnipeg Art Gallery. Courtesy of Colleen Cutschall**

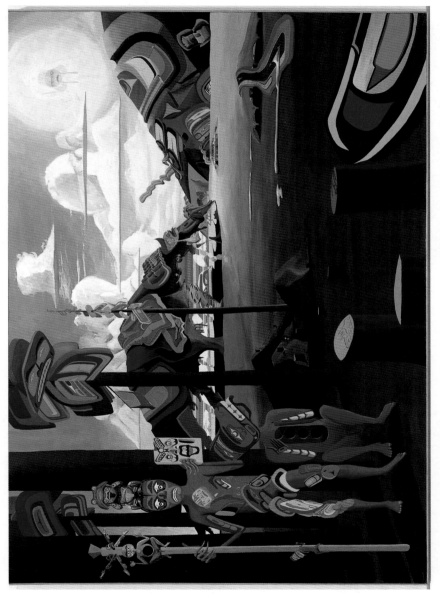

Plate 1 Lawrence Paul Yuxweluptun, *Scorched Earth, Clear-cut Logging on Native Sovereign Lands, Shaman Coming to Fix* (1991), acrylic on canvas, 6'5½" × 9½". Courtesy of the National Gallery of Canada, Ottawa

Plate J James Luna, *Artifact Piece* (1987), mixed media installation and performance, Museum of Man, San Diego, Catifornia. Courtesy of James A. Luna. Photo by Robin Holland

Plate K Calm Little Turtle, *Earthman won't dance except with other women* (1992)

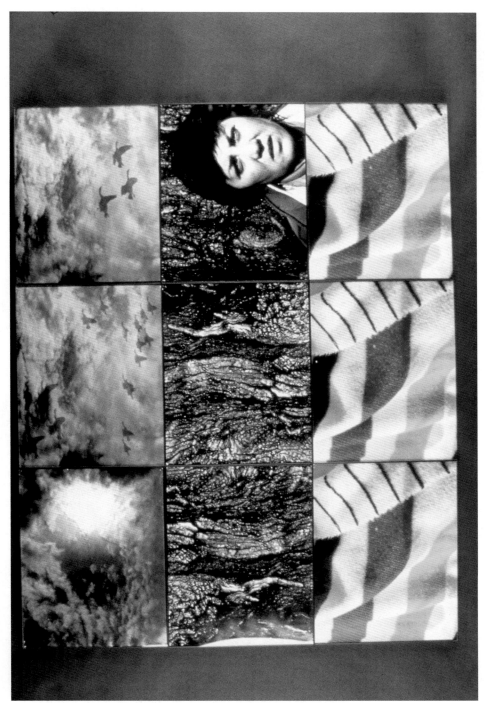

Plate L Jolene Rickard, *I See Red in '92* (1992), ektacolor/silver prints, 24" × 36"

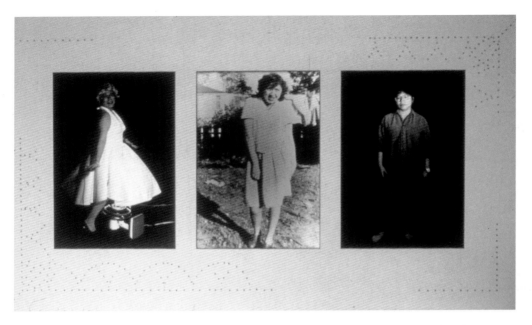

Plate M Shelley Niro, *This Land is Mime Land: 500 Year Itch* (1992)

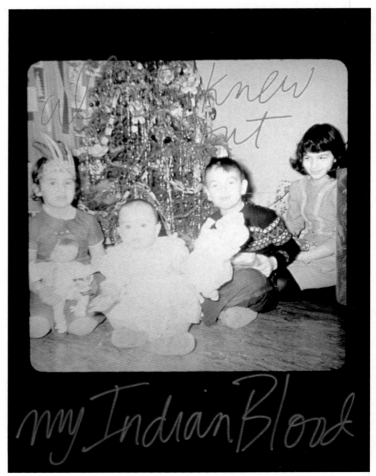

Plate N Rosalie Favell, *All I knew about my Indian blood* (1994)

Plate O Emmi Whitehorse, *Forest Floor* (1993), oil and chalk on paper on canvas. Courtesy of the artist

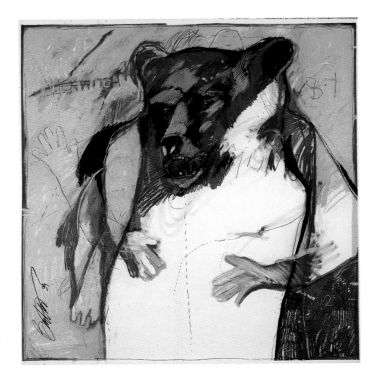

Plate P Rick Bartow, *Nickwitch* (1994),
pastel and graphite on paper, 50½" × 45".
Courtesy of the artist and the Froelick
Adelhart Gallery, Portland, Oregon

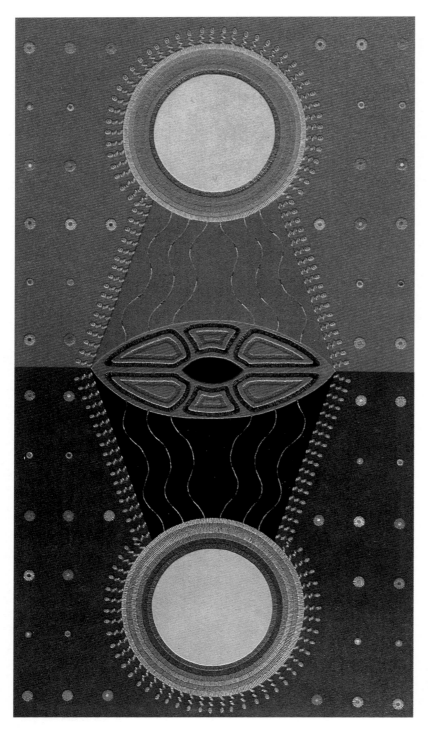

Plate Q Colleen Cutschall,
*The Second Time: The Courtship
of the Sun and the Moon* (1988),
acrylic on canvas, 40" × 72",
Kenerdine Gallery,
University of Saskatchewan.
By permission of the artist

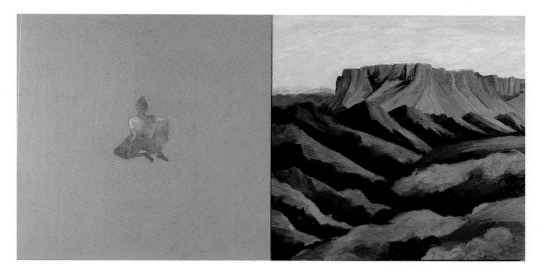

Plate R Kay WalkingStick, *Danaë in Arizona* (1997), oil on canvas. Courtesy of the artist

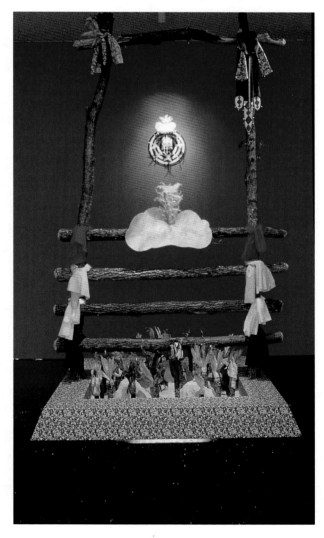

Plate S Colleen Cutschall, *Garden of the Evening Star* (1996), mixed media installation at the Winnipeg Art Gallery, Winnipeg, Manitoba. Courtesy of the artist

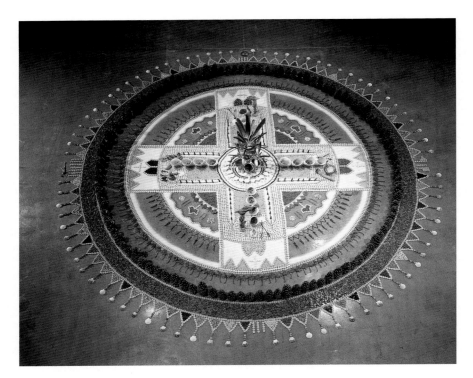

Plate T Sara Bates, *Honoring* (1997), natural materials, 12' diameter. Courtesy of the artist

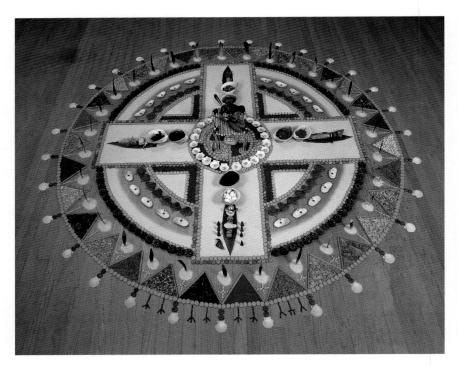

Plate U Sara Bates, *Honoring Gawexsky* (1997), natural materials, 12' diameter. Courtesy of the artist

Part II

Editor's Introduction to Part II

Which story? Told by whom? To what audience and under what circumstances? One of the defining characteristics of aboriginal American art since the 1960s has been the investigation of stories, narratives, and histories – both verbal and visual. Sometimes Native (hi)story has been the subject of scrutiny, celebration, or revitalization, as for example in the mythic pictures of the Woodlands School (Norval Morrisseau, Daphne Odjig, and others) or Colleen Cutschall's "Voice in the Blood" series of "beadwork" paintings (1990).[1] Elsewhere, Euro-American (hi)stories, including those "told" by museums, about Native art and culture have been the subject of indigenous artists: Fritz Scholder's photo-essay *Indian Kitsch: The Use and Misuse of Indian Images* (1979); Edgar Heap of Birds' site-specific reconceptualization of historic spaces, such as *Building Minnesota* (1990, Plates 16, 17); Teresa Marshall's sculptural installation *Elitekey* (1990, Plate D); Gerald McMaster's exhibition "Savage Graces" (1992); and Robert Houle's *Kanata* (1992, Plate E) are merely a few of the many, many examples I could cite.[2] There are no signs that this impulse to analyze how knowledge is formed and transmitted – that is to say, how power is constructed and maintained – is diminishing among contemporary Indian artists. Witness the bitter, ironic, funny, and provocative reclamation of history made manifest in Diego Romero's neo-Attic/Mimbres painted pots (Plate 18). In postmodern parlance, such work constitutes a "discourse on representation": whose ideas, memories, or values are represented, in what form, and toward what end?

Similarly, in recent years, art history and museum practices (collecting, exhibitions, and catalogues) have also been interrogated, by Native and non-Native artists and writers alike, as modes of representation that emerge in specific social and political contexts. Post-colonial theory, feminism, and the "politics of identity" have contributed to an atmosphere in which the ideology and methodology of art history and museums have been demystified and problematized. Can art historical discourse be transformed in such a way as to be relevant to First Nations' desire for the restoration of sovereignty? Does art history – post-colonial, postmodern or otherwise – wrench objects brutally and irreparably from their holistic context? What would serve as the

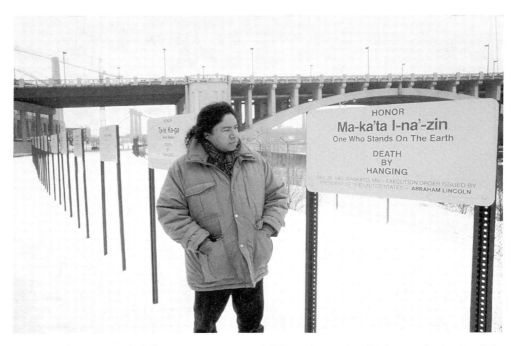

Plate 16 Edgar Heap of Birds, *Building Minnesota* (1990), a signage installation on the banks of the Mississippi River in Minneapolis, Minnesota. By permission of the artist

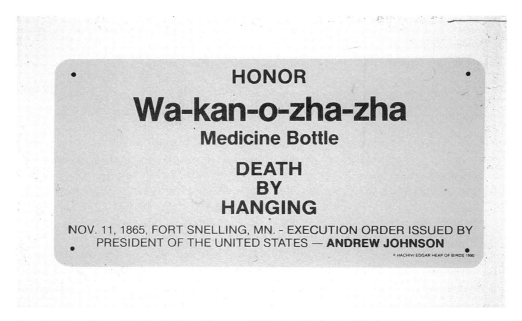

Plate 17 Edgar Heap of Birds, *Building Minnesota* (1990), detail of part of the installation. By permission of the artist

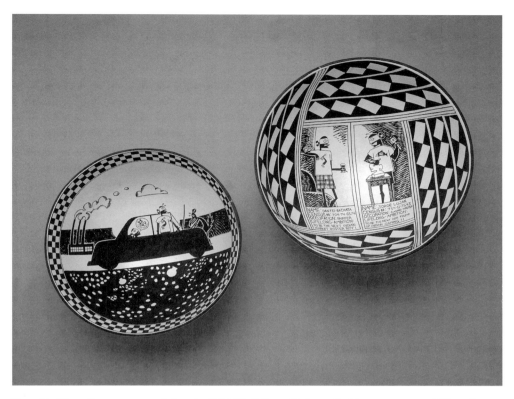

Plate 18 Diego Romero, ceramic bowls, 1997–98, Gallery 10, Santa Fe. Photo courtesy of Diego Romero and Gallery 10

epistemological foundation of an indigenous art history? These are among the topics examined in this section.

Art history, in fact, might be visual and performative, as well as textual. In his essay, "Towards an Aboriginal Art History," the Plains Cree artist–curator–anthropologist Gerald McMaster reads a body of recent Native art as a collective "insistence on the reality of an aboriginal art history." The *mainstream*, he writes, is a "duplicitous narrative," the recognition of which necessitates the revelation of "other histories." Linking universalism, modernism, and colonialism, McMaster replaces the trope of the mainstream with that of merging tributaries. The resulting flooded land, so to speak, constitutes a conceptual parallel to Michel Foucault's heterotopic space, or what McMaster calls the juxtaposition of incommensurable spaces. And although he clearly values traditional cultural forms, McMaster acknowledges ("mixing," "flooding," "merging") the pitfalls in maintaining "local cultural identities" in a time increasingly marked by frenetic "pluralistic globalization." Thinking about the role of art in this new art history, McMaster writes that one of the "language games" played by Native artists as they aggressively invent "new discursive spaces," is to make "new word" synonymous with "new work." Thus, conceiving of aboriginal identity as a "homeland of opportunity and inspiration," he compares Robert Houle's search (inspired at least in part by Barnett Newman's primitivism) for an appropriate plastic language to Jimmie Durham's desire for a dialogue with society: new discursive strategies inform a new visual art. He stresses,

too, the historical and conceptual importance of aboriginal works of art (e.g., the work of Houle, Edward Poitras, Rebecca Belmore, and Carl Beam) that relate to both Native land and the larger world of art (history). These artists, McMaster notes, must make difficult choices about technology, audience address, and aesthetic materials that articulate a desire for sovereignty and self-determination.

Like McMaster, Ruth Phillips is attracted to "plural histories of art traditions" that belong to specific "communities," and which may be considered "as parallel, contemporary and interactive with those of the dominant culture." Her essay, "Art History and the Native-made Object: New Discourses, Old Differences?" is written out of the recent "radical reformations to art history and anthropology" that have occurred partly in response to a "critique of the western art and culture system" mounted by colonized peoples, feminists, Marxists, and others. Where McMaster speaks of incommensurate spaces, Phillips writes of the opening and closing of "particular spaces" for the practice and study of Native American art. Similar also to McMaster's methodology is Phillips's interest in documenting Native "exploitation of the western historical tradition in art" in order to reclaim and preserve aboriginal values. To do this she considers art history's contribution to the "suppression and museumification of Native culture." Signaling the instrumentality of a recent theoretical critique of ocularcentrism – or privileging of the visual – Phillips cites Native performance and installation art as an exploration of the "politics of vision." Rejecting an object-oriented history of (fine) art, she recommends investing instead in the notion of "visual culture," which allows us to discover and appreciate the linkage between contemporary Native artists and "earlier generations working in very different formats and media."

There is a parallel, obviously, between the museumification of Native art identified by Phillips and what Charlotte Townsend-Gault describes as the diversity of First Nations art and artists, in which the museum is for some an "Indian morgue," and for others a source of aesthetic inspiration and cultural revitalization. Like her essay – "Hot Dogs, a Ball Gown, Adobe and Words: The Modes and Materials of Identity" – Townsend-Gault is based on the Northwest Coast, but she writes outward from the work of Lawrence Paul Yuxweluptun and Robert Davidson to engage with a wide range of related strategies in the work of Carl Beam, Rebecca Belmore, Jimmie Durham, Edgar Heap of Birds, and James Luna. Using a slippery story built on the visual kenning of a hot dog as the Northwest Coast's ovoid-formline, she poses a troubling and, given the market value of neo-traditional art (c.f., Davidson, Dempsey Bob), critically important question: can conflicts over what we might call aesthetic correctness be separated from Native identity, land rights, and demands for sovereignty? With the "materials and modes of identity" as a unifying structure, she notes that disparate artists are conjoined (and not always comfortably) in their determination to resist assimilation by "maintaining a defining tradition or by showing that tradition is un-constraining." For example, in discussing why the visual codes of Northwest Coast art lent themselves to Claude Lévi-Strauss's structural analysis, Townsend-Gault documents Davidson's desire to "re-articulate a relationship with an ancient set of codes." In this way, such work (which in the western aesthetic system is called sculpture) can be understood as the reification of a resurgent community. And, in discussing the controversial neo-surreal, "salvation" paintings of Yuxweluptun, Townsend-Gault shows that "his work brings out the productive, defining relationship between aboriginality and modernism" that has been obscured in histories of twentieth-century art in British Columbia. His aggressive syncretism, she argues, challenges the postmodern idea that "the function of art is to have none." To my mind, the useful constant at the heart of this wide-ranging essay is Townsend-Gault's insistence that visual style and cultural argument are not dialectical opposites, but the stuff of critical synthesis.

Some of the ideas, themes, and conclusions in Lucy Lippard's essay, "Independent Identities," which focuses on Native women photographers, portraiture, and "image independence," vibrate sympathetically with the other essays in this section. Noting the complicated relationship between "the feminist 'mainstream' " and Native women artists, Lippard writes that "many Native women photographers see their prime audience as Native people," not other feminists. For example, Lippard states that Hulleah Tsinhjahjinnie is engaged in "cultural nationalism rather than cultural feminism." Lippard's awareness of feminisms and primary and secondary audiences is not dissimilar to Townsend-Gault's concern with the issue of audience address in recent Native (performance) art. And, like McMaster, who also pays attention to the importance of land and place, and who speaks of juxtaposed spaces, Lippard considers the work of several photographers, including Shelley Niro, Jolene Rickard, and Melanie Yazzie, in terms of their ability to generate a "multicentered space from the threads of culture." Similarly, Lippard's interest in "layered and coded approaches to communal images" is shared by Townsend-Gault. Both of them have identified what Lippard calls an aesthetic strategy that reveals "only as much as the viewer can understand." This ability to understand is conditioned, obviously, by a number of factors; nonetheless, as Lippard explains, some photographs, such as those by Rickard, demonstrate the need to "recognize multiple knowledge systems." Photographic self-representation enables "image independence," and shows how stereotypes constructed by non-Indian photographers "neatly bypass most realistic modern [Native] female identity." In several instances then, these photographs (e.g., Niro's *The Rebel*, 1987) are "replacing absence with presence." And just as Phillips and Townsend-Gault show how recent Native art and its critical reception have problematized museum representations, the photographers discussed by Lippard collectively make manifest an ambivalence widespread in Native nations about historic photographs of indigenous people. Even though such images are a source of family and tribal history, "image independence" underscores a colonial/ethical dilemma about photographic representations as a way of creating and controlling identity.

Margaret Dubin's essay, "Sanctioned Scribes: How Critics and Historians Write the Native American Art World," is based, in part, on a historiography of Native art since the mid-century and on a series of interviews and studio visits she conducted with artists such as Tony Abeyta, Doug Coffin, and Emmi Whitehorse. Her historiography is a welcome addition to the literature and both scholars and artists will be surprised, I expect, by some of her conclusions. In particular, after conversations with the historian J. J. Brody, Dubin offers a historicist reading of *his* historicist reading of the so-called New Indian painting of the 1960s. In his book, *Indian Painters and White Patrons* (1971), Brody went to some length, she writes, to show how such painting (e.g., the work by Fritz Scholder) was "shaped by history more than by any natural aesthetic evolution." Acknowledging that art practice, exhibition, critical discourse, and market shares form a structural system, Dubin argues for a "history of Native American art that is politically informed, and a criticism of contemporary Native American fine arts that is historically rooted." In examining the movement of objects through this system, she calls to our attention the "profoundly unequal power relations in the Native American art world, where labor is persistently divided along racial lines." In other words, there are many indigenous artists, but few indigenous gallerists, museum curators, or critics. Thus Dubin writes the history and criticism of twentieth-century Native art in terms of "mechanisms of cooperation and the imperialist division of labor." I find, far too often, that "criticism" of recent Indian art is neither complex nor critical, but something that we might well call Romantic reportage. Dubin's insistence, therefore, that criticism has a decided impact on distribution and that many contemporary Native artists have a conflictual relationship to critics and criticism, is

refreshing. She does admit that recent Indian art poses a problem for many critics. "The simultaneous production of disparate forms," which Dubin understands (and rightly so) as a hybridization that blurs "tribal and chronological boundaries, is impossible to reconcile with the western concept of aesthetic evolution." Paradoxically, it is troubling, she notes, that "criticism" of Native art frequently focuses on maintaining or reconciling difference. That is, such discourse emphasizes authenticity over quality. To her credit, quality is neither a concept nor term that Dubin shies away from. Even so, she writes that "as long as western eyes are guiding the decisions of both institutional and individual collectors, Indian artists deserve fair and sophisticated treatment according to western aesthetic standards." Only time will tell, though, whether the following statement is realistic or idealistic: "If artists excluded from important exhibits fare well at the hands of critics who know how to evaluate Native American art, continued exclusion on the basis of quality will be difficult to sustain."

Notes

1 Deidre Simmons and Robin Ridington, *Colleen Cutschall: Voice in the Blood* (Brandon, Man.: Art Gallery of Southern Manitoba, 1990).

2 Fritz Scholder, *Indian Kitsch: The Use and Misuse of Indian Images* (Flagstaff, AZ: Northland Press in cooperation with The Heard Museum, 1979). On Heap of Birds's *Building Minnesota*, see Joan Rothfuss, *Building Minnesota* (Minneapolis, MN: Walker Art Center, 1990). On Teresa Marshall's *Elitekey*, see Diana Nemiroff's dialogue with the artist in Diana Nemiroff, Robert Houle, and Charlotte Townsend-Gault, *Land, Spirit, Power* (Ottawa: National Gallery of Canada, 1992): 196–203. The "catalog" for Gerald McMaster's exhibition "Savage Graces", which opened at the Museum of Anthropology at the University of British Columbia in Vancouver, is a special journal issue: *Harbour* 3 (Winter 1993–4). On Robert Houle's *Kanata*, see Michael Bell, *Kanata: Robert Houle's Histories* (Ottawa: Carleton University Art Gallery, 1993) and Ruth Phillips's essay in this volume.

Gerald R. McMaster

Towards an Aboriginal Art History

The Canadian artist Carl Beam[1] once joked to an audience of aboriginal artists that the mainstream in Canada was not that fast. In fact, he said, "there are very few people [in] it . . . it's not a roaring torrent . . . it's more like mud puddle, or tiny creek at best . . . it might [look] a mile deep but it's only up to your knees."[2] One may wonder if his audience understood the significance of his comment. Clearly, Beam awakened the consciousness of an audience which for so long was closed within its own discursive boundaries, yet wanted so much to be part of the mainstream. What did he and others mean by the "mainstream"? What he did was to cleverly lay bare a duplicitous narrative in which so many had come to believe.

Following the lead of this interaction between Beam and his audience, this essay examines the question in the context of a metadiscourse on art history and the strategies that are being engaged in, against, and outside it, by aboriginal artists. To make this analysis bear on actual art practice as well as the other way around, I present the work of a few leading artists whose works help frame these issues.

In the following, I consider the field of art history in terms of a Western-specific discourse as the "mainstream."[3] I then conduct a critique of the universalism that underlies the very idea of "mainstream"; as well, I bring into the discussion a need for the recognition of other histories, of how contemporary aboriginal artists are framing the issues in languages of their own. Finally, I look at how the works of several artists provide us with a discourse that structures some contemporary artistic practices.

Grands récits

In the final sentence of "A Time to Choose," from *Art and Otherness*, the art critic Thomas McEvilley made a meaningful distinction that helps us understand Beam's critique, saying that "it may well be that History is over – but histories endure."[4] What he calls into question is a Eurocentric History

(upper case), whose dominant intellectual space is now coming into contact with, and being perforated by, other histories (lower case), especially by those which do not count Europe as part of their lineage. It is a critique that subsequently implicates disciplines like Art History (also upper case letters). In this essay, instead of using the upper case designation, I will use qualifying prefixes; this has the potential of revealing other histories.

To make Beam's use of colloquial metaphor and his critique of the mainstream resonate with more theoretical discussions requires a frame of reference. For instance, Jean-François Lyotard described *grands récits* or "grand narratives," as the legitimating myths of modern culture in terms of "a science that legitimates itself with reference to a metadiscourse."[5] Fredric Jameson further described European history as an "uninterrupted narrative."[6] Kaja Silverman uses the term "dominant fiction"[7] to express a similar idea, which describes how dominant society organizes, constructs, and constitutes the world through basic elements as foundations. The values that emanate from the dominant fiction, for instance, uphold an influential sense of identity. The art critic Victor Burgin commented on European art history's disciplinary practices, noting that they are inscribed within a notion of a common sense that "tends to construct a history and teleology of art by projecting the dominant contemporary notions of art into the past and the future."[8] David Trend argued that "although the imaginary mainstream purportedly includes a majority of people, it excludes everyone. . . . When stripped of its mystifying pretensions . . . [it is a] rather small minority of people."[9] He called the way in which this small group functioned a "Eurocracy." And finally, Mieke Bal viewed the critique of art history not as contradictory, but more in terms of its "astonishing vitality."[10] These powerful ideas contribute to reflexive critiques; for our purposes of discovering other histories, however, they advance only a partial understanding.

Notwithstanding the observations made by McEvilley regarding the possibility of the postmodern condition effecting new spaces, fissures at the master narrative's border had already begun to open early in the twentieth century. These fissures, which were effected by "artists, literati, and anthropologists who . . . had a romantic/racist conception of Native peoples and a preservationist approach to their art, both of which were reflected in their social activism and art criticism."[11] For example, the American artist Barnett Newman argued in the catalog of an exhibition he curated in 1944:

> It is becoming more and more apparent that to understand modern art, one must have an appreciation of the primitive arts, for just as modern art stands as an island of revolt in the stream of Western European aesthetics, the many primitive art traditions stand apart as authentic accomplishments that flourished without benefit of European history.[12]

Today, our understanding of such contested histories has been reinforced by feminist, post-colonial, and postmodern critiques, which reveal fields of knowledge as bound up in colonial domination in place where dominant cultures seek to tell the story.

On the basis of my understanding of some of the foregoing critiques I would add Pierre Bourdieu's assessment of the disciplinary field of art history as a "field of force,"[13] where diverse struggles take place, whether as a result of younger artists displacing their elders or non-Western art histories insisting on their visibility. Such a field is beset by those outside European history who have understood the texture of democracy enough to effect change. And I intend to discuss further the conjunction of the spatial (the practices within the field) with the temporal (the historical narratives), both of which have contributed to the spirit of the time.

Historically, the conditions in Canada that justified independent narratives came into force about the mid-eighteenth century, as the colonialization process became the fundamental principle for European and aboriginal relations. These relations have always been circumscribed within a framework of power – dominant versus subordinate, majority versus minority, cowboys versus Indians, Self versus Other.[14] Ironically, Canada's relative youth, its small and diverse population, and spacious geography, provide a legitimate basis for Beam's critique about the seemingly depthless nature of a Canadian mainstream. However, although the Western discourse attendant on these power relations has never acknowledged coexistent visual histories, these multiple histories extend back for at least five centuries.

The mainstream remains a dominant ideology. Though the idea of center/periphery has undergone some interesting shifts – there are centers in margins and margins in the center – the idea of the mainstream remains problematic.

Universality

Thomas McEvilley, among others, has sharply criticized the modernist[15] practice of colonizing the frontier spaces, as part of a universalist ideology where local knowledge is effaced in the name of universalizing standards. This notion of universality,[16] which developed as recently as the nineteenth century,[17] paints a demeaning picture by conferring an image of inferiority upon the Other, and in turn constructs for the colonizer the idea of superiority. According to Michel Foucault, domination can be carried out only by those who have laid the grid over the top of the Other. Colonizing the space of the Other and imposing "transcultural criteria of universal quality," for example, is part of Western domination whose assumption is that the Other is striving towards similar goals.[18]

The modernist discourse adopts a frontier mentality, in that modern consciousness is an aspiration to change, progress, and individual freedom. It is a forward movement that marks a fundamental break with tradition and is characterized by continual developments in technology whose value is signified by the term "new." Furthermore, modernist artistic practice is a belief in the progressive search for essential, fundamental and universal qualities, some of which have been discovered in aboriginal art forms. So while governments were doing all they could to create social, ideological, political and cultural boundaries, Western artists were being inspired by aboriginal art to "create a world consciousness out of a universal art, one based on the integration of modern and American Indian art."[19] To some extent, the modernist argument of universality revealed the specific cultural identity which it supposedly transcended. As well as being aesthetically intriguing, modernist formalism was thought to contain universal values that Westerners could locate in works.[20] McEvilley sees the universalist attitude as modernist, and therefore as colonialist:

> It can now be recognized that Modernist internationalism was a somewhat deceptive designation for Western claims of universal hegemony. In hopes of entering the international art discourse, a nonwhite or non-Western artist was to repress his or her inherited identity and assume a supposedly universal one; but that "universal" identity was just an emblem of another tribal cult that temporarily had an upper hand . . . [W]hen whites saw history as exclusively their own, African, Indian, Chinese, and Amerindian societies were regarded by white Westerners as ahistorical because they weren't dominated by the need to feel that they were evolving toward some ultimate consummation. Colonialism was justified as a means to drag the

supposedly ahistorical into history — at which point non-European peoples were supposed to gradually become like Europeans or, more recently, European Americans [and Canadians].[21]

In Canada, for example, this ideology was enacted through laws to civilize the aboriginal people, to bring them into modernity from their "primitive" world. Modernism and modernity's influence was largely successful. But people cannot be dragged into modernity, or subjected to its ideology without resistance. As I have pointed out elsewhere, the passive acceptance of colonial messages by aboriginal people was largely a fiction, and resistance to colonization existed everywhere.[22]

We now know that the modernist project has come apart and is exposed to pluralistic environments, which create new possibilities where boundaries disappear. The events of the world since the late 1960s have perhaps given us a collective optimism that seemed only the claim of a few in the past. This new vision and thinking has been described as postmodern. The former modernist ideology suggested a one-way movement and progress, a colonization into the space of the Other, whereas in postmodernism it is barriers — intellectual, symbolic, and physical — that are being re-examined, offering new possibilities for understanding "identities" in demonstrating that these boundaries are permeable from both sides.

The resistance to universal ideology of the West by aboriginal people has been in progress for some time, creating in turn insularity; it will take time for before the two sides become engaged on an equitable basis.

Tributaries

If, indeed, we are witnessing the "end of Western Art History", the suggestion is that only its linearity is at stake, not its spatial presence. McEvilley, we recall, revealed the presence of Others; and as Beam points out, the mainstream's true identity has been betrayed. Therefore, how do we signify the presence of Others in relation to the continuing dominance of the master narrative? I want to argue that two ideas can be put forward: first, we have to recognize the existence of other histories and second, we must recognize that the end of History is signalled by its relativity in relation to these others. So, let us modify the spatial metaphor of the mainstream by inserting the idea of a tributary flowing into the discursive practices of art and contributing to the mainstream. Furthermore, this merging of tributaries is a condition of the present that then invokes the "end of (mainstream) Art History," leading us to consider the relative or proportionate position of *all* histories. Here I invoke Foucault's idea of a "heterotopic space," or the coexistence in an impossible space of a large number of fragmentary possible worlds, or more simply, incommensurable spaces that are juxtaposed or superimposed on each other.

The notion of the mainstream is a discourse to which *we* have become subjects, and thus are constituted within its framework. Its teleological thrust is a progressive colonialism, forever "moving forward into the future," flooding out and disabling cultures that stand in its way, constituting new subjectivities of the subjugated. This power relation, however, has undergone massive realignment where resistance has been taken into consideration and alternatives taken into account.

The risk in suggesting the presence of many tributaries is in reproducing not another canon or metanarrative, but many micro-narratives[23]; it is, however, an idea that foregrounds previously invisible aboriginal histories, but makes them small-scale. The tributaries are smaller, though no less

important, histories that feed into the mainstream. However, their relation with the mainstream suggests a subjectivity, which situates the Other within dominant discursive practices and potentially subordinate positions, leading to yet newer power relations. This system of relations, as we know, includes such references as center/periphery, high/low, and Western/primitive, all of which construct identities and subjectivities.

The mainstream, so the argument goes, is at an end. But does the story end there? I agree with McEvilley who says that all the histories are now spilling out as effluents into the sea. For me, this sea or ocean signifies the "global," not the "universal," where we are all spatialized in a postmodern moment and where cultural identities and Otherness become relative, as does the production of art. Not only is there no singular canon, but now there are many micro-narratives about art. Linda Hutcheon recycles Michel Foucault's notion of the discontinuity of history, or "temporal dislocation," as a new instrument of historical analysis. Her idea is a way of looking not for the common denominators, but for the interplay of different and heterogeneous discourses. Hutcheon states, "as we have been seeing in historiographic metafiction . . . we now get the histories (in the plural) of the losers as well as the winners, of the regional (and colonial) as well as the centrist."[24]

In this postmodern moment, this ocean of cultural identities, boundaries are blurred as all art becomes equal, or at least, equally interesting. The field has to accommodate conflicting, negotiating, interrogating histories, traditions, and identities. The conjoining of these histories leads inevitably to a situation where no one history is more important than the other, and everyone now maneuvers strategically for a new position. We live in a time when borders and boundaries are more permeable, when communication and economies are becoming globalized, all of which causes some creative confusion.

To bring the focus closer to home, let us note that strident efforts by aboriginal peoples to retain local cultural identities can be shortsighted in the face of rapid "pluralistic globalization." There are also potential contradictions in this situation. As aboriginal people struggle to reclaim land and to hold on to their present land, do their cultural identities remain stable? When aboriginal self-government becomes a reality, how will the local cultural identities act as centers for nomadic subjects, and how will artists function therein? As I show in the next section, many ideas are sustained, others invented, some borrowed, and still others are syncretized.

New language games

The practice of post-colonial writers has been to advocate a "re-placement" of language, which involves seizing it from the center and "re-placing it in a discourse fully adapted to the colonized place."[25] As I noted at the outset, aboriginal artists such as Carl Beam have long understood this strategy, and it is in his work and that of others that we find the efficacy of these ideas.

Edward Poitras once proposed an alternative, modernist-like strategy wherein we would expect to witness something utterly different, a conjunction between the old and the new.

> I would like to suggest that a group of us malcontents get together and perform the sacred ritual of the Dadaists for the origin of a new name. We will choose a new language that nobody can identify with and we will purchase a dictionary for it. We will shoot an arrow at this dictionary and the word upon which the tip of the arrow touches will be our new name. This will give us the new freedom that we need, because nobody will know what to expect.[26]

This aggressive strategy suggests formulating new discursive spaces. In fact, at the time Poitras was participating in a show called "New Work by a New Generation" (1982). It brought together aboriginal artists not as malcontents, but rather as exceptional individuals who considered their aboriginality as a constituent part of a whole. In this exhibit "new work" became synonymous with "new word", as the curator, Robert Houle, announced:

> The transformations experienced in the studio make the artist emerge as a new aesthetic personage. Thus, a new plastic language is created to transform these experiences and thoughts into works of art. The new language has the power to evoke the supernatural creatures found in the meditative formalism of Haida graphic art, to echo the incantations recorded with a secret code on a Potawatomi prescription stick, and to summon the animal spirits found in the fetish assemblages of shamanistic art . . . In a way, the endowment of natural objects with an aesthetic quality is not unlike the transformation of "found" objects when placed in a specific cultural context such as an art gallery.[27]

The exhibition was presented in a prominent gallery that was situated in a small prairie city.[28] Houle had built a case for aboriginal artistic practice on the verge of entering the mainstream, by presenting fresh and contemporary art work. He used the term "plastic language" to suggest not only the practice of making new forms, but the capacity of these artists to synthesize their aboriginality without being apologetic.

From these examples, we can start to grasp how language is employed by Beam, Poitras, and Houle, and therefore how critical it is to our understanding of their practice. Each of these artists has stood in some imagined space, either at the edge of the mainstream or between it and an aboriginal community. The latter is of course where their aboriginality is a powerful force, one that signifies a kind of homeland of opportunity and inspiration. Yet, like many creative individuals, they sought freedom to leave home for communities that spoke their artistic language. Like Beam, perhaps they were surprised to find the art community deceptive. What they were able to find was an ambivalent art community: willing to accept *them*, but not very ready to accept the significance of *identity* in their work. So they looked for syncretic strategies that collapsed two or more sources together. The American artist Jimmie Durham explained that, "Once you address the 'artworld' you look to do it with the most 'universal' way possible."[29] There is no other way. He continues: "your background is there and there are exclusionary rules. Still, one shouldn't take comfort in it, enjoying being a victim. One should have as much of a dialogue with as much of the society as is possible."[30] Houle's plastic language is analogous perhaps to Durham's dialogue. Both are strategic, though the former is a game-plan while the latter is already engaged. Both, however, provide us with a discourse that structures their practice.

Communities create languages or discursive strategies that are intelligible to them. To survive, the community either has to become a dominant force or be a capable player in the field of force.

The players

The significance of the contemporary art practice for aboriginal artists is now even more dynamic than it was in the early years of the 1970s and 1980s. In this section, I analyze five works – one is an

ancient site and the other four are by contemporary artists – and show how they begin to frame a critical discourse. I end the final section with the work of Carl Beam.

The first work is from an ancient and sacred space popularly known as the Peterborough petroglyphs (Plate 19). These petroglyphs, near the city of Peterborough, Ontario, were rediscovered by local anthropologists working in the area in the 1960s. It is said that local aboriginal people always knew of their existence. More recently, the site has become an international attraction, causing authorities to erect a covered building to protect it from decay and vandalism. When you go there, you will notice offerings of tobacco indicating its continued use.

The petroglyphs are equivalent to France's cave paintings at Lascaux in being the most famous of their kind in their country. The Lascaux paintings begin Art History's narrative trace through Egypt, Greece, Italy, and colonial North and South America; likewise, this work begins the aboriginal art historical narrative. But there is a difference. Though Lascaux is far removed from the modern European, Peterborough continues to be used by aboriginal people (and artists) as a source of inspiration, spirituality, truth, understanding, and wonder. As Durham has observed, "We have a

Plate 19 Peterborough petroglyphs, Ontario

need to maintain and recuperate land and culture that directly involves artistic work with political work: two necessities that are inextricably bound to each other."[31] Though this site is not used for political purposes, it is part of a vast number of similar sites across North America that continue to provide aboriginal people with important connections to the land. Not dissimilar to the way churches function for Christians, these sites are persistent reminders for aboriginal people of the mysteries of the land. And, like the artists commissioned by the church, the people who conceived of these images were no doubt acutely aware of the magnitude of this space. Other local residents sought special connections to this space on a regular basis rather than on specific "days of the week." These profound images are mediators between two worlds, yet contemporary people can appreciate them for their beauty without understanding their spiritual significance. What they do continue to signify is the importance of the land in the aboriginal consciousness. Politically, as I have indicated, they give form to an aboriginal art history.

As the Peterborough petroglyphs are visual mediators between two worlds, so too are the works of contemporary aboriginal artists, who are as acutely aware of their identities as they are of the art world. Indeed, the adjective "aboriginal" seems like an inescapable identity; now more than ever "aboriginal" serves as a reminder of their responsibility to their aesthetic, historical, political, social, and economic identities. Despite the problematic specification, they realize the connections they have to the two communities, both of which exist for them to use to their advantage, and both of which are a historical reality, despite historical segregation. Given the importance of these dual communities, the following works are both historically and conceptually important, since they relate both to the idea of the mainstream and to that of the land.

Houle is an artist who understands sacred spaces. On two occasions he gave differential treatment to this idea. In early 1989, as artist-in-residence at the Winnipeg Art Gallery, he created a body of work called *Manito-wapah* or *The Place Where God Lives* (1989, Plate F). Each of the four oversized paintings (colored red, green, blue, yellow) refer to the sacred place the Saulteaux called "Manito-wapah," which eventually became Manitoba. In the presence of the works, one has a sense of the place and its meditative qualities. They become a group of religious paintings. *The Place Where God Lives* is a work that reappropriates and reclaims Manitoba. It gives form abstractly to the tribal narratives Houle grew up with. The paintings make allusions to landscape, but are not landscape paintings; instead, they are about a special place. They are perhaps landscapes for the mind, but they speak also about a *real* space. The works are modernist in their handling and placement, yet equally important is their pure reference to an ancient aesthetic of simplicity. This work that signifies one sacred space now hangs in that most hallowed of places for artists, the National Gallery of Canada. Nevertheless, *The Place Where God Lives* is not out of place in either space.

The second work, Houle's *Anishnabe Walker Court: Part 2* (1993, Plate 20), is an installation at the Art Gallery of Ontario in Toronto. In the photograph we see Houle's work in the foreground, while German artist Lothar Baumgarten's work appears in the distance. Baumgarten's permanent installation, *Monument to the Native People of Ontario*, which was made for the exhibition "The European Iceberg: Creativity in Germany and Italy Today" (1985) pays homage to local tribes of southern Ontario. Houle installed his work almost ten years later on invitation by the AGO to respond to works in their collection. Baumgarten's upper case lettering (BAUMGARTEN) is situated overhead above the very high archways; Houle's lower-case lettering ("houle") is at chest height. Baumgarten's work can be seen, all at once, from inside the courtyard, while Houle's work requires the viewer to walk the courtyard's outer periphery. Of Houle's work, Michael Bell has written that Houle "engages the notion of museum representation of native history and comments

Plate 20 Robert Houle, *Anishnabe Walker Court: Part 2* (1993), installation at the Art Gallery of Ontario, Toronto

upon it by juxtaposing and overlaying his language and personal artifacts in another museum space, formulating another history."[32] This differential treatment, directed towards the artist and the institution in which it rests, is what is intended. Baumgarten positions his works like a monument and thus speaks on behalf of the aboriginal people; Houle ironically quotes the authority. Is Houle positioned hierarchically lower, "outside," and therefore marginally, for a reason? It would seem that Houle seeks to undermine this space. Indeed, that is the politics of this work, because it calls into question representational practices of art, in which representation of the Other is legitimate from a critical distance. Because Houle is an aboriginal artist enacting this critique of representational practices inside a Euro-Canadian exhibition, it might have seemed to some like self-righteousness. Instead, we see a work whose juxtapositioning induces us to respond critically.

The remarks and work of Edward Poitras frequently cross boundaries. When I asked how he felt about having his work collected by ethnographic museums, he replied: "Having my work here, I feel at home with my ancestors. In the National Gallery, they would look out of place." Not only was this statement a leap of faith at a time when artists were seeking approval from the mainstream, but it gave further endorsement to those more interested in tradition. He did not object to the notion that his work might be regarded as "ethnographic" because it was in the museum, rather, he dismissed the arbitrariness of such categorization in the first place. He saw new meaning in his inclusion in the museum and exclusion from the National Gallery. Even though ethnographic museums are frequently attacked for containing remnants of salvaged cultures, he saw other connections. It was as though he were rejecting inclusion into the mainstream. (Incidentally, he *was* selected by the National Gallery in 1989 to take part in a national exhibition.)

In the work *Offensive/Defensive* (1988, Plate 21), installed outside the Mendel Art Gallery, Saskatoon, Saskatchewan, Poitras used two kinds of turf to signify identity re/construction. It is a notably deceptive piece. The two pieces of turf – one natural prairie sod from the Gordon Indian Reserve, the other from the Mendel Art Gallery lawn – were interchanged. The work, which plays on contradictions, is a metaphor for identity and relocation, indicating the (un)sustainability of identities in different spaces, urban and rural. The urban sod on the Reserve died, but returned to life shortly thereafter, while the Reserve sod flourished on the city lawn immediately. The metaphor seems to be: one's identity can remain relatively unaffected in urban environments, but this is not so in the smaller rural/Reserve community.

This work received negative reactions from some members of the aboriginal community who felt it was irresponsible to suggest that aboriginal cultural survival is possible only in the city. But this is not what Poitras meant. In his view, there is a chance of cultural survival only on the Reserve, where traditions tend to be maintained. *Offensive/Defensive* proposes the idea that personal identity has a stronger likelihood of remaining unchallenged in urban areas: you can be who you are or who you

Edward Poitras, Offensive and Defensive,1989. Photo:courtesy of the artist

**Plate 21 Edward Poitras, *Offensive/
Defensive* (1988), installation made
of sod, outside the Mendel Art
Gallery, Saskatoon, Saskatchewan**

want to be. In smaller communities like the Reserve, members know who you are. Thus, in coming to the Reserve community for an extended period, one must make certain sacrifices to fit within the existing patterns, which may be rigid or fluid. If one works within the community codes, it is more likely that group identity will persist.

Rebecca Belmore's sound and performance installation, *Speaking to their Mother* (1991, Plates 22 and 23), was initially presented in Banff, Alberta. Sometime later she arranged to take it across Canada, asking aboriginal people from across the country to participate. There are at least two ideas inscribed in this piece: communication and sacred time/space. In the Banff photographs, Chief John Snow of the nearby Stoney tribe stands beside the artist; he speaks into the attached microphone, his voice amplified by the megaphone. Everything and everybody becomes a witness. The work's efficacy is that it brings to our attention the continued belief in the relation of humanity to the rest of nature. Belmore created an opportunity for everyone to speak without prejudice, fear, or embarrassment to the universe, because at the moment of enunciation, everything and everybody – the animals, the grass, the wind, the rocks, the sun, the mountains – are witnesses to the address. Belmore's work in this instance depends on performance and space for its efficacy. The fact that she uses technology as a medium of communication is not at issue; similar technologies are continually used in large public gatherings by aboriginal people. Amplification is for reaching beyond. We raise, lower, or mediate our voice, depending on the space or situation. Belmore's point, as I see it, is not just amplification, but a belief in the power of communication with some type of audience.

Plate 23 relates to the space where the expiation occurs. The artist's insistence that the event take place outside carries with it the idea of inclusiveness – everybody and everything. Having the event

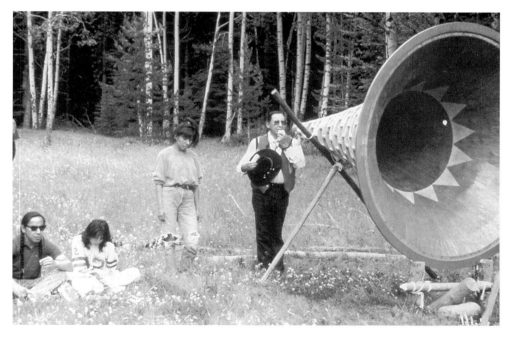

Plate 22 Rebecca Belmore, *Ayumee-aawach Oomama-mowan: Speaking to their Mother* (July 1991), sound and performance piece, 6' 6" diameter, at Banff, Alberta. Courtesy of the artist. Photo by Michael Beynon

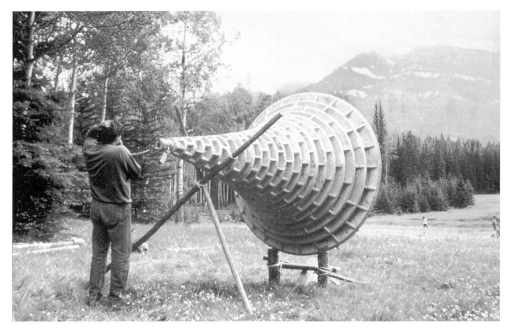

Plate 23 Rebecca Belmore, *Ayumee-aawach Oomama-mowan: Speaking to their Mother* (July 1991), sound and performance piece, 6' 6" diameter, at Banff, Alberta. Courtesy of the artist. Photo by Michael Beynon

out of doors places everyone on an equal basis; no one is greater or lesser than anyone else. What Belmore helps to create is a moment, a sacred time, a liturgical moment, where every responsible action is subject to everybody and everything. As traditional spiritual beliefs indicate, there are key times of the year for large formal performance gatherings, but none for personal enunciations. Belmore's performance is more informal and not subject to specific tribal orientation; rather she creates time/space and context.

Each of these artists asserts a kind of sovereignty, which is exercised in their art and practice, placing them in strategic attitudinal situations, unlike our impoverished ancestors who were heavily controlled by legislation. Contemporary aboriginal artists can make choices and they are essential in the articulation of aboriginal people's consciousness of self-determination.

The artist flying still

I end as I started, with Beam and another of his critiques:

> Why a whole nation of people collectively would not want to be in Canada escapes me. . . . If they are artists, they might be chasing the tail of the American dog, or the European dog, as it were. We seem to be analysing our own art out of context for ourselves. . . . What a person learns in a BA, or even in a Ph.D., generally, is not applicable in Canada because it's based on a European role model in terms of history.[33]

This is his call for an Indian-made critical discourse, one that has an aboriginal perspective with the possibility of convergence with other discourses. I use one key work of his that has received various interpretations, including the one offered here.

Beam's *The North American Iceberg* (1985, Plate G), "suffers" from one distinction: it was the first work by a contemporary aboriginal artist to be purchased by the National Gallery of Canada. I say this because it has been used synecdochically, in that it has been taken to stand for a whole body of which it is only a part. In other words, it was the first work to enter the proverbial fortress as a kind of Trojan horse containing, potentially, an entire discursive network previously ignored by the mainstream. In a way, then, it gave him the legitimacy which he skilfully used to press into the mainstream's own discursivity, that of maintaining its own pre-eminence. If Beam was quick to test the depths of the mainstream, how then do we read this work against that discourse? What does he mean by the "North American Iceberg"? Within the context of this essay and with his remarks at the beginning of this paper, coupled with the realization that the work was done just after the exhibition "The European Iceberg", demonstrate that what we are dealing with is Beam's insistence on the reality of an aboriginal history.

Is he referring to another master narrative? It might seem so, but as we can surmise from the piece, he is making a case for the mainstream's avoidance of a 500-year historical relation with aboriginal peoples of North America. Even the Gallery's good will can be seen as shortsighted unless it addresses this history as a legacy. In *The North American Iceberg* the artist is pictured from three different angles; we become the fourth image looking at aboriginal history in this "revolving sequential." This then allows the viewer to become part of the picture, whether we are confronting the various figures staring back at us, or witnessing world events – space travel or the assassination of Anwar Sadat – or trying to suture together all the disparate images.

The work is also an objection to the extraordinarily arrogant title of its namesake, "The European Iceberg."[34] A characteristic of icebergs is that they float in similar waters, occasionally colliding, but always focused on their own centrality, until of course they melt and their waters become one. The "European iceberg" imposes its force on the contemporary art world; the "North American iceberg" critiques it as it speaks about its history. Both ideas address their own grand narrative. Finally, Beam adds a doubly-loaded, paradoxical phrase: "the artist flying still." Is it the artist who continues to fly? Is this a reference to the filmic repetition of the Muybridge photographs of a bird in flight, or is it the artist's own sequential revolution? Indeed, his head hovers atop the rest, as do the other representations. Or, is it a "koan" – like the sound of one hand clapping – where there are contradictory elements?

We began with the notion that art history was at an end, that it is undergoing changes both within and without. Indeed, as we enter the next millennium and look at the past and the present situation, we do see many changes, many of which have been influenced by artists. We can argue that an aboriginal art history has existed, but the question remains, have we come to "the end of an aboriginal art history"?

Notes

1 Carl Beam was born in 1943 in West Bay Indian Reserve in Manitoulin Island, Ontario. His mother was Ojibwa and his father was non-Indian.

2 Carl Beam, *Networking: Proceedings from National Native Indian Artists' Symposium IV*, ed. Alfred Young Man (Lethbridge, Alberta: University of Lethbridge, 1988), p. 91.

3 I use the term "European" as in "European art history," to denote Europe-specific and "Western", as in Western art history," to include those countries that see Europe as its antecedent.

4 McEvilley, *Art and Otherness*, p. 145.

5 Lyotard, *The Postmodern Condition*, p. xxiii.

6 Fredric Jameson, *Postmodernism*.

7 Silverman, *The Threshold of the Visible World*, p. 178.

8 Burgin, *The End of Art Theory*, p. 142.

9 Trend, *Cultural Pedagogy*, pp. 82–3.

10 Bal, *On Meaning Making*, p. 209.

11 Rushing, *Native American Art*, p. 13.

12 Barnett Newman, *Pre-Columbian Stone Sculpture*.

13 Bourdieu, *The Field of Cultural Production*.

14 The military and political relations of the next two centuries led Aboriginal people to capitulate to the reality of their circumstances. Thus, they accepted that they would live peacefully as wards of the government in small territories called "reserves," which were located far from white populations. It was not until after the Second World War that aboriginal people began to speak out against these conditions; furthermore, it was not until 1960 that aboriginal people in Canada had the freedom to vote. Even though they continue to live within these conditions, Canada in turn has always had to live within the conditions set by its much larger and more dominant neighbour to the south.

15 Herbert Kohl, in *From Archetype to Zeitgeist*, p. 14, says "Modernism [had] two faces, one rational, orderly, and planned, the other alienated, rule breaking, and defiant. Both tend toward the abstract, breaking down objects into component shapes and forms and unfolding the surface of reality to reveal underlying structures and forces."

16 Gregory Jusdanis, in *Belated Modernity and Aesthetic Culture*, explains the fallacy of applying European theories to non-Western cultures and traditions, and argues that they are not as universal as is often believed; that this universality is valid and useful only within Eurocentric cultures. He says, "All methods are valid in their own contexts. The fallacy lies in masquerading a particular ideology as universal. As a European-oriented discipline, literary criticism cannot evade its European character. Western theories do not automatically have validity outside the traditions that produced them," p. 10.

17 David Theo Goldberg, in *Multiculturalism: A Critical Reader*, 3–12, develops a genealogy of the monocultural conditions that gave rise to the discourse of universality against the history of multiculturalism.

18 McEvilley lecture, March 12, 1994.

19 Rushing, *Native American Art*, p. 193.

20 McEvilley, lecture, March 12, 1994.

21 McEvilley, *Art and Otherness*, p. 131.

22 McMaster, "Border Zones: The 'Injun-uity' of Aesthetic Tricks."

23 McEvilley, *Art and Otherness*, p. 144.

24 Hutcheon, *The Politics of Postmodernism*, p. 66.

25 Ashcroft, Griffiths, and Tifflin, *The Empire Writes Back*, p. 38.

26 Quoted in Houle, *New Work by a New Generation*, p. 63.

27 ibid., p. 4.

28 The city was Regina, the gallery was the Norman Mackenzie, and the exhibition was held at the very moment of a large gathering of aboriginal peoples from around the world. This gathering, called the "World Assembly of First Nations," was the prime motivator for the spirit of the time.

29 Jimmie Durham, *The Bishop's Moose*, p. 8. Durham himself fell victim to exclusionary rules. After many years of identifying himself as a Cherokee Indian, the US Public Law 101–644 (The Indian Arts

and Crafts Act of 1990) effectively banned him from claiming Cherokee status and using it to advertise because he could not prove he was registered with a federally recognized tribe (cf. McMaster 1995). Though his identity is problematic I still regard his writings as remarkably in(cite)sightful.

30 ibid., p. 9.
31 ibid., p. 9.
32 Bell, *KANATA*, p. 8.
33 Beam, *Carl Beam THE COLUMBUS PROJECT*, p. 21.
34 Curated by Germano Celant, "The European Iceberg: Creativity in Germany and Italy Today," at the Art Gallery of Ontario, February–April 1985, it was the "first and most ambitious exhibition of its kind in Canada and indeed on this continent," p. 9.

Bibliography

Art Gallery of Ontario (1985) *The European Iceberg: Creativity in Germany and Italy Today*, Toronto: Art Gallery of Ontario.

Ashcroft, Bill, Griffiths, Gareth and Tifflin, Helen (eds) (1989) *The Empire Writes Back: Theory and Practice in Post-Colonial Literatures*, New York: Routledge.

Bal, Mieke (1989) *On Meaning Making: Essays in Semiotics*, Sonoma, CA: Polebridge Press.

Beam, Carl (1989) *Carl Beam THE COLUMBUS PROJECT Phase I*, Peterborough, Ontario: Art Gallery of Peterborough.

Bell, Michael (1993) *KANATA: Robert Houle's HISTORIES*, Ottawa: Carleton University Art Gallery.

Belting, Hans (1987) *The End of the History of Art?*, Chicago, IL: University of Chicago Press.

Bourdieu, Pierre (1993) *The Field of Cultural Production: Essays on Art and Literature*, New York: Columbia University Press.

Burgin, Victor (1986) *The End of Art Theory: Criticism and Postmodernity*, Atlantic Highlands, NJ: Humanities Press International.

Durham, Jimmie (1989) *The Bishop's Moose and the Pinkerton Men*, exhibition catalogue, New York: Exit Art.

Goldberg, David Theo (ed.) (1994) *Multiculturalism: A Critical Reader*, Cambridge, MA: Basil Blackwell, 1994.

Hutcheon, Linda (1989) *The Politics of Postmodernism*, New York: Routledge.

Houle, Robert (1982) *New Work by a New Generation*, exhibition catalogue. Regina, Saskatchewan: Norman Mackenzie Art Gallery.

Jameson, Fredric (1992) *Postmodernism, or The Cultural Logic of Late Capitalism*, Durham, NC: Duke University Press.

Jusdanis, Gregory (1991) *Belated Modernity and Aesthetic Culture: Inventing National Literature*, Minneapolis, MN: University of Minnesota Press.

Kohl, Herbert (1992) *From Archetype to Zeitgeist*, Toronto: Little, Brown, and Co.

Lyotard, Jean-François (1984) *The Postmodern Condition: A Report on Knowledge*, Manchester: Manchester University Press.

McEvilley, Thomas (1992) *Art and Otherness: Crisis in Cultural Identity*, Kingston, NY: Documentext, McPherson and Company.

McMaster, Gerald (1995) "Border Zones: The 'Injun-uity' of Aesthetic Tricks," *Cultural Studies 9*, 1: 74–90.

Newman, Barnett (1994) *Pre-Columbian Stone Sculpture*, New York: Betty Parsons Gallery.

Rushing, W. Jackson (1995) *Native American Art and the New York Avant-Garde: A History of Cultural Primitivism*, Austin, TX: University of Texas Press.

Silverman, Kaja (1996) *The Threshold of the Visible World*, New York: Routledge.

Trend, David (1992) *Cultural Pedagogy: Art/Education/Politics*, Critical Studies in Education and Culture Series. New York: Bergin and Garvey.

Young Man, Alfred (ed.) (1987) *NETWORKING: Proceedings from National Native Indian Artists' Symposium IV*, Lethbridge, Alberta: University of Lethbridge.

Chapter six
Ruth B. Phillips

Art History and the Native-made Object
New Discourses, Old Differences?

> By reducing our cultural expression to simply the question of modernism or postmodernism, art or anthropology, or whether we are contemporary or traditional, we are placed on the edges of the dominant culture, while the dominant culture determines whether we are allowed to enter into its realm of art.
>
> (Loretta Todd[1])

> Is the past that in which we intervene, or is it that which may yet intervene in us? And if we are not satisfied with this choice, how else can we have or be had by the past?
>
> (Stephen Melville and Bill Readings[2])

The engagement of art history and art criticism with objects made by the aboriginal peoples of North America is relatively recent. The first exhibitions of these objects in art galleries began relatively late in the history of the appreciation of "primitive art," around 1930, and it was only during the 1960s that professionally trained art historians began teaching Native American art in university art departments.[3] For most of this period scholars and curators have seen their project as a two-pronged struggle, first to claim a piece of the material culture turf traditionally held by anthropologists, and, second, to have that turf recognized by mainstream art historians as a legitimate field of inquiry. During the past two decades, however, the discourse surrounding Native art has been moving in new directions, driven by the radical reformations to art history and anthropology as disciplines and by the growing Native critique of the western art and culture system.

In this paper I will first outline briefly the early development of Native American art as a field within art history and then identify three important and interrelated trends that, I would argue, have emerged since the mid-1980s from the continuing interrogation of art history. The first of these

trends is the consolidation of a critique of the ocularcentrist bias in western culture that has for centuries privileged a strictly delimited form of visual experience; the second is a movement to reposition art history within a new field of visual culture, and the third is a strengthened interdisciplinary engagement between anthropological and art discourses. Each of these trends opens or closes particular spaces for Native American art both as a field of study and in terms of contemporary practice. (The category "Native art" is, of course, part of the terrain being questioned; I use the phrase in this paper to refer to the construct that developed under modernism and the old art history, and that remains embedded in general discourse – according to which certain Native-made objects are defined as having autonomous aesthetic content and, consequently, greater value.) Recently, too, a number of Native writers and artists have begun to articulate a more comprehensive critique of the characteristic western privileging of the visual and the material within expressive culture, and this will be discussed in the last section of the paper.

Art history, old and new, and Native American objects

The process by which Native American objects have become established as "art" flows from two academic projects of the first half of the twentieth century: anthropological material culture studies and the promotion of "primitive art" by early twentieth-century modernists.[4] There is a growing consensus that the classification of some Native American objects as "fine art" was definitively accomplished in a series of landmark exhibitions held during the 1930s and 1940s.[5] The process by which this occurred was inbred and circular; while anthropologists relied on the criteria and classifications established by nineteenth-century aestheticians and art historians, artists and critics used the writings of anthropologists to select "art" from the spectrum of made objects. Scholars and curators from both fields unapologetically employed western criteria in the evaluation of style, genre and quality, and their connoisseurship process was hampered by very inadequate knowledge of comparative examples. Yet their validations of Native American historical objects as art was significant because the ability to produce "true" sculpture and painting was (and continues to be) generally accepted as a sign of a people's overall level of cultural achievement. The efforts to promote Native objects as art (though often as commodified "crafts" or "folk arts") helped both to counter the Vanishing Indian narrative and to create a narrow space for the further development of contemporary Native artistry.

When the first professionally trained art historians began to address Native art in the early 1970s, their research, in keeping with trends in the discipline, was directed at problems of attribution, historical stylistic change, and Panofskian iconographic studies.[6] In their work of interpretation Native Americanists followed the Panofskian paradigm of iconographic study, which, as Melville and Readings have put it, shows, "how to insert an object within a general history of meaning, and how to see through an object into the history of meaning to which it belongs."[7] In her paper, "Native Art as Art History: Meaning and Time from Unwritten Sources,"[8] Joan Vastokas defined the project as it was then seen. She argued passionately that the kinds of textual analogues sought by western art historians in literary and historical texts could be supplied for Native art from archaeological and ethno-historical sources.

Vastokas's paper was written in 1984, just as the impact of the revisionist movement known as "new art history" began to be widely felt in North America. This movement, which was first named in Britain in the 1970s, developed out of encounters with French critical theory, feminist theory and British cultural studies in both North America and Europe.[9] New art historians borrowed semiotic

and poststructuralist modes of textual analysis and applied them to visual images. They sought explanatory understanding in the matrix of social and economic factors surrounding the creation of works of art rather than in individual artist's biographies, and they began to scrutinize the representational practices of their discipline with reference to the ways that these conventions supported and produced particular ideologies of class, race, and gender.

In an earlier (1989) consideration of Native American art and new art history I wrote optimistically of the great potential that this revisionist movement offered to historians of non-western arts.[10] I argued that many of new art history's key issues had already been problematized by scholars of non-western art because cross-cultural study had sensitized them to the ways that western paradigms of art deform emic, or culture-based, understandings of objects. The de-contextualization of the visual object for purely aesthetic contemplation and the hierarchical classification of objects as art or craft according to criteria of media or use are especially problematic to most Native American concepts of the made object. The general raising of consciousness about such issues promoted by new (and especially by feminist) art history promised to encourage the more integrated and holistic study of the object demanded by Native American and many other art forms.

Methodologically, the increased interdisciplinarity and broader historical contextualization promoted by new art history paralleled and was influenced by similar developments in related fields, such as new historicism in literary studies, Geertzian "thick description'" in anthropology, and the prominence of microhistory in historical studies.[11] Under the pressure of these new paradigms, art history, like those other disciplines, moved away from set canons of great works organized into narratives of the progressive rise of western culture. In their place are being inserted plural histories of art traditions belonging to particular communities and considered as parallel, contemporary and interactive with those of the mainstream culture.

The anti-ocularcentrist critique

As numerous writers have pointed out, new art history was neither a unified nor a consistent movement, but a loose and fluid amalgam drawing on diverse bodies of theory and method that were potentially disharmonious and contradictory. Reaction to the first revisionist wave has crystallized in recent years, I would argue, around two issues: first, the anti-ocularcentrist critique, and, second, the replacement of art history with a broader field of visual culture. The anti-ocularcentrist critique is located in a body of work produced by a multidisciplinary group of scholars including Martin Jay, W. J. T. Mitchell, Hal Foster, Norman Bryson, and Rosalind Krauss. It grows out of an awareness of the threat posed to the appreciation of visual art by, on the one hand, semiotic and other language-based analytical approaches in which the visual object is reduced to a text and, on the other, by the extreme ocularcentrism of mid-twentieth century formalism (exemplified by Clement Greenberg's criticism) which defined artistic experience as one of pure visuality. An important element of postmodernism in art, the critique of ocularcentrism was stimulated in part by its proponents' need to distance themselves from this modernist critical tradition (to which a number, such as Krauss, had been significant contributors). In different ways each of these writers has attempted to locate a viable middle ground between the exaggerations of poststructuralism and formalism. In his book *Downcast Eyes: The Denigration of Vision in Twentieth-Century French Thought*, Martin Jay argues that the de-privileging of vision and image in favor of language and text was a central thrust of the French critical theory that has contributed so fundamentally to new art history.[12]

Although participants in this critique remain focused on visual experience they emphasize the historically (and, by implication, culturally) specific nature of seeing. As Hal Foster wrote in a key text, his 1988 edited volume, *Vision and Visuality*, "vision" refers to the "natural" sense of sight, while "visuality" refers to "sight as a social fact."[13] "The *sine qua non* of this discussion," Foster wrote "is the recognition that vision *has* a history, that there are different regimes of visuality."[14] In this he was developing further, within the ideological and social contexts featured by new art history, important insights already advanced by Gombrich and Panofsky.[15] An important component of the ocularcentrist critique has been the examination of how specific historical "scopic regimes" inscribe particular relationships of power. In his *Vision and Painting: The Logic of the Gaze* (1983) Norman Bryson focuses on the invention of perspectival pictorial space, one of the most compelling technologies ever created for the illusionistic rendering of space and form. This particular scopic regime (which remained the primary representational trope throughout the centuries of western colonialism) divorces the see-er from the seen with unparalleled rigor. By making the depicted object available to the unobstructed and intrusive gaze of the subject, perspectival drawing lends itself as a tool of domination – by men of women, by white imperialists of other races, by scientists of nature.

The notion of "scopic regimes" has proved a powerful tool in the hands of post-colonial artists. Yet, as will become evident in the last section of this paper, the anti-ocularcentrist critique does not resolve some of the major issues being raised by Native critics about the ways that the visual bias of western art discourses destroy the integrity of Native objects. From the vantage point of students of non-western art, I would argue, the anti-ocularcentrist critique does not cancel but rather recuperates the primacy of visual experience, since the visual remains the defining category. When applied cross-culturally to objects originating in societies where the (also aesthetic) expressive forms of ritual, story-telling, music or dance are of equal or greater importance, the western inscription of its art and culture system operates as a continuing colonial legacy.

It is also true, however, that the critique of ocularcentrism has provided an important intellectual armature for the postmodernist development that has proved so fruitful for the projects of many artists from marginalized communities. Postmodern performance and installation are particularly effective modes within which to explore the politics of vision because they move the work of art off the wall and into the viewer's space, allowing the gallery to become like a ritual ground, a didactic arena, a political forum. They readmit to the realm of visual art a range of contextualizing strategies such as written text, vocalization, dramatic movement, and the construction of three-dimensional environments, supplying the contextualizing possibilities that, as Brian O'Doherty observed in *The White Cube: The Ideology of the Gallery Space* (1986), were missing from the modernist art gallery. High modernism's minimalist aesthetic, as he wrote, excluded the "provincial" artist: "The mark of provincial art is that it has to include too much – the context can't replace what is left out, there is no system of mutually understood assumptions."[16]

Three recent projects by Robert Houle, Colleen Cutschall, and Gerald McMaster demonstrate the new relationships between painting and installation that have been developed by Native artists, as well as the specifically political, ritual-spiritual, and socially critical uses to which contemporary artists are putting the traditional space of the art gallery. Robert Houle's 1993 show, "Contact/Content/Context," shown at the Carleton University Art Gallery in Ottawa, had at its centre his 1992 painting *Kanata* (Plate E), the artist's repainting of Benjamin West's *The Death of Wolfe*. The scene is rendered in grisaille, with only the pendant figure of the Indian in the lower left colored in. It is framed by two large color fields of red and blue that simultaneously signify the British and

French colonizers and gesture to the artist's engagement with the abstraction of Barnett Newman.[17] The other elements of the exhibition were a series of text and image collages mounted along the walls, tape recorders that gave voice to Native views of history spoken in Saulteaux and English, an artifact case containing the artist's moccasins, and a circle inscribed on the floor around a parfleche and an offering of tobacco. The juxtapositions of these elements created a complex play of messages about the Native history of political exclusion and about the suppression and museumification of Native culture to which discourses of art and artifact had contributed. As Houle himself has said in glossing his title,

> The historical relationship between the First Nations and Canada since CONTACT spans an empire and a post-colonial era. Today, the politics of multiplicity and the ideological grounding in listening to *other* voices has given me the opportunity to challenge authority — the CONTEXT upon which my work can have maximum empowerment for the viewer. Tomorrow the politics of representation and the spiritual integrity of the past will govern the CONTENT to be found in my art.[18]

Colleen Cutschall's one-woman show "House Made of Stars," organized by the Winnipeg Art Gallery in 1996, also combined painting and installation. All gave visual expression to concepts of Lakota cosmology that are inscribed in oral tradition, ritual movement, and traditional architecture. These concepts, which explain the relationships between the configurations of the stars, the mythic origins of the universe and earthly topography, were painted schematically and illusionistically, and spatialized through installation. The installation *Sons of the Wind*, for example, represents the four sons of the creator being, Tate, who were sent out to create the spatial and temporal order of the world, establishing the quadrants of the four cardinal directions as well as the division of time into day and night, months and years, and becoming the four winds that govern the regular alternation of the seasons (Plate H). Cutschall materializes the sons as four pillars, tinted with symbolic colors, that link the airy realm of the sky and the birds to the human domain of solid land. These columnar forms are identifiable with the centering axes of the tree/sundance pole. They also strongly evoke the fundamental forms of the classical tradition in western art. Cutschall's appropriative strategy here is the opposite of Houle's deconstructive repainting of the West picture. As in her use of the illusionistic, perspectival landscape in several of the wall paintings in the exhibition Cutschall exploits the western historical tradition in the service of a Native project of cultural reclamation and preservation. Moving through her exhibition the visitor realizes the Lakota ritual path, temporarily transforming the white cube into something like a sacred space.

Of the three exhibitions, Gerald McMaster's "Savage Graces," organized by the Museum of Anthropology at the University of British Columbia in 1992, was perhaps most directly related to the critique of ocularcentrism, and specifically to issues of colonial power relations, pictorial representation and Indian stereotypes (Plate 24). In the first room, hung with large wall paintings, the artist approached his subject from within the western pictorial tradition. The remainder of the exhibition, however, consisted of a parodic museum in which a taxonomy of Indian stereotypes, inscribed in commercial packaging, children's toys, games, "fine art" paintings, postcards, photographs and other objects, was displayed in ethnographic specimen cases (Plate 25). Through strategies of inversion and irony typical of McMaster's recent work[19] the artist examined the politics of vision with regard both to painting and to "the museum as a way of seeing."[20]

Plate 24 On the left: Gerald McMaster, *Untitled* (1992), acrylic on canvas, 4' × 4' , from the "Savage Graces" installation at the Ottawa Art Gallery. Courtesy of Gerald McMaster

Plate 25 Gerald McMaster, *Not Recommended for Children* (1992) mixed media installation in the "Savage Graces" installation at the Ottawa Art Gallery. Courtesy of Gerald McMaster

"Savage Graces" purposely juxtaposed two modes of object display, the art gallery and the ethnographic museum. It presented as a continuous spectrum visual representations of Indians from fine, popular and commercial art, hand made and mechanically reproduced. In this sense the exhibition can be read as a programmatic statement of the utility of the visual culture concept to critical artistic work. As with so many works by contemporary post-colonial artists, McMaster's project was as much a contribution to the reformulation of the art historical field as it was a product of that reformulation. Indeed, the importance of this kind of positioning of acts of visual representation was being urged by Native scholars years before it was proclaimed by art historians. In her important 1973 dissertation on the American Indian in vernacular culture, for example, Cherokee scholar Rayna Green examined the iconography of the Indian not only in paintings, prints and drawings, but also in cigar store Indians, ships' figureheads, weathervanes, carousel figures, dolls, firedogs, advertising, commercial packaging, textiles, pottery, and Wild West shows.[21] She argued not only that these popular and commercial arts reflected constructs of aboriginal people developed within elite academic and artistic cultures, but also that elite writers and artists were influenced by vernacular arts. According to her analysis, "ideas about the Indian are conveyed by whites who insist on certain aspects of Indian personality, culture, and behavior and on certain aspects of Indian–white relations as (1) whites act them out, (2) Indians re-enact them for whites, and (3) they are projected on and into objects, verbal utterances, and actions associated with the Indian and with his image."[22]

Visual culture and the new anthropology of art

As many books and exhibitions have shown, cardboard stereotypes of Indianness have been embedded in western art and popular culture for centuries and grow yearly more numerous.[23] The crushing weight of this imagery helps to explain why the notion of "visual culture" is so helpful for a new Native American art history. Visual culture embraces the full range of visual representations in photography, film, video, television, journalism, electronic media, traditional fine art media, folk and popular crafts and scientific and technological imaging.[24] If the origins of the ocularcentrist critique can be traced to French critical theory, visual culture's erasure of the boundary between fine and popular arts can be traced to British cultural studies. One of its root texts is John Berger's *Ways of Seeing* (1972), a book that not only aligned magazine advertisements with old master paintings but was issued both as a television series and a popular paperback book.

There is another reason, beyond the need to deconstruct and erase stereotypes, why the visual culture model is important to the study of Native American art. For more than a century and a half (the length varies in different parts of North America) a considerable amount of the visual creativity of Native Americans has been expended in the realm of popular and commoditized art and touristic performance. Until recently, Native participation in mainstream fine art was impossible because of the economic and racial barriers that prevented attendance at professional art schools. Before this period Native painters either became commercial artists, or were classified as folk or naive artists. It is, therefore, impossible to recover a sense of the continuous Native presence in art history if we limit ourselves to the fine arts. An empty space gapes in accounts of the history of Native art during almost the entire modernist century; in standard accounts, the production of "authentic" and "traditional" art is perceived to end in the reservation period, while a contemporary art employing western fine art media did not begin until the early 1960s. The traditional Native arts promoted by the primitivists were defined as belonging to a tribal past, available for appropriation as a means of

restoring authenticity to modernist western art. As a corollary, contemporary makers of "traditional" art were regarded as inauthentic if they were guilty of innovative incorporations of "modern" Euro–North American genres and styles.

One proponent of the visual culture model, W. J. T. Mitchell, has recently written of art history's need to expand its horizon "not just beyond the sphere of the 'work of art' but also beyond images and visual objects to the visual practices, the ways of seeing and being seen, that make up the world of human visuality."[25] Such a call removes the walls that have been erected to separate commoditized productions from "fine art," the visualizations of Indianness created by traveling entertainers and Hollywood movies, and the works of "amateur" and "professional" artists. The visual culture framework thus permits not only a more comprehensive narrative of the history of Native art, but also one that makes more sense of the work that contemporary artists are doing, and how this work is linked to earlier generations working in very different formats and media.

Anthropology and art history

The concept of visual culture, as its proponents point out, has much in common with the anthropological subfield of visual anthropology, a relatively recent development which predates the concept of visual culture.[26] It focuses on that aspect of anthropological representation that occurs not in textual but in visual forms, such as ethnographic photographs and films, and is concerned with the medium-specific ways that visual representations communicate images of other cultures. Art historians who, as we have seen, wanted to counter the reductionist tendencies of text-based post-structural analyses found in visual anthropology a useful support for their defense of the integrity of the visual. Increasingly, it appears that the only things still separating visual anthropology and visual culture are their respective traditional but less and less habitual concerns with the non-West and the West. The goal of "reclaiming visual anthropology as a space for the representation of visual culture from the naive realist and exoticist inclinations that have beleaguered practitioners' efforts to date," announced in the flyleaf of a 1995 anthology of essays from the *Visual Anthropology Review* edited by Lucien Taylor, is congruent with the projects of many artists and art historians, Native and non-Native.[27] Theorists of ocularcentricity in visuality "cross over" to write in each other's journals. Taylor writes that the essays in his collection all "share the desire to clear a space for the theoretical analysis of the ocular," and he includes contributions from Hal Foster and Martin Jay.

The concerns of anthropologists and art historians have been merging in other ways as well. An increasing number of anthropologists have found the western art world itself a necessary subject of study because of its power and centrality to the representations of the cultural groups they traditionally study. The museum as a forum of display and the art market as a forum of the negotiation of value have become popular subjects of analysis – and with them the discourses generated by art historians and art critics that constantly fuel the system as a whole. As much as (or more than) literary or anthropological texts, these systems "produce" other cultures for broad audiences. Much of the work in this area takes as its point of departure seminal essays by James Clifford in *The Predicament of Culture*.[28] These were part of a debate surrounding the 1985 exhibition "'Primitivism' in 20th Century Art: Affinities of the Tribal and the Modern" at the Museum of Modern Art in New York. As George Marcus and Fred Myers wrote in their introductory essay to *The Traffic in Culture: Refiguring Art and Anthropology* (1995), their interest in the art world was thrust upon them by the regularity with which research led them to practices of circulating, displaying, and

representing different kinds of art. On the one hand they note, the production of art is an increasingly important activity for "anthropology and its traditional subjects [who] are increasingly involved in the production of art and the institutions on which art production depends." On the other, art discourses form an important topic for anthropology because "in contemporary cultural life, art is becoming one of the main sites of cultural production for transforming difference into discourse, for making it meaningful for action and thought."[29]

The Native response: elusive unities

There has been, over the past decade, a greatly increased visibility of Native American art in various kinds of art worlds. There have been many more exhibitions of Native art in art galleries. The 1992 "Land/Spirit/Power" and "Arts of the American Indian Frontier," for example, were major exhibitions of contemporary and historic Native art at the National Galleries of Canada and the United States, both museums that had only rarely before displayed aboriginal objects.[30] The 1990s also saw a widespread attempt to globalize introductory art history surveys in universities, and a notable increase in the number of panels devoted to Native American and non-western art at professional meetings.[31] How significant are these changes? Has postmodernism opened the door to a truly de-centered and post-colonial representation of the visual aesthetic expressions of the world's peoples? Has modernism's colonizing representation of those arts as primitive art or scientific specimen been replaced by non-colonizing postmodernism? Or, as some critics allege, are we witnessing a neo-primitivist moment that remains appopriative in terms of power relations and Eurocentric in terms of critical discourse?

The Metis film-maker Loretta Todd has attacked postmodern "inclusiveness" as one more appropriative strategy. "Everything about us," she has written,

> from our languages to our philosophies, from our stories to our dances – has become material in a quest for further discovery, for new treasures . . . their forays have given the new explorers greater licence in their cultural, political and artistic practices. Our cultural autonomy is too often ignored and our cultural uniqueness – our difference – is reduced to playing bit parts in the West's dreams.[32]

Despite the pretensions of postmodernism, she argues, the terms in which Native art can be discussed continue to be determined by the concerns of non-Native people, even when they involve an expiatory working out of old guilt. For Todd the imposition of the dichotomous categories of the traditional and the contemporary are a prime example of this control. "The theories seek to impose a world view, and to assimilate my view into theirs, even while they preach multiplicity." For Todd, postmodernism is appropriative, because it denies to Native people the ownership of their own history. Aboriginal artists and writers need to resist western terms, she writes, because:

> When we articulate the dichotomy of the traditional versus the contemporary, we are referencing the centre, acknowledging the authority of the ethnographer, the anthropologist, the art historian, the cultural critic, the art collector. We are caught in the grasp of neocolonialism, in the gaze of the connoisseur or consumer, forever trapped in a process that divides and conquers.[33]

During the 1990s a group of Anishnabe artists in Canada have mounted a critique of mainstream art institutions and discourses that parallels Todd's. The artists, who share an artistic orientation usually referred to as "Woodlands School," take as their subjects traditional Anishnabe spirituality and worldview.[34] Working with a set of graphic conventions derived from pre-contact rock art, incised birchbark medicine scrolls, and other visual forms, the artists seek understandings of orally transmitted traditional knowledge and explore the relevance of these teachings for such contemporary concerns as personal empowerment, the unity of the family, and the preservation of the environment. During the 1960s, when two of the most important innovators of this art, Norval Morrisseau and Daphne Odjig, came to prominence, and during the 1970s, when a host of younger artists were inspired to follow their model, Anishnabe painting found a ready collectors' market and was regularly shown in public art galleries – though not generally by the most prestigious.[35] Since the late 1980s, however, as postmodernism has gained dominance Anishnabe art has been largely excluded from display by the large urban museums that have been showing the work of art-school trained artists working in more current mainstream modes. Discouraged by the falling off of markets and public attention, many of the artists have stopped painting.

Against this trend, three artists from Manitoulin Island, Blake Debassige, James Simon Mishibinijima, and Leland Bell, as well as others such as Ahmoo Anjeconeb and Roy Thomas, have persisted in their artistic project and have also become increasingly vocal in its defense.[36] Debassige contrasts his own attempt to "study as much as I could about my own relations," to the "extremely eclectic" styles adopted by the urban art-school graduates who "just jump from one style that seems to be the hit of the day to the next.[37] Like Todd, he links the power to say what art is to political empowerment: "Native art has to do with the same question as self-government," he has stated.[38]

James Simon Mishibinijima also stresses the importance of connectedness to his community and particularly to elders, "You collect each word," he says, "Elders talk to you through the mind and they talk to you through the heart."[39] These "words" translate into color and form on his canvases: "sometimes one on one with the forest and yourself, look at the greens and the Thunderbird is creating these plants, these trees."[40] Mishibinijima tried a move to Toronto, but found it impossible to paint away from the land and the community of Manitoulin.

Similarly, Leland Bell's canvases inscribe ancient systems of mystical meaning. His glowing colors symbolize the four cardinal directions, the sacred symbolism of the numbers four and seven, and represent through images of rocks, rainbows, and birds, sacred meanings of the creation, spiritual messengers, and gifts of knowledge[41] (see Plate 26). Bell has also defended his artistic project in relation to mainstream art discourses. Against the accusations of "quaintness" – which he sees as a way of identifying Anishnabe painting as being "not quite art or not quite part of the establishment of art," and of "ugliness" – which he attributes to ignorance of the underlying system of representation, he puts his own sense of mission.[42] His "little job," like that of his colleagues, is, on the one hand, a social and political one. By showing "the beauty of our culture" the Anishnabe artist counters the fear of outsiders and the sense of inferiority that lingers among Native people themselves. "We have to have a consciousness of being relevant today, that we're not victims of our own past," Bell says.[43] Like his colleagues, he also sees his mission as a continuing personal spiritual quest, analogous to that of members of the traditional Midewiwin medicine society: "My quest is not so much to become famous and to become rich but to find those colours that nobody else could see . . . Whether I find them is not important. It's the task of searching for those colours which is important."[44]

The apparent gulf between "traditional" and "contemporary" Native arts was the subject of a 1995 exhibition organized by the Thunder Bay Art Gallery. The gallery invited a series of artists including

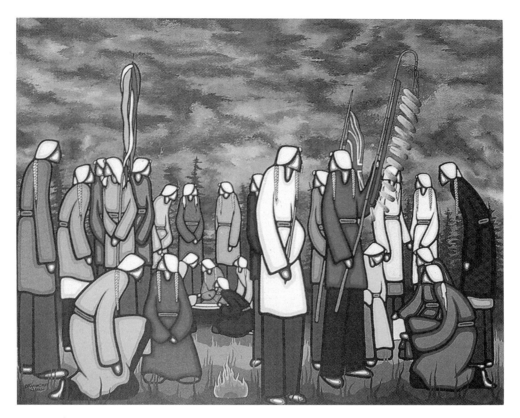

Plate 26 Leland Bell, *Unceded People* (1991), acrylic on canvas, 5' × 6', collection of the artist

Debassige, Rebecca Baird, Shelley Niro, Jolene Rickard, Colleen Cutschall, Jim Logan, and Jane Ash Poitras to address the relationship of traditional arts – including those usually defined as crafts – to contemporary (postmodern) Native art.[45] The works in the show, executed in diverse media and formats including beadwork, easel painting, installation, and photography, forged new links between worlds of art-making artificially segregated from each other by western systems of classification. Debassige exhibited paintings as well as an embroidered birchbark box made in collaboration with master beadworker Lillian Cheechoo and quillworker Delia Bebonang (Plate 27). Debassige's design for the box commemorated his father who had recently died. Its depiction of a strawberry plant, the fruit that grows along the path followed by the dead to the afterworld and nourishes their spirits, was an offering and a sacred representation; its four leaves and tendrils form the cross of the four directions and inscribe a fundamental image of cosmic order.

Shelley Niro's *Chiquita, Bunny, Stella* – a photographic installation which juxtaposed portraits of Iroquois women artists with the feather fan, cornhusk doll, and beaded bag each had made – directly challenged the art/craft boundary (Plate 28). According to the artist it joined two kinds of aesthetic concepts, "the place of these objects in Iroquois aesthetics" and their "place in emotional 'connectedness' to other people who can respond to the items that these persons have created."[46]

The essay that Deborah Doxtator contributed to the catalog of "Basket, Bead and Quill" illuminates the questions that inform this essay about the fit or misfit of aboriginal concepts of the

Plate 27 Blake Debassige, *The Journey Westward* (1995), "strawberry basket" of porcupine quills, beads, leather, sweetgrass, 3¼" × 7" × 7". Photo by Judy Flett

object with contemporary western art discourses. Doxtator asks how the kinds of objects western-ers have identified as "Native art" signify meaning within aboriginal communities.

> Like picture writing on utilitarian objects, basketry, pottery, clothing, or in wampum belts or pictographs, these objects as metaphors are not transcriptions of word for word linear sentences but of concepts and processes. Each symbol does not correspond to an English phoneme which when connected to others forms a word and sentence which explicate a meaning. Like the words in our languages they emphasize movement, action, and mean not one thing but several. A metaphor presents knowledge as an "instant fusion," not as a narrated argument of one opinion. It involves the iconic flash of understanding of an idea using both one's conscious or "rational" and unconscious or intuitive mind simultaneously.[47]

Although Doxtator insists on the autonomy of the physical, *seen* object in the construction of meaning, the visual is not the organizing category. Like Niro she emphasizes the connections among objects, memory (of individuals, ancestors), and a network of emotional ties within a Native community. She also stresses the significance of materials themselves. "Ideas like spiritual power," she writes, "can be embodied and exist in concrete physical form such as in objects, signs, animals, plants, trees, people. Our stories contain many instances where beings transform their outward shapes from animals to human beings to plants and stars and back again."[48]

Like Todd, Doxtator argues that the western classifications of art and craft, contemporary and traditional, distort indigenous ideas about the significance of made objects. "The relatively recent categorization of art forms such as basket, bead and quill as art objects within a hierarchical Euro-

Plate 28 Shelley Niro, *Chiquita, Bunny, Stella* (1995), installation of tinted black and white photographs of Iroquois women, each 48" × 36", with feather fan, cornhusk doll, and beaded bag, each sculpture 20" × 8" × 8", at Thunder Bay Art Gallery, Ontario. Courtesy of Shelley Niro. Photo by Judy Flett

North American art aesthetic side-steps the recognition of Native aesthetics and conceptual systems as viable ways of understanding art," she writes.[49]

> If tradition or valued knowledge is made up of these visual and concrete metaphors and our varied interpretations of them, then continuity depends not upon exact sameness of form or interpretation, but on the process of continued interaction with these powerful cultural metaphors. Visual artists have continued to refer to these metaphors in their work whether they have created in the styles of what art historians have called the 'Woodland School' or the 'modernist' style for the simple reason that visually these metaphors remain culturally very powerful to us.[50]

I retain a vivid memory of standing outside the Ojibwa Cultural Foundation on Manitoulin Island and watching James Simon Mishibinijima deep in conversation with an elder who had come by on business with the Center. Several of Mishibinijima's paintings, which he was delivering to the Center to be displayed for sale, were leaning against the side of the building. The two were speaking in Ojibwa, the elder gesturing as he commented on the canvases, the artist intensely concentrated on his words. The 'art' on the canvas was the outer trace of a world contained in oral tradition, and it was evidently acting as a threshold to that world as the artist had intended it should.

This role for art is very similar to that described by Fred Myers in relation to contemporary Pintupi painting from Australia.[51] Like Anishnabe painting, Australian Aboriginal painting has been subjected to the vagaries of a western art world that alternately includes and excludes the work of different artists depending on the fashions and perceptions of "affinity" of the particular moment. Recently, the contextualizing sensibility of postmodernism has accepted works such as Shelley Niro's *Chiquita, Bunny, Stella* that aim to deconstruct the western hierarchy of art forms far more readily than did the modernist art gallery of "pure visuality." Yet the modernist–primitivist sensibility of the 1960s and 1970s proved more welcoming than today's art world to the work of Anishnabe painters.

Both Doxtator and Todd resist the dialectical structures that create such either/or situations, structures which they regard as a continued unfolding of Eurocentric obsessions. They urge on us more holistic and community-based understandings of Native-made objects, both contemporary and historic, which will restore interlinkages with oral traditions, relationships to family, community, and land, and to transcendent realities. As art historians debate the merits of old art history, new art history, and visual culture, their arguments offer important correctives and clarification. The further development of this emergent Native discourse is anticipated with interest.

Notes

1 Loretta Todd, "What More Do They Want?" in *Indigena: Contemporary Native Perspectives*, ed. G. McMaster and L. A. Martin (Vancouver: Douglas and McIntyre, 1992), p. 75.

2 Stephen Melville and Bill Readings, "General Introduction," in *Vision and Textuality* (London: Macmillan, 1995), p. 16.

3 The pioneering institutions were Columbia University, under the late Douglas Fraser; the University of Washington, under Bill Holm; and the University of New Mexico under J. J. Brody. The number of North American universities teaching Native American art history remains shamefully small.

4 On Boas, the main anthropological theoretician, see Aldona Jonaitis (ed.) *A Wealth of Thought: Franz Boas on Native American Art* (Seattle: University of Washington Press, 1995). See also Janet Catherine Berlo, "Introduction: the Formative Years of Native American Art History," in Berlo (ed.) *The Early Years of Native American Art History* (Seattle: University of Washington Press, 1992); and Ruth B. Phillips and Christopher B. Steiner, "Introduction," in Phillips and Steiner (eds) *Unpacking Culture: Art and Commodity in Colonial and Postcolonial Worlds* (Berkeley, CA: University of California Press, 1999).

5 Key moments in this history have been documented by W. Jackson Rushing, "Marketing the Affinity of the Primitive and the Modern: René d'Harnoncourt and 'Indian Art of the United States'," in Berlo, *Early Years*, pp. 191–236; Diana Nemiroff, "Modernism, Nationalism and Beyond: A Critical History of Exhibitions of First Nations Art," in D. Nemiroff *et al*, *Land, Spirit, Power: First Nations at the National Gallery of Canada* (Ottawa: National Gallery of Canada, 1992); 15–41; and Molly H. Mullins, "The Patronage of Difference: Making Indian Art 'Art, Not Ethnology'," in G. Marcus and F. Myers (eds) *The Traffic in Culture: Reconfiguring Art and Anthropology* (Berkeley, CA: University of California Press, 1995), 166–200.

6 The list of this first generation is not long. It includes students of Professor Douglas Fraser at Columbia (including Joan Vastokas, Aldona Jonaitis, Lee Ann Wilson, David Penney), of Bill Holm at the University of Washington (Robin Wright, Barbara Loeb, Kate C. Duncan) as well as several others, such as Zena Pearlstone, who studied at UCLA, Evan Maurer, who came out of a modern art background at the University of Pennsylvania, and Joyce Szabo, a student of J. J. Brody at the University of New Mexico.

7 Melville and Readings, *Vision and Textuality*, p. 21.

8 *Journal of Canadian Studies* XXI, no. 4 (1986–7), pp. 7–36.

9 See A. L. Rees and F. Borzello (eds) *The New Art History* (London: Camden Press, 1986) and H. Belting, *The End of the History of Art?* trans C. S. Wood (Chicago, IL: University of Chicago Press, 1987). See also the special issue of *Art Journal* devoted to "The Crisis in the Discipline", 42, (1982).

10 "What is 'Huron' Art?: Native American Art and the New Art History," in *Canadian Journal of Native Studies* IX, no. 2 (1989), pp. 167–91.

11 See R. Phillips, "Fielding Culture: Dialogues Between Art History and Anthropology," *Museum Anthropology*, XXVIII, no. l, (1994), pp. 39–46.

12 Berkeley, CA: University of California Press, 1994.

13 New York, 1988, p. ix.

14 ibid., p. xiii.

15 Panofsky, "Die Perspektive als symbolische Form," in *Vorträge der Bibliothek Warburg 1924–25* (Leipzig/Berlin, 1927), and E. H. Gombrich, *Art and Illusion* (London: Phaidon, 1960).

16 San Francisco: Lapis Press, 1986, p. 79. It is not surprising that the first Native American artists to embrace modernism – Oscar Howe, Joe Herrera, Allan Houser, Fritz Scholder, Daphne Odjig, and others – were attracted to styles such as cubism and collage that retained elements of figuration. Even artists such as Alex Janvier or Robert Houle, who were interested in possibilities of abstraction, maintained subtle references to indigenous artistic traditions or contemporary issues in titles, motifs, and media.

17 These elements of the painting can also be read as a specific homage to Newman's *Voice of Fire*, (1967) whose acquisition by the National Gallery of Canada in 1990 had generated a national controversy.

18 Exhibition label text, also in M. Bell, *Kanata* (Ottawa: Carleton University Art Gallery, 1992).

19 For a discussion of McMaster's uses of irony, parody and comic tone see Allan J. Ryan, "Gerald McMaster: Maintaining the Balance," in *The Cowboy and Indian Show: Recent Work by Gerald McMaster* (Kleinburg, Ontario: McMichael Canadian Art Collection, 1991), pp. 8–18.

20 See Svetlana Alpers, "The Museum as a Way of Seeing," in I. Karp and S. Lavine (eds) *Exhibiting Cultures* (Washington, DC; Smithsonian Institution Press, 1991), pp. 25–32.

21 "The Only Good Indian: The Image of the Indian in American Vernacular Culture," Ph.D. dissertation, Dept of Folklore and American Studies, Indiana University, 1975.

22 ibid., p. 318.

23 For a comprehensive assessment by a Native scholar that preceded McMaster's artistic achievement in *Savage Graces* see *Fluffs and Feathers: An Exhibition on the Symbols of Indianness, A Resource Guide* by Deborah Doxtator (Brantford, Ontario: Woodland Cultural Centre, 1988). Recent films such as the Disney studio's *Pocohantas* and the plethora of commercial products that spun off from it evidence the continuing power of Romantic stereotypes despite the increasing numbers of scholarly critiques.

24 See the essays by Carlo Ginzburg, James D. Herbert, W. J. T. Mitchell, Thomas F. Reese, and Ellen Handler Spitz in "A Range of Critical Perspectives: Inter/disciplinarity," *Art Bulletin*, LXXVII, no. 4 (1995), pp. 534–52.

25 ibid., p. 55.

26 Visual anthropology goes back to the 1960s. Like the other disciplinary fields and subfields discussed here, it changed substantially in the 1980s.

27 New York, 1995. The book's subtitle is "Selected Essays from '*Visual Anthropology Review*' *1990–1994*."

28 *The Predicament of Culture: Twentieth Century Ethnography, Literature, and Art* (Cambridge, MA: Harvard University Press, 1988). See especially pp. 189–251, "Histories of the Tribal and the Modern" and "On Collecting Art and Culture."

29 Marcus and Myers, *Traffic in Culture*, p. 4.

30 The larger interest in "global" art is also indicated by exhibitions such as "Dreamings: The Art of Aboriginal Australia" (Asia Society Galleries, New York City, 1988), "Les Magiciens de la Terre" (Centre Pompidou, Paris, 1989), "The Other Story," (Hayward Gallery, London, 1989), and "Africa Explores" (Center for African Art, New York, 1991).

31 The opening up of organizations like the College Art Association and the Universities Art Association of Canada occurred only in the mid-1980s. The revisions of survey courses are more recent. See the special issue of *Art Journal*, Fall (1995) devoted to teaching the first year survey, and the review of recent art history survey texts by Mark Miller Graham in *Art Journal* (55) 2: 99–102.

32 Todd, "What more do they want?", p. 71.

33 ibid., p. 75.

34 The term "Anishnabe" refers to several Great Lakes peoples, including the Ojibwa, Odawa, Potawatomi, Menomini, Winnebago, and Cree.

35 The largest and most prominent exhibition, "Norval Morrisseau and the Emergence of the Image Makers," was organized for the Art Gallery of Ontario in 1984, but was not followed by others of similar scope.

36 See Royal Ontario Museum, *The Art of the Anishnawbek: Three Perspectives*, Toronto, 1996; and Blake Debassige, "Dualism: The Physical and the Spiritual," in B. Debassige and S. Hogbin, *Political Landscapes Two: Sacred and Secular Sites* (Owen Sound, Ontario: Tom Thompson Memorial Art Gallery, 1991).

37 Teresa S. Smith with Blake Debassige, Shirley Cheechoo, James Simon Mishibinijima, and Leland Bell, "Beyond the Woodlands: Four Manitoulin Painters Speak their Minds," *American Indian Quarterly* 18, 1 (1994), p. 4.

38 ibid., p. 5.

39 ibid., p. 13.

40 ibid., p. 15.

41 ibid., p. 17.

42 ibid., pp. 17–18.

43 ibid., pp. 17–19.

44 ibid., p. 22.

45 According to curator Janet Clark, the gallery also wanted to contextualize its collections of commoditized arts such as baskets, beadwork and quillwork, sold for over a century and a half through the tourist trade. See "Introduction," *Basket, Bead and Quill* (Thunder Bay, Ontario: Thunder Bay Art Gallery, 1995), p. 5.

46 Artist's statement, ibid., p. 32.

47 "Basket, Bead and Quill, and the Making of 'Traditional' Art," ibid., p. 6.

48 ibid., p. 17.

49 ibid., p. 17.

50 ibid., p. 17.

51 See "Representing Culture: The Production of Discourse(s) for Aboriginal Acrylic Paintings," in Marcus and Myers, *Traffic in Culture*, pp. 55–95.

Chapter seven

Charlotte Townsend-Gault

Hot Dogs, a Ball Gown, Adobe, and Words
The Modes and Materials of Identity

Is the contemporary art of the Northwest Coast great art in the present, or is it the relic of a great past, a hidebound tradition with a contaminated present? Is "art" a colonizer's term, a restriction and distortion of the cultural expressions of the past which fails to do justice to the visual culture of the present? Or has the conflict between aboriginal and Euro-American aesthetics been both productive and extending? Can such matters, which are about a kind of power, be separated from Native identity politics or the politics of land, rights, and sovereignty, without coming adrift in the postmodern flux? The situation on the Northwest Coast in the 1990s poses such questions pointedly, but they apply equally elsewhere.

By way of answers, the artists discussed here are moving their ideas out from under the sheltering rhetoric of special (read ethnic) pleading where it would be forever marginalized in a discursive vacuum. Ransacking hybrid pedigrees and skewering the conflict of epistemologies, these artists variously and knowingly, for different audiences, show in their work the purposes that are revealed by many other Native artists since the mid-1980s: to remember, to condemn, to overturn, to instruct, to translate across cultural boundaries, and yet to withhold translation, to make beautiful things, according to various ideas of beauty, and, sometimes, riotously and discomfitingly, to entertain.

An urban legend of sorts, which the protagonists have allowed me to relay, shows how some of this plays out on the Northwest Coast now. Late one summer afternoon in 1983 the Coast Salish artist Lawrence Paul Yuxweluptun, just out of art school, went to visit his old friend the Kwakwaka'wakw[1] carver Beau Dick in his studio in the Gas Town district of Vancouver. "There was Beau and a bunch of Kwakiutls carving away at a chunk of cedar, passing it around, taking turns working at it. They had beer and some dope and hotdogs. I asked what they were up to: 'We're hot-dogging it,' Beau told me." It was at that moment that Yuxweluptun got the idea

for a drawing that would make a few points that he thought were blindingly obvious but nearly always overlooked.

The carvers' plan was to sell the mask, a Dzonokwa,[2] the result of their collective efforts. This they did later that afternoon without difficulty to a well known purveyor of Native art in Gas Town, raising $79 for a night out. Meanwhile Yuxweluptun whipped out the sketchbook and pencil he habitually carried and drew one of the hot dogs. This was to flaunt a bit, in the mutual admiration/provocation society between Dick and himself, the fact that *he* was no carver – carvers being trapped in the "3 D-ism of a moribund tradition," stuck with a genre unamenable to the realities of beer and hot dogs, their uses and abuses. "You can't carve a beer bottle on a totem pole", he often says, "but you *can* paint one." This he did in *Alcoholics on the Reservation* (1988) and *Throwing Their Culture Away* (1988).[3] From the point of view of some carvers Yuxwelptun's two-dimensionality diverges dangerously from tradition, perhaps even betrays it. His large, vivid canvases blend Salvador Dali with pop, Odilon Redon with comic strip, a mannered kitsch with pastoral, to show the wreck of the land and the endurance of its spirit denizens. His work stretches elements of a generic Northwest Coast style further than they have been stretched before. All of this comes into the story. "It's a pretty good legend, the legend of the hot dog," he said to me. "You can use it if you want."

Switching heuristic devices from the legendary to the semiotic – for it is a characteristic of the discourse that there are markedly different ways of thinking about the art of the Northwest Coast in currency – the episode encodes a number of the central issues of cultural expression in contemporary British Columbia: tradition, revival, authenticity, hybridity, and commercialization. By setting these issues in real time, and a real place, the story is intended not to deflate their seriousness, but to show that the aboriginal inhabitants of the Northwest Coast are not trapped in some supernatural time warp, the impression obtained from what might be called the "breathless awe" approach. That assimilation is the enemy is agreed upon by artists as different as Dick, Yuxweluptun, and the Haida artist Robert Davidson, as is the fact that it is best resisted by maintaining a defining tradition, or by showing that the tradition is un-constraining. In their arguments neither the carvers, nor Yuxweluptun in his choice of subject, are in thrall to the purity commissars.

The Northwest Coast is distinguished from the rest of Canada by the relative lateness of contact with Europe, its cultures flourishing after many others in the eastern part of the continent had been decimated or even exterminated.[4] The treaties, which have left a legacy of unsatisfactory settlement across the country, were, with a few exceptions, not concluded in British Columbia. The province encompasses the ancestral lands of some 200,000 people or about 5 percent of the population; until 1991 it had not, exceptionally in Canada, recognized claims to aboriginal title. One of the results is that the current land claims settlement process provides a focus, if not a consensus, for negotiating the future: employment, education, language, and resource management. The situation is complicated by the ecologically troubling history of resource extraction and land management in the province, where logging, mining, and the damming of rivers have paid little regard to the environment. Historical deception, contemporary bureaucracy, and environmental devastation have given Yuxweluptun his subject: a clash of ideologies and of social and spiritual goals, in wild and surreal intermingling. One such is the fiercely laconic *Leaving my Reservation and Going to Ottawa* (1986), in which a depleted Native figure carrying a brief-case makes off across a landscape of hanging files to the nation's capital of bureaucracy.

The drawing of the thoroughly assimilated food item that is central to the legend, shows that a hot dog is amenable to the formline, ovoid, and U-form (the basic components of all Northwest

Coast styles) just as an eagle's eye, a bear's ear, or the blowhole of a killer whale can be. Yuxweluptun uses a "traditional" mode, preserving culturally distinguishing signs, to prove that "a wiener in an Indian hand is an *Indian* hot dog. Hot dogs are food on the reserves. We do our food hunting in the supermarkets now, the same as everyone else."[5] Needling away at the variants of ignorance about Native people and Native art, his irony savors the sentimental banality of an often desperate situation, which also happens to be a significant aspect of his paintings.

The delicately rendered drawing led to a large painting (*Haida Hotdog*, 1984, 66" × 111") in which the hot dog is as gross and intrusive as a Tom Wesselman nude, and just as detached. "Pop art had been internationalized. I culturalized it," Yuxweluptun has remarked. Since he has also inherited a white culture in the ice hockey he learnt growing up as an "urban Indian," he helped himself to their art history as Barnett Newman and Jackson Pollock had helped themselves to his. The surrealist mode, which disrupted any idea that there was a simple or obvious relationship between art and life, had a close affinity with both the methods and results of early twentieth-century ethnography; they exchanged discoveries.[6] Both surrealism and ethnography depended heavily on artifacts and epiphanies gained from "primitive" societies. The process of taking (some of this) back and, in his turn, appropriating their style to do so, has given Yuxweluptun his manner, for example *Oil Spill USA* (1986), *Native Winter Snowfall* (1987) with its reference to an essentialized Group of Seven landscape, or *The Universe is So Big, the White Man Keeps Me on My Reservation* (1987).[7] His work brings out the productive, defining relationship between aboriginality and modernism that has largely been obscured in this region by decades of ignorance and prejudice.[8]

The argument, commonly attributed to anthropologists, but in fact made in many quarters, that if Native artists abandon tradition they loose their identity, even betray it, raises the question of what "tradition" is, and, by consigning their cultures to a past seems to overlook its present. Yuxweluptun likes to point to what he calls "the loophole in the Indian Act"[9]: the silence of that patronizing and paternalistic piece of legislation which has determined what Indians can and cannot do since it was first enacted in 1871, but which appears to have overlooked its artists, its self-representation. Having taken on the idea of art as a route to personal freedom and a source of power, he can produce a painting of religio-political enormity such as *Scorched Earth, Clear-cut Logging on Native Sovereign Lands, Shaman Coming to Fix* (1991, Plate I). Likewise, in *Protector* (1990) he re-casts ancient animist beliefs in the light of a belief in salvation. Part of the solution must necessarily be political, but not all of it can be. In the mythologies of coastal people it is clear that humans are not the main protagonists in the drama of life and that humans do not necessarily always triumph over other living beings. The theme of transformation between the human realm and that of animals and spirits tells of an imaginative closeness between species based on an understanding of the absolute dependence of the human species on the others. This relationship is at the basis of the rights in the land that Canada's First Nations claim, as they always have claimed, despite other arrangements of a sophistry and duplicity that only colonizing self-interests could devise. As a chief expressed it during the Gitksan/Wetsuweten land claim hearings:

> For us the ownership of territory is a marriage of the Chief and the land. Each chief has an ancestor who encountered and acknowledged the life of the land. From such encounters came power. The land, the animals and the people all have spirit — they all must be shown respect. This is the basis of our law.[10]

Now, in many of Yuxweluptun's paintings, the sun sheds molten tears over the barren land. In his virtual reality work, *Inherent Rights, Vision Rights* (1991–2) it is the moon that weeps over the longhouse. Whether such works represent a knowing use of some hybrid tropes in a desperate wake-up call, a cartoon apocalypse, or the last gasp of a worldview that encompassed the spirits, is up to his audiences to determine. Or is it? Are we to assume that Yuxweluptun is enervated by the same cynical fatalism that the Western intellectual tradition has produced as a response to international monopoly capitalism, under which sensitivity to local conditions is not on the agenda? But whose words are those, anyway, for what is happening? Yuxweluptun insists on a difference which implies a solution, or, as he says, "salvation," a term from which cynicism turns. The open question is whether he can blend genres with this eclecticism (which habitually carries with it the possibility of open-ended, new, or recombinant meanings) and still hope to determine readings and command moral imperatives. In this he is standing against a widely accepted idea of a postmodernism that blends Jean-François Lyotard and Jean Baudrillard.[11] It is supplemented in Vancouver by the influence of the Frankfurt School, which can be brutally synopsized as maintaining that the function of art is to have none. For Yuxweluptun the assertion of a function for his work is the ultimate weapon in his fight against assimilation, and remains constant through the fluctuations of aesthetic and intellectual fashion.

The legend of the hot dog continues: the squirts of ketchup have been read as the islands of Haida Gwaii; this was not intended by the artist, who has titled the drawing *Haida Hotdog*, but is accepted as accretion to the legend. It was also read as a provocation towards the carvers, the Haida artist Robert Davidson in particular, a man who is devoting his life and talents to the revival of the time-sanctioned style of his ancestors, thus proving their vitality as well as their endurance. The legend tells therefore of the disputes within the community of Native artists and amongst its observers and self-appointed guides – disputes between falling under the influences that might be encountered at art school, and accepting as part of the deal influences such as hot dogs, which are unavoidable if you don't want to live your life in an "Indian morgue." This is Yuxweluptun's term for museums. It is the diaspora of aboriginal Northwest Coast material – the uprooted poles, masks, and weavings – most of it to museums in Europe and the United States, that has given the art of the region its great réclame elsewhere, being variously re-articulated by the Surrealists, by Lévi-Strauss, Newman, Pollock, and others.[12]

For Davidson, however, museums have been essential sources. When he began to research seriously the history of the styles that he was learning from his father and uncle, he discovered, to his dismay, that in his home community of Massett, on Haida Gwaii, only two carved boxes remained. When his grandmother wanted to demonstrate what she remembered of a masked dance from her childhood she had to improvise, putting a brown paper bag, with holes cut out for the eyes, over her head. The indignity of history obscured by the conversion of most of his grandparents' generation to Christianity, sent Davidson to the museums – Haida treasuries for him – to pore over the *Gajiit*, dogfish, frog, and above all the eagle. The artist Bill Reid, who had already done much to discover his own Haida heritage, was important to Davidson at this time. He also learned from the scholar Bill Holm whose research unlocked the logic of the formline, ovoid and U-form, in his *Northwest Coast Indian Art: An Analysis of Form*.[13] Although the book is not uncontroversial, for Holm is non-Native and concern over cultural appropriation became inseparable from the identity politics of the 1980s, it is described by Davidson as a "Bible." It amounted to the technical grammar of a visual language, guiding him in the trial and error through which any language student must go. It confirmed the idea of Franz Boas, ethnographer of the Kwakiutl, and widely dispersed through his

Primitive Art,[14] that Northwest Coast art should be thought of as being determined by its "rules." When Holm's study first appeared it played a vital part in rescuing the art from the perception of a kind of crude arbitrariness, the visual correlative of the racial prejudice all too common in the non-Native population at the time, which prevented it from being taken seriously. But it has also helped to reduce the visual expression of the cultures to a design style. Comparable laws govern, for example, the design of Greek vases and their visual periodicities, and the French anthropologist Claude Lévi-Strauss famously claimed that the art of the Northwest Coast should be considered alongside the art of classical Greece.[15] Indeed it was the idea of rules that made the Northwest Coast prone to structuralist analysis, as exemplified in Lévi-Strauss's *La Voie des masques* (1975).[16] It has been an important part of Davidson's project to re-articulate a relationship with an ancient set of rules.

Changing intellectual fashion and new evidence based on the use of infrared photography[17] are beginning to rewrite the idea of rules, which now tend to be seen, by some at least, as inhibiting rather than legitimating the creativity of the tradition. Davidson himself has pushed the language very far in his works on paper; they include the large acrylic and gouache *Every Year the Salmon Come Back* (1983), *Rock Scallops* (1988), and *Portrait of an Eagle Transforming* (1988–9). The viewer's attention is forced to turn to new compositional issues provided by the two-dimensional rectangle or square, the framing edge, and the new relationships of forms and scale that they create.

Referring to a demonstrable ability to adapt to new ways and new materials, many First Nations artists have articulated the notion that "our tradition is to innovate." The often cited example is the imaginative extension of the woodworking tradition made possible with the arrival on the coast in the nineteenth century of metal tools and commercially available paint. With a work such as *Nanasimget and the Killer Whale* (1987) (Plate 29) Davidson positions himself as heir to this tradition of innovation. It is a narrative sculpture telling the Haida legend of a wife captured by a killer whale. Liberated from the familiar formats of screen, pole, or staff, the emblematic characters of Nanasimget's story – a dorsal fin with hands and eyes locked in struggle around it – determine the forms. Sculpture would be an appropriate term now that the informing criteria are its own elements and not the demands of a given form.

The line of carvers, though stretched perilously thin, never broke. Davidson, whose own son is now one of his apprentices, was taught to carve by his father and uncle who handed down what they had learned from their grandfather, the revered artist Tahaygen (Charles Edenshaw). He is amongst those who have given the lie to that version of events which suggests that this remnant population could only be doomed to assimilation and their culture to extinction. There is no reason to suppose that other great carvers of the past were in their day any more anonymous than Davidson is in his. Only a tragic but not total loss of memory stands between them and their successors.

In 1969, when he was 23, Davidson was responsible for the first pole to have been raised in Massett in fifty years, and in 1977 for a longhouse with an immense carved facade in memory of Tahaygen. Most commissions inevitably come from outside his community: the Pepsico Sculpture Park in New York, for example, or the talking stick he made for Pope John Paul II. While each of these works mark a stage in his personal development as an artist in the Western sense, they also show him fulfilling another role, in which art is the opposite of functionless: marking the resurgence of a community, memorializing an ancestor, broadcasting to the world that the Haida are here.

With poles by First Nations carvers in public parks, shopping malls, and office buildings there is inevitable tension between this communicating function and the tendency, more recent in British

Plate 29 Robert Davidson, *Nanasimget and the Killer Whale* **(1987), red cedar and acrylic, height 6' 2",
private collection. Photo by Ulli Steltzer**

Columbia than elsewhere, of government and business to take up the signs of aboriginality to give themselves a history. Both aspects were in evidence at the Commonwealth Games in Victoria in 1994 in which many First Nations people contributed to a spectacular display, in arenas and harbor, of Native culture. Edgar Heap of Birds pointed to this tendency as an appropriative habit of colonizers in his 1989 screenprint,

WE DON'T WANT INDIANS
JUST THEIR NAMES
MASCOTS
MACHINES
CITIES
PRODUCTS
BUILDINGS

(*Telling Many Magpies, Telling Black Wolf, Telling Hachivi*, 1989)

And yet something has changed since the days when all Natives in the province were slurred as "siwash," the trader's patois term derived from the French *sauvages*. The Musqueam, on whose land Vancouver's new International Airport terminal stands, are partners in the design of its passenger areas, which also contain important new work by their artists. At a time when no individual culture can expect to maintain an exclusive signifying system, is the wide availability of Native designs to be written off entirely as appropriative commercialization and trivialization? What kind of price is there to pay for the increasing market demand for Native production? These are matters being negotiated by all Northwest Coast artists.

If the wide aesthetic distance between Davidson and Yuxweluptun does not show a serious rift between First Nations artists, it does show up the folly of thinking of Native art as anything cohesive. Oral histories and the history of colonial oppression; the recovery of ancient cosmologies and new technologies; cultural and economic degradation and resistance and recovery – if these are dialectical opposites, the art is often to be found in their critical synthesis, in which the histories of various visual cultures are also brought together and turned inside out. If there is a link between the very disparate work discussed here, it is the declared relevance of the land to the ways in which the artists situate themselves.[18] "Globalization," which makes them colleagues in a contemporary world, and puts their work in conversation, cannot take that away. It takes various forms: for Rebecca Belmore there is the defining principle "we are of this land"; Carl Beam refers to his latest work, his adobe house, as "living in Mother Earth"; Jimmie Durham's fury at the abomination of the flooding of Echota and the ancient Cherokee lands, fuels the bitter, untranslatable irony of his work; Edgar Heap of Birds recognizes an aboriginal connection between the red earth of central Oklahoma and the red earth of Australia. However, an understanding of the land, and then how to get to its meaning through art, could equally be inverted: an understanding of the modes and power of art and how to use it to position ways of knowing that are informed on some level by the land. Native people do not have a monopoly over the way that land is articulated, since they are also part of a society that inherits the earth of Gustav Mahler, William Wordsworth or Jean François Millet, of Salvador Dali, Georgia O'Keefe, and Edward Weston.

Like many of her generation Rebecca Belmore perceives herself as caught between the culture of her Anishinabe-speaking[19] grandmother, with whom she is only partially able to converse, and the culture that opened up for her at the Ontario College of Art. Who her audiences are, and how they

are constituted, have always been prime issues for Belmore. She usually works in performance and site-specific installation, finding them more compatible with Native culture and audiences than a visit to the temples of art would be. Some contradictions are beyond resolution and she positions her work at the site of conflict.[20] The title of *I'm a High-tech Teepee Trauma Mama* (1988), a riotous cabaret act, performed with her sister and cousin, for the Native Student Council in the Ontario town of Thunder Bay where many Anishinabe people live, tells its own story. It followed her participation in *Twelve Angry Crinolines* (1987), a ludicrous street procession, by twelve women artists, at the time of the visit of the Duke and Duchess of York to Thunder Bay. Calling her own act *Rising to the Occasion*, Belmore was decked out in a surreal agglomeration of red velvet and beaver lodge, tin kettles and trade trinkets, worn with the hauteur and disdain proper to the artifice of a fully-fledged crinoline. Thus arrayed, Belmore was more sure of her right to be there than any Victorian grande dame in the colonies, more regal than the duchess, and, as signalled by the wired braids that waved above her head, more attuned to the cross-cultural vibes than the humiliating cliché of the Indian maiden was ever allowed to be. It has been a widely remembered performance, and the dress itself was recently acquired by the Art Gallery of Ontario.

In part, the effect of these early works depended, as she made them do, on her nativeness to get a hearing. But, in contrast with a previous generation of Ojibwa artists, whose encounter with modern art had led to the Woodland School,[21] she was not doing this through a visual style so much as through a cultural argument. In wanting to shake the categories of the exclusively constructed art world she was contributing to that counter-discourse, now worldwide in scope and consequences, that questions a dominant aesthetics because it is challenging dominant, that is, colonialist, ideologies. At the same time, Belmore knows that her own work is implicated in this aesthetic system. Arguably, the assurance of her work depends on her grasp of the protocols of the art world, which reproduces itself by overturning them. At a time when the apparent certainties against which modernism chafed have evaporated so that postmodernism appears to have grown from arbitrariness, Belmore's certainties come from being Ojibwa. She has taken ideas about making things, about Native women's anonymity, about place and the politics of paying attention, and made of them the criteria from which her art takes its meaning. It also happens to be a clever synthesis of ideas about class, gender, and anti-colonialism that have gained wide currency from the work of Pierre Bourdieu, Homi Bhabha, and Trinh Minh-ha.[22] But it declines to bludgeon the "issues."

Belmore's reach for an audience has been inseparable from her determination to find ways of giving a voice to the Anishinabe, particularly women. *Mawa-che-hitoowin: A Gathering of People for Any Purpose* (1992) grew out of this ambivalence, being both made for an art gallery, in fact Canada's National Gallery, and setting itself in opposition to an art institution's apparent detachment from the predicament of individual Native people. She had noticed that her people, especially Ojibwa women, tended to get together in the meeting rooms of country motels, dreary and alienating spaces, unconnected with their everyday lives and the problems and issues which, partly for that reason, they were there to discuss. She had persuaded eight women in her home community of Thunder Bay to lend her their favorite chair. Ranged in a circle they turned their backs on the equally irrelevant, but enabling, gallery space. They were set apart from it by a pool of warm light illuminating the specially constructed wooden floor on which they stood. This floor, the literal basis for their stories, was a telling amalgam of incised Ojibwa floral motifs and the kind of floral linoleum familiar in reservation houses. Each chair was equipped with headphones so that the gallery-going audience was brought into the circle; you could sit and listen to the voice of its owner telling her story – in many cases not easy to take – and become part of the circle.

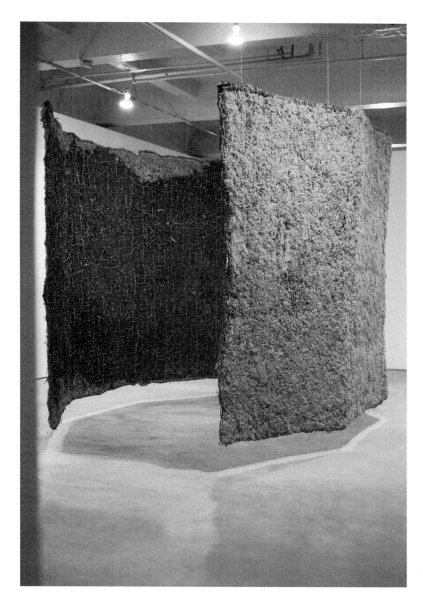

Plate 30 Rebecca Belmore, *Wana-na-wang-ong* (1994), installation made of spruce roots, lichen and sphagnum moss, 12' × 20', shown at the Contemporary Art Gallery, Vancouver. Courtesy of the artist. Photo by Michael Beynon

With land as a defining attachment, she brings to her Ojibwa idea of place an ability to incorporate sensory responsiveness to local specifics – claimed by many, exhibited by few. *Wana-na-wang-ong*, the Anishinabe name for Sioux Lookout where she played as a child, translates roughly as "beautiful" and "curve." Belmore, who enjoys playing off the perceptual structures of art historical conventions, began by trying to picture its northern Ontario landscape in Group of Seven terms. Two-dimensional, greenish-brownish rectangles, pinned to a wall, came into her mind. She felt sure she could improve on such a representation by making something "beautiful" and "curved" from the actual stuff of the land. The result, titled *Wana-na-wang-ong* (1994), was two curved tapestries of

woven spruce roots and curly vines, 12' × 20', hanging free (Plate 30). Springy, grey-green sphagnum moss had been insinuated into every space and secured by tentacles of creeping spruce used as warp and weft. The resulting dense curvature around the viewer was both uniform and endlessly varied. On the outside, the mossy pile was irresistibly tactile. Inside the two curves, eyes and nose were up against the peaty mesh of roots – the point of view of a vole or beetle. An abstraction about the qualities of a particular place, embedded in its Native name, had been given physical realization, both sensuous and tough, beyond language.

The Temple (1996) similarly made art out of the look, the sensuous apprehension, of real water, not its representation. *Temple* was a site-specific installation made for the Power Plant in Toronto in 1996, a public gallery situated where the city of Toronto meets the shore of Lake Ontario. About 1,400 clear plastic bags, the kind in which milk may be bought, were filled with water from three sources: the city's drinking water, the Don River which flows through it, and the lake. Some of the refinement and sophistication associated with a temple of art, that Western idea, was here brought to the worship of an element, and every culture's unsophisticated dependence on it. But this is a temple for the invocation of impurity. At the top of an imposing flight of stairs a telescope bored through the wall to allow a long focused view of the lake – which is, after all, dead water. *Temple* is elementally frightening, carries echoes of Robert Smithson's entropic vision, is certainly dystopian, and yet, as in everything Belmore does, there is beauty in its resolution.

Ayumee-aawach Oomama-mowan: Speaking to Their Mother (1991, Plates 22, 23) is a huge, and beautifully constructed, wooden megaphone. Since 1991 it has since been set up in several places in Canada allowing people, literally, "to address Mother Earth." The Assembly of First Nations used the megaphone as part of the formal Aboriginal People's Protest at the exclusion of their representatives from the First Ministers Conference being held in Ottawa in June, 1996. It enabled them to voice their anger at the persistence of government doublethink outside the Prime Minister's official residence during the conference dinner. Later they voiced it again near the External Affairs Building. The choice of this department of the government was determined not so much by irony as by the wish to make a historical point about the distinction between aboriginal nations and the nation called Canada. This move into an overtly political context was, for the artist, the ultimate vindication of the work. Belmore comments, "Perhaps I have moved this artwork into a different place by allowing it to enter into an official political realm. Hopefully, it insists and continues to echo: we are of this land."[23]

The hope of reforming or extending the audience for art forces the question of whether this kind of politically informed work can make a difference, either to the definition of art or to a political situation. The artist James Luna is unequivocal:

> I make work for Indian people first, because I believe that's my audience. Even though I may have a show where very few Indians come, if any Indians come at all, because that's not something the community does on a frequent basis, but I make it in a kind of way that's very simple and direct. I think that's something about Indian logic and it's for Indian people to get – not so much enjoy or like, or say, pat me on the back for – it's for Indian people to get first and then they can also say whether they like it or dislike it, or whatever. But if they get it, then I've succeeded[24]

This gives Luna's work one of its defining qualities: there is little distance between artist and work; he is reporting from the front line of his own life. "In my work, I'm not just criticizing a condition.

I am in the condition."[25] For more than a decade this has enabled him to insert himself — which is to say insert his work — into the discursive present of installation and performance art and, in doing so, to make a difference, if exposure and publicity are an indication, with deadly, timely accuracy. Luna announces himself as a "Contemporary Traditionalist Tribal Artist" and sets out to change the fact that "Native Tribal people are the least known and most incorrectly portrayed people in history, media and the arts."[26] His subjects are the too-long submerged history of his people, the tension between acknowledged debasement and evident survival, the consequent identity search, the gross misrepresentation from outside, and the self-representation from within. His performances and installations are about ignorance and type-casting and ways of understanding. By proving that it is possible to be both subversive of ways of knowing and enlightening he goes some way towards resolving the paradox of originality and aboriginality — the assumption that they are more than semantically incompatible. In *Artifact Piece* (1987, Plate J) Luna displayed himself as a "dead" cultural object, illustrating with deadly accuracy what the Haida/Tsimshian art historian Marcia Crosby has called the construction of the imaginary Indian:

> interest in First Nations people by Western civilization is not such a recent phenomenon; it dates back hundreds of years, and has been manifest in many ways: collecting and displaying "Indian" objects and collecting and displaying "Indians" as objects or human specimens, constructing pseudo-Indians in literature and the visual arts.[27]

In his performance, and subsequent video, *The Creation and Destruction of an American Indian Reservation* (1990) Luna used minimal means, a pared down semiotics and the cyclical form of Indian thought, to enact the historical changes of land use and tenure represented by the reservation. The performance suggested a form of escape from this alien imposition in as much as the reservation was shown not as a state of being but as stage in a continuing process. Luna confronts all the existential demons but comes up with compacted images that burn themselves into the brain. It seems safe to assume that his primary, Indian, audience is aware of the numbing effect of catalogues of misfortune and the purple prose of complaint. Certainly Luna avoids both. But he knows that they are part of the discourse, as is the mawkishness of the American dream of Indians found, say, in the film *Dances with Wolves* (1989), and the harangue of its countervail. Puncturing these attitudes is a large part of Luna's project and of the way he situates his art. The taunt "So you've always wanted to be an Indian?" shaped his contribution to the Whitney Biennial in 1991 (Plate 31). Entitled *Take a Picture with a Real Indian*, it challenged visitors to the exhibition to choose which life-size cut-out of the artist, which version of an Indian, they wished to be photographed beside — in street clothes, full regalia, or breech-clout. The riotous, bitter, dry-as-a-bone, irony of coyote was surely not invoked in vain.

In *History of the Luiseño: Christmas '90* (1992) Luna, alone in his home on the reservation on Christmas Eve, drinks his way through a twelve-pack of beer, a scene punctuated by short bursts of inanity from the television and rambling telephone conversations. Amongst many things, this video (made from a performance) shows Luna's refusal "to embrace the 'authentic' Indian produced by the Western science of anthropology (which) would be to adopt a Western construct — a textbook or domesticated Indian".[28] He is Luiseño, this is what he does on Christmas Eve; ergo this is the culture of the Luiseño. At a stroke, it cuts through the fatuous celebratory aspect of the current usage of the term "culture" as well as any spurious ethnographic authenticity it might have. *History of the Luiseño* also represents his own un-retouched autobiography, his to do with as he likes.

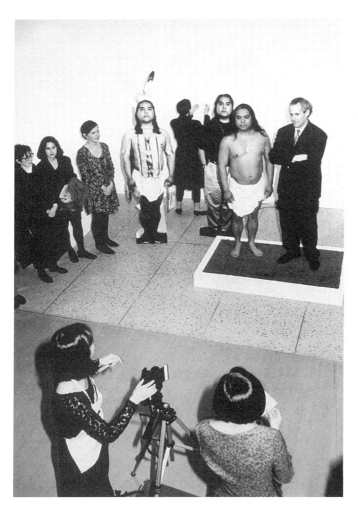

Plate 31 James Luna, *Take a Picture with a Real Indian* (1991), performance at the Whitney Museum of American Art, New York. Courtesy of James A. Luna. Photo by Sheldon Collins

The injustices of history cannot be corrected; Luna is concerned with their consequences on the economy of everyday life, its strengths and its denigration, expressed in the demotic voice. But they may be forgotten, which is what Heap of Birds tries to prevent. To that end, he borrows the demotic of advertising. Both artists have developed a plain mode of address – to be distinguished from the speculative rhetoric, derived from Foucault, Derrida *et al.*, which characterizes so much Anglo-American writing about "culture." Heap of Birds uses the mass media to make signs – assertive, declarative, obtrusive – which block the view or argue with their context. He shares strategies with artists such as Jenny Holzer, Barbara Kruger, and Alfredo Jaar to assault the scandal of national amnesia and international torpor in which all are implicated. For example, the title of *Building Minnesota* (1990, Plates 16,17) sounds heroic. It involved setting forty large metal signs, ranged like billboards along the Mississippi where it runs through downtown Minneapolis. They honored the forty Dakota men who were sentenced to death by Abraham Lincoln after the U.S.–Dakota conflict of 1862. Many choose to forget the dishonored treaties and intolerable pressuring of the aboriginal population upon which Minnesota was built. It is typical Heap of Birds strategy, delivering what he

calls "insurgent messages for America." In 1990, buses in San Jose, California carried his posters that proclaimed in a self-evident sequence:

SYPHILIS
SMALLPOX
FORCED BAPTISMS
MISSION GIFTS
ENDING NATIVE LIVES

DAY / NIGHT (1991), the public signs he set up in Seattle, were a declaration that the many transient, intertribal people to whom the streets of Seattle are home are rather more important than the travestied Native signs that adorn American sport and commerce. *Native Hosts* was a sequential signage work, displayed in 1988 in New York, in Vancouver in 1991, but apposite anywhere in North America. It reminds anyone assaulted by the public announcement style notices that "Today your host is . . . ," followed by the name of the local tribes or bands.

His grandfather, Many Magpies, died in a Florida prison where he had been incarcerated with other Cheyenne warriors for objecting to their forcible move to Oklahoma, the land at the end of what the Cherokee called the Trail of Tears. The grandson is now rooted in the land of the Concho Reserve where he is headsman in the Cheyenne Elk Warrior Society, playing an active role in its ceremonial life, which is focused on the summer solstice. As such, and as an artist, is he far away from some "center"? And if so, his position is "East of where? West of what?," as he likes to ask.

Heap of Birds is persistent. His strategy is to stay on the attack, continuing to make "insurgent art." He resists changes of fashion that might put him on the defense. And yet, "you get so upset and sad doing that everyday." Accordingly, he also paints. "Painting, the way I look at it, is a kind of triumph"[29] — a triumph over his grief, his history, and over the conventional sources of legitimation. The *Neuf* paintings, which he has been making since the early 1980s, represent the beauty of his land, but seen as a complex, optical phenomenon not as a composition. The colors of the land — rock, earth, grass, trees, bushes — are seen in passing through, as they rush by the peripheral vision. The caress of these big leafy brush-strokes has been refined over the years but since the land persists why should not the matter and manner of painting it persist too? And there is a certain logic to the repetition of the *Neuf* sequence. There are fixed places, there *are* great certainties, everything is *not* relative. Aesthetic development is not integral to the concept of these paintings; but deepening and extending an experience is. This puts two aesthetics in terminal conflict. Heap of Birds is traducing the conventions of development and originality associated with the history of painting, not to make a point about the limits of avant-gardism but to make a point about the land — its consistency, not its change.

The same applies to Heap of Birds's drawings, in which words and phrases are written in black marker on huge sheets of white paper, or built up from a mass of strokes achieved by a flick of the wrist (see Plate 32). There must be music playing and they come unpremeditated into his head. This is comparable to the Surrealist's automatic writing and the resulting juxtapositions could similarly be said to be wild and improbable, were it not the case that the history of the Cheyenne has actually been wild and improbable. To take one instance from one drawing: the conjunction between soldiers' hats and the uteruses torn from their female victims and worn as trophies: would a picture necessarily tell more than those two words, "uterine hats"? The marker drawings, as they are called, address the difficulties of language: the imposition of an alien language, the efforts to obliterate

**Plate 32 Edgar Heap of Birds, *Want* (1995), marker on rag paper, 6' 6" × 9' . Courtesy of the artist.
Photo by Deborah H. Helmick**

Native languages, the ultimate failure of translation, that naming something is not to know it fully or even to understand it. These assemblages of words confront the ultimate difficulty, or definition, of "visual" art, as expressed by Jimmie Durham: "we know things and we know in ways through art that we cannot know through what we call language." The marker drawings counter this with a kind of poetry where one word, alone or in combination with two or three others, sets up a resonance through a whole network of memory and transference. (These are processes on which recent work on consciousness has thrown some light,[30] but which remain fairly mysterious.)

Heap of Birds' work on the spectacolor light billboard pulsing above Times Square in 1982 taunted passers-by, most of whom were unlikely to understand the language of the Cheyenne, or that its word for white man is *vehoe*, spider: "*vehoe* trap you." That was the point: they didn't understand. The need, or the strategy, to withhold translation, is well illustrated in a conversation that took place in 1992 between Jimmie Durham and Jeanette Ingberman, about one of his works that incorporated a text in Cherokee:

JI Obviously a lot of people who come in to see the show won't know the meaning of the Cherokee words.

JD And I don't want them to know.

JI That doesn't matter to you?

JD What I want them to know is that they can't know that. That's what I want them to know. Here's a guy having his heart cut out with an obsidian knife and he's saying something in Cherokee and I don't want people that come into the gallery

> to know what he's saying . . . The first text is the real things, turquoise, words, gold, emeralds, obsidian and flint, the second text is the Cherokee counterpoint, and the third text is that you don't know what the Cherokee means.[31]

This withholding of translation is a variant on what Homi Bhabha has identified as "limit-text, anti-West."[32] It is a point where trans-cultural incompatibilities are not going to be negotiated any further, a position of power for one who speaks the language, who knows the secrets. Durham's assertions about cultural absolutes are complemented by the display of his own, untranslated, sculptural assemblages. His published work, much of it about language, provides a kind of text for the declaration of identity in hybridity at its most oblique and its most plausible.[33] He is a vigilant guard and critic of the way his work is translated, which is to say received. Durham's comment on Heap of Birds' way of contending with "the strict limits imposed" upon Native artists is revealing of his own: "[Heap of Birds] has examined the scene with a cold and clear eye. He has understood well the necessity of moving strategically within what is called 'career goals' participating correctly in the 'right' places and the 'right' exhibits (within the strict limits imposed upon us)."[34]

Since Durham's days as an active member of the American Indian Movement in the early 1970s his acute sense of his Cherokee identity has been imbricated with his identity as poet and artist. Neither have been allowed to settle into predictability: "People think, 'I'm going to see Jimmie Durham's work. He does socially responsible, political, Indian art.' And I want to say, 'Ha, that's not what I do. You made a mistake.' "[35] Durham's work, as writer, poet, activist, highly influential visual artist and sometimes reluctant representative of his people is full of such pre-emptive strikes.

A case in point was his response to the Indian Arts and Crafts Act of 1990, which was designed to protect and promote Native artists and craftsmen and to guard against misrepresentation.[36] The law stipulated that any Native artists exhibiting their work as Native art must be able to produce proof of their identity. Durham's opposition was expressed in another context: "I've lived all my adult life in voluntary exile from my own people, yet that can also be considered a Cherokee tradition. It is not a refusal of us, but a refusal of a situation and of imposed-from-without limits."[37] Durham was not alone in objecting that this legislated scrutinizing of identity was another instance of "imposed-from-without limits" and had other consequences: further ghettoizing or assimilating or dividing Native people amongst themselves. As for its effect on "identity," Durham, reserving the right to be perverse in the face of perversity, went public in 1993: "I am not Cherokee. I am not an American Indian. This is in concurrence with recent U.S. legislation, because I am not enrolled on any reservation or in any American Indian community."[38]

An eloquent and agile poet and polemicist, Durham constantly reminds us that words cannot nail down all the meaning; we have seen that he believes that visual art operates in a realm of its own. He knows, therefore, that it is impossible to write about visual art and yet he does so provocatively. He also knows that every piece of writing becomes inescapably an artifact of its time and place. Like other artists whose work is in some sense about the strategies of production and reception in which they themselves must engage, he is implicated in his own critique. Recent work has centered on an identification between himself and Shakespeare's Caliban, the "wild" character of *The Tempest* whose relationship with Prospero, the master of the books, articulates the encounter between the New World and Europe, as seen by the latter. It has allowed for deliberations on otherness and mimicry in which the uncertainties of identity owe something to the Europeans Franz Kafka and Italo Calvino, how they expressed the torments of the soul, as well as to the discourse on post-coloniality.

For a number of years a characteristic Durham device has been the figure made from discarded, battered materials, lashed, glued and hammered together, often surmounted with animal skulls, inlaid and painted, transformed with paint and fur, shells and nails; words may be added. He says, "I do feel an urgent need to reclaim – to make reclamation – of 'wasted' things."[39] They also make reference to the bricolage-effect of many museum displays of artifacts in which the resulting disorientation of cultural signs should not be allowed to disguise the fact that the display itself is responsible for what orientation the viewer may have. (This is closely related to the idea made manifest in Luna's *Artifact Piece*.) Neither animal nor human, each of Durham's composite figures has been invented differently, but each bears a disconcerting resemblance to the artist. A throng of these figures installed at the Institute of Contemporary Art in London in 1992, with the title "Original Re-Runs," upset art gallery protocols for a well-mannered distance between works of free-standing sculpture and between art and people. The sense of mourning and accusation and in-your-face irony was literally palpable.

Although Carl Beam's use of language and its contradictions has much in common with Durham, Luna and Heap of Birds, as titles such as *Semiotic Converts* (1989) suggest, he situates himself rather differently. "I don't need the tribal bonds. I'm not saying the tribal rituals aren't useful. They are. They help people to belong to an alienated world. There are so many forces that want a piece of your soul. But a tribal culture is only a temporary resting place."[40] Beam identifies with the idea of the artist as an individual imbued with unusual expressive powers and who resists being cast as part of a movement or an ethnic group or a trend, hence his *Self Portrait in my Christian Dior Bathing Suit* (1980). He identifies himself as Ojibwa but chooses to make work that is evidence of the interpenetrations of influences, even as its subject is frequently that of invasion and suppression. He did so long before hybridity received much attention.[41]

His technique is to retrieve photographic images, old, faded, defaced by Beam himself or by anonymous forces, and to reassemble them to bring out another way of looking at the images and thus of the history they purport to tell. Beam's critique of the post-Columbus invasion focuses on the arrogance of power. He seeks to counter it by pointing out the powers of Native ways of calculating value which were not calculations or measurements at all; hence *Burying the Ruler* (1992) and *Time Dissolve* (1992). In works that combine images and texts from multiple sources he decries the suppression of the narrative mode; the mis-perception that "information equals knowledge equals good"; grids, linear thinking, and plexiglass boxes; and the classifying, categorizing impulse of a legal system that favors property over people.

Positive points of identification for Beam's work would be his ability to think through images, his dialectical juxtapositioning of words and images, and a multiple-point perspective. The poly-morphous attributes which might characterize Beam's work as postmodern inevitably recall Robert Rauschenberg, which is not to say that his work is *like* Rauschenberg's. Douglas Crimp, distinguishing the latter's work from painting, called it "a hybrid form of printing." It had moved:

> from techniques of *production* . . . to techniques of *reproduction*. . . . And it is this move that requires us to think of Rauschenberg's art as postmodernist. Through reproductive technology postmodernist art dispenses with the aura. The fantasy of the creating subject gives way to the frank confiscation, quotation, excerptation, accumulation, and repetition of already existing images.[42]

Whether or not Crimp's confident definition of postmodernism can stand the test of time, the situation it outlines is further complicated since Beam was one of the first to recognize, if not the

hybridity of the Native person then the hybridity of Native representation. His emphasis on its very reproducibility removed it from simple postulates of authenticity and originality. He uses a range of techniques to mimic, copy, and reproduce the invasion and ruin of ways of representing the world which were also ways of being in the world. And yet, all the explicitness and passionate anger of Beam's ideas cannot counteract the looming, sombre presence of his work. It is yet another variant on the blending of didactic function with an idea of art that exists for itself alone. Deconstruction, as practiced by both artists and commentators, has tended, through querying the construction of beauty, to have had the effect of erasing it. This tends to overlook the fact that some consensus on beauty is still possible and can be politically effective.

The Columbus Project,[43] begun in 1989, is a vast meditation involving texts, installations, prints, paintings, and a 20-foot-long reconstruction of one of Columbus's boats, for which the word inchoate would not necessarily be a criticism. The boats' cargo was a slow-release and unproductive collision of epistemologies, in which the invaders laid waste a wisdom and replaced it with something that does not appear to work so well. In a deliberate attempt to reverse this situation Beam has spent the mid-1990s building in adobe. The house, adapted to the Canadian climate, was built for his family on Manitoulin Island, an Ojibwa community in northern Ontario (Plate 33). He thinks of the project as his art, architecture, and sculpture at once, calling it "living in Mother Earth." It also deals directly with the relationship between poverty, the housing debt and the thrall to middle-class, single-family, suburban dwellings that blights lives and eco systems.

The actions of the artists discussed here, for their works *are* actions, are a challenge to the legitimating powers of the institutions, media, etc. in so far as they ignore them. Thus Belmore takes

Plate 33 Carl Beam, adobe house, built mid-1990s, Manitoulin Island, Ontario. Photo by Ann Beam

her art into the political life of her community, and Beam takes his into his own life. Luna's non-Christmas *is* Luiseno culture because he is living it, and Heap of Birds has acquired the authority to make art by fiat out of an unmediated cultural exchange. Beam, much of whose important work has depended on the sanction of the defining frame of the art gallery now defies it. Part of their work is a deliberate unsettling of definitions of art and a querying of its sources of power, in order to assert some that are less familiar; this, finally, is the point of the Legend of the Hot Dog. Yuxweluptun, for instance, says that he depends on a power that is extrinsic to the work, even though he often paints its spirit emissaries. Belmore relies on art's power to communicate; Luna depends ultimately on the sanction of his own people; and Heap of Birds draws on a profound, universal sense of aboriginality – a source of power in itself. Their strategies have much in common with critical post-conceptual artists but in the end it is their history in which their cultural identity is rooted – it is not self-ascribed. As Durham has put it, "For complex reasons, modern political systems have told us that art either has no function or that its function is to support a political system. I think of art as a combination of sensual and intellectual investigations in reality. The fact that governments want to control art is certainly part of the reality that art must investigate."[44]

Identity politics is in danger of being reduced to a glib phrase; the languages used, the "talk," of both Natives and others to discuss their work, is something to which these artists are finely attuned. They have come to maturity in the understanding that art and its discourses are inseparable. The challenge to a non-Native audience is not to re-sociologize the Natives but to recognize them, their difference and the difference they make; and, since action rather than passive reaction is invited, to help ensure that they make a difference. Here is a vital contribution towards the realization that art is inseparable not just from "society" but from a symbiotic relationship with a climate of reception, with historical determinants. They have done much to reanimate a debate which, in the "Western tradition", goes back at least as far as Plato and Aristotle, as to who and what does, or should, define art and impinge on how it is judged. In doing so they have pushed that debate outside art discourse and into social, economic, political, and ethical discourses which were always an important part of its origins.

Notes

1 Kwakwaka'wakw is now the transcription of their name preferred by this First Nation. However Kwakiutl, the term through which they became best known, is still in use, as is Kwagiulth which should strictly be applied only to the members of one group of the Kwakwaka'wakw. The complexities of this orthography reflect the complexities of history and of the present and are simply reported on here.

2 An ogress who lived in the forests threatening to devour children. The mask is usually painted black with rounded red lips.

3 If this jibe implies that the three-dimensional forms associated with the Northwest Coast tradition cannot be updated it is, in one sense, inaccurate. For instance, see David Neel's masks which personify pollution, racism, and other contemporary ills, Wayne Alfred's *Christ at Gol-Go-Tha* (1988) and the pole, in Duncan on Vancouver Island, that incorporates Rick Hansen in his wheelchair. One response, that these are simply not high art, begs all the questions.

4 See for example Keith Winter, *Shananditti: The Last of the Beothuks* (Vancouver: J. J. Douglas, 1975); Ingeborg Marshall, *A History and Ethnography of the Beothuk* (Montreal: McGill-Queen's University Press, 1996).

5 And yet Yuxweluptun himself is a hunter and fisher, who has at times provided for his family with moose and deer.

6 Several of the articles collected in James Clifford's *The Predicament of Culture: Twentieth-Century Ethnography, Literature and Art* (Cambridge, MA: Harvard University Press, 1988) helped to initiate a spate of research into the relationship between surrealism and ethnography, early and late. It is particularly provocative with respect to Claude Lévi-Strauss, one of the architects of 'Northwest Coast art'.

7 The Group of Seven, painters active mainly in Ontario in the 1920s and 1930s, gave themselves the task of representing Canada to itself. Although they succeeded in providing an array of defining icons for the nation – the lone windswept tree, snowfall in the bush, rocky lake shores, and mountain peaks – their style owed more to nineteenth-century landscape conventions than to twentieth-century experiment.

8 That modernism is in an important sense dependent on "primitivism" has been widely acknowledged in international debates that were fuelled by the exhibition at the Museum of Modern Art in New York and by the accompanying catalogue *"Primitivism" in 20th Century Art: Affinity of the Tribal and Modern*, ed. William Rubin (1984). The historic reasons why this relationship might not be acknowledged so readily on the Northwest Coast are revealed by Douglas Cole in *Captured Heritage: The Scramble for Northwest Coast Artifacts* (Vancouver: Douglas and McIntyre, 1985). In *Native American Art and the New York Avant-Garde* (Austin, TX: University of Texas, 1995) W. Jackson Rushing, in insisting on the independent validity of Native art practice, is at pains to disentangle the usages of the term "primitivism" from the influences of modernism.

9 In 1884, for instance, an Amendment to the Indian Act prohibited the major Native ceremonials and to this day the Act gives the federal government control over the lives of some 1.5 million people, or roughly 5% of the population of Canada. The Indian Act applied to British Columbia Indians once the province joined confederation in 1871.

10 A Gitksan chief quoted in Peter Knudsen and David Suzuki, *Wisdom of the Elders* (Toronto: Stoddart, 1992), p. 128.

11 Lyotard's definition of postmodernism centers on its rupture with the controlling historical narratives of the Euro-American tradition; see for example Jean-François Lyotard, *The Postmodern Condition: A Report on Knowledge*, trans. Geoff Bennington (Minneapolis, MN: University of Minnesota Press, 1984). Baudrillard is cited here mainly for his deliberations on simulacra and their contribution to unsettling ideas of authenticity; see for example *Simulations*, trans. P. Foss, P. Patton, and Beitchman (New York: Semiotext(e) 1983).

12 See, for example, the discussion of Newman and Pollock in Rushing, *New York Avant-Garde*, 126–37, 169–90, and Claude Lévi-Strauss *Structural Anthropology* (New York: Basic Books, 1963) and *La Voie des Masques* (Geneva: Albert Skira, 1975).

13 Bill Holm, *Northwest Coast Indian Art: An Analysis of Form* (Seattle, WA: University of Washington Press, 1965).

14 Franz Boas, *Primitive Art* (New York: Dover, 1955).

15 Claude Lévi-Strauss, "The Art of the Northwest Coast at the American Museum of Natural History," *Gazette des Beaux-Arts* 24 (1943): 175–82.

16 Lévi-Strauss, *La Voie des Masques; The Way of the Masks*, trans. Sylvia Modelski (Seattle, WA: University of Washington Press, 1982).

17 A decade of research has resulted in a publication: Bill McLennan, Karen Duffek, and Lyle Wilson, *The Transforming Image* (Vancouver: University of British Columbia Press, forthcoming).

18 Marcia Crosby has recently posted a warning about the over-determinism of the "new" signposts of "Indianness" as they "persist in art practice; that is, as they are determined by aboriginal peoples' 'inseparability' from the representation of aboriginal leadership and land, and the conventions of authenticity, originals, and tradition. These signposts include transcendent aboriginal cultures and

seamless histories that present Indians as natural stewards of the land, and by extension, the Earth." Marcia Crosby, "Bordering Complexity," in *Nations in Urban Landscapes*, exh. cat. (Vancouver: Contemporary Art Gallery, 1996).

19 As on the Northwest Coast there are many shifts in orthography as First Nations seek more accurate ways of transcribing their names into English. Anishinabe, which may be spelled in a number of ways, is coming to replace Ojibwa, but not everywhere. Use of both terms here is meant to reflect this situation.

20 Edgar Heap of Birds has articulated something very similar: "It is my feeling that art work in the media of performance and installation offers an opportunity like no other for Indian people to express themselves without compromise in traditional art forms of ceremony, dance, oral traditions and contemporary thought. Within these (nontraditional) spaces, one can use a variety of media, such as objects, sounds, video, slides, so that there is no limit in how and what is expressed" (Edgar Heap of Birds, "Allow Me to Introduce Myself," *Canadian Theatre Review* 68 (Fall 1991).

21 The Woodlands School is the designation for a pictorial style, now widespread amongst artists from the First Nations of the Eastern Woodlands, deriving initially from the work of Norval Morrisseau and Daphne Odjig, which was itself based upon the representational codes found in pictographs, divining boards, and other expressions of the ancient cultures of the area.

22 See, for example, *Pierre Bourdieu, Distinction: A Social Critique of the Judgement of Taste*, trans. R. Nice (Cambridge: Polity Press); Homi K. Bhabha, *The Location of Culture* (London: Routledge, 1994); Trinh T. Minh-ha, *Woman, Native, Other* (Bloomington, IN: Indiana Press, 1984).

23 Personal communication, 1996.

24 *Tribal Identity: An Installation by James Luna* (Hood Museum of Art, Dartmouth College, 1995), p. 5. The installation was in place October 11 to December 24, 1995.

25 Quotation taken from the soundtrack of *Beyond Tradition*, 1990, a videotape produced by San Diego State University.

26 ibid.

27 Marcia Crosby, "The Construction of the Imaginary Indian," in *Vancouver Anthology: The Institutional Politics of Art*, ed. Stan Douglas (Vancouver: Talonbooks, 1991), p. 267.

28 Crosby, "Imaginary Indian", p. 268.

29 Quotations are taken from the soundtrack of the video *18 Songs* made with the artists of Tandanya and Boomalli, Australia, in 1995.

30 See, for example, Antonio R. Damasio, *Descartes' Error: Emotion, Reason and the Human Brain* (London: Picador, 1993).

31 Jimmie Durham in conversation with Jeannette Ingberman; see Jeannette Ingberman *et al.*, *Jimmie Durham: The Bishop's Moose and the Pinkerton Men* (New York: EXIT Art, 1989), p. 31.

32 Homi K. Bhabha, "Of Mimicry and Man: The Ambivalence of Colonial Discourse," *October* (Spring 1984).

33 See, for example, Jimmie Durham's book of poems, *Columbus Day* (San Rafael: West End Press, 1982) and a collection of his writings on art and cultural politics, *A Certain Lack of Coherence* (London: Kala Press, 1993).

34 Jimmie Durham, "A Central Margin," in Nilda Paraza *et al.* (eds) *The Decade Show* (New York: Museum of Contemporary Hispanic Art, 1990): p.168.

35 Jimmie Durham, quoted in Laura Mulvey, Dick Snauwaert, and Mark Alice Durant, *Jimmie Durham* (London: Phaidon, 1995), p. 119.

36 *Indian Arts and Crafts Act of 1990*, Public Law 101–644, 104 Stat. 4662, ct of 11/29/90.

37 From a letter from Jimmie Durham to the curators of "Land, Spirit, Power: First Nations at the National Gallery of Canada", March, 1992.

38 One version of this statement appeared in a brief letter to the editors of a leading contemporary art magazine: *Art in America* 18 (July 1993): 23. The predicament is elaborated on in *Prickly Pear Pamphlet* No. 10: Nikos Papastergiadis and Laura Turney, *On Becoming Authentic: Interview with Jimmie Durham* (Cambridge: Prickly Pear Press, 1996).

39 See Durham's letter as in n. 37.

40 Carl Beam quoted in Ian McLachlan, "Making *Mizzins* – Remaking History: The Columbus Project of Carl Beam," *Artscraft* (Summer 1990): 11.

41 A recent account of the re-articulations of aboriginality in a hybrid social setting is given by Marcia Crosby in "Lines, Lineage and Lies, or Borders, Boundaries and Bullshit," in *Nations in Urban Landscapes* (Vancouver: Contemporary Art Gallery, 1997).

42 Douglas Crimp, quoted from an earlier article in *Appropriating Appropriation* (1983) reprinted in *Theories of Contemporary Art*, ed. Richard Hertz (Englewood Cliffs, NJ: Prentice-Hall, 1985).

43 Part of the project is documented in *The Columbus Boat*, a catalog accompanying an exhibition of the same name, curated by Richard Rhodes, at the Power Plant, Toronto, in 1992.

44 Remarks culled from a text prepared by Durham at the time of the International Association of Art Critics (Stockholm 1995); quoted by permission.

Lucy R. Lippard

Independent Identities

> *Identity is a complex visitor. If it doesn't get you on race or tribalism, it will then surely get you in the gender game. . . . Identity travels in all social circles, acting unaware of the ripple effect of doubt it causes . . . possessing no knowledge or concern of and for Native etiquette. . . . Identity has no idea of a holiday, a night off, or just plain resting its feet. Identity will always tell you where to go.*
>
> Hulleah Tsinhnahjinnie[1]

For better and for worse, portraiture is at the heart of discussions about photography by and of Native people. And because self-representation is crucial to the construction of independent identity (at least in western minds), it has also been crucial to feminist art and photography since 1970. There is a conjunction here, but not a simple one. Indian women have not necessarily accepted (or been accepted by) the feminist art "mainstream" of the last twenty-five years, owing to the culture, race, and class divisions that have been the women's movement's potential nemesis. In fact, the pre-eminent Native photography critic, Theresa Harlan (Laguna/Santo Domingo/Jemez), who first raised many of the issues I pursue here, has written:

> Feminism does not preclude racism and classism. I can trace my own feelings to my experiences of being ignored during discussions by women who identified them-selves as feminists and who, as an afterthought, would turn to me for "the indigenous woman's perspective."[2]

And Hulleah Tsinhnahjinnie (Creek/Seminole/Navajo), along the same lines, wrote:

> While my mother and aunt were cleaning the houses of white women they [white women] were developing their theories of feminism . . .[3]

The belief and value systems of mainstream feminism and Native feminisms are different enough to throw coalitions off course. Most Native women will say they are Native first and feminists (if at all), second. The same goes for Native artists who are "two-spirited" or lesbian – a word very rarely used in Native contexts even by those women who are clearly out and confident of their community status. (The term "two-spirited" is preferred because it defines a concept that has been in the cultures all along; there is no such internal word for feminism, although there have, of course, always been strong Native women who have resisted domination by men.) All of this is not so much a matter of language, or semantics, as of lived experience – itself a bulwark of feminist art.

The uneasy encounter with feminism is informed by the art of several Indian women photographers whose bodies of work have included self-portraiture, such as Tsinhnahjinnie, Jolene Rickard (Tuscarora), Shelley Niro (Mohawk), Rosalie Favell (Métis), Carm Little Turtle (Apache/Tarahumara), Rebecca Belmore (Ojibway), Shan Goshorn (Cherokee), and Melanie Yazzie (Navajo). But precisely because feminism is not their prime agenda, their work must be considered first in the broader context of portrait photography and its nefarious history among Native peoples.

Harlan writes that one reason photography is a convenient weapon in the struggle for what I call image independence is that it "can be readily distinguished from the Native arts documented and discussed by anthropologists, art historians and enthusiasts. . . . Native photographers can resist conventional notions about Native artists."[4] At the same time, it is a case of "out of the frying pan into the fire," because photographic conventions, while not associated with Native art, do weigh heavily on images of Native people. For those contemporary photographers who are portraying themselves, or their own people, the challenge has been to resist more than a century of visual distortion and downright lies, and to complement and build on the rare positive examples as well as absorbing what is useful from outside the culture.

> I wonder sometimes where people get their silly ideas about Indian people. I know I don't resemble the things I hear Indians are supposed to be. Of course, I'm proud of my heritage. What always seems to surprise non-Indians is that I'm interested in other things too. I like Japanese food; I like English movies. And that doesn't make me any less Indian. Actually we're lucky – we have the best of both worlds.
>
> Patty Leah Harjo (Seneca/Seminole)[5]

The historical identity of Indian women, as seen through the eyes of the paternalistic culture that has represented them for some 150 years, both resembles and differs from images of western women. Indigenous women, like their male counterparts, were seen as amoral savages and children of nature; they were idealized as "Indian princesses" and tragic "maidens" paddling their canoes bravely over waterfalls, sending their men off to battle, stoically enduring terrible hardships (like rape and mutilation by "Indian fighters"), and so on. At the same time, even in today's somewhat cleaned-up media, these Pocohontas/Sacajawea images continue to conflict with the other image of the mute (or dumb) and submissive squaw crouched in front of the tipi. Stereotypes of the Indian woman as either "spiritual warrior/goddess" or "squaw" are western-created counterparts of the madonna-or-whore syndrome. They neatly bypass most realistic modern female identities.

There are enough parallels with representations of white women to suggest a certain sisterhood, but most white feminists seem totally unaware of where these similarities stop, of the diversity and complexity of Native women's experiences in all their varied cultures and geographical

circumstances of contact and conquest. Very few Indian women are included in the new array of women's art exhibitions that are commemorating the 1970s in the 1990s. Harlan says she "can't help but groan," thinking about how the popular images of Native women

> will invalidate a Native woman who does not seem so "spiritual" or "goddesslike" and how it plays into the operator's hand. But I must also laugh, thinking of anyone calling one of my older female relatives a "goddess" and knowing what their quick response would be.[6]

Most Native women artists today are mixed-bloods on one level or another: mixed with Europeans, or African Americans, hispanos, or other tribes. Mixed seems a feeble term for their difficult lives as artists, perhaps students, wives, mothers, and wage earners, in cities, universities, small towns on and off the reservation (or all of the above), with poverty and racism often howling at the door. It is no accident that updating the roles of Indian women in contemporary everyday life vies with historical correction as the most popular subject matter for these photographers, many of whom are building independent identities while trying to maintain communal bonds.

Because contemporary Indian life has to include daily resistance to the imagined Indian that seeps from the past into the present, historical images are frequently incorporated into the art. A good deal of attention is paid to living relatives and female ancestors – some of whom are known personally, others only through stories and oral histories. There are of course few self-portraits by the foremothers themselves. Even if they had had the camera and the means, they would probably not have been motivated to portray themselves. Native photographic self-portraits of either gender were rare until relatively recently, perhaps even culturally inconceivable before extreme circumstances encouraged this self-inflicted invasion of privacy. When Washoe basket-maker Sarah Jim Mayo included a portrait of herself and her father on a basket presented to Woodrow Wilson as part of a land rights case, such "claims to superior status within the egalitarian Washoe tribe" brought her only ostracism by other women, who called her a witch.[7]

By including their foremothers in their art today, Indian women photographers are replacing an absence with a presence. When Jolene Rickard was asked to write an essay on a historical photograph, she chose one of her great-grandmother selling beadwork in a bark booth at the New York State Fair in the 1940s. But rather than reproduce the image as she had received it – a hand-me-down from the dominant culture that had framed Florence Nellie Jones Chew according to its own preconceptions – she made her own montage (*The Bird That Carries Language Back to Another*) (Plate 34). Recasting the portrait in a more respectful context, she brought her great-grandmother's face to the foreground, emphasized equally in scale with the beaded bird she had created. Not just a bit of tourist frippery, the beadwork constitutes a meaningful message for the Tuscarora: it is "an island of memory in the fog. . . . In joining the beaded bird with berries and my great grandma Flossie, I show how the berries feed the birds, the beads feed me and all the Ska ru re who walk the path of the 'good mind.' Cultures that adapt survive."

"I felt the need to put myself in the image," said Rickard, "but isn't that what all artists do?" Yes. But here the self is in the image symbolically rather than pictorially, as heir to her great-grandmother and to the bird's message. Rickard uses historical images to "reconstruct reality," attributing the decline of women's power and authority in the matriarchal Iroquois nations to "pressure from nationalistic governments, surrounding our communities since the 1700s, demanding patriarch-to-patriarch relationships."[8]

Plate 34 Jolene Rickard, *The Bird that Carries Language back to Another* (1992), silver print,
17" × 11"

Harlan contends that "Native women photographers' use of self-imagery and images of women goes beyond the reversal or deconstruction of Native American portraiture as practiced by early and contemporary non-Native pictorialists" because their references are "rooted in their communities to construct the context for their work."[9] The context is one that has traditionally dismissed western views of genius in favor of the contributions of individuals to a communal enterprise. So far, Native Women artists appear to have been less easily seduced into the rugged individualism mold. They perceive the self-portrait as a matter of humility – questioning or gently mocking oneself before (or rather than) confronting the general culture.

This question of "individualism" in Native American art is seldom addressed except in the context of signed and unsigned pottery. (What we now call art was once seen as a mnemonic or narrative device; the first self-portraits were pictographs: hand prints on rock walls that asserted individual presence within the larger spiritual powers of place.) At the same time, Indian communities are changing and individualism is becoming more and more "normal." Some are dismayed to see old values disappearing; others are resigned. Ideally, Native people can be placed squarely in the present shared by everyone else in this country, but without giving up their pasts. As Santa Clara Pueblo scholar Rina Swentzell put it,

> How does one talk about the community when it's all moving so fast? The older way of seeing community is seeing people as integrally connected. That's why the word Art never came up. Because in a basic way everybody was connected to what the group needed in order to survive.[10]

It was pointed out to me that today men, women, *and* families indulge in a good deal of individualism and competition when it comes to creating regalia for ceremonies or pow-wows; but once the action is underway, what Shelley Niro calls "the circle effect" takes over: "you belong to a group, you don't mind not being an individual."[11]

Context is important to the artists themselves but perhaps even more so to their Native audiences. Familiarity, like an accessible face, can be a bridge between the home and alien ways of seeing. For outsiders looking at these women's works, the context is usually out of reach, and while that could be said of any audience for any "personal" artwork, it is more deeply inherent in the labyrinth of images of and by Indians than in most other areas, simply (again) because of the history. Most contemporary artists blithely dismiss history; Native artists must confront and correct it.

Imagined, disguised, and downright faked portraits of Indian people in the nineteenth and well into the twentieth centuries were the staples of anthropological, "historical," and documentary photography, and often used as weapons against the very "Indianness" they claimed to portray. Yet after all the valuable criticism is said and done, the faces of the people cannot be rejected out of hand because of their dubious origins. Let us not fall into the trap that postmodernism has set for us – of disregarding and even disavowing the elusive issues of human emotion, motivation, conflict, and contradiction. There is considerable dignity and resistance in many nineteenth-century pictures which must not be mistaken for dimestore "nobility" and torn away with the colonial packaging.

The only defense the turn-of-the-century sitter had against misrepresentation (aside from outright refusal) was the expression on her or his face. A certain amount of stiffness and impassivity can be attributed to the long exposures, but I wonder if some of the "stoic" look, the "passive squaw" and "stone-faced chief" clichés were not voluntary defenses against yet another intrusion. Perhaps these were the best weapons at hand, in those days when the ultimate weapon – the camera – was

always in "other" hands. The Native subjects could not, after all, just stick their tongues out. Rudeness in Native cultures is (ideally) confined to the arena of clowning and humor, which could and can be brutally honest; neither was understood or tolerated by most white people, especially missionaries, teachers, and government agents. Writer and photographer Rick Hill (Tuscarora) says that in any case, Native people believed all along that their own image of themselves was what mattered, "that their traditional values and identity were more important than anything else."[12]

Hulleah Tsinhnahjinnie often does stick her tongue out. In a 1994 installation called *Photographic Memoirs of an Aboriginal Savant* – fifteen images with texts on general issues such as education, borders, land, stereotypes – she pulls no punches.[13] Several components include portraits of the artist, beginning in early childhood and ending with a facedown in which the "aboriginal savant," in "a moment of reflection," narrow-eyed and wearing a shirt and tie that is an oblique reference both to gender and to photographs of Ishi, says unequivocally: "Don't Fuck with Me!" (Plates 35, 36).

Tsinhnahjinnie, who was raised on and around the Diné (Navajo) nation, started out as a painter (her father is the well-known Andrew Tsinajinnie). She attended the Institute of American Indian

**Plate 35 Hulleah Tsinhnahjinnie,
"A moment of reflection," 14" × 11", from
Photographic Memoirs of an Aboriginal Savant
(1994), an installation of images and texts**

139

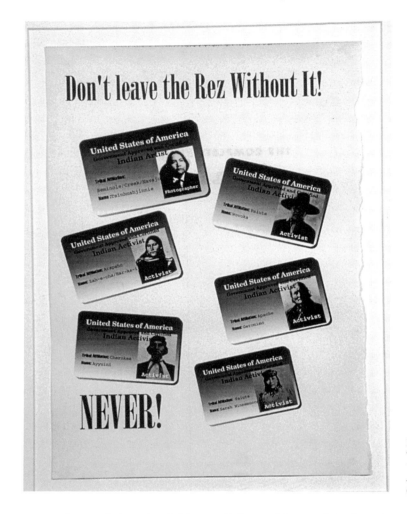

Plate 36 Hulleah Tsinhnahjinnie, "Don't leave the Rez Without It!" 14" × 11", from *Photographic Memoirs of an Aboriginal Savant* **(1994)**

Arts and then the California College of Arts and Crafts, where she turned to photography as a weapon when her aesthetic/ethnic subjectivity came under fire. Early documentary photos (the *Metropolitan Indian* series) that could be called social collages showed urban Indians in regalia on their way to ceremonies, pow-wows, or shopping malls, set against urban streets, subways, highways. She then began to work in actual photo collage, framing, for instance, portraits of Indian women and a little girl in television screens, bringing them up, as Rickard did later with her grandmother, from a helpless background to a powerful foreground.

Tsinhnahjinnie also used self-portraits in the *Senses Since Census* series, which includes a widely-reproduced triptych of unsmiling self-portraits titled and inscribed: *Would I have been a member of the Nighthawk Society or the Snake Society or would I have been a half-breed leading the whites to the full-bloods?* (Her source is the story of Eufala Harjo, a full-blood resister against the Dawes Act in the 1920s.) Across her mouth in each image is a huge press-type "tattoo" of her BIA census number, evoking a gag, concentration camp numbers, and traditional California and Pacific Islands ornament. Tsinhnahjinnie told an interviewer that the census number was "written on my inner arms and on

my forehead – so that there are no questions about authenticity."[14] The political agenda may not be obvious to non-Native people; it is a commentary on the controversial Public Law 101–644, better known as the Arts and Crafts Board Act, and its criteria for being a "real Indian." This is fused with commentary on the Dawes or General Allotment Act of 1887, when Indian people across the US lost their lands and were forced further into assimilation.

Tsinhnahjinnie considers land the prime Indian cultural issue, the ground, so to speak, in which all else grows. Her impetus is cultural nationalism rather than cultural feminism; there is no suggestion of the Mother Earth imagery that informs many white feminists' identification with a generalized nature. A series called *Oklahoma, The Unedited Version* (responses to Angie Debo's history of American Indians) includes a montage of a Native woman in buckskin dress on horseback: at the left, she looks over her shoulder to take a long hard look at a map of Oklahoma counties that bear Indian names (but did not remain homelands for Indian people); at the right, the same figure walks straight out of the television set, escaping the media to enter a more real world. In 1996, Tsinhnahjinnie was commissioned to photograph Native women leaders for *Native American Hawaiian Women of Hope*, a Bread and Roses project of District 1199 in New York. She held out for, and won, the right to portray each woman on her home ground, even when landscape did not enter into the portrait. She felt this was the only way to ensure that the subjects were themselves, in place.[15]

In 1992, three Navajo graduate students at the University of Colorado in Boulder – Melanie Yazzie, Laura Shurley Olivas, and Kenn Yazzie – also used self-portraits as a way to confirm their connections to the land and to reframe the relationship between fake and "real." Their installation – *Three Little Indians* – presented crudely touristic cut-outs of Navajos modeled on the conventional head-through-the-hole backdrop with an array of stereotypical Indian pictures. But behind this imposed facade is the place the subjects really live: translucent full-length photographic self-portraits are overlaid on the delicate tracery that is the mapped Navajo Nation, the land in which they are rooted. The backdrop is reality, the facade is fake. The landbase *is* the context.

A similar concept lies behind two self-portraits by Canadian Ojibway Rebecca Belmore. In the vertical triptych *Standing – Sleeping – Floating* (1992), she lies with eyes closed on the earth, secure between photos of a wooded landscape and a floating canoe paddle. In the 1993 *X-Mark* installation, a full-length photo panel of herself, arms folded, gazing directly at the viewer, is flanked horizontally by two taller panels of Lake Superior in winter: her landscape, but also a border. Other elements of the installation comment on treaties, official history, natural artifacts, and the incompatibility of Native and European world views, "two symbolic systems that cannot be translated into each other, two acts of naming that evoke separate worlds."[16]

Tired of explaining to the world at large that Indian space is not one place but has many views, that indigenous people are not all alike, contemporary photographers are making art with a humor and vitality that is sometimes angry, but amazingly free of bitterness. Creation of such a multicentered space from threads of cultures lost to many and almost invisible to a general public is not an easy task. The misunderstandings and misinterpretations that greet their efforts result as often from ignorance as from bias (though ignorance is a product of bias). "It's hard work to maintain the relationships to our communities when the Great White Photographers who idealize us are still welcomed with open arms," says Rickard. "Today you can't send your kids to ceremonial centers every day for their dose of Indianness."[17] So the role of image-makers is crucial to this cultural continuum, along with the contributions of elders, educators, and spiritual leaders – crucial, but not always compatible, if the artists are challenging the rhetoric and rigid academic frameworks manipulated both by whites and by some Indians.

Photography's modernist identity as a self-conscious image, and its postmodernist identity as a shifting reflection are subverted by Native photographers in favor of another set of values. In the hands of some Native artists, the picture is often valued primarily for its coded meaning for those who are familiar with the subject. For instance, Rickard took great pleasure in her work of the early 1980s – handsome documentary photographs of Tuscarora people – in painting tiny red symbols on the black and white photos. These graphics simultaneously satirize the "scientific" white view of Indians and refer to the subject's clan or name or some story unlikely to be decipherable to outsiders.

For some, like Navajo poet Suzanne Benally, photography itself remains opaque: "I've never quite appreciated photographs and have rarely taken them, even of my children. I've felt that the life we live and the stories we hear and tell are the real and imaginative substance called memory."[18] This statement resonates as a call to resistance at a time when North American society is becoming increasingly dependent on photography and its cinematic, videographic, and electronic offspring. Yet the ancient stories are being replaced by pictures; family albums replace oral histories. ("The camera is just very intimidating," observes Carm Little Turtle. "Among families, though, taking photographs was always acceptable."[19]

Two of Shan Goshorn's series of manipulated self-portraits – *Coming Into Power* and *Taken to the Water* – attempt to merge the story and the image. "Unlike many non-Natives who view lineage as a line with no connection from one end to the other," she says, "we see ourselves as belonging to a spiral, with ancestors and descendants ever winding, almost touching, illustrating the impact and relationship our generations have upon each other." In a culminating image she includes photographs of her grandmother with her mother as a baby; her mother with her sister and herself, and then herself with her stepdaughter and then with her son – a "continuum of the seventh generation."[20]

Such images of the self in context function as healing processes. They restore the power and sense of self that were almost lost during the last century. "Some Native people believed that with each photograph their souls would weaken," writes Harlan. "This fear was looked upon as the illogical belief of a backward and simple people. Yet I believe our grandmothers and grandfathers were right. The loss they sensed was very real and generations later is still felt by Native Americans today."[21] In fact, the soul-stealing concept is not only a still workable metaphor, but might be called the forerunner of all theories of "representation."

"Before the picture," says Oren Lyons (Onondaga) "the subject was free and unencumbered. After the picture, the photographer had indeed captured the identity of the person – his or her face. The photographer now had something he or she did not have before, the image and identity of another human being. At this point, the ethical question arises: What will the photographers do with the image?" At the same time, Lyons acknowledges that like most of us, he goes back to nineteenth-century pictures of his people, scrutinizing them for details: names, faces, and "the continuing relationship between land and people, the continuity of life." Writing in the context of a preface to a collection of Toba Tucker's photo-portraits of Iroquois people, he adds, "I am pleased and grateful that someone back then understood the importance of records."[22]

On the other hand, Harlan, like Vine DeLoria and others, questions our current preoccupation with historical representation of Native people:

> My question is how much can we really learn from photographs taken of Native Americans by Euro-Americans? My answer is very little. . . . The fixation of the

> Euro-American arts and photographic community on imagery created by Euro-Americans with Native American subject matter disallows and invalidates Native voices and visions. . . . The Native community must wean itself from relying on non-Native authorities and interpretations.[23]

And Rickard compares the process to "trying to see your face in a shattered mirror."[24] (Consider, too, the irony of these quotations in the context of this essay.)

This is a prime impetus for Native self-representation, and to this end, many Native women photographers see their prime audience as Native people, which is not, by definition, a feminist audience. Tsinhnahjinnie, for instance, wants to see "photography taught so that no matter for what age, be it an elder, young adult, or child, the camera becomes a part of the community. I believe we must claim the camera for our own."[25]

What, then, is the role of self-portraiture in this enterprise? It can be said generally that women of color have a very basic reason to picture themselves: nobody else is portraying them, outside of political or anthropological documentaries. Yet the Indian women who choose to portray themselves are bucking several cultural tides, like Sarah Jim Mayo. At the same time, they may be allowing themselves to be vulnerable in order to call out similar feelings, experiences, and memories in their Native sisters and by so doing to facilitate change.

Jackson Rushing recalls going through hundreds of slides of early student work from the Institute of American Indian Arts in Santa Fe and finding

> dozens of self-portraits, which have blurred, indistinct and/or fragmented facial features. Lloyd New, founding director of the IAIA, explained that these were self-portraits of young artists who knew that neither were they enfranchised as members of American society, nor were they living the reality of their ancestors (as they perceived it through representation). Realizing their marginality, relative to 'mainstream' culture, and experiencing simultaneously a sense that they were not leading *authentic* Indian lives, they portrayed themselves in a liminal identity.[26]

This split-down-the-middle, unity or dualism theme is reflected in recent self-portraits by Indian men (Jesse Couday, Joe Feddersen, Richard Ray Whitman, among others) and by some women painters, especially those who were raised outside Indian communities (Kay Miller and Kay WalkingStick, for instance). For various reasons, perhaps even including a residue of traditional modesty, Native women artists were less likely in the 1970s to put their own faces forward, to merge their identities with an emblematic Indian, than were their male colleagues. In a culture that emphasizes individual achievements within the collective good a self-portrait might have been almost unseemly.

But, interestingly, most Native women photographers present themselves more straightforwardly in the 1980s and 1990s, seeing self-portraits as a way of speaking directly to the viewer. It is a literal strategy, but an effective one that appeals to many audiences. Women artists may feel more constrained than men to "show themselves" to their viewers, to initiate, via image, more intimate relationships or, on the other hand, to form themselves within or against the dominant gendered imagery. Self-portraiture is an attractive option in this society where women, like Indians, are still used to perpetrate their own dependent images. A feminist reading recognizes in the representation of Indian people the myth of paternalist "protection" as a barrier to autonomy, the

pedestal and gutter syndrome in which those who are threatening or denigrated are placed beyond the pale – above it all or below it all.

Layered and coded approaches to communal images are the other side of the coin, a strategy to reveal only as much as the viewer can understand. Little Turtle, for example, is interested in women's rights, societal conflict, and relationships. But her figures of both men and women (some of whom represent herself) are always faceless, often shot from the waist down. Her tableaux are dramatic but ambiguous, clearly about relationships, memory, dreams, and family, yet she was never included in the 1980s rage for "tableau" or "directorial" photography, probably because she is Indian and because her set-ups were outdoors, literally outside of the expected techniques. Landscape, she remarks, is not "negative space," but a participant in her dreamlike scenes. "They're not really straight portraits," she says. "In fact, sometimes the person won't be there in the image at all, just his belongings, but it will still be a portrait."[27]

In one of Little Turtle's images, "Earthman" dances with a Raggedy Ann Doll rather than with his lover, who sits with her back turned (see Plate K). In a book on urban Indians I found a photo of a

Plate 37 Melanie Yazzie, *She Teaches Me* (1996), detail of installation 5' × 13'

child dressed up as Raggedy Ann, and she often turns up in the autobiographical works of Melanie Yazzie, who also uses family images (Plate 37) to combat stereotypes. For Yazzie, Raggedy Ann is an alter ego. She had the doll as a child and identified with it because its reddish hair resembled her own, a redder brown than that of most Navajos. She was teased and called "red ant," and recalls Raggedy Ann as "something everyone loved, and I wanted everybody to love me too."[28] Another Yazzie icon and Native stand-in is the dinosaur, a dig at the "vanishing race" syndrome, and her use of a suitcase as a component of self-portraiture reflects her education "away," in boarding school, and in Mexico, as well as the travel bug she caught later.

Even within the highly individualist contemporary art world in which Native Americans must sink or swim like everyone else, Indian self-portraits are seldom self-aggrandizing, self-important, or particularly self-conscious. In the early 1980s, for instance, the young New York artists Jolene Rickard and Jesse Couday, Tuscarora and Tlingit respectively, cut their hair in an identical "Hopi" style, took each others' photographs, and collaged them together in various ways. Their point was identification with each other as Indian people across gender and tribal identity. The double images, called *One Spirit*, are also clear examples of Native self-portraits that simultaneously reflect individualism and communalism.

At the time, Rickard was making portraits of her friends and relatives and of the land itself on the Tuscarora Reservation near Buffalo, NY (where she now lives with her Tuscarora husband and daughter, next door to her parents, down the road from his mother and her sister, and near numerous other relatives.) In a 1988 image called *Three Sisters*, Rickard places herself firmly in a traditional context with a self-portrait head, facing upwards, eyes closed as though dead or dreaming, set between two images of growing corn, her long hair echoing the curling leaves. Harlan interprets the self-portrait at the top of another work as telling us that Rickard "occupies a place of awareness and self-knowledge."[29]

In accordance with the necessity to recognize multiple knowledge systems, Rickard frequently uses multiple images in bands, combining black and white and color, for a layered effect reflecting different levels of chronology, existence, and metaphor. In 1992, to de-commemorate Columbus, she made the hard-hitting series *I See Red in '92*, including another self-portrait placed over an image of the (no longer enacted) Fireball Ceremony at Tuscarora, a drawing of a buffalo, a toy "red indian," and a white feather – "all stereotoypical commodifications of Native culture." Rickard describes this work as "placing 'us,' the original people, in the world we inherited."[30]

In another striking work from this series, the upper black and white bands picture geese flying across a dramatic sky (a reference to Sky Woman falling on the backs of fowl as she entered the world to give life to the Tuscarora), the next band has close-ups of a tree trunk accompanied by a frowning, questioning self-portrait, and below, in color, is a handsome blanket (Plate L). Rickard writes that the world began with Sky Woman, who "took her place in eternity as Grandmother Moon. . . . In 1992 I am thinking of how it will end. The disease-filled Hudson Bay blanket is just a metaphor for all the threats against the Indian way. But, we are strong and will survive as long as any human does."[31]

Shelley Niro too has given herself wings in a soaring, near-abstract 1994 series called *Flying Woman*. She is best known for her more down-to-earth self-portraits, which are fully contextualized within place and family, and at times good-humoredly mock the construction of the self. Niro was raised in the Iroquois community of Six Nations Reserve in Ontario, Canada, and lives near there now (although she has also moved around a lot, living in suburbs where she was "the only Indian in the supermarket").[32] Niro explores the social context of portraiture itself, focusing, often

humorously, on persona, clothing, pose, gesture, and expression. *This Land is Mime Land: 500 Year Itch* (1992) (Plate M) is a triptych beginning with a marvelously silly picture of herself (in her glasses) as Marilyn Monroe with a fan blowing her skirt up as she holds the camera's remote control. The second image is a snapshot of her mother in modest, self-effacing pose (quite the opposite of another delightful portrait of her mother in *The Rebel*, sprawled seductively across a red car hood). The third is Niro's "normal" self, a synthesis of the internal and external influences that have formed her own identity. The three represent "historical, personal, and contemporary." In other works in this series she is disguised as Elvis, Santa Claus, and the Statue of Liberty. Niro mocks both the originals and their inappropriate simulation by women who wannabe Monroe, guys who wannabe Elvis in "Mime Land," where outsiders (women or Indians or homosexuals) are forced into "costume" as a survival strategy, then turn it around to work for freedom and independence.

In another stereotype-bashing series called "Mohawks in Beehives," Niro again made fun of the sex kitten image as imposed on Indian women, with shots of herself and her three sisters hamming (or cheesecaking) it up against a decorative ground resembling traditional Iroquois beadwork. (*I Enjoy Being a Mohawk Girl* is the title of one of these works, and clearly she does.) In a piece called *Are You My Sister?*, Niro extends family by pairing her female relatives with portraits of women from other Native Nations, reaffirming, as Lynn A. Hill has observed, "the presence of a sisterhood as characterized in most matriarchal societies."[33]

Niro is willing to call herself a feminist (although she knows it can be turned into a dirty word and thinks maybe it should be "humanist" instead). Unaware of the "persona" works of the early 1970s by feminist artists such as Martha Wilson, Adrian Piper, and Suzanne Lacy, she has wittily and often movingly reinvented their insights in a Native context. "I use photography as a mirror to myself and also to those around me. In Native people, I see a lot of happiness and an emerging kind of confidence which glows from the inside, of warmth and love."[34] Noting, as so many women have reminded me, that Native people are "doers not sayers," Niro's work suggests another parallel with feminist aesthetics – the avowed commitment to process over product.

Where many of these artists' work is unobtrusively rooted in their home grounds (however much they may have traveled or studied internationally), Rosalie Favell's art is inspired by displacement, alienation, memory loss. As an urban Canadian Métis in Winnipeg, she comes from a very different background, with a family descended from Indians, fur traders, and settlers. One of her most poignant images is an enlarged family snapshot from her childhood titled *All I Knew About My Indian Blood*, in which she is lined up with three siblings in front of the Christmas tree; she is the one wearing a toy feather headdress (Plate N). As in many mixed-blood families, there was uneasiness about the Native background and about variations of skin color within the family; another snapshot from this series is inscribed *It Bothered Me That My Skin Was So Different From Mom's*, and another: *I Tried To Scrub My Tan Off*.

Favell grew up "a culturally invisible person" because they "didn't talk about" her father's Indian blood. (On top of this he was one of the "country born" and therefore communityless Métis who had no government-appointed status.) As an artist, she returned to her family photo albums as the raw material for a "visual search and rescue mission,"[35] exploring her family tree in Manitoba as well as her own history as a woman who loved women from an early age. Another snapshot series tells the painful story of a broken love affair with a Cree woman in which, as the photographer, Favell herself is significantly invisible. The irony in her work is that she has appropriated the images of a childhood in which her Indianness was submerged in order to bring her identity back to the surface.

Contemporary Native photographers are, as Harlan has written, "message carriers" from one world to another. But the process cannot stop with transmission. As Gayatri Spivak and others have said, people must not only be able to speak, but they must be listened to, heard, and understood as well. No new art is truly addressed (especially by an antithetical system) until a context, or discourse, is created around and within it. (This is where I hope we outsiders have a role; we can collaborate with Native women to create unbiased contexts where more equal interactions can take place.) The challenge for non-Native viewers, writes Harlan, is to become informed. "The 'you are here' spot on the map has shifted suddenly to a new and unknown location."[36]

Notes

1 Hulleah Tsinhnahjinnie, in *Image and Self in Contemporary Native American Photoart* (Hanover, NH: Dartmouth College, Hood Museum of Art, 1995), p. 14.

2 Theresa Harlan, "As In Her Vision: Native American Women Photographers," in *Reframings: New American Feminist Photographers*, Diane Neumaier (ed.) (Philadelphia, PA: Temple University Press, 1995), p. 114.

3 Tsinhnahjinnie, quoted by Harlan, in "As In Her Vision," p. 114.

4 Harlan, *Reframings*, p. 123.

5 Pattie Leah Harjo, quoted in *Moccasins on Pavement: The Urban Indian Experience, a Denver Portrait* (Denver, CO: Museum of Natural History, 1978), p. 44.

6 Harlan, *Reframings*, p. 123.

7 Marvin Cohodas, "Washoe Innovators and Their Patrons," in Edwin L. Wade (ed.) *The Arts of the North American Indian: Native Traditions in Evolution* (New York and Tulsa, OK: Hudson Hills Press and Philbrook Art Center, 1986), p. 211.

8 Jolene Rickard, "Cew Ete Haw I Tih: The Bird that Carries Language back to Another," in Lucy R. Lippard (ed.) *Partial Recall: Photographs of Native North Americans* (New York: The New Press, 1992), pp. 109–10.

9 Harlan, *Reframings*, p. 114.

10 Rina Swentzell, original manuscript version of "In and Out of the Swirl: A Conversation on Community, Art and Life," by Lucy R. Lippard and Rina Swentzell in *Parallaxis* (Santa Fe, NM: Western States Arts Federation, 1996), p. 14.

11 Shelley Niro, in *The Female Imaginary* (Kingston, Ont.: Agnes Etherington Art Centre, Queen's University, 1995), p. 19.

12 Rick Hill, [Statement], *Exposure*, Fall 1993, p. 25.

13 Hulleah Tsinhnahjinnie, *Photographic Memoirs of an Aboriginal Savant* (Davis, CA: C.N. Gorman Museum, 1994), n.p.

14 Hulleah Tsinhnahjinnie, "Direction of New Work," in *Minus/Plus* (Buffalo, NY: CEPA, Fall 1991), p. 12.

15 Tsinhnahjinnie, in conversation with the author, 1997.

16 Rebecca Belmore paraphrased by Coco Fusco, in *Make Yourself at Home: Race, Ethnicity and the American Family* (Atlanta, GA: Atlanta College of Art Gallery, 1995), n.p.

17 Rickard, in conversation with the author, 1996.

18 Suzanne Benally, "Women Who Walk Across Time," in Lippard, *Partial Recall*, p. 103.

19 Carm Little Turtle, in Lawrence Abbott (ed.) *I Stand in the Center of the Good: Interviews with Contemporary Native American Artists* (Lincoln, NE: University of Nebraska Press, 1994), p. 140.

20 Shan Goshorn, quoted in Theresa Harlan, "A Curator's Perspective: Native Photographers Creating a Visual Native American History," *Exposure* (Fall, 1993), p. 17.

21 Harlan, "Curator's Perspective," p. 14.

22 Oren Lyons, "Ethics and Images," in *Hodinonshonni: The Onondaga Nation, Portraits of the Firekeepers by Toba Pato Tucker* (Syracuse, NY: Everson Museum of Art, 1994), pp. 5, 6.

23 Harlan, "Curator's Perspective," p. 15.

24 Jolene Rickard, "Guest Essay," *Native Peoples* (April–June 1996), p. 5.

25 Tsinhnahjinnie, [Statement], *Exposure*, Fall 1993, p. 28.

26 W. Jackson Rushing, "Authenticity and Subjectivity in Post-war Painting: Concerning Hererra, Scholder, and Cannon," in Margaret Archuleta and Rennard Strickland (eds) *Shared Visions* (New York: The New Press, 1991), p. 17.

27 Little Turtle, in Abbott, *I Stand*, p. 140.

28 Melanie Yazzie, in conversation with the author, 1996.

29 Harlan, *Reframings*, p. 117.

30 Rickard, quoted by Harlan, *Reframings*, p. 118.

31 Rickard, in Phil Young (ed.), *For the Seventh Generation: Native American Artists Counter the Quincentenary, Columbus, New York* (Columbus, OH: Golden Artists Colors Gallery, 1992), p. 17.

32 Niro in conversation with the author, 1997.

33 Lynn A. Hill, *AlterNative: Contemporary Photo Compositions* (Kleinburg, Ont.: McMichael Canadian Art Collection, 1995), p. 20.

34 Niro, in conversation with the author, 1997.

35 Rosalie Favell, from an unpublished statement, 1996.

36 Harlan, "Curator's Perspective," p. 20.

Margaret Dubin

Sanctioned Scribes

How Critics and Historians Write the Native American Art World

Visit your neighborhood bookstore, or scan the arts section of your local newspaper, and you could get the impression that Native American artworks are either primitive objects fashioned from animal carcasses by a people long dead, or adolescent pictures produced by living people mired in their spiritual past. Such objects are neither the relics of a great civilization, nor the experiments of a vibrant artistic community filled with existential angst. They are the products of primitive society, or alternatively the products of poverty, responses to market demand that are better suited to home decorating than art criticism.

This is how Native American art gets written about in most of the popular press. It is a simple and powerful vision, easily adaptable to coffee-table books and fully supported by the discourse of the imagined Indian (see Berkhofer 1979 and Pearce 1988). Unfortunately, it is a vision that stands undisturbed by the bulk of American scholarly research and writing. During the early twentieth-century artifactual mode of anthropology, Native American art remained inaccessible or deeply contextualized. To borrow a phrase from Gerald Vizenor, it was reduced to the mere evidence of culture. In the purview of art historians, tribal artists have received more individual attention. But as cultural "others" whose aesthetic traditions are embedded in an unrecorded past, tribal artists are consistently separated from their non-Native peers. They are withheld from the flux of time, denied their place in what anthropologist Joseph Masco eloquently terms a "shared modernity" (1996: 844).

In this essay I argue for a history of Native American art that is politically informed, and a criticism of contemporary Native American fine arts[1] that is historically founded. To understand the system that connects history to criticism, and the whole of art writing to the production and consumption of artworks, I turned to sociologist Howard Becker's *Art Worlds* (1982).[2] In this book, Becker describes the social network that connects people who do different jobs (e.g. production,

distribution, evaluation) in the Western art world. Because his focus is cooperation, the division of labor is primarily a practical issue. When this model is applied to the Native American art world, however, the division of labor is revealed to be political. Where Becker's sociological approach eclipsed power relations in the mainstream art world, it highlighted the profoundly unequal power relations in the Native American art world, where labor is persistently divided along ethnic lines. This essay pays attention to both the mechanisms of cooperation and the imperialist division of labor within the Native American art world, in the context of the published writings of its sanctioned scribes.

Early contributions to Native American art history paralleled Euro-American patronage of Indian arts in the 1920s and 1930s. During this period a significant shift in federal policy occurred, signaled by the end of land allotments and the institution of programs geared toward economic recovery, including the Indian Arts and Crafts Board Act of 1935. While some crafts, such as baskets, had already found favor in the public eye as models for the Arts and Crafts Movement, other objects had been officially discouraged, or banned outright as accessories to a barbaric lifestyle. In the new political climate, Indian products were reclaimed as part of America's heritage. At the urging of enthusiastic patrons of the arts, the government supported the revival of traditional crafts and the development of new ones as a means for tribes to achieve economic independence.

The subsequent renaissance of material culture was publicized by major museum shows, such as the "Exposition of Indian Tribal Arts" (1931) and "Indian Art of the United States" (1941), both in New York City (for more information on these exhibitions see Rushing 1995: 97–120). The catalogs published in conjunction with these exhibits called for a body of literature distinct from the material-culture literature of anthropology. Ethnographies were useful references, especially where they reconstituted authentic forms, but their emphasis on utility in the tribal context was inappropriate for objects destined to be used as decorations in non-Native homes.[3] In accord with Indian art's promotion from "artifact" to "art," consumers wanted confirmation of an object's worth outside of its context of production, along with professional explanations of aesthetic continuity and change.

The first historians of Native American art faced a task of mammoth proportions: a people formerly thought to be dead, or dying, were now producing arts that were somehow connected to an ancient but unwritten history. The notion that modern, industrialized America could sustain such a people, and such a production, inspired prose filled with patriotic reveries and Romantic sentiments. In his introduction to the catalog that accompanied the Exposition of 1931, Herbert J. Spinden, curator of the Department of Ethnology at the Brooklyn Museum, praised the "natural abilities" of "the Indian." He reminded readers that Indian art is part of the American heritage, and he suggested that by reclaiming this heritage Americans could recover their souls.

> We have in our Indians a reality of Arcady that is not dead, a spirit that may be transformed into a potent leaven of our own times . . . Shall it be said that we conquered the world and lost ourselves, that we slew beauty as a vain sacrifice to unsufficing machines?
>
> (Spinden 1931: 8)

Held up as the ideal in a critique of modern industrialism, "the Indian" fared hardly better than before, when his ways of life had been disparaged. Though recalled fondly, he was still primitive, singular, and stereotyped, still separate from a modernity wrought by colonialism.

The catalog for "Indian Art of the United States" retreated somewhat from the pulpit of primitivism. This exhibition, mounted at the Museum of Modern Art by René d'Harnoncourt, manager of the Indian Arts and Crafts Board, and Frederic H. Douglas, curator of Indian art for the Denver Art Museum, was engineered to support the new federal program for Indian artists. To this end, it included examples of contemporary work. Still, most of the catalog was reserved for historic objects, which the curators separated into geographic regions that broadly replicated ethnographic culture areas. Following the criteria of anthropologists, adherence to tradition was identified as the key characteristic of authenticity. Because contemporary works diverged from this ideal, or perhaps because there was no established strategy for historicizing new media and forms, new work was discussed separately, in an intertribal chapter titled "Indian art for modern living." In this chapter, the curators advocated patronage of Indian crafts not as a moral action but an economic one, practical for both the producers and consumers. In places the prose approached propaganda, lauding contemporary products for their utilitarian and decorative functions within the modern American home.

The production of contemporary arts and crafts persisted after government support waned (for information on the decline of the Indian Arts and Crafts Board after World War II, see Schrader 1983: 278–98). Native American art history continued to be written primarily as a survey of authentic forms, with evaluation based on adherence to tradition.[4] The interpretation of innovative works that made use of Western media and techniques remained weak, a testimony to the popularity of the imagined Indian and a consequence of the occlusion of colonial history. Beyond allusions to a far-distant past in which all Indians were artists and all art was utilitarian, new forms remained unhistoricized and unconnected to the larger events that shaped the worlds of their creators.[5]

The 1971 publication of *Indian Painters and White Patrons* by J. J. Brody marked a critical turning point. A revised version of his dissertation in art history at the University of New Mexico, Brody's book was the first serious attempt to contextualize the artistic renaissance of the 1920s and 1930s within the social and political dynamics of an emerging (and imperialist) art world.

Today Brody is a pre-eminent scholar in the field of Native American art history, but at the time he was a relative newcomer. Brody encountered Indian art for the first time in the 1950s, while a student at the University of New Mexico in Albuquerque. As he recalled many years later in a lecture at the Oakland Museum of California (1997), he approached Indian art from the viewpoint of an urban person trained in Western fine arts. What intrigued him most was the apparently easy coexistence of new and old forms, and, within the medium of painting, what he perceived as the emphasis on stylistic conformity over quality. He couldn't understand why collectors made such a fuss over the flat paintings produced in the style of the Santa Fe Studio School. To his eye, much of this work was "sugar candy," decorative yet unfulfilling.

Brody decided to write his dissertation on the genealogy of American Indian "easel" painting. Was this increasingly popular form the extension of an ancient tradition, as early art historians described it, or was it new, an "invented tradition" encouraged by Euro-Americans within the patronizing dynamic of colonialism? The topic raised some eyebrows in the art history department. "Remember," Brody said in his lecture,

> this was the late 60's. The Civil Rights movement was just ten years old. The general consensus among whites in the Southwest was that [Indian objects] were not 'art,' that they were made because of social circumstances. They were traditional and not

creative. It was a novel idea then, to look at Native American art as a historically explicable event.

Indian Painters and White Patrons, the book that grew out of Brody's dissertation, departs from previous histories of Native American art in several ways. Most significant, perhaps, is its structure, which juxtaposes a conventional culture-area history of prehistoric "pictorial arts" with a political history of Indian–white relations. At first glance, the summary of federal Indian policy seems unrelated, or at best tangential, to the development of Indian arts. Previous art historians and anthropologists had certainly thought so, attributing change to natural rather than social or political forces. But as Brody moves through the major events, from the so-called Indian wars, to reservations, boarding schools, the Dawes Act, and finally the New Deal, it becomes clear that he is setting the stage for a crucial moment, one shaped by history more than by any natural aesthetic evolution.

In the most powerful section of the book, Brody reveals the racist nature of Euro-American participation in both the craft revival and the development of "easel" painting in the Southwest. Against a backdrop of severe social and economic depression in Indian country, wealthy immigrant whites easily assumed the dominant role in patronage relationships in which Indians were encouraged to paint images of their traditional activities. In virtually all of these relationships, Indian artists were "treated as social and intellectual inferiors" (Brody 1971: 89). According to Brody, "[e]ven the most sensible, humanistic, and scientifically objective of the Whites seemed unable to avoid (or even recognize) attitudes that can be described only as paternalistic and racist" (1971: 90). Patrons encouraged their charges to paint, but then proceeded to hire them as stable-boys, janitors, or performers. When Indians were used as subjects for the patrons' own paintings, they were depicted not as hired hands but instead Romantically, as traditionalists.

Not surprisingly, Brody concluded that despite any continuities in form, modern Indian painting had developed in response to the needs of the dominant society. Indian paintings were used as the currency of social welfare, as accessories to the ethnographic record (as in Parsons 1962), as instruments of cultural critique, and as decor in non-Native homes. Even if Indians had later "taken" painting and made it their own, as Brody noted in his last chapter, the medium's early history stood as a reminder of the intimate connection between colonial and art histories.

Reactions to *Indian Painters and White Patrons* were mixed. As Brody recalled in his 1997 lecture, dealers were upset because the book seemed to undermine their claim to be selling authentically Indian art.

> Traders were shocked, some never spoke to me again. They saw what I was doing as entirely subversive of their profession. [They thought of Indian art as] works produced in a primitive tradition. They couldn't see the history.

This reaction is consistent with the overwhelming disregard for colonial history in the marketplace, where any Native American object, no matter how violently or unethically obtained, is fair game for sale (and profit). Brody's reading of the situation not only implicated traders in the colonialist system of patronage, but it devalued the paintings, stripping from them the authenticity provided by their link to the pre-contact past.

On the other hand, Brody recalled, Marxist colleagues applauded the book as a classic exposition of class struggle. In this reading, Indian artists were seen as passive participants in a system that was simultaneously racist and capitalist, and paintings were a symbol of oppression. Then and now, Brody

disavowed this interpretation, pointing out that an individual's participation in this nascent art world was voluntary. The ultimate goal of *Indian Painters and White Patrons* was not to moralize, but to analyze an art form, to develop a strategy for distinguishing "good" paintings from "bad." In the long run, Brody concludes, the patronage system produced paintings that were bad, "timid" in their reluctance to confront the circumstances of their genesis and "sterile" in their blunt commercialism.

Brody's strategy of interweaving aesthetic and socio-political histories was radical, prescient of the concerns of the "new" art historians. But while no one could deny the impact of colonial history and Euro-American desire on Native American art, other art historians were slow to incorporate Brody's politically-informed narrative into their own writing. They preferred the Romantic and politically sanitized approach of Dorothy Dunn's *American Indian Painting of the Southwest and Plains Areas* (1968). Like the traders who dismissed Brody's book, Dunn viewed Indian painting as a natural outgrowth of a primitive artistic tradition. Dunn taught Indian students how to paint on paper, yet she insisted that "Indian painting is New World conceived," that it

> reveals the aboriginal concept of man's relationship with the unique American environment – the soil and the gigantic terrain, the powerful natural forces, the indigenous substances and beings.
>
> (Dunn 1968: xxvi)

Meanwhile, beyond the museums and the academic departments, Native people were busy dismantling their Romantic image by voicing political concerns and engaging in protests. By the late 1960s it became clear that federal efforts to hasten assimilation through termination and relocation had failed. Alienated from their land and cut off from federal services, urban Indians across the country joined forces in protest actions, such as the takeover of Alcatraz Island (1969–71) and the occupation of Wounded Knee (1973). Some tribal artists responded to the tenor of the times by incorporating social and political commentaries into their work (see Wye 1988: 46–7). But America's idealized vision of art as apolitical, coupled with the vision of Indian art as hailing from a primitive tradition, effectively sequestered these works from the more impassioned coverage of current events.[6]

A rather curious exception to this practice was the July–August 1972 issue of *Art in America*, a "special issue" dedicated to "The American Indian." This atypical issue addressed an eclectic group of political and historical topics, including "The Indian in the Western Movie," "The artist-explorers," and "Black Mesa: Progress Report on an Ecological Rape." Only two articles were about Indian art: the frequently cited "23 Contemporary Indian Artists," by the Lumbee artist and curator Lloyd Oxendine, and "The Navajo Blanket," by non-Native art historians Tony Berlant and Mary Kahlenberg.

While the latter article was unremarkable, Oxendine's piece was noteworthy in several respects: it was one of the first surveys of exclusively modernist Native American art, and it was one of the first surveys of any kind written by a tribal person. As an artist and curator, Oxendine was privy to recent developments in the Native American art world. He acknowledged the importance of the newly-founded Institute of American Indian Arts in Santa Fe, New Mexico, a school where young artists from across the country were learning the techniques of modernism and the cultural language of pan-Indianism. He interpreted contemporary work as a response to these techniques and as a reaction to the conservatism of early twentieth-century Indian painting. In a significant

reversal of the Western tendency to position Indian artists outside the discourse of modern experience, Oxendine recognized Indians artists as participants and innovators. He described the transformation of conventional forms into protest art, contemporary expressions of the "radicalization of younger Indians in the late sixties" (Oxendine 1972: 59). Indian art executed within the new political consciousness could finally be seen as part of a larger movement in response to social circumstances, the "American counter-culture."[7] This helped Indian artists gain visibility on the national scene.

As Indian artists such as Bill Soza (Cahuilla/Apache), David Bradley (Chippewa), and Jean LaMarr (Paiute/Pit River) responded more directly to the issues and events of their times, the connection between aesthetic production and social context became more difficult to ignore.[8] At the same time, it became increasingly difficult to connect contemporary to historic forms. Western art writers are encouraged to understand the avant-garde in terms of its engagement with and rupture from historical precedent. In the Native American art world, however, old and new forms exist simultaneously and self-consciously. Parodies of the old share space with studied recreations and radical innovations. The simultaneous production of disparate forms, which I conceptualize as a hybridization that blurs tribal and chronological boundaries, is impossible to reconcile with the Western concept of aesthetic evolution.

In the absence of an established strategy for understanding this process of hybridization, writers relied (and frequently still rely) on an interpretive framework based on the Western qualitative oppositions of traditional/contemporary and art/craft. The distinction between "traditional" and "contemporary" refers to proximity to pre-contact media or forms. The distinction between "craft" and "art" is nominally about quality, but it frequently reduces to a separation of media along the lines of traditional/contemporary. The arbitrary nature of these distinctions allows them to be reconstituted to accommodate unfamiliar works. The hierarchical nature of these distinctions is invidious, recalling the colonial separation of "artifact" from "art." The terms are especially troublesome to contemporary artists who reject racial authenticity as a measurement of quality.

Pueblo potter Nathan Youngblood was delighted when he received an invitation from the White House to participate in a 1995 exhibit of the nation's finest crafts. In his comment to a reporter, however, he made it clear that he considered himself an "artist," not a "craftsperson." "In the last 25 years," Youngblood said, "artists have taken pottery to such a level that people are beginning to understand there is a possibility of its being fine-art quality and not just craft" (Youngblood, in Patton 1995: 55). Haisla/Northern Kwagiutl artist Lyle Wilson discards the distinction altogether: "These two labels are inadequate – perhaps irrelevant – in their description of the artistic process" (Wilson, in Duffek 1989: n.p.).

The need for a new critical framework approached crisis level in the early 1990s, when hundreds of artists reacted to America's celebration of the Columbus quincentenary with works that were simultaneously culturally grounded, politically aware, and formally avant-garde. Meanwhile, the epistemological crisis of Western art history (Belting 1987, Minor 1994, Rees and Borzello 1988) finally reached the Indian art world, where it demanded the production of texts more inclusive (e.g. Phillips 1995), more attentive to social and political context (e.g. Berlo 1992, Rushing 1995, Townsend-Gault 1991, 1995a, 1995b), and more connected to other art worlds (e.g. Lippard 1990).

In the ideology of the "new" art history, distinctions between traditional/contemporary and art/craft can be dismissed as academic antinomies that deny tribal products the stature and complexity of Western arts. In practice, however, it is difficult to speak around them. The concept of a "Native

American fine arts movement," for example, has acquired currency among critics, as well as artists and collectors. According to Margaret Archuleta and Rennard Strickland, who moved the phrase into popular usage in their 1991 exhibit "Shared Visions," this "movement" encompasses twentieth-century painters and sculptors whose work draws on European and American conceptions of art as much as on their tribal traditions. The term is useful, but its definition is problematic because it "perpetuates the specious distinction between 'fine arts' and 'crafts'" that has historically segregated American Indian artists (Rushing 1992: 6).

The very existence of a cohesive field of objects capable of being gathered under the heading of Native American art is dubious. With producers hailing from more than 500 different cultural groups, not including cultures married into, any formal unity derives more from shared social and historical experiences than a pre-contact intertribal aesthetic.[9] The prevalence of brightly-colored palettes and abstracted symbols in the work of contemporary Southwestern artists, for example, has less to do with a pan-Indian aesthetic than with the expectations of non-Indian consumers. But because criticism is expected to build on the foundation laid by art history, and because so much of Native American art history has been Romantic and apolitical, critics tend to interpret contemporary abstract works as extensions of an ancient, pan-Indian, symbol-laden aesthetic.

Artists find this humorous and sad. As one character remarks in Rennard Strickland's fictional but uncannily accurate drama, "It's kinda funny to think of white men standing over modern Indian nonrepresentational paintings, looking for tipis and buffalo and war bonnets in an abstract design, and declaring it Indian on the basis of the number of triangles that might be taken for tipis" (1986: 94).

> I want real art critics and historians to look at us, not dingbat anthros and Boy Scout hobbyists.
>
> (Joan Redbird, fictional Indian artist in Rennard Strickland's drama,
> *Tall visitor at the Indian gallery; or, The future of Native American art*
> (1986: 305)

> Artists complain about not getting serious criticism. Well, I say, "Fine, hang your work in a public space and I'll do my job."
>
> (W. Jackson Rushing, critic and historian of
> Native American art, 1997)

In 1961, Clement Greenberg issued one of his most famous proclamations on art. "In the long run," he wrote, "there are only two kinds art: the good and the bad." Most citations end here, reinforcing the notion that Greenberg's art criticism was both elitist and arbitrary. This may well be true, but consider his statement in context:

> This difference [between good and bad art] cuts across all other differences in art. At the same time, it makes all art one. No matter how exotic, a given body of art – as Chinese painting, African sculpture, Persian weaving – will begin to assimilate itself to the art with which we are already familiar as soon as we recognize the difference between the good and the bad in it.
>
> (1993: 117)

Regardless of the ethnocentrism in a Western art critic's method of evaluation, the inclusion of non-Western arts (if only temporarily) in the field of objects worth judging raises their status in a way that cultural relativism cannot. By comparing Chinese painting, African sculpture, and Persian weaving to "the arts with which we are already familiar," Greenberg acknowledged their quality outside of their cultural context. He moved "exotic" objects out of the officially objective field of ethnology, and into the more emotional field of art criticism.

Some scholars say this is a terrible mistake, that non-Western objects need their context to stay meaningful. Others discard the whole concept of art criticism, associating its positive manifestation with patronage and its negative manifestation with censorship. It is not my intention here to assess the value of criticism or the necessity of cultural context for the interpretation of art objects,[10] but to acknowledge that criticism influences the market, and that many contemporary Native American artists feel they are denied the attention of professional critics. Artists who wish to engage with the mainstream contemporary art world, in particular, dismiss the typical coverage of their work as amateur and full of clichés characterizing the disjuncture of an Indian-in-the-white-man's-world. "There's not a lot of serious art criticism about any particular artist within the Native American [community]," complained the Navajo painter Tony Abeyta (1996). Critics "like the idea of the creative spirit among Native Americans," but because they don't understand the complexities of being an Indian artist, Abeyta says; they write about Indian art as a cultural phenomenon. "They say, 'Indian art is a regional, Southwestern, appease-the-White-people device. . . . [And] Indians are still just evolving from selling trinkets and baubles under the portal, but they're doing it through galleries.'"

Ignorance coupled with primitivist preconceptions makes for a particularly patronizing brand of criticism. Navajo painter Emmi Whitehorse laughed as she recalled one writer who flew in from California to ask her about shamanism:

> I was trying very hard to steer him in the other direction, but he kept coming back to the subject. It's something that I don't have a business in, because that's a totally different profession. . . . I think his impression must have been that we, as Native people . . . there . . . is religion and there is ritual to everything we do, every day. Not so, especially now, most people just watch t.v. all day, and there's nothing to that, there's no ceremony involved in that.
>
> (Whitehorse 1996)

At the other end of the spectrum are those writers who interpret Whitehorse's ethereal brushless oils in terms of their affinity to the work of Paul Klee and other modern European primitivists (see Plate O). For example, a writer for *Art Guide* magazine wrote: "[T]he bright colors and fanciful shapes of many of Whitehorse's pastels suggest the whimsy of Klee or Dubuffet" (*Art Guide* 1988: 21). Santa Fe critic Lis Bensley wrote that "Whitehorse's style suggests many influences: her own heritage with her petroglyph-like figures, and the effect [of] Mark Rothko and Paul Klee" (1993: n.p.). In the magazine *ArtSpace*, William Peterson claimed that "Like Klee, [Whitehorse] uses a free-associational approach of mobile fantasy, in which a fragile, searching line develops a personal pictographic vocabulary among shifting planes of color" (1990: 38). Whitehorse did study the history of Western art at the University of New Mexico, and she is a great admirer of Rothko, but she characterizes the sources of her imagery as primarily personal, deriving from life experiences that may or may not be related to her reservation upbringing or university training. Some critics

have difficulty acknowledging that inspiration can come from sources that are eclectic, and sometimes very ordinary (e.g. the image of a bird on the label of a Belgian beer).

To be fair, few critics specialize in contemporary Native American art. Most of the reviews published in American newspapers and magazines are written by people with little knowledge of Native American culture, art history, or the processes by which Native artists learn their media and negotiate the market. As a result, reviews tend to read more like reports than critiques.

Cherokee painter Kay WalkingStick identifies the lack of "serious critical discussion of Native American art outside of its relationship to ethnographic or tribal art and artifacts" as one of the biggest problems facing contemporary Indian artists (1992: 15). "Good, risky, original art is being done by Native Americans," WalkingStick writes. "It is deserving of serious critical analysis and it takes no great leap of faith to analyze or appreciate it" (1992: 15).

Native artists want criticism on a par with that of elite Western artists, not the watered-down versions reserved for children and the creators of the *art brut* collected by Jean Dubuffet. To Whitehorse, thoughtful criticism is an acknowledgment of quality. "The work has to be intriguing enough . . . [to] provoke a dialogue with a critic," she explains. In this way, even negative criticism is useful: "If [the critics] have a fine-art training, I'll respect their review" (Whitehorse 1996). At the same time, many artists are ambivalent about criticism from non-Indians, even well trained non-Indians, because the structure of the situation replicates the power relations of imperialism.[11] There are times, says Whitehorse, "when a critic comes in and previews a work, and he says this work stinks, because it's badly painted," and the artist won't accept this judgment.

> The artist will say, "That's easy for [the critic] to say, because he's a white person. He has no business telling me how to paint." It's like being Native American gives him an excuse to do bad art and get away with it.
>
> (Whitehorse 1996)

Criticism from Native peers is not always an improvement. Negative comments can be interpreted as an attack on the unity of the Native American art community, or dismissed as evidence of jealousy or ethnic mutiny. As one Hopi painter explained, the Native American art community is suffused with an "us versus them" attitude that falls out along the imperialist division of labor. Tribal people who "cross over" into the careers of critic, historian, museum curator, or gallery owner are viewed with some degree of suspicion.

Greenberg's call for a pluralistic appreciation of aesthetic quality is valiant, but nowhere does he propose a method for determining the good and the bad in the arts of the "other." This is not surprising, given the inscrutability of his own methods for evaluating Western art. But the notion of connoisseurship, especially white male connoisseurship, is anathema to the proponents of feminist and ethnic arts. Lucy Lippard dismissed Greenberg's concept of transcendent quality as a masked form of ethnocentrism that functions to exclude rather than include. "The notion of Quality," she wrote, "has been the most effective bludgeon on the side of homogeneity in the modernist and postmodernist periods" (Lippard 1990: 7). Yet she herself recognizes quality, hailing it as the inspiration for her book, *Mixed Blessings*: "[T]his book was written because artists and writers of color are making some of the most substantial art being made today" (1990: 10). And like other well known critics, her method of measuring quality remains mysterious. This leaves us with an essential

dilemma: if art can be criticized, and indeed should be criticized, how should the arts of people both different and unfamiliar be approached?

In the Western art world, criticism and history go hand-in-hand. History provides criticism with a structuring framework, a continuous field of objects into which – or against which – new works can be situated. Conversely, criticism revives art history with a sense of occasion. With the passage of time, of course, the art of criticism becomes the art of history, a rationalized element of a logical aesthetic continuum.

What keeps Western art history distinct from other art histories, and allows it to progress in a linear fashion, is the persistence of a socially- or culturally-bounded group of producers. Western artists do "borrow" elements from the aesthetic repertoires of other cultures, but this is usually interpreted not as ethnic mutiny but as a temporary and incidental cross-fertilization inspired by specific historic conditions. When Adolph Gottlieb incorporated Native American images into his *Pictographs* series, for example, he was responding to what has frequently been described as an impasse in American painting.

> Equally dissatisfied with the often pious sentiments of regionalism, the aggressive yet uninspiring mode of American social realism, and the mechanistic aspects of geometric abstraction . . . Gottlieb felt compelled to find his own voice, one more in tune with the tumultuous events at the outbreak of World War II.
>
> (Kotic 1994: 59)

Gottlieb was participating in the art history of his own community, which in a time of social and political crisis sought solace in the wisdom of a primal unconscious, as represented by the arts of ancient and "primitive" societies (for more information on Gottlieb's interest in Native American art, see Rushing 1995: 161–8).

This has not been the case for non-Western artists. Those who claim membership in formerly "primitive" cultures, in particular, are expected to perpetuate their own historical forms. Indian people are generally viewed as more connected to the past – often an imagined past – than to the present. Because they are not seen as equal participants in a shared modernity, their interpretations of non-Native forms and styles are frequently viewed as mimicry rather than intelligent responses to larger human conditions.

Conversely, the revival of tribal forms is often seen as a direct continuation of ancient traditions, rather than an appropriation of symbols in promotion of sovereignty, or a personal aesthetic choice. When Native California artists Harry Fonseca and Frank LaPena find inspiration in the prehistoric rock art of North American tribal groups, for example, they are maintaining a "spiritual connection" (Archuleta 1988: 21) and "bridging the chasms of time and history" (Bernstein 1988: n.p.). But the artists' own discourse about their work tends to disturb the neat separation of Native American and Western art histories. LaPena, a Maidu painter and printmaker who teaches art at California State University, Sacramento, says he "looks at Chumash rock art through the eyes of an Abstract Expressionist" (LaPena 1997). His words confound the critic who would connect his work to some prehistoric tradition.

Given the persistent focus on authenticity over quality, it is not surprising that there is very little criticism – in the sense of this-is-good, this-is-bad – of Native American art. In the absence of an accepted strategy for evaluation, the overwhelming majority of writing is concerned not with

judgment, but with the maintenance and reconciliation of difference. Like the process of collecting, the process of writing has been framed by the tension between sameness and otherness, haunted by the conflicting desires to reconcile difference and to exoticize. This is manifested in the rhetorical moves that establish alterity, then reduce it by the invocation of familiar stereotypes.

A brief review of "The Submuloc Show" in the *Washington Post* typifies this maneuver. This 1992 show was one of several traveling exhibitions prompted by the 500th anniversary of Columbus's arrival in America. Sponsored and curated by ATLATL, a national Native American artists' association, the show included politically-informed works by tribal artists who had been working in modernist styles for years. The writer from the *Post*, however, saw primitives wielding paintbrushes: "With newspaper texts and videos appearing beside totems and beads, it is clear that Indian art is an actively evolving tradition" (McCoy 1992: n.p.). Alterity established, the writer takes refuge in the ecological-Indian stereotype: "[T]hanks to native beliefs in the sacredness of the Earth, [the show] provides a breath of fresh air in the midst of this country's environmental muddlings" (ibid.).

In another example, a 1989 interview with Apache sculptor Bob Haozous is prefaced by musings that mirror the imagined Indians documented by Roy Harvey Pearce (1988) and Robert Berkhofer (1979).

> When Haozous speaks about the natural, he means an Indian cultural relationship to nature, uncontaminated by Western civilization. Similarly, Haozous' discussion of the individual must be understood as deeply embedded within a communal society . . . In sharp contrast to the Romantic vision of the individual . . . the contemporary Indian artist shapes his relationship to the community from the tradition of the shaman or warrior who is valued for his ability to extend and perfect tradition, not shatter it.
>
> (Krantz 1989: 23)

In the text of the interview, however, Haozous speaks about the loss of tradition, and about his ironic reconstruction of Indianness.

> I use international concepts that the Europeans attributed to Native Americans when they first met them, such as the Great Environmentalist, the Honest People, the Free People, that certainly are not true today, but did give a foundation, however questionable, on which to base my art.
>
> (Haozous, in Krantz 1989: 24)

Variants of the Indian-as-naturalist stereotype include the Indian-as-spiritual-being and Indian-as-shaman. One author describes the graphite and pastel drawings of Yurok artist Rick Bartow as expressions of a "shamanistic state of consciousness" (see Plate P). The writer cites Bartow's manner of overlaying human and animal figures, then smudging the lines between the images, as evidence of the artist's connection to ancient shamanic practices. Bartow persistently disavows the "shaman" label, yet the writer persists:

> While Bartow says he has not actively practiced any specific shamanic or Native American medicine tradition, his art seems to reflect fundamental shamanic and Native beliefs in the transformational, healing powers of animals.
>
> (White 1988: 16)

Where the alternative is an erasure of difference, some artists opt to accept these stereotypes, if only as a marker of ethnic pride. When Krantz asks Haozous if his "concepts" are clichés, Haozous responds defensively: "They're not clichés, they did exist and they exist today. There's a big difference between a non-Indian and an Indian today" (Haozous, in Krantz 1989: 25). Flathead painter Jaune Quick-to-See Smith revives the "natural-Indian" stereotype in her assessment of Bartow's work: "Unlike Europeans, Indian people view themselves as part of nature. They paint the landscape in a tender way, because they feel a part of it. Indians think animals have souls." (Smith, in Wasserman 1986: n.p.)

What allows these stereotypes to function as mediators of difference is the common conceit that Native artists exist in two separate "worlds": their "Native world" and the "modern world." Artists who work in contemporary media, in particular, are "walking in the hazy borderland between worlds" (Allison 1991), translating an "indelible heritage" into a "modern world" (Bensley 1993). As Krantz writes, "Bob Haozous is a Native American sculptor whose life and work straddles the often diverging worlds of mainstream America and his Indian heritage" (1989: 23). In the Indian world, there is "no word for art." In the "modern" world, art is produced for art's sake, and cultural baggage is left at home. These ideas, rooted in the racialism of the dominant society, have been appropriated by tribal artists for their own purposes. Together they constitute what Apache anthropologist Nancy Mithlo calls the "Top Indian Art Clichés." In a paper titled, "Is There Really No Word for Art in Our Language?" (1995), Mithlo describes how her Native students use these clichés to "escape much tougher questions" (1995: 2). This is a dangerous practice, she says, because it implies that the "continuation of Native identity is not dynamic or changing to present circumstances" (1995: 3).

Many critics have a particularly difficult time with political art, in part because it defies all of the above strategies by directly addressing the ways in which Native people and their art have been, and continue to be, received. Political art aims to provoke reaction, or at least cause discomfort, by implicating the viewer in the crimes of colonialism. In accordance with the mores of late-twentieth century political correctness, however, writers tend to avoid the point of direct confrontation. Statements too blatant to be glossed over are written about in general or historic terms, rather than terms that are specific and personal. In her review of "Legacies: Contemporary Art by Native American Women," a group show at the College of New Rochelle in New York, a local newspaper columnist wrote, "[t]he overwhelming impression of this exhibit is of peoples who are, understandably, still angry over the American government's attempts to rob them of their identities" (Gouveia 1995: 5C). This was the writer's solitary nod to the prevailing attitude of an exhibit in which Cherokee artist Joanna Osburn-Bigfeather stretched small white christening dresses on birch bark frames, representing "Indian children being ripped open and splayed in order to skin them of their cultural roots and to force the dominant society's idea of education and civilization upon them" (Osburn-Bigfeather 1995: 5).

Some critics cannot entirely conceal their discomfort. William Zimmer's review of "Legacies," which appeared in the *New York Times*, provoked a negative reaction from several of the participating artists because of its patronizing tone: "American Indians are fortunate in that they have a tradition that is of vital importance to them — and at least romantically appealing to the rest of us" (Zimmer 995: 20).[12] Shan Goshorn's photographs of Indian images in American advertisements were intended to demonstrate how this Romantic appeal can turn into racial typecasting. Zimmer's reaction to Goshorn's work was flippant and insensitive: "Certainly Crazy Horse Malt Liquor is offensive, but who can really begrudge the Cleveland Indians their grinning imp?" (1995: 20)

Here Zimmer's complaint is not about the quality of the artwork, nor about the efficacy of

Goshorn's photographs in conveying her political message, but about the nature of the protest itself. In the context of a national debate over the use of racist images to promote professional sports teams, his remarks were inappropriate. In an exhibition review, they are doubly so. They also show a remarkable level of ignorance about the circumstances of production and the criteria for evaluation of political art (as well as photography).

When it comes to Native American art, most critics hedge around their charge to evaluate. They hide behind the clichés of alterity, knowing that for the majority of their audience, these clichés will resonate with the truth of an imagined Indian. W. Jackson Rushing is one of a small number of writers who has ventured to evaluate. In some circles this makes him brave, in others, foolhardy, but to my mind his is the first sensible writing, in many cases, on contemporary Native American artists and artwork. This is not just because he is critical, but because he knows how to criticize the work he reviews. Rushing is knowledgeable about tribal histories and cultural references, but he holds contemporary tribal art to the standards of the art world in which it strives to move. In other words, he is not afraid to cast a negative judgment, occasionally, when he feels a work is weak or incomplete.

In reviewing "Many Moons," an exhibit of Doug Coffin's new work installed in 1993 at the Wheelwright Museum of the American Indian in Santa Fe (Plate 38), Rushing described the large totemic sculptures in terms of their overall appearance and emotional impact, explaining specific tribal references the average viewer might have missed. He then proceeds to evaluate the installation, both as a whole and as a collection of individual works, in terms of aesthetic quality to the trained Western eye (which, after all, is the eye of most potential consumers).

> I found *Moon Serpent* to be an ungainly object, an ineffective use of the space, and not very well crafted . . . [T]he seams of the serpent's spine, where glass and metal came together, are rough and unfinished, and the overall image is almost a caricature.
>
> (Rushing 1994: 30)

According to Rushing, the "ersatz" quality of this and several other poles suggests that the work "is not yet fully resolved." Nevertheless, as "an ensemble of objects [the poles] do establish a compelling presence in the gallery, one that depends on the interplay of reflected and refracted light and the poetry of symbols and symbolic materials" (1994: 31).

Rushing, who describes himself as a "white guy from Texas," has no room in his writing for the clichés of alterity. Artists don't live in two worlds, they face challenges and histories that vary by tribe, gender, generation, and individual circumstance. The challenge in writing about Native American art is to recognize areas of difference, as well as areas of merging social and cultural practices, as they coexist within and influence the nature of our shared modernity. The goal, as I see it, is the normalization of the relationship between Native and non-Native arts, a move made all the more urgent by multiculturalism's entrenchment of Native American minority status. As Kay WalkingStick writes, without critical discussion multiculturalism becomes "just another way to segregate artists" (1992: 115).

As long as Western eyes are guiding the decisions of both institutional and individual collectors, Indian artists deserve fair and sophisticated treatment according to Western aesthetic standards. Anything less recalls the patronizing contests of past Southwestern Indian fairs, where non-Native judges huddled around baskets and pots pointing out signs of cultural corruption. There is another compelling reason for a fair and sophisticated critique of Indian art, and that is the exposure of racist

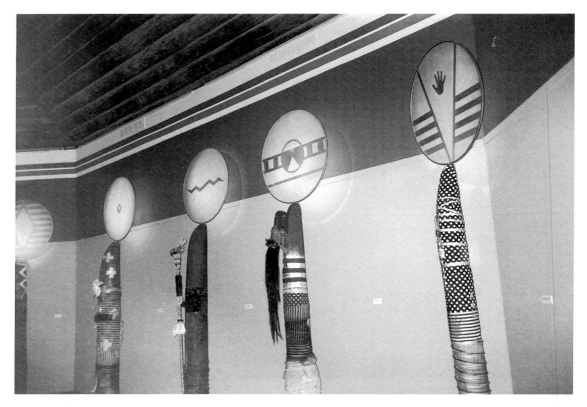

Plate 38 Doug Coffin, *Many Moons* (1993). Courtesy of the Wheelwright Museum of the American Indian, Sante Fe

attitudes in Western art institutions. Many elite art institutions excuse their exclusion of Native American art on the basis of inferior quality. If artists excluded from important exhibits fare well at the hands of critics who know how to evaluate Native American art, continued exclusion on the basis of quality will be difficult to sustain.

Notes

1 In the interest of brevity, and because the writing most accessible to me focused on the contemporary "fine arts" of painting and sculpture, at least two important genres of artistic production have been omitted from this study: contemporary pottery, textiles, and other works in the so-called traditional media; and contemporary Inuit and Aleut prints and sculptures. These genres of work are written about in much the same way as the art addressed in this essay, but the criticism of works in traditional media, in particular, addresses different problems than criticism of works in new media.

2 On the link between art history and art criticism, see also Gee 1993.

3 Since this time the literature has been dominated by art historians, with the notable exception of anthropologist Nelson Graburn. Where arts are the topic of contemporary anthropological studies, they are generally contextualized and historicized (e.g. Parezo 1983). The similarity of this approach to the "new" art history suggests a *rapprochement* between the two disciplines.

4 In the years between 1941 and 1971, several comprehensive surveys of Native American art were published, including Covarrubias 1954, Dockstader 1961, and Feder 1971. Northwest Coast art also received increased critical attention, culminating in the seminal work of Bill Holm (1965). Because art historians relied on museum collections for their data, and because museum collections primarily consisted of historic material, most surveys neglected contemporary arts and artists. Anthropologists still writing about material culture were more attuned to contemporary developments, probably because their fieldwork brought them into contact with living artists. In John Adair's 1944 study of Navajo and Pueblo silversmiths, for example, the author devotes two chapters to the daily work of a "modern craftsman," a 27-year-old Navajo man named Tom Burnsides.

5 There are exceptions to this rule, especially among the enthusiastic female patrons of Southwestern arts. Anthropologist Clara Lee Tanner wrote about contemporary Southwestern painting (1957), as well as the work of contemporary Navajo weavers (1964). Dorothy Dunn (1955, 1968) documented the work of the young Indian painters she taught at the U.S. Indian School in Santa Fe. Both women, however, were products of their times, and relied on Romantic or primitivist stereotypes to validate contemporary Indian arts.

6 For a detailed account of the takeover of Alcatraz Island, see Fortunate Eagle 1992. For information on the American Indian Movement and the seige of Wounded Knee, see Smith and Warrior 1996.

7 Sixteen years later, three Native American artists were included in the New York Museum of Modern Art's 1988 survey, "Committed to Print: Social and Political Themes in Recent American Printed Art." According to curator Deborah Wye, the same pluralism that "extended [aesthetic approval] to art with discernible subject matter" (1988: 8) in the late 1960s and early 1970s cleared space for the work of ethnic artists. Unfortunately, when Wye grouped prints by Jean LaMarr, Edgar Heap of Birds, and Rudy Begay in a section titled "Race/Culture," she inadvertently reinforced the segregationist framework that had excluded these works in the first place.

8 Soza split his time between activism and art, participating in the occupation of Alcatraz Island in 1970, and the takeover of the Bureau of Indian Affairs Building in Washington, DC, in 1971. As he tells it, "I had various exhibits of my work from 1966 to 1973, but I was a federal fugitive at the time, so I couldn't attend" (Soza, in Hill 1992: 97).

9 As Charlotte Townsend-Gault writes about contemporary First Nations art in Canada, "[g]iven the diversity of the work – in history and intent as well as appearance, Native artists being confronted with as many aesthetic choices as any others – I would say that First Nations art is not an art category at all, but a shared socio-political situation, constituted by a devastating history, the powers of the Indian Act, the social geographies of the reservation system, by tribal and local politics, by the shifting demographics of the non-Native in pluralist society, and by the worldwide ethnic revival" (1995b: 94, see also 1991: 67).

10 The debate over the necessity of cultural context is significant, and I do not mean to imply that I have sided with one faction or the other. It is important to recognize, however, that this is no longer a battle between anthropologists and art historians. As the "new" art history shifts the scholarly gaze from objects to contexts of production, aesthetic judgment is losing favor in the art-historical discourse. In this sense, art history is becoming an anthropology of art, in method if not in result.

11 The issue of culturally-based aesthetic appreciation also complicates the situation. In a study that compared Anglo and Inuit evaluations of Inuit sculpture, Nelson Graburn found both a "remarkable lack of agreement among the White evaluators" and a "profound difference between the evaluations by White people and by the Inuit" (1986: 271). Other anthropological studies of cross-cultural art appreciation support this finding (see the essays in Forge 1973 and Jopling 1971). But if Native artists do evaluate their work differently from outsiders, it is not clear how this fact should influence the criticism of a body of work collected primarily by outsiders.

12 According to Osburn-Bigfeather, at least one artist wrote a letter to the editor protesting Zimmer's review.

References

Adair, John (1944) *The Navajo and Pueblo Silversmiths*, Norman: University of Oklahoma Press.

Allison, Lesli (1991) "The Hazy Borderland Between Worlds," *Pasatiempo* (Sante Fe), August 16–22, p. 14.

Archuleta, Margaret (1988) "Networking: From Sacramento to Seattle," *Native Peoples* 1/3: 19–23.

Archuleta, Margaret and Strickland, Rennard (1991) *Shared Visions: Native American Painters and Sculptors in the Twentieth Century*, New York: The New Press.

Art Guide (1988) "Cross culture," *Art Guide*, p. 21.

Becker, Howard S. (1982) *Art Worlds*, Berkeley, CA: University of California Press.

Belting, Hans (1987) *The End of the History of Art?*, trans. Christopher Wood, Chicago, IL: University of Chicago Press.

Bensley, Lis (1993) "Women Share a Vision, Sense of Culture," *Pasatiempo*, August 26.

Berkhofer, Robert F. (1979) *The White Man's Indian: Images of the American Indian from Columbus to the Present*, New York: Vintage Books.

Berlo, Janet Catherine (ed.) (1992) *The Early Years of Native American Art History*, Seattle, WA: University of Washington Press.

Bernstein, Bruce (1988) *Frank LaPena: The World is a Gift* (exhibit brochure), Santa Fe, NM: Wheelwright Museum.

Brody, J. J. (1971) *Indian Painters and White Patrons*, Albuquerque, NM: University of New Mexico Press.

Brooklyn Museum (1995) *The Pictographs of Adolph Gottlieb* (exhibit brochure), Brooklyn, NY: The Brooklyn Museum.

Covarrubias, Miguel (1954) *The Eagle, the Jaguar, and the Serpent: Indian Art of the Americas*, New York: Alfred A. Knopf.

Dockstader, Frederick J. (1961) *Indian Art in America: The Arts and Crafts of the North American Indian*, Greenwich, CT: New York Graphic Society.

Douglas, Frederic H. and d'Harnoncourt, René (1941) *Indian Art of the United States*, New York: Museum of Modern Art.

Duffek, Karen (1989) *Lyle Wilson: When Worlds Collide*, Vancouver: University of British Columbia, Museum of Anthropology Museum Note No. 28.

Dunn, Dorothy (1955) "America's First Painters," *National Geographic Magazine* 57/3: 349-78.

—— (1968) *American Indian Painting of the Southwest and Plains Areas*, Albuquerque, NM: University of New Mexico Press.

Feder, Norman (1971) *American Indian Art*, New York: Harry Abrams.

Forge, Anthony (ed.) (1973) *Primitive Art and Society*, London: Oxford University Press.

Fortunate Eagle, Adam (1992) *Alcatraz! Alcatraz! The Indian Occupation of 1969–1971*, Berkeley, CA: Heyday Books.

Gee, Malcolm (ed.) (1993) *Art Criticism Since 1900*, Manchester: Manchester University Press.

Gouveia, Georgette (1995) "Current Exhibit at CNR is Both Beautiful and Bitter," *Gannett Suburban Newspapers* (Westchester County, New York), Sept. 17, p. 5C.

Graburn, Nelson (ed.) (1976) *Ethnic and Tourist Arts: Cultural Expressions from the Fourth World*, Berkeley, CA: University of California Press.

—— (1986) "White Evaluation of the Quality of Inuit Sculpture," *Etudes/Inuit/Studies* 10(1–2): 271–83.

Greenberg, Clement (1993) [1961] "The Identity of Art," in John O'Brian (ed.) *Clement Greenberg: The Collected Essays and Criticism*, Chicago, IL: University of Chicago Press, pp. 117–20.

Hill, Rick (1992) *Creativity is Our Tradition: Three Decades of Contemporary Indian Art at the Institute of American Indian Arts*, Santa Fe, NM: Institute of American Indian and Alaska Native Culture and Arts Development.

Holm, Bill (1965) *Northwest Coast Indian Art: An Analysis of Form*, Seattle, WA: University of Washington Press.

Jopling, Carol F. (ed.) (1971) *Art and Aesthetics in Primitive Societies*, New York: Dutton.

Kotic, Carlotta (1994) "The Legacy of Signs: Reflections on Adolph Gottlieb's Pictographs," in Lawrence Alloway, *et al.*, (eds) *The Pictographs of Adolph Gottlieb*, New York: Hudson Hills Press in association with the Adolph and Esther Gottlieb Foundation.

Krantz, Claire Wolfe (1989) "Interview: Bob Haozous," *Art Papers* March/April, pp. 23–6.

Lippard, Lucy R. (1990) *Mixed Blessings: New Art in a Multicultural America*, New York: Pantheon Books.

Masco, Joseph (1996) "Competitive Displays: Negotiating Genealogical Rights to the Potlatch at the American Museum of Natural History," *American Anthropologist* 98(4):837–52.

McCoy, Mary (1992) "'Submoloc': Reversing the Tide," *Washington Post*, June 27.

Minor, Vernon Hyde (1994) *Art History's History*, Englewood Cliffs, NJ: Prentice-Hall.

Mithlo, Nancy Marie (1995) "Is There Really No Word for Art in our Language?" Paper presented at the Native American Art Studies Association, Tulsa, Oklahoma, October 20.

Osburn-Bigfeather, Joanna (1995) Essay in "Legacies: Contemporary Art by Native American Women," in catalog for exhibition held September 3–October 29, Castle Gallery, College of New Rochelle, NY, pp. 4–6.

Oxendine, Lloyd E. (1972) "23 Contemporary Indian Artists," *Art in America* 60/4: 58–69.

Parezo, Nancy (1983) *Navajo Sandpainting: From Religious Act to Commercial Art*, Tuscon, AZ: University of Arizona Press.

Parsons, Elsie Clews (1962) *Isleta Paintings* (Bureau of American Ethnology Bulletin 181), Washington, DC: Smithsonian Institution.

Patton, Phil (1995) "Today's Crafts Join our Nation's Past at the White House," *Smithsonian* 26/3: 52–7.

Pearce, Roy Harvey (1988) [1953] *Savagism and Civilization: A Study of the Indian and the American Mind*, Berkeley, CA: University of California Press.

Peterson, William (1990) "Emmi Whitehorse," *ArtSpace* July/August, pp. 38–9.

Phillips, Ruth B. (1995) "Why Not Tourist Art? Significant Silences in Native American Museum Representations," in Gyan Prakesh (ed.) *After Colonialism: Imperial Histories and Postcolonial Displacements*, Princeton, NJ: Princeton University Press, pp. 98–125.

Rees, A. L. and Borzello, Frances (eds) (1988) *The New Art History*, Atlantic Highlands, NJ: Humanities Press.

Rushing, W. Jackson (1992) "Critical Issues in Recent Native American Art," *Art Journal* 51/3: 6–14.

—— (1994) "Doug Coffin's 'Many Moons,'" *Akwe:kon Journal* 11/1: 30–1.

—— (1995) *Native American Art and the New York Avant-Garde: A History of Cultural Primitivism*, Austin, TX: University of Texas Press.

Schrader, Robert F. (1983) *The Indian Arts and Crafts Board*, Albuquerque, NM: University of New Mexico Press.

Smith, Paul Chaat and Warrior, Robert Allen (1996) *Like A Hurricane: The Indian Movement from Alcatraz to Wounded Knee*, New York: The New Press

Spinden, Herpert J. (1931) "Fine Art and the First Americans," in *Introduction to American Indian Art*, Part II, New York: The Exposition of Indian Tribal Arts, pp. 3–8.

Strickland, Rennard (1986) "Tall Visitor at the Indian Gallery; or, The Future of Native American Art," in Edwin Wade (ed.) *The Arts of the North American Indian: Native Traditions in Evolution*, New York: Hudson Hills Press, pp. 283–306.

Tanner, Clara Lee (1957) *Southwest Indian Painting*, Tucson, AZ: University of Arizona Press.

—— (1964) "Modern Navajo Weaving," *Arizona Highways* 60/9: 6–20.

Townsend-Gault, Charlotte (1991) "Having Voices and Using Them: First Nations Artists and Native 'Art'," *Artsmagazine* 65/6: 65–70.

—— (1995a) "The Salvation Art of Yuxweluptun," in *Lawrence Paul Yuxweluptun: Born to Live and Die on Your Colonialist Reservations*, Vancouver: University of British Columbia, pp. 7–28.

—— (1995b) "Translation or Perversion?: Showing First Nations Art in Canada," *Cultural Studies* 9/1: 91–105.

WalkingStick, Kay (1992) "Native American Art in the Postmodern Era," *Art Journal* 51/3: 15– 17.

Wasserman, Abby (1986) *Portfolio*, San Francisco: American Indian Contemporary Arts.

White, Timothy (1988) "Out of the Darkness: The Transformational Art of R. E. Bartow," *Shaman's Drum* Summer, pp. 16–23.

Wye, Deborah (1988) *Committed to Print: Social and Political Themes in Recent American Political Art*, New York: Museum of Modern Art.

Zimmer, William (1995) "Light and Heat from American Indian Women," *New York Times*, September 24, p. 20.

Interviews, personal communications and lectures

Abeyta, Tony: July 23, 1996, Taos, New Mexico.

Brody, J. J.: April 19, 1997, Oakland, California, lecture.

Lomahaftewa, Dan: July 17, 1996, Santa Fe, New Mexico.

LaPena, Frank: April 19, 1997, Oakland, California, lecture.

Rushing, W. Jackson: June 17, 1997, telephone conversation.

Whitehorse, Emmi: June 27, 1996, Santa Fe, New Mexico.

Part III

Editor's Introduction to Part III

For the first fifty or sixty years of this century, the actual voices of indigenous artists were largely, but not exclusively, silenced by a patronage system and a critical literature, both art historical and anthropological, that represented them as nature's children, folk artists, or the noble, if primitive other. Their resistance to this institutionalized, if unintentional, racism was seldom expressed overtly, let alone published. Instead, it was far more likely to be encoded covertly in their work. Indeed, just choosing to be a professional artist was to be politically engaged in cultural work that challenged the preconceptions held by Euro-American culture about Native people and the nations to which they belonged.

As research on Indian art in the first half of the twentieth century continues, we will no doubt learn more about indigenous artist's voices. For now, suffice it to say that one of the first direct challenges to the strictures of the art system was the letter written by the Lakota painter Oscar Howe in 1958 to the Philbrook Museum in Tulsa, Oklahoma, decrying that institution's aesthetic paternalism.[1] Under the impact of various stimuli, the pace quickened in the 1960s and artistic self-determination became a major theme of Native artists in Canada (e.g. Alex Janvier) and the United States (e.g. T. C. Cannon), such that today their voices are heard in a variety of contexts: in books, exhibition catalogs, and art journals; on the boards of national organizations, including their own (ATLATL in the U.S. and SCANA in Canada); at major conferences and symposia; and, perhaps most important of all, in universities and art school classrooms.[2] The writers in this section, then, are all practicing artists, and they are teachers and curators as well.

The first of these essays, "The Story as Primary Source: Educating the Gaze," by the painter and printmaker Joe Feddersen and the poet Elizabeth Woody, celebrates a "mythology of place," which the indigenous nations of North America honor and cherish. This text, however, is by no means the first collaborative work done by Feddersen and Woody. In 1992 they created a remarkable inter-textual installation, *Histories are Open to Interpretation*, for "The Submuloc Show / Columbus Wohs," an anti-Columbian quincentenary traveling exhibition (curated by the noted painter Jaune

Quick-to-See Smith) organized by ATLATL, a national service organization for Native American arts based in Phoenix, Arizona.[3] Their photo-assemblage *4/4 Skins* was created for the exhibition "For the Seventh Generation," curated by Phil Young in 1992. And they also published a photo-assemblage with text in "Broadside No. 5" issued by *Reflex Magazine* (March/April 1992). Feddersen and Woody begin the present essay by demonstrating that without the attendant stories, the "cultural significance" of Native art was "irrelevant and inaccessible to the collector." Indeed, they offer a credible and persuasive argument that stories – or what ethnographers might call oral history – are a "primary source" of the impulse to make visual art. As such, without the stories, we are left with "decontextualized collections" that inadvertently generate "false simulations of the native image today." They urge us not to confuse the history of the acquisition and subsequent provenance of a work of art with the more important story of "who made the piece and why." Following this and a provocative commentary on petrographs as divine stories, they discuss their collaborative exhibition, *Archives*, which was held at the Tula Foundation Gallery in Atlanta, Georgia in 1994, and which was based on their conscious decision to examine "information storage and Indian identity." Like their earlier *Histories are Open to Interpretation*, the "Archives" installation was, at least in part, a language-based conceptual piece about information and ideas, although it was more emotional, poetic, and visually engaging than most conceptual art, which is all too often cerebral and dispassionate. For "Archives", Feddersen and Woody elaborately juxtaposed artist's books, photographs of hands (bearers of identity), and computer-projected texts, including Woody's delicate poem-as-family tree. Other materials included photocopies from periodical literature on the federal legislation of Native identity and a moving letter written from Woody to Feddersen that speaks warmly of the nurturing nature of home, family, and local country. If the warp of this essay is oral history and the mythology of the self, then the weft is a sense of personal responsibility that comes from being grounded in a particular community that is rooted, like berries and corn, in a specific place. As Feddersen and Woody speak to us about contemporary visual art in relation to family archives and to ceremonies as a performative archive of humanity, we find ourselves connecting with "the intimate in a colloquial voice."

The painter Kay WalkingStick, who understands spirituality as an effort to participate in the mythic, announces unequivocally in her essay, "Seeking the Spiritual," a need to deal with "the grand existential and metaphysical questions that we must all face." Recalling the birth of her grand-daughter, she chooses to validate the poetry of our lives, as opposed to accepting without question the rational discourse offered by science about our "present shape on earth." By her own admission, WalkingStick is a seeker of mystery, describing herself as a "Cherokee woman who is part white," whose "primary spiritual education," nevertheless, was in "mainstream Christianity." She takes the time to inform us about her life experience and her worldview because many writers have speculated about the meaning of her sensuous, emblematic paintings and she wants to set the record straight. Thus she refuses oversimplified explanations about what motivates her to make painterly, telluric dyptichs that reveal both the "inside and outside of perception." She also comments, wryly, on the tendency to either deconstruct her images or, alternately, read content *into* them on the basis of presumptions about gender and ethnicity. It's not as though WalkingStick is uninterested in theory and criticism or iconographical analysis, *vis-à-vis* her art, but that she is searching first and foremost for an aesthetic content beyond language, one which is based on the (meta)physical fact of the work. And so, like the richly impasted symbolic abstractions of the American abstract expressionist Richard Pousette-Dart, which she admires, the spiritual truth of WalkingStick's paintings is paradoxical: luscious material fact signifying the ineffable. I cannot stress enough the importance of

the physicality of her painting, and especially its tactile surface, in coming to terms with her devotion to "the great mystery of consciousness." In fact, her own discourse makes it impossible to ignore the facticity of her surfaces: "I think of myself as . . . a painter of earth in all its rawness." Thinking about her essay here and reflecting on her earthy surfaces, some of which are "dried blood red" in color, I recall Robert Houle writing that the emotional intensity of her painting directed the audience to "feel the subcutaneous layer of pain of someone who is preoccupied with the land in the way that only a member of nation that has been dispossessed can be."[4] Speaking as an "inhabitant of the earth," whose body is inscribed metaphorically in the skin-like surface of her painting, WalkingStick closes her essay with a moving recollection of Hopi ceremonial. In doing so she locates both the specificity and universality of *unity* in human experience.

In 1990 the Lakota artist Colleen Cutschall held a solo exhibition of her paintings, "Voice in the Blood," at the Art Gallery of Southwestern Manitoba. The fifteen large acrylic paintings, which featured brushstrokes that simulated the tiny, incremental ridges of traditional Lakota beadwork, reified in images for the first time stories about creation, sacrifice, the primal parents, and growth of the (natural) world (Plate Q). Gender, ritual, and translation from the oral to the visual were also key components of this important body of work. Since that time her paintings and installations have explored similar themes, and the essay here, "Garden of the Evening Star," documents a performance created during an artists's residency that focused on the "Arch in Patriarch."[5] On the grounds of a Trappist monastery she investigated "an ethnographic model of a cosmic garden," no longer extant, in which the Pawnee sacrificed young Lakota women. The performance, *Garden of the Evening Star*, constituted an interdisciplinary engagement with landscape architects, horticulturists, and other related practitioners that asked thorny questions about the gender of architecture, violence against women, and the epistemology of gardens and gardening. Asserting that consciousness itself is not gendered, Cutschall speculates about the assigning of gender to space, form, nature, and the act of constructing. Connecting Pawnee gardening to ritual practice, and thus to sky, stars, and the cyclical rhythms of nature, she notes how ancient metaphysical truth (stars "are the breath of gods") became "artifacts of culture" that are studied by both occultists and ethno-astronomers. Ritual and ceremony, she writes, are actions that express a cosmic garden, adding that to conceive of gardening as maintaining control over a small plot of ground conflicts with the Pawnee belief that "permanence is in opposition to regeneration and temporality."

It is important to observe that as a Native American professional artist, Cutschall is not atypical of her generation. She is college educated, but informed by indigenous cultural practices. Her work is not easily categorizable (is she a modern traditionalist? a tradition-oriented modernist? do these labels matter anymore?) and she is a teacher, writer, lecturer, and activist. Furthermore, like so many working artists today – Native or otherwise – her modes of production are flexible and situational: she is a painter whose work expands into performance, sculpture, architecture, and is often highly conscious of, if not driven by, a variety of textual fields, including aesthetics, anthropology, feminism, the natural sciences, and the politics of cultural identity (see Plate S).

Sara Bates shares with Cutschall (and the other artists in this section) the wearing-of-many-hats: artist, curator, writer, lecturer, and community activist. Self-identifying as a Cherokee woman, her essay, "Honoring," is the textual equivalent of "honoring and celebrating" in visual art her nation's tradition of respecting the rhythms of nature because therein lies the order and structure of things. Bates is known for installations, made *in situ* on the floor of the exhibition space, that involve gathering, assembling, and then recycling *artistic* materials from the biosphere. She makes what she calls "my sense of place" concrete, if ephemeral (!), by collecting flowers, pine cones, and shells,

which function talismanically as a gathering of experience. This "ecological materialism" is the basis for Bates's profoundly beautiful, but temporary "honoring" circles that have both personal and tribal symbols. Such circular forms offer a "type of self-transcendence" that she believes is necessary for us to "meet the challenges of a global environmental crisis." For some, Bates's "honoring" circles may vibrate sympathetically with Plains Indian medicine wheels, or Navajo and Buddhist sand paintings. Indeed, she is intentionally asserting the primacy in art history of certain Native American *aesthetic* forms: "The geometric abstractions of the modernists presented nothing new to the world since our ancestors have always known and seen these rhythms." Linking her methodology as an artist to ethological studies, and informed and inspired by the writings of Ellen Dissanayake on cultural evolution and diversity, Bates speaks both about the synergism of her own body and the disastrous politics of development/toxicity. Given this despoliation of the biosphere, she stresses the reality of traditional Native cultural forms and practices that reaffirm a "deep sense of the sacred." For her, art is therefore not in a domain distinct from the one that includes ritual medicine, honoring prayers, tall grass, and thunder.

Given an opportunity to write for this volume about any aspect of recent Native art and its reception that concerned them, and unbeknownst to each other, Feddersen and Woody, WalkingStick, and Bates each chose to include a personal story that locates the sentient self, who experiences joy and suffering, within the ritual life of a community. Between them in these pages there are two funerals and a celebration of birth, reminding us of the inextricable bond between life and death. And Cutschall, too, writes of the "primordial space of our lives," in which we experience the "germination, gestation, birth, life, death, and rebirth" that constitutes the "integration of the cosmos." They all also write, of course, about aesthetic strategies and various critical issues that contemporary Native American and First Nations artists face. But after reading the essays by WalkingStick, Cutschall, and Bates, I realized that Feddersen and Woody's emphasis on storytelling (indigenous national histories) as central to Native visual art – an anti-high modernist proposition – was both a prefiguration and the leitmotif of this section. This is especially true since their story, like those of their colleagues here, was about individuals and their families in and on sovereign land.

I decided to close this volume with a section of artist's writings because "the end" is always yet another beginning. "What survives in a culture," Sara Bates writes, "is what the people accept and bring forward."

Notes

1 See W. Jackson Rushing, "Critical Issues in Native American Art," *Art Journal* 51 (Fall 1992): 8, and Oscar Howe, letter to Jean Snodgrass (King), April 18, 1958, quoted in Jeanne Snodgrass King, "The Preeminence of Oscar Howe," in Frederick J. Dockstader (ed.) *Oscar Howe: A Retrospective Exhibition* (Tulsa, OK: Thomas Gilcrease Museum Association, 1982), p. 19.

2 An exhaustive list of Native professors of fine art is prohibited in this context, but a random short list would include the following: Edgar Heap of Birds, University of Oklahoma; Robert Houle, The Ontario College of Art; Kay Miller, University of Colorado at Boulder; and the contributors to this volume: Sara Bates, San Francisco State University; Colleen Cutschall, Brandon University; Joe Feddersen, Evergreen State College, and Kay WalkingStick, Cornell University.

3 See *The Submuloc Show/Columbus Wohs* ed. Carla A. Roberts (Phoenix, AZ: ATLATL, 1992). On *Submuloc* see my essay, "Contrary Iconography: The Submuloc Show," *New Art Examiner* 21 (Summer 1994): 30–5.

4 Robert Houle, "Kay WalkingStick," in Diana Nemiroff, Robert Houle, and Charlotte Townsend-Gault, *Land, Spirit, Power: First Nations at the National Gallery of Canada* (Ottawa: National Gallery of Canada, 1992), p. 214.

5 Some of the material and ideas from this performance were incorporated into an exhibition; see Shirley J. Madill, Allan J. Ryan, and Ruth B. Phillips, *House Made of Stars* (Winnipeg, Man.: Winnipeg Art Gallery, 1996).

Joe Feddersen and Elizabeth Woody

The Story as Primary Source
Educating the Gaze

> You don't have anything if you don't have the stories . . . the rituals and the
> ceremony are still growing.
>
> (From *Ceremony* by Laguna Pueblo author Leslie Marmon Silko)

Every indigenous culture has a creation story. From the time of first contact many "art" collectors, with rare exceptions, refused to acknowledge the importance of such stories or the mythology of place honored by indigenous people. As a result, the cultural significance of the artwork was irrelevant and inaccessible to the collector, who was initially enamored of its pure physical beauty. Ethnographic data and history based on objects vacuumed up out of the Americas without the consent of the first peoples usually omitted the story as a primary source. Artifacts presented to Western Europe as factual evidence were, and in many instances are still, analyzed and interpreted with a superimposed filter referenced from values of the Western worldview. Displaced "ethnographic" items became souvenirs, no more valued than "exotic show pieces." The non-Native viewer's first experience of Native art is often made through these ethnographic collections, along with historic photographs and popular culture. This voyeuristic view of Native art and culture is void of responsibility about their continuation. Subsequently, these decontextualized collections and repositories of materials are the root of many false simulations of the Native image today.

External definition even taints the way in which indigenous people see themselves; as Native artists and scholars research lost pieces of ceremony or ways of life they enter a maze of contradictions. Native art has a history different from that of Western culture and serves its purpose differently in a Native community. At times it runs in tandem with Western art and at other times runs its own course. In mythic history and oral history the presentation of the story reveals our shared histories. The rendition simultaneously provides specific descriptions of what sets us apart

from our neighbors and defines our relationships with other participants in the environment, such as the animals, plants, and regional geographic markers.

The Native perspectives found in art, literature, and oratory record the biographies of individuals even within the context of contemporary experiences. These stories teach us about ourselves, voice societal values, and document mistakes or accomplishments. Contemporary history – for those who are unfamiliar with Native people's sovereignty and treaty rights in the United States – is best understood if one becomes familiar with events like the recent losses and gains for Native peoples through bureaucratic policies. The Termination Act of the 1950s eradicated federal recognition of several tribes and their sovereignty. The relocation programs of the 1960s moved Native people from reservations to urban centers. In the Indigenous Fishing Rights adjudication in the 1970s there was judicial recognition of the sovereign rights of indigenous people to their means of subsistence. In the 1990s the Native Arts and Crafts Act requires Native people to prove tribal membership and blood quantum in order to sell art and craft work as "Indian." The Native Language Act makes it legal to teach indigenous languages. And the Religious Freedom Act states that Native people have the same religious freedom as other U.S. citizens. The stories in these diverse scenarios bind Native people together with a common history.

Our stories are sometimes documented in "alternative" book forms, as well as the usual sources found in oral histories passed on from time immemorial. People do not often realize that some marks on rock were created not only by people, but by supernatural and divine forces, too. Rock art in the Americas is often located at sacred sites, points of emergence, crossroads, or were placed at the time of some extraordinary event. The images serve as reminders for humanity of valuable lessons given to them by *divine* means.

In the Columbia River Gorge, which is part of the homeland of the Plateau people to whom we belong, a primary example of the exotification is the inappropriate use of the image "Tsagaglallal" or "She-Who-Watches." This unique petrograph is now a common commodity to be found in gift shops throughout the region. On rubber stamps, jewelry, paintings and clothing, she can be seen and interpreted by all. The image, red ochre on stone, located near Horse Thief Lake Park in Washington State, was cast there by Coyote, in the time before people were real people (Plate 39). Tsagaglallal was the last of the women chiefs, and taught her people how to build houses and gather food. Coyote informed her that "the world was going to change and women were no longer going to be chiefs." In response, she asked to be allowed to watch over her people in perpetuity and her wish was granted.

Owing to change, in the geography and society of the area, the idea of this image and its value have also changed. Rock art is a culturally hot commodity, carted off to museums, sold to private collectors, or neglected completely by developers building new communities in the once heavily populated sites of indigenous peoples in the Northwest. These artworks serve the land and indigenous history by providing a greater connection to the story of how we came to be, how we have learned to become human, and what prophetic visions we have inherited. Tsagaglallal overlooked the village of Woody's great-great grandparents and is part of her return to rock art as story. In a casual discussion with a rock art fanatic who is working to save the remaining images even from the Native people, he recently claimed to Woody that Tsagaglallal was originally a death mask, created to ward off the evil spirits of the European-originated epidemics. He further stated that she was made in the late 1700s. How he came to that conclusion is unclear since carbon dating is inconclusive in the case of rock art. The pigment is primarily mineral, and the animal materials used as a medium chemically bond the pigment with the rock and then disappear. The age of petrographs

Plate 39 Tsagaglallal, "She-Who-Watches," a petrograph in Horse Thief Lake Park, Washington State. Photo (1926) courtesy of Oregon Historical Society

is unknown, since the burden of proof in talking of antiquity and even of proving authentic ownership of this particular image is limited by current scientific methods. In *Red Earth, White Lies* Vine Deloria tells us that even though oral histories are true, the scientist often discounts Native histories as a method of proof or explanation.

Coyote claims the image as his deed. He responded to the wishes of a leader to watch over her people. Whereas the fanatic individual noted above inserted his presence into the history and meaning of the image of Tsagaglallal, Coyote's claim to ownership is made through a deep appreciation and desire to protect her. In both instances, the sensitive ethnographic scholar and fanatic may serve the image, even though they may not "see" the image from an indigenous perspective. Unfortunately for indigenous people, it is the conqueror who controls and writes history. Being part of the primary source by lineage, we see "She-Who-Watches" as a mnemonic artifact that marks and provides a connection to both ancient and personal history.

The fact that material aspects of our culture are an acquirable commodity and open to redefinition by the outsiders is a part of colonization, which rationalizes all that has been changed by violence and aggression. This rationale brings to the viewer a gaze that is difficult to maintain or dismantle when the altered story of the image is contested by living Native individuals who are part of the lineage that cares for the image or story. Simply, many viewers are predisposed to hold certain ideas about "Indians." There is an assumption of purity in indigenous cultures and ignorance of the duration of our multi-millennial histories. Which is to say, there is a cultural filter that must be identified and acknowledged for an honest exchange of information or education to be derived from the art work of a Native artist.

In 1993 Woody served as a fellow in the Americans for Indian Opportunity's (AIO) Ambassadors Program. During one of the conferences, the fellows met with Nahuatl leaders in Cuernavaca,

Mexico. "Capitan," a Nahuatl elder, described to the gathering the massive libraries that existed before the Spanish destroyed them. Books made in stone like the Aztec Calendar, survived the conflagration. He said that if the books had not been destroyed, today we would be able to read the stars and possess great knowledge. This prompted Woody to acknowledge how the many heirlooms found in family collections serve a similar purpose. The design and markings are a form of writing. And, while it is often said there was no widespread use of a written language in the pre-contact epochs of Native civilization, this is simply not true, especially if one looks to petroglyphs throughout the land, site landmarks, the elaborate designs in wampum belts of the Haudensaunee people and the wood bark books of the Lanape in the Eastern Woodlands.

This was affirmed to Woody in a different context at a Southwest writer's conference titled "Between Four Sacred Mountains." After showing slides of historic textiles and relating interviews with weavers, Roseann Willink (Navajo) explained that Navajo weavers use patterns to help the person remember a sequence of songs, prayers for protection, or a significant event. The weavers wove little bits of shell or feathers into the designs and referred to myths that would aid and protect the owner. These textiles were overlooked during the collecting of the trading-post era on the Navajo Reservation. Most collectors saw the spectacularly intricate weavings as more important than the simple blankets made for personal use that held stories and songs with these fine details.

This collector's gaze is presented as the only validation of "authentic" materials and viewpoint. We confuse the story of acquiring the piece with the story of who made the piece and why. Many times the art and its function remains a mystery, until people like "Capitan" share their history. He explained to the ambassadors that the "Aztec Calendar" is a story of all the earth's people. It tells of our past and our future. As Capitan read it, the ambassadors cheered and shivered as this future was revealed. He explained our task as Native people is to share with the world our knowledge in order to save humanity and to open consciousness for this possibility.

After much discussion we decided to make the viewer of our upcoming installation examine information storage differently and address the issues of "Indian identity" through an unusal method of narrative through portraiture. In September, 1994, we installed our fourth collaborative exhibition titled, "Archives," at the Tula Foundation in Atlanta, Georgia; it was sponsored by Lillian Friedlander. It was an exhibition comprised of unusual book forms that specifically explored how many people use cultural items to signify and preserve ideas. We intertwined four different ways of looking at identity. We interwove the personal, community, mythic, and historic.

The "Archives" installation took the form of a squared spiral to make use of five walls. At the entry we positioned an 8 × 12 foot book on glass shelving. The book was composed of colored photographs of a pair of hands veiled with text from a poem (Plate 40). The viewer was drawn into the next room by a one-level glass shelf. Along the edge of the glass a correspondence addressed from Woody to Feddersen was transcribed in a single line of rub-on letters. The quotes recorded from the Americans for Indian Opportunity Ambassadors were located in the smaller frames with variable fonts. This we referred to as *Anecdotes of Wisdom* (Plate 41). The larger framed writings were xeroxes printed in blue. They hung on the wall and cited articles from various periodicals concerning issues of Indian identity. In the back wall section of the "Archives" exhibition we placed fifteen colored images of hands, 20 × 30 inches each (Plate 42). This section had great impact upon the viewer. The gallery manager told us, "When individuals turned the corner into the exhibition space, they would gasp, and stand transfixed by the hands before following the text around the room." The photographs were larger than life and in the hands one could see the individual character of each subject (Plate 42).

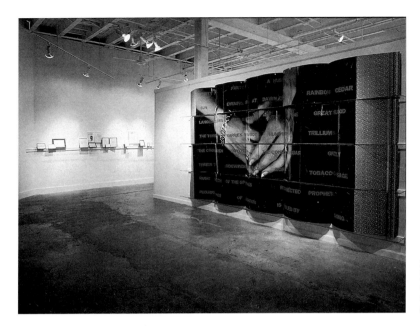

Plate 40 Joe Feddersen and Elizabeth Woody, "Archives" (1994), Tula Foundation Gallery, Atlanta: entry of the installation

Plate 41 Joe Feddersen and Elizabeth Woody, "Archives" (1994), section of the installation: *Anecdotes of Wisdom*

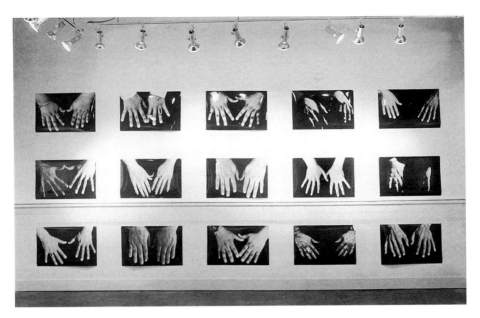

Plate 42 Joe Feddersen and Elizabeth Woody, "Archives" (1994), photographs of hands, each 20" × 30"

You began to see beyond the "gaze" at skin color and sense the layers of history for each individual. One pair of expressive, well muscled hands spoke of the classical pianist who owned them. Another older pair with manicured fingers and elegant rings belonged to a former United States Senator's wife. The flesh tones went from light to very dark, from smooth to worn, outdoor textures. From the college professor to the forester, you did not see the face for identification, only the marks left by labor and age on the surface of their skin. From this the viewer is distracted from the naive and rigid judgments made by representative images of Natives when looking at hands.

Woody photographed the AIO's Ambassador's hands that make up the visual image for the poem's backdrop and the single portraits. In our previous collaboration, "4/4 Skins" we used hands, because it is said that they carry with them the history of that person. In Navajo tradition, the hand represents the family. The thumb is the self, the pointer, one's mother, next the father, the grandmother and finally, the pinkie is grandfather. In the catalog *For the Seventh Generation: Native American Artists Counter the Quincentenary, Columbus, NY*, what we state about "4/4 Skins" applies to both "Archives" and the sets of hands:

> This suite analyzes the visual format and perception in that there are discrepancies between 'physical fact and psychic effect'; the issue of blood quantum makes the genealogy of one more important than the actions or expressions of the total person.

In "Archives" we used the computer-projected words of a poem in deep red set over a large photograph of a pair of hands. This image was superimposed on the opened-out and juxtaposed sections of four books (See Plate 43). The poem, *Thirty Second Parts of a Human Being*, reads:

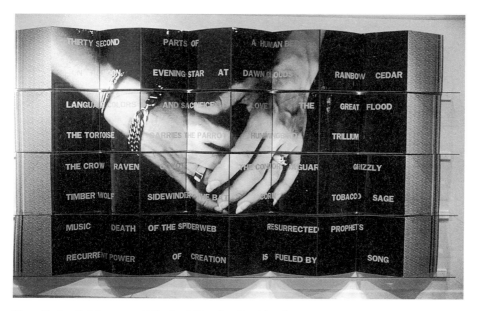

Plate 43 Joe Feddersen and Elizabeth Woody, "Archives" (1994), *Thirty Second Parts of a Human Being,* 8' × 12'

> SUN MOON EVENING STAR AT DAWN CLOUDS RAINBOW CEDAR
> LANGUAGE COLORS AND SACRIFICE LOVE THE GREAT FLOOD
> THE TORTOISE CARRIES THE PARROT HUMMINGBIRD TRILLIUM
> THE CROW RAVEN COYOTE THE CONDOR JAGUAR GRIZZLY
> TIMBER WOLF SIDEWINDER THE BAT CORN TOBACCO SAGE
> MUSIC DEATH OF THE SPIDERWEB RESURRECTED PROPHETS
> RECURRENT POWER OF CREATION IS FUELED BY SONG.

The thirty-two segments of this poem allude to Woody's official blood lineage. Woody's Bureau of Indian Affair's Certificate of Indian Blood lists her as "31/32 Indian" and "1/32 Other." To Woody, the thirty-two parts are rightly described as animals and events from various Creation stories, rather than tribal and European units of ancestry. Feddersen states in his lecture about the installation, "This illustrates the relationship between the mythic and the self. Mythology is part of how one perceives the self. The poem talks of all these animals as part of the Creation stories. Many of them are on the endangered species list today."

The series of quotes taken from the Ambassadors' Program's testimonials were placed on glass shelving in a variety of small frames around the room. The frames on glass are like a family gallery of photographs. In every family there is one individual who collects the family photographs of events and people to keep record. The individual is not trained as an archivist, but acts out of a personal responsibility to family. The framed quotes appear to be like conversations in small groupings. The Ambassadors voiced with authority a vision of the collective future of Native peoples that was thus offered as a personalized communal history. The viewer is allowed to see the words and phrases as

Plate 44 Joe Feddersen and Elizabeth Woody, "Archives" (1994), texts in the installation

significant and unique, yet still related to a whole. Oratory, which is always highly valued by Native Americans, is a means by which they withstand and oppose the conqueror and their rigid preconceptions.

In formal frames on the walls above the glass shelving, blue xeroxes magnified fragments from periodicals, emphasizing certain phrases discussing Indian identity and the Native Arts and Craft Act (Plate 44). This juxtaposed the tone of voice of the fragments with the voice of individuals in the smaller frames. The primary idea expressed by Feddersen is that the media filter the definition and meaning of what our society thinks of as Indian. Our individual voices become obscured by the larger voice of mainstream authority.

At the start of this installation Woody sent a letter to Feddersen from the Hyatt Regency, on May 13, 1993. It was attached to the edge of the shelf in the form of rub-on letters, and ran from start to finish of the shelf. The letter read:

> Well, Joe, am back east again. Saw Reyna tonight at the big reception. It's been a long trip, long week. My Great Aunt Amelia passed away and we went over the mountain, took the car, my mother and sister to Warm Springs. Although it was a somber event, people were saying good things, and I really felt good, I went over. Sometimes being there is the best medicine there is. My people are beautiful and as I was flying here, I shed a few tears, thinking how it is to be so far away. The more I travel the more I understand how precious our country is. The truth and honesty that pours out of the "folks" at home. A portion of our family was not there, but Cyrus Katchia, his sister Caroline Tohet lead out their family and people. As Cyrus passed us, he waved his eagle feather at my mother and I to join the women. I was so touched to be remembered, but I couldn't speak. As I twirled, and moved my hands, my body began to feel sure, and the world centered. I loved this woman and I hope my

thoughts helped. One cousin said, "Pray hard for everyone. If we get strong the world will get better." The salmon, deer meat, roots, fruit, corn, potatoes, and the meal shared renewed my strength. . . . As Jolene and I walked up the road, the air was rich with the exquisite smells of earth, sage, juniper. We were cupped in the liquid sense of sky, the mountain in the distance, the ground . . . I wonder at times why I stay away so long. I guess because I would miss it if I did visit more. Sometimes, the work I do doesn't seem to fit, and then I know I am gathering things, ideas, meaningful images when I travel. Then I realize I am gathering things, like knowledge. . . . Reyna filled me in on the wedding. Asked me questions about this and that. I forget not everyone does things the same. . . . Take care, Joe. E.

Feddersen explains,

The letter was not staged for the art project. It talks of traditions being embedded in personal history. Traditions like the Wedding Ceremony, sharing food communally in the Longhouse, the way one feels while dancing, are all perceptions of an internal nature and placed within the external context of being in a place like Washington, D.C. This letter was written after Woody visited the Warm Springs Reservation and flew immediately to a series of meetings with national policy makers.

Through the letter we connect with the intimate in a colloquial voice, one that claims personal identity and self-knowledge, while disregarding the public realm's influence. It also demonstrates how we often forget the important relationship of the person to a specific place and community. "She-Who-Watches" asked Coyote to help her remain as witness for her people in a mythological timeline, for eternity. She is not a passive observer, but serves as a potent reminder that we are not alone or weak. Her voice and gaze is one of action, her motive to be part of our claim and cultural knowledge of the land. It is the story that differentiates and illuminates knowledge of Native people, whether it is the personal, communal, mythological or historical. We recognize in our common histories the significant and specific issues of cultural survival.

Oral history and visual arts are valid forms of education. The responsible artist learns and teaches us to derive from the past our future story of family and tribe. We can run in tandem with the mainstream, but we may never possess privileges in that arena as long as we remain "indigenous" in content and specific in service, as opposed to enriching pan-Indian and mainstream culture. This a matter of the responsibility of being a tribal person instead of simply having the chic facade of "Indian-ness." The stories, intellectual property that belongs to the individual, family, or tribal groups serve the community, while the outside audience will always gain from this wisdom honed by time. To recognize the source of the stories is to escape the conventions of the "mainstream" and to see the principled consumerism of the practical and elaborate traditions of indigenous peoples.

Note

We have explored similar themes to those described here, in the layered intertextual installation "Histories are Open to Interpretation," the photo assemblage "4/4 Skins" and the *Reflex* magazine photo assemblage with text, a broadside titled "Inheritance Obscured by Neglect: Waterways Endeavor to Translate Silence from the Currents."

Bibliography

American Friends Service Committee (1970) *Uncommon Controversy: Fishing Rights of the Muckleshoot, Puyallup, and Nisqually Indians*, Norman, OK: University of Oklahoma Press.

Cole, Douglas (1995) *Captured Heritage: The Scramble for Northwest Coast Artifacts*, Seattle, WA and London: University of Washington Press.

Deloria, Vine, Jr. (1995) *Red Earth, White Lies*, New York: Scribner.

hooks, bell (1995) *Art on My Mind*, New York: The New Press.

Ramsey, Jarold (1977) *Coyote was Going There*, Seattle, WA: University of Washington Press.

Silko, Leslie Marmon (1986) *Ceremony*, New York: Penguin.

Vizenor, Gerald (1994) *Manifest Manners: Postindian Warriors of Survivance*, Hanover, NH: University of New England Press.

Young, Phil (1992) *For the Seventh Generation: Native American Artists Counter the Quincentenary, Columbus, New York*, Columbus, NY: Chenango Council of the Arts and Golden Artist Colors.

Zolbrod, Paul (1995) "How to 'Hear' Stories in Navajo Rugs," *El Palacio* (Summer): 22–31.

Kay WalkingStick

Seeking the Spiritual

How does one address the spiritual in art without sounding like an airhead? We all recognize the spiritual dimension in artists from the 1950s such as Mark Rothko, but it certainly is not a 1990s concern. In fact, I was told by a young art historian, that if art doesn't have a political edge it isn't worth addressing.[1] I understand the spiritual as that which attempts to describe or approach the mythic, that which we do not or cannot comprehend, but nevertheless recognize as prime components in our lives: birth, death, consciousness, and the mystical. In other words, the grand existential and metaphysical questions that we all must face – the biggies.

I participated in the birthing of my granddaughter. She entered the air as we all do, covered in white goop, limp and misshapen from her travails. Dear babe, she took in a gulp of air, yelped, and her limp little body filled with oxygen and coursing blood and she became pink and human. All of this can be biologically explained; the transformation is fully understood, yet it is a mystical and moving experience, nonetheless. This little animal creature held the seed of humanity in her DNA. The gifts of thought, language, reasoning, and love were all there in that odd little body, all there in perfect harmony. Our evolution over the millennia can explain our present shape on earth, but it doesn't erase the sense of the mythic that attends such a common occurrence as birth.

Death holds the same kind of fear and wonder. A sentient being exists, then does not. The body remains; the being is gone . . . a common occurrence that we'll all experience firsthand. It is a simple fact of biology. But on a deep level, that nonrational level where we often live, death is also incomprehensible. This is simply the human condition. Does one properly call this mythic wonder spirituality? It is surely a part of spirituality, as is the sense that there is a cosmic energy, a divinity, a universal power, a creator, who is beyond our rational comprehension. These are the mysteries I seek. This search has lead me on interesting paths, but my primary spiritual education has been in mainstream Christianity. I do not practice a traditional Cherokee religion. I was not raised in it although I feel completely comfortable in that Native surrounding. I am not an animist, I have never been in a sweat lodge, I don't have any crystals, and although I burn sage I don't use tobacco as

another sacred herb. Nevertheless, I think of myself as a Cherokee. I was raised with that identity by my Scotch-Irish mother. I am the daughter of a Cherokee father and carry a traditional Cherokee name. Because of that identity, and that funny name, wherever I go, I face the world as a Cherokee woman who is part white, not as a white woman who is part Cherokee. This is my reality.

I live in a mainstream America where I received a Western Christian education and it is this education that has fueled my thoughts of the mythic as well as my knowledge of Native traditions. (Many Native people share this experience of balancing two worldviews – worldviews which are not *always* so far apart.) There is a balance in my paintings – a balance of apparent opposites. It is through contrasts that we see meaning. Leading a life of harmony and balance is a common notion in a number of Native religions: walking the beauty path, as the Navajos say. In fact, it is a common theme in many religions. There is a duality in the paintings representing that balance which is crucial to the whole. As a bi-racial woman the balancing of apparent opposites has a psychological comfort for me, but to ascribe the drive to make these diptychs to that need for comfort would be an oversimplification. It is as if the two sides of reality are shown – the inside and the outside of perception – and both are raw, intense, and manipulated – and both are mysterious. Neither is fully clear, neither is sharply defined. It's all part of the great mystery of consciousness.

Another major theme in my work is that the earth is sacred. Tribal people around the globe have always known this. In the West over the centuries, this knowledge has been lost, but in the United States many people are coming back to that point of view. I see the notion of the sacred earth as a universal today. How could anyone not see the earth as sacred? We are the earth and it is us. We are one with it. I'm a landscape painter, I'm told, but I think of myself as an earth painter, a painter of the earth in all its rawness. My paintings are rough, raw, and almost ugly sometimes. I like the combinations of colors that are not pretty but a bit nasty like pepto-bismol pink and dried blood red. I want people to have a visceral reaction to my work, as well as an aesthetic reaction. The more realistic portion of the painting isn't really realistic, and the more abstract is not ephemeral but solid and wall-like. There are simple shapes on the more abstract side that are derived from parts of a circle or sometimes a cross. The parts of a circle are just that and like any simple shape suggest meaning, but don't signify anything specific.

All my life viewers have made assumptions about my paintings, and me. The identity of the artist shapes the meaning especially in this age of deconstruction. If I showed with women then the arcs in the paintings were vulvas, if I showed with Indians the arcs were bows. Somehow my gender and funny name precluded the possibility that the arcs were simply shapes, part of a circle. The predelictions of the viewer also affect the reading of the shapes. What appears to be a set of convex lenses to one viewer appears to be a butterfly to another. Neither is inappropriate and neither is "correct."

The cross symbolizes the four sacred directions, and has that meaning to me because it directly addresses the earth and its spirit, but if it is seen as a Christian cross or a plus sign or the astrological sign for Gaia, that's fine, too. All of these meanings are appropriate. In fact, there is a neither/either sense to the meanings of my paintings. If they live after me, they will be read by another generation of art historians and critics writing in an as-yet-unknown context. That's fine too, because the verbal, theoretical reading is always the lesser of the two readings. It is the visual, aesthetic reading that is most crucial. It is the power of the blacks or the nastiness of the piss yellow, or the cut and cutting surface; it is the fear, disgust, pleasure, or joy that the visual experience can elicit that is the most important quality to me. I want to touch people – to know that they are visually moved, that somehow no language, no talk, no explanation is necessary, and that through the visual experience alone they are challenged to think, feel, and respond.

This philosophical-visual response, the need for the spiritual in art, is not past its prime. It continues within us and fulfills the need to convey archetypal ideas to one another. I attempt to address the formless divinity through the physicality of paint and just as the physical act of sex can transport one into a place beyond all physicality, so to, can concrete paint lead one beyond the physical form. To use David Penney's words, "it is the cosmos beyond sensory experience . . . the place without time, which we all inhabit"[2] that I seek.

I have come to realize that the land is a stand-in for my body. We speak of grandmother earth (*eloheh elisi* in Cherokee) or of the great goddess, or Demeter/Ceres, or just Mother Earth. It is none of these mythic forms, but my self, my body that is in these paintings. Which perversely brings me back to the spiritual. It is through the body and the mind that we experience the spiritual. We need an awareness of the body/mind relationship in order to seek the spiritual; we need both a body and a mind to transcend. The poet José Garcia Villa said, "All spiritual truth is paradox."[3] So too, the paintings are first physical things, and it is through that physicality that I try to address the spiritual in all of its meanings and manifestations.

Painting, like language, is magical. It is made of the simplest ingredient: oil, pigment – which is often only refined dirt – and a support of cloth or wood. It transmogrifies into beauty, ugliness, meaning, revelation, narrative, and decoration. I believe in the power of its magic.

My paintings have been affected by my heritage, but they are not about Native Americans or Native spirituality. They are about me, and I am a homo sapien like anyone else, an inhabitant of the earth (see Plate R). We are more alike than different and the questions I address in my paintings are questions for us all. My primary theme is unity: unifying the divergent in our personal, political, and spiritual lives, as well as unifying the immediate visual with archetypal memory. The themes I address are not popular themes today. I don't address the superficiality and decay of the end of this millennium. I address the questions in the back of my head . . . old questions, unanswerable questions. God isn't dead and neither is painting. Not yet.

I drove back to Phoenix across the desert from Cocopah, Arizona, one cool and rainy March morning, rested in my apartment for an hour and then got back in the car to drive north to Hopi. I had been invited by my Hopi friend from the Heard Museum to a ceremonial dance at Shongopovi Village on Second Mesa. We drove up to Flagstaff where there was wet spring snow falling and stopped to pick up food. The Cherokee tradition is to take food to ceremonies; at Hopi the tradition is a bit more specific: women take baked goods so I bought a cake at the A&P. The weather was really nasty, but my friend said that it always clears up by the time you arrive in Hopi. North of Flagstaff the snow changed to rain, and when we finally arrived in Hopi the sky had indeed cleared, but it was pitch black. We drove up the mesa, one of the most rugged and remote places in this country, curving around on what seemed like nonexistent roads and came to stop in front of my friend's aunt's house. The rest of the family was already there, sitting around chatting and eating apple pie in the main room. The house was very old; some of it was adobe, some of it wood which had been added over the centuries. Most of the newer homes in Shongovopi are now cinder block, not stone and adobe as they once were, but they still have a wonderful handmade quality. There was a small room off the main room where Aunt Lula makes Hopi blue corn piki bread. There were three generations of this extended family sitting and chatting, eating pie, and waiting for the appointed time for the Katsinas to arrive from the San Francisco Peaks. They are considered Spirit Friends by the Hopi people. The family spoke Hopi and also English, no doubt out of politeness to me, but very soon I was stretched out on one of the cots like the children, taking a snooze. At about 11 p.m. the kids and I were awakened and told it was time.

We bundled up. I wore a shawl over my head and shoulders. It's the Cherokee way to show respect and so women always wear shawls when walking or dancing on sacred ground. In addition I thought I might be a bit less conspicuous if I were covered. I was the only non-Hopi at this first dance of the new year, which is the return of the Katsinas to Hopi after the winter, and I felt a bit conspicuous. (As a wag once said to me: Hopis look like Hopis, but Cherokees can look like anything!) We women and children walked from the houses to the kiva, keeping our eyes to the ground, as we were instructed, breathing the sharp, clean air of a celebratory night. I wanted to star gaze, but didn't. As we entered the kiva, a partially below-ground ceremonial chamber, I pulled my shawl over my head and waited until everyone entered so that I could sit at the rear. The room was crowded with people; the women and children sat near the door facing a lowered dance space. I felt humble and pleased to be sitting in the kiva. The privilege of it was overwhelming, and quite unlike any other religious experience I'd ever had.

The Spirit Friends descended into the kiva; there would be many different groups of Katsina spirits that evening. The first to arrive were the Cow Katsinas who made wonderful, deep, plaintive sounds, and were beautiful to behold. There was a kiva chief who thanked the Katsinas for coming to assist with the prayers for rain and bountiful crops to come. He sprinkled corn pollen as an offering. Are there any Indians who do not believe that corn is sacred? I think not. The Cow Katsinas departed and the Long Hair Katsinas descended and danced their complex and beautiful prayer songs. We who watched were silent, even the children were soundless, as we were all mesmerized by the beauty and seriousness of the sacred songs. The Long Hair Katsinas dance to a drum beat in a slow, rhythmic, up and down movement that is spell-binding. Each group of Katsinas came down through the opening in the ceiling of the kiva. No one was permitted to watch that, and no one did. It was as devout a group of people as I had ever seen: total concentration, total focus, even on the part of the smallest participant. And we were participants, I felt, not watchers. There were five groups of Katsinas that night. I was told that different Katsinas come for each of the winter dances and each of the summer dances. They come to bless the planting, to ensure that the crops will grow, that the ground will be fertile, and to bring the rain. The Katsinas sing not only for the Hopi people, but for the entire world, so that we may all eat.

After each group of Katsinas finished their songs they handed out gifts of cookies and apples on a string to the children. It was very late, perhaps 1.30 a.m. and I was awake, but no longer alert. My friend elbowed me and I thought I'd made a gaff for sure, snoring perhaps in a momentary nod-out. But she said, "He wants to give you something." I looked up, and there was a Katsina handing me a strung apple. I looked at his hand, which was chalky white, beautiful, and delicate. I couldn't look up. I couldn't look into his face; I knew instinctively that one doesn't look in the face of a Spirit. I was transported. I had really received a gift from a Spirit Friend and the elation of that experience lasted like the glow at Christmas time. It was a great feeling. The next day, as I walked around the plateau of the mesa feeling blessed, I looked towards the San Francisco Peaks and wondered about this powerful reaction that I had had the previous night. I realized that through the strength of the commitment of the community there was a true transformation. The Katsinas are Spirits who transcended any humanness by the commitment of the Hopi people to their religion and beliefs. The Divine shows in them like an inner light.

All of the Hopi communities make huge sacrifices to ensure that their religion, culture, and beliefs will continue, indeed so that the people of the earth can continue. The Hopis know that they are fulfilling the Creator's role for them. That is true spirituality, and the art, religion, and culture of an entire community expresses it. Art, religion, and culture are unified for the Hopi as they are for the Cherokee and we have a word for that united idea — *Eloheh* — which also means "the earth."

Notes

1 I have, of course, made political art, especially for the celebration of the 500th anniversary of the Columbus invasion. From about 1991 to 1993 all of my work had a sharply directed political edge. In addition, my work from 1973 to about 1979 had a strong undercurrent of political anger. Nevertheless, I see the primary content of my work over the last thirty years as a search for the spiritual.

2 *Native American Art Masterpieces*, David Penney (Southport, CN: Hugh Lauter Levin Associates, 1996), p. 112.

3 Personal journal of the author, June 23, 1995.

My thanks to Gloria Lomahaftewa for her assistance with the final portion of this essay.

Colleen Cutschall

Garden of the Evening Star

I am a Lakota professor of art and art history and a working artist addressing issues of sacred time and space and their relation to Plains architecture and astronomy. The following was an introduction to a performance work developed during a brief exploratory residency with seven other women artists at St Norbert's Art and Culture Centre in Manitoba, Canada. The residency was based on the theme of the Arch in Patriarch. We met with audiences at the beginning of the residency to outline the topics we would pursue and then met again at the end of the residency to review the culmination of ideas and exhibit artwork. The performance work took place in early spring, May 3, 1996 in the outdoor vegetable garden and in the formerly sacred Christian grotto next to the LaSalle River with a full moon, evening star, and firelight beneath the ruins of a Trappist monastery.

My exploration was to find some basis on which to examine an ethnographic model of a cosmic garden, no longer grown. In an attempt to locate a structure to examine the meaning of gardens and their origins as controlled space, I was introduced to the proceedings of a conference that looked at the meaning of gardens. The discussion was among landscape architects and professors of that discipline, horticulture, and other related fields. My questions were as follows, although not necessarily in this order. What do stars have to do with Pawnee earthlodges? What can Pawnee star maps tell us? Why did the Pawnee sacrifice young women from other Plains tribes such as the Lakota? What does it have to do with Pawnee historical architecture? If the space in which a young woman is sacrificed is called the Garden of the Evening Star then what is the meaning of garden for the Pawnee? Does her sacrifice have any relation to violence against women? Does the meaning have answers for our understanding the female principle in architecture apart from its cosmological meaning for the Pawnee? Is a garden intrinsically female? Can a garden be feminist? What would constitute a garden's feminist ideal? Does the last question assume that gardens have consciousness? Or do we simply project our consciousness on its form?

The space of the consciousness is what people would identify as the earth, the theater or garden of our lives. This is also the space that artists and architects claim as their surface, pedestal, or site. Consciousness itself is not gendered, that is to say, the idea or mind can be free from gender because it is the space free to receive form and action, free to be male or female. But action and erection require form to perform and to construct. Uprightness and verticality are often assigned as male principles in design and cosmic structure. Horizontality and curvilinear forms are often assigned as feminine attributes of design. A successful work does not require the viewer to know the artist's gender nor are there currently restrictions on the type of art that artists make. Nor is there an expectation that artists must work from a gendered field of technique, design, knowledge, etc. Nature would seem to me to be the most obvious reflection of female. It is one that accepts paradox and opposition. Unfortunately it is the practice of pragmatists to believe that the earth does not have consciousness, nor do plants, nor do animals. Their culture has been so far removed from direct dependence on nature that it has lost the meaning of the old symbols and hence is largely disassociated from the earth. For them earth is real estate and product.

I exist in a time when my people no longer live permanently in their old structures but reconstruct them for their ceremonies and rituals and then return to their square houses. Few have gardens or the tools to tend a garden or a place to have a garden. Historically they built vegetable gardens and tended crops and cleaned areas they lived and worked in, but the idea of a garden for delight is only very recent and at this stage of our history would resemble for some of them a symbol of wealth and power as it developed in Europe from the Renaissance through the nineteenth century.

> The garden has been viewed philosophically as the balancing point between human control on one hand and wild nature on the other. The garden has represented safety from the threat of wild nature or escape from barbarian outsiders. The garden has been nature-under-control, an idealisation of what society believed that nature should be and should look like.
>
> (Francis and Hester, 1990: 2)

In the garden as in society there is an ongoing battle of seeming opposition where these apparent irreconcilables are clarified and mediated because the garden accepts paradox (ibid.: 4). I have outlined these oppositions as sky and underworld, with earth as the mediating ground or space in which we can negotiate our position in the cosmos. I have also outlined how Plains culture was founded on these principles and how their cities and villages and camps were arranged in a ritual manner mirroring the male and female aspects of the heavens. The space was earth and the sky was the action bringing the snow, thunder, rains, sleet, hail, clouds, winds, and sun. The stars conveyed the direct message about action to be taken on earth and when. They were the breath of the gods, the superior beings in charge of the cosmos. In modern times this idea has become a cultural artifact studied by archaeo-astronomers, and an object of speculation studied by occult groups, ethno-astronomers, religious historians, art historians, anthropologists, artists, archaeologists, architects, and tourists.

If a garden is also a source of action requiring intimate and direct involvement then the expression of the action for a cosmic garden is ceremony and ritual. Francis and Hester have written,

> Gardening gives us a sense of control over a small patch of earth in spite of all that

is left to chance, such as the possibility of drought and insect infestation. With control comes responsibility, commitment to stewardship of the earth. Through gardening, we are reconnected to "mother earth" and to the larger ecology of the world in which we live.

(1990: 6)

I have discussed the earth as a site or space in which that reconnection occurs. Reconnection implies a need to connect, to know, to become a part of, to have direct involvement, and to affect. It is the impulse to bring thought or consciousness into action or form or both. It also implies permanence; repeated action is needed to create and maintain the garden. On the meaning of permanence in the garden Plains culture radically departs from the Western concept. The Pawnee would see permanence as being in opposition to regeneration and temporality. While the Pawnee would be in accord with function and practicality, it would be on another level. According to Weltfish, "The Pawnee had many tasks to accomplish in the early spring before the time of planting. Some of them were practical and some ceremonial, but to the Pawnee who believed that nothing on earth could move without the heavens, no practical task could be undertaken unless the appropriate ceremony had preceded it" (Weltfish 1965: 79).

Architecture is a great example of form resisting gravity, time, space, erosion, and death. Given that the Plains people's ideals were certainly of an ordered universe their architecture was to be one in harmony with its processes and cycles; temporary, portable, and ecologically friendly architecture were its forms. By design its forms were round, denoting the never-ending process of regeneration and renewal. The earthlodge was made by and owned by the women. They were also the cultivators of the corn gardens. An examination of Western garden ideology provides us with some links by which to re-examine the Pawnee garden.

The power of the garden lies in its simultaneous existence as an idea, a place, and an action. While each has value as a way of thinking about gardens, viewing them together offers a deeper, more holistic perspective on garden meaning. One cannot examine a garden as a physical place without probing the ideas that generated the selection of its materials and the making of its geometry. One cannot fully understand the idea of the garden without knowing something about the process that created it. Also in the act of gardening resides both ideology and a desire to create physical order. The garden exists not only as an idea, or a place or action but as a complex ecology of spatial reality, cognitive process, and real work.

(Francis and Hester 1990: 6)

Our gardens often are an unconscious expression of a conscious concretion of an order that is important to us. Uncovering the order is a key to the meaning of the garden. Understanding the order is essential to the creation of meaningful gardens. For centuries, Western society has interpreted the garden largely on its surface aesthetic or formal properties. Infrequently were its ecological, social, or emotional orders consciously considered. Many scholars have told us that the garden is a statement about our place in the cosmos, a physical realization of a world view.

(Riley 1990: 60)

For the Pawnee, the first ceremonial act of the year was to awaken the whole earth from its winter sleep. After their long and arduous travels over the plains on their winter buffalo hunt, they returned to their villages at the time of the spring equinox; the ritual recitation of the creation was made by the five priests, and repeated for each of twelve sacred bundles of the original villages that formed the Skidi Pawnee federation. The position of the stars was an important guide to the time when this ceremony should be held. The earthlodge served as an astronomical observatory and as the priests sat inside at the west, they could observe the stars in certain positions through the oculus of the smoke hole and through the long east-oriented entrance-way. After watching the horizon at sunset the priests sat inside at the west end (the place of the alter) (Weltfish 1965: 79).

The Pawnee listened for the thunder that is low, deep, and rumbling, starting in the west and rolling around the entire circuit of the cosmos. This thunder was the voice of Heaven, and when it came from the south they knew that it was the signal for the creation ritual to be performed. The ritual was part of the sacred lore of the Evening Star bundle which at this time was kept in the earth-lodge of Old Lady Lucky Leader. The five official priests gathered there and began their preparations for the ritual. The same ritual would be repeated for each of the twelve major bundles, including the Evening Star which they were about to perform, then Morning Star bundle, then Big Black Meteoric Star and nine others. At intervals, all during the month of March, the priests went in succession to the different households where each of the bundles was kept, performing the ritual to renew their powers. Their responsibility lay heavy upon them, for they and they alone must bring the world back to life again. Would they now be able to bring back the abundance of summer – the green grass, the trees, the animals reborn, the waters flowing free, the warmth of a summer day? (Weltfish 1965: 80)

The Pawnee pantheon of gods and goddesses was created by Heaven to bring this thought out over space. First he built the structure, starting with the west by creating Evening Star with the moon as her associate; then in the east he created Morning Star and his associate the sun, then the North Star and the South Star (Canopus). Then Heaven created the four stars of the semi-cardinal directions saying to them, "You four shall be known as the ones who uphold the heavens. There you shall stand as long as the heavens last, and although your place is to hold the heavens up, I also give you power to create people. You shall give them the different bundles which shall be holy bundles. Your powers will be known to the people, for you shall touch the heavens with your hands, and your feet shall touch the earth."

Now Heaven spoke to the Evening Star in the west. So that they might do her bidding, he sent her clouds, winds, lightning, and thunders, and these she was to place between herself and her garden; they would later assume human form, appearing in the dress of priests, each with a gourd rattle in his right hand. With these arrangements made, Heaven was now ready to create the world.

It was the storms that carried out this mission, one great thunderstorm to create the lifeless structure and a second to endow it with life. Next to be created were the timbers and the underbrush. Fourth in the great creation were the waters. And the fifth creation was that of cultivated seeds (Weltfish 1965: 81–2).

Power and sexuality have been two prominent themes in representing gardens. Nature is a common metaphor for sexuality in its most powerful, even fearful form, and according to Riley (who has created a typography of the garden) characterizes raw nature in the tropical jungle. The lawn is a symbol of the ultimate taming of nature and human behavior. We can see the progressive transformation form forest to forest glade, to meadow, to garden, to lawn as a metaphor of increasing control over, or sublimation of, the raw sexual content of nature. In this progression, the garden is middle ground, where sexuality is controlled but still potent and available (Riley 1990: 67).

The sexuality and potency of the stars is best expressed in the creation myth of the Pawnee. To the stars, Heaven had assigned the task of creating people in their own image. Now Morning Star called them all into council, but in the course of their proceedings, a great conflict developed between him and the Evening Star. Now in order to bring light and life into the world, Morning Star had to set out from his home in the east to conquer Evening Star and mate with her. Evening Star was ready for him. In the semi-cardinal world quarters she had placed four fierce animals: wolf in the SE, who had the power of the clouds; wildcat in the SW with the power of the winds; mountain lion in the NW with lightning, and bear in the NE with his power of the thunder. While other male gods had come from the east trying desperately to overcome the powers of Evening Star's garden, they had all died in the attempt. Now Morning Star with his helper, the sun, had succeeded, but he had one more obstacle to overcome. Evening Star had provided herself with vaginal teeth "like the mouth of a rattlesnake with teeth around," and these Morning Star had to break with a meteor stone in order to mate with her. As a result of his success, a girl was born to Evening Star. She was the first human being that the stars had created. She stood on a cloud and was carried to earth by a funnel-shaped whirlwind. Now moon and sun mated, and they created a boy who was also carried to earth (Weltfish 1965: 82).

Central to recovering the meaning of myth and sacred time is the re-enactment of the myth in ritual. After the priests had completed their rounds for the creation ritual during the month of March, the second ceremony in the cycle involved the sacrifice to Morning Star of a young girl who had been captured from the enemy. This was compensation to the Morning Star for all his trouble during creation. The young girl lived for a year metaphorically as the Evening Star goddess, and was well taken care of by the Pawnee priests. At the designated time as indicated by the stars, she was ritually prepared for four days before being brought to the scaffold; this was placed over her dug out garden, which was filled with eagle down. Here the priests would mutilate her body and all the male Pawnee would repeat their actions. Her life-blood spilled into the *kiwaru*, the garden, which the Pawnee translated as "bed."

The association of death with sleep or the bedroom is deeply ingrained in Western society. One example is how churches were redecorated as bedrooms as part of funerary rites. Francis and Hester also indicate how closely these themes are tied to the garden.

> The garden is also experience, a place to meditate, reflect, escape from conflict, or prepare for death. We often go to the garden alone. The walk down the garden path is a personal experience, one difficult to convey to others. As experience, being in the garden is what is important. This passive, contemplative experience makes gardens timeless.

So the garden is a symbol of thoughtful space, one which still has an element of rationality. The case of gardens as memorials would indicate that this is so.

In the body of the sacrificed young woman we have a symbol of ultimate fertilization as her flesh and blood are cultivated with the earth. The third of the spring ceremonies was concerned with the corn itself. The sacred corn included in all the bundles was of a specially cultivated breed that was ordinarily not eaten. At this ceremony these seeds were distributed to each of the sacred bundle owners so that the sacred ears of corn could be grown for their bundles. A woman's body provided the *axis mundi*, the reciprocal communication between the Pawnee and their star gods. It is these three ceremonies that constituted the Pawnee spring awakening and the renewal of the people and the regeneration of the earth and cosmos.

The earth presides over the length of our lives from the primordial space of the womb, through germination, gestation, birth, life, death, and rebirth. More than a repetitive and cyclical process of nature, rebirth signifies a shift into a fuller integration of the cosmos. The fact that this fuller integration occurs at the end of our created realities meant that the present becomes simultaneous with the moment of death. The extent of our lives is the space in which we cultivate personal and individual control. Gardens form part of the landscape architect's vocabulary while each exists for us individually as an object of consciousness, a created structure of time reflected back to us in the regenerative process of nature. Only mythical time, the great time, is cyclical, repeatable, and renewable.

As for the question about whether a garden is intrinsically female, the answer is emphatically yes if it has the smallest reference to nature. For Plains people, the earth is the mother and nurturer of life. As to whether a garden can be feminist the answer is yes if it is linked directly to the actions of the Pawnee. They must act responsibly, politically, socially, emotionally and intellectually. When the passive character of the feminine principle is active and open, ready to receive form and influence form it becomes feminist, a free agent of change. Movement and action are required to make new life, adjust to change. Movement has the potential to bring us to our greatest understanding of freedom and creative expression. To be effective is to obey the active male principle, in order to create new life, art, architecture, and gardens.

We cannot ignore the fact that for Native North America, blood and sacrifice were prominent elements of a belief and ritual system, most of which is no longer practiced. I have often wondered how our history would have been different if left uninterrupted by European contact. I am also fully aware of the crimes carried out against women today on an hourly and daily basis. These malicious and criminal acts are carried out without the will or consent of the women involved. This does not make these acts equivalent to what is now interpreted as a senseless sacrifice. In the case of the Pawnee Morning Star sacrifice, a young girl is taken against her will to become the sacrificial victim of her enemies. But even to her own people the path she was on was one of cosmic destiny, far more powerful than that of a Pawnee warrior. Like Euro-Americans, I have acquired many latter twentieth-century values and find myself questioning the positions of my ancestors and theirs. In our current position we no longer have to worry about whether the Pawnee practice of sacrificing a young girl will continue. The old Pawnee cultural rites have all disintegrated along with language and worldview. The destruction of that culture was a violent act, but now no one notices or remembers it. Blood sacrifice and self-mortification as a ritual act were common practice throughout North America. In some places and times it was not always a willing act and enemies often filled the need for ritual offerings. But one cannot judge the Pawnee leaders of the past solely on their practice of the Morning Star ceremony. They must also be judged as leaders who carried out their responsibilities to regenerate the earth and its inhabitants.

The artists of Arch and Patriarch, none of whom were professional actors, agreed to assist me in consolidating some of these aspects of the Pawnee Spring Awakening in a performance whose roots are in the rituals. In a brief performance we tried to introduce themes that took the Pawnee a year to prepare for and actualize. The intensity of the ritual aspects were offset by transforming priest roles into priestess roles and by having the Evening Star goddess/sacrificial young woman distribute sacred seeds to the audience to help regenerate her garden. The following year the Garden of the Evening Star became an installation work in the exhibition "House Made of Stars," in which the *kiwaru* is replaced by a corn garden.

References

Francis, Mark and Hester, Randolph T., Jr. (eds) (1990) *The Meaning of Gardens*, Cambridge, MA and London: MIT Press.

Riley, Robert B. (1990) "Flowers, Power and Sex," in Francis and Hester (eds) *The Meaning of Gardens*, Cambridge, MA and London: MIT Press.

Weltfish, Gene (1965) *The Lost Universe, Pawnee Life and Culture*, Lincoln, NE and London: University of Nebraska Press.

Sara Bates

Honoring

There are rhythms deep within my body that vibrate continually with the earth's mind, will and intention. I perceive the environment as an aware, conscious entity permeated with spiritual power, both human and nonhuman, that continually informs me about the harmonious, deep self-organizing intricacy of matter. I seek to stay in constant consultation with the reality principle that allows the earth to speak. Humanness cannot be fully defined without acknowledging our relationships with what is not human. For the largest part of our human existence, our sense of place has been determined by interactive, reciprocal, sensuous, relationships with the landscape that surrounds us. We use our senses to receive nourishment and messages from the nonhuman world. Our human bodies are designed to accept this energy and sensuous vibration from the living environment intuitively. We hear the vibrations in the flowing rhythm of the pulsing ocean, feel the direction of a winter storm on our skin, see the bursting energy of the sunlight as it creates small rainbows in crystal dew drops, and smell the richness of freshly turned earth when planting season begins. Every aspect of the sensuous earth draws us into a relationship with the natural world. I am Cherokee from Muskogee, Oklahoma. The Cherokee traditional belief system teaches us to respect the environment because it holds the order and structure of things. I have been honoring and celebrating these rhythms for a large part of my life.

What I have witnessed and experienced while participating in this creative process has established empirical information which I can rely on as "truth," even though each experience is unique and non-repeatable. I clarify this understanding of "empirical" because the scientific world requires that repeatable experiments be undertaken which provide repeatable, measurable, results in order to claim "empirical" information. For me, sensorial experience, philosophical reflection, and empirical information are instantaneously blended in one form of "knowing." Today many people rely almost entirely on their relationships with other human beings and human-made technologies. It seems that not many people believe in the possibility of "hearing things," or "seeing things," or "feeling things" in one time, a never-to-be-repeated, unique moment, that can deeply inform us of

the "living" spiritual dimension and ancient reciprocity of the multi-voiced landscape. I find this way of "knowing" the most reliable because it permanently establishes the relationship between human beings and the environment. It is through all of these relationships that my collective sensibilities are nourished and renewed daily. I wonder sometimes if the lack of focused attention on our interactions with the environment, and the possible loss of these sensibilities, is the cause of the ecological crisis we face today. I have talked with a number of people who are asking the same question as they view their daily lives and the things that capture their attention. Some even express a conscious fear of the natural world.

This sensible, sensuous, information is absorbed into my being when I gather from the earth's body. These "one time" open-ended experiences create for me a deep understanding of the earth's rhythms, and my sense of place. This relationship between the natural world and human beings is sacred, reciprocal, and mutually dependent. Interactions with the environment are a respectful and spiritual exchange. It is understood that the presence of human beings affects the interplay of nature's forces. The moments of conscious integration with the natural world are forever embedded in my memory. The memory of previous gathering experiences, each one unique, builds a synergistic system of knowing, a kind of ecological materialism, that grounds my being. It is an open-ended collaboration with the earth that is always in the process of becoming. The concept of being in harmony with this interplay requires very careful attention to the paths chosen each day in terms of where you choose to place your focus: such things as acknowledging the sky, touching the vines that grow on the buildings on your walk to work, stepping on the grass without shoes to feel the sun nourishing the grass under your feet, and to remember, that these are the things that sustain life.

It is important to honor events and experiential knowledge, to celebrate the stages of knowing. The "Honoring" pieces I create center on the traditional world view of my tribe, the Cherokee. They represent how I, as one Cherokee, incorporate these worldviews into my everyday life. I connect and honor these fluid relationships with the natural world by participating in gathering from the natural environment. Circular forms are then created which express this process through the infusion of tribally specific symbols and other personally developed symbols which are more than a representation of a concept or phenomenon, or simply an emotionally charged icon; many times the symbols become part of the symbolized reality itself. For me, the circle becomes a living "messenger" dissolving time with the sensuous experiences of the moment. These experiences facilitate unusual insight into the interconnectedness of life forms, and transcend individual experience. Touching, watching, and shaping form connects me with the beauty of this spontaneous willingness deep within me to love, admire, and care about all my relatives within the biosphere. I do not doubt the importance of the nature of my attachments, nor the expression of this love. However, during many critiques while I was in graduate school my "Honoring" work was viewed by many as narcissistic, and naive. I was told by some of my peers that, "When you get over this Cherokee stuff, you might make some real art!"

"Biologists often love their organisms. Ecologists often love their field sites. Does anyone really doubt it? Read E. O. Wilson's work and imagine how he feels toward ants. Watch Jane Goodall interact with chimpanzees and ask what she feels for them. Read some of George Woodwell's essays, or Rachel Carson's, and gauge the depth of their passion."[1] This deep feeling of the interconnections of the earth's body is what can bring a real sense of sublime integration, wholeness, and balance. "This passion, this ability and willingness to admire and care about other species and places, may be among biologists' most admirable qualities. Our attachments may even be necessary and important.

Nobel Prize-winning geneticist Barbara McClintock speaks about her 'feeling for the organism,' her intimate knowledge of the individual corn plants in her research projects, and her deep enjoyment of that knowledge."[2] McClintock's biographer, Evelyn Fox Keller concludes, "Good science cannot proceed without a deep emotional investment on the part of a scientist."[3]

I view these sensuous understandings of the non-human world as healthy and essential views of reality. The "Honoring" circles offer a type of "self transcendence." It seems that some type of transcendence is needed in the world if we are to meet the challenges of a global environmental crisis. This transcendence I create through "Honoring" reveals "who" and "how" we are in relationship to our human communities, as well as our non-human communities within the biosphere.

The symbol I work with most often is the circle containing an equal-armed cross. In Cherokee symbolism, this is the symbol found on water spider's back. She is the one who brought the "first fire" to our people, and this form symbolizes the Sacred Fire. As you can see in the story that follows, all could speak, relationships in the natural world are direct, immediate, and without boundaries. The story was told by two Cherokees, Swimmer and John Ax, to the anthropologist James Mooney in 1897.

> In the beginning there was no fire, and the world was cold, until the Thunders (*Ani'-Hyun'tikwala'ski*), who lived up in *Galun'lati*, sent their lightning and put fire into the bottom of a hollow sycamore tree which grew on an island. The animals knew it was there, because they could see the smoke coming out at the top, but they could not get to it on account of the water, so they held a council to decide what to do. This was a long time ago.
>
> Every animal that could fly or swim was anxious to go after the fire. The Raven offered, and because he was so large and strong they thought he could surely do the work, so he was sent first. He flew high and far across the water and alighted on the sycamore tree, but while he was wondering what to do next, the heat scorched all his feathers black, and he was frightened and came back without the fire. The little Screech-owl (*Wa'huhu'*) volunteered to go, and reached the place safely, but while he was looking down into the hollow tree a blast of hot air came up and nearly burned out his eyes. He managed to fly home as best he could, but it was a long time before he could see well, and his eyes are red to this day. Then the Hooting Owl (*U'guku'*) and the Horned Owl (*Tskili'*) went, but by the time they got to the hollow tree the fire was burning so fiercely that the smoke nearly blinded them, and the ashes carried up by the wind made white rings about their eyes. They had to come home again without the fire, but with all their rubbing they were never able to get rid of the white rings.
>
> Now no more of the birds would venture, and so the little *Uksu'hi* snake, the black racer, said he would go through the water and bring back some fire. He swam across to the island and crawled through the grass to the tree, and went in by a small hole at the bottom. The heat and smoke were too much for him, too, and after dodging about blindly over the hot ashes until he was almost on fire himself he managed by good luck to get out again at the same hole, but his body had been scorched black, and he has ever since had the habit of darting and doubling on his track as if trying to escape from close quarters. He came back, and the great blacksnake, *Gule'gi*, "The Climber," offered to go for fire. He swam over to the island and climbed up the tree

on the outside, as the blacksnake always does, but when he put his head down into the hole the smoke choked him so that he fell into the burning stump, and before he could climb out again he was a black as the *Uksu'hi*.

Now they held another council, for still there was no fire, and the world was cold, but birds, snakes, and four-footed animals, all had some excuse for not going, because they were all afraid to venture near the burning sycamore, until at last *Kamame'ski Amai'yehi* (the Water Spider) said she would go. This is not the water spider that looks like a mosquito, but the other one, with black downy hair and red stripes on her body. She can run on top of the water or dive to the bottom, so there would be no trouble to get over to the island, but the question was, how could she bring back the fire. "I'll manage that," said the Water Spider; so she spun a thread from her body and wove it into a *tusti* bowl, which she fastened on her back. Then she crossed over to the island and through the grass to where the fire was still burning. She put one little coal of fire into her bowl, and came back with it, and ever since we have had fire, and the water spider still keeps her *tusti* bowl.[4]

Symbols reveal the accumulation of knowledge and wisdom. Life moves in a circle and all creation is related, so the circle offers a kind of universal truth. While the circle, with the equal-armed cross inside, symbolizes for Cherokees the *Sacred Fire*, it is a symbol found in most ancient cultures. This symbol, along with the circle that has a dot in the center, are two of the oldest marks made by human beings. It has the visual nature of locating the center and representing balance.

Some art historians have described the "Honoring" as a union between spiritual and artistic realms, but I do not separate these realms. I arrive at the museum with two medium storage trunks of gathered natural materials. I touch each of these materials when unpacking them and arrange them in grid-like forms on the floor on of the museum. Each circular "Honoring" begins with a prayer. I speak to the "Old Ones," the members of my clan, the Wolf Clan (*Ani'Waya*), and all that has gone before, and I ask them to be with me and to help me to bring honor. From that point on, it is the natural world that "speaks" and informs the shape and content of the artwork. The circles range in size from 7 to 12 feet in diameter and are constructed spontaneously, beginning in the center and working in a spiral, counter-clockwise motion, to the outer perimeter of the circle. This counter-clockwise motion begins to feel like a dance and a sense of renewal and transcendence begins to fill my body with warmth along with a deep sense of connection and beauty.

I recycle everything I honor. Some things are returned to the natural place where I found them. This living dialogue that I "see," "hear," and "feel' during the time I'm with the land, gathering materials, determines what I ultimately return to the earth. When the exhibition period is completed, everything is picked up, put back in the boxes and recycled into a new form at a later date. I continually create these forms in my studio and other places whether anyone sees them or not. It is, in some ways, how I create my own reality, but most of all it is how I celebrate my treasured relationships within the biosphere.

The "Honoring" demonstrates a correlation between Cherokee traditional art and contemporary "mainstream" art in terms of aesthetics. Ideas demonstrated in geometry such as repetition, congruence, and mirroring are important modernist ideas in mainstream art. These expanding geometric patterns are demonstrated in the natural world and are as old as matter itself. The geometric abstractions of the modernists presented nothing new to the world since our ancestors have always known and seen these rhythms and patterns. Creating visual images validating this

beauty was a part of everyday life long before the modernists theorized a "new" movement in mainstream art history. Visual records demonstrating the ancient knowledge ancestors maintained regarding these ideas are undisputed by history. Yet, for many art historians, the modernists are still given intellectual credit. Creating things of beauty for yourself, the home, the family, the village, the earth, and the universe, demonstrating the creativeness of the human spirit in touch with human and nonhuman existence has always been a part of human experience. The geometric patterns come from the natural world, from visible things such as lightning, concentric circles in pools of water, spider webs, snowflakes, pine cones, shells, flower petals, turtle shells, rainbow, parched earth, and rock formations. This is the palette of our ancestors, the literal stuff of the earth.

Creating the "Honoring" circle allows an instinctual solidarity with the natural world. Working in this way is an effort to recapture the quality of this experience. The process takes me to a place of evolutionary memory that brings into view the undivided elements of nature that are immediately reciprocal and knowable. What comes into my body is a view of reality that is unshakable, because I know beyond all else, that it is these rhythms that sing my existence and survival. It is possible to work with this process for eight to ten hours without ever realizing that an hour has gone by. It is that engaging. The image becomes transparent, as if I can see through it to something beyond matter that moves matter. It is a state of peaceful, unconditional love, a place of complete integration, of knowing everything at once; there is no fragmentation, everything is a part of the whole.

There is an aesthetic power in this kind of unity that is healing not only for me, but seems to extend to the viewer. It is the consciousness of nature. It is the beauty of all those gathered voices from the natural world that speaks to the deepest part of ourselves. Michael Miller, Preparator, at the Los Angeles Municipal Art Gallery told me something interesting after I had installed my work in the "Utopian Dialogues" exhibition in November of 1993. He said that people were wanting to come during their lunch hour and sit with the "Honoring" circle. I asked if anyone had said why, and he said the most common response was that it reminded them of when they were a child, and inside themselves they know something about this process. I thought, what if it is a deeper memory, an instinctual memory that is remembered by the material substance in our bodies? I know my body awakens to this synergism when I'm gathering from the earth's body and creating these forms. This comment also suggested to me that it is possible for the artist and the viewer to share certain perceptual capacities that are quite possibly a part of our shared human nature, and that one might conclude that it is possible during an aesthetic experience that the perceiver actually participates in the artist's perceptual experiece. I have always said when speaking about my work that you don't have to be Cherokee to access the artwork. You can access the artwork because you are a human being, and deeply related to the earth. You know that deep within your body. It is a natural gift that we, as human beings, share.

The ideals that Western civilization bring forward in "progressive" anthropological thought and philosophies are distancing us from our tribal stories. Such stories are the philosophies that are embedded in ancient, elemental, human understandings and satisfactions that demonstrate deeply understood "truths" about what it means to be a human being. It seems that everything that is considered "intelligent" and "sane" today is opposed to the way that human beings have lived for 99/100ths of human history. Ellen Dissanayake, in her book *Homoaestheticus: Where Art Comes From and Why* (1992), states that:

> It is worth emphasizing how long we were "feral" or "natural," and how recently we
> have been domesticated into separate cultures. As animal taxa go, hominids are quite

recent, becoming distinct only about four million years ago. But for 39/40th of that four-million-year period, during all of which time we were gradually "evolving," we inhabited essentially the same environment and lived in essentially the same way, as nomadic savannah-dwelling hunter-gatherers in small groups of twenty-five or so. "Cultural" diversity has occurred so recently that what happened to us for 3,900,000 years in that essentially uniform environment and way of life is what still touches us most deeply and continues to inspire our strongest feelings.[5]

Dissanayake goes on to suggest that what this means is that contemporary society is buying into philosophical and historical views of human existence and experience that can't be anything but "pitifully (and literally) superficial,"[6] regarding the answers to questions about our human ways of being in the world. "We misrepresent our human depth to the extent that we regard human history as being only some ten thousand or at the most twenty-five to forty thousands years in length (rather than one hundred to four hundred times longer)."[7] In view of this, the implications of misreading human nature, not understanding ourselves and our needs, and the destruction of natural motivations toward subsistence perspectives (those perspectives that sustained us for 99/100ths of our existence as a species) could be devastating, and far reaching.

For some time now, I have been deeply concerned about the Western concept of "sanity." We know at our present rate of production and consumption (according to projection reports published by physicists, geologists, biologists, ecologists and others in the scientific world) that we could pollute the environment in fifty to sixty years beyond sustainable living for our grandchildren. The earth could be too toxic for many human and nonhuman life forms to exist, and we could bring about our own extinction. Are these the actions of a society with any regard for the survival of its grandchildren?

I keep hearing all these plans regarding "equal opportunity" for all minorities in the United States and global "economic opportunities" that will allow minorities in this country, and Third-World people, to participate in these "catching-up" agendas to bring them "up" to what we define by our standards in this country as being "above" the "poverty level." At the present time, only 10 per cent of the global population participates in the standard of living demonstrated in Western society. What will happen in terms of waste and toxicity when 20 per cent of the world is living as we are? With this current mission of the "catching-up" policy of equality, is our projection for survival of the species now cut down to twenty-five or thirty years? What is "sane" about this kind of thinking? It is important to remember that we must all be engaged in the universal human task of making sense of our individual and collective experiences in ways that ensure our survival.

My artwork for the last decade has been involved in connecting aspects of artmaking with humanness and everyday living in relationship with the earth. The methodology could be called a kind of ethological study. Ethology is the study of the behavior of animals in their natural habitat. I am so taken by the ideas that surround Dissanayake's theory that an ethological perspective is needed in order to properly position artmaking in our society today. She states for example, that "the behavior of making art is universal and essential, that it is a biologically endowed proclivity of every human being, and not the peripheral epiphenomenon that other explainers of the subject, including most evolutionary biologists, have heretofore assumed."[8]

It is axiomatic in modern sociobiological theory that individuals have evolved to pursue what is in their best interests. The preponderance of studies in human

behavior and evolution to date concern themselves with aggression and dominance: in law, economics, politics, ethics, or criminology. Subjects like homicide, rape, war, gender conflicts, and despotism, and traits like envy, competitiveness, status seeking, and deceit are the usual fare, so that it is all too easy to look on the admittedly bleak side of the fundamental sociobiological theorem that "individual self-interest" is the driving force in human affairs. Starkly valid as this may be, it should not be forgotten that in human evolution, the development of behavioral means to promote cooperation, harmony, and unity between and among individual members of a group has been every bit as important as the development of aggression and competitiveness. The arts, in concert with ritual ceremonies, play, laughter, storytelling, synchronized movement, and the sharing of self-transcendent, ecstatic emotions, are no less evolutionarily salient and intrinsic to our humanness than individual conflicts of interest.[9]

In 1997 I spent some time talking with those who maintain our religious ceremonial grounds, mostly discussing some of the changes that have taken place over time regarding our religious practices. In my research, I have discovered that linguistic forms and ritual forms described by ancestors in documented manuscripts in our own language are continually being redefined to reflect the Christian way of being in the world, and less about the deep relationship between human beings and the natural world. It seems to be a kind of "trickle-down" effect caused by patriarchy and the Christian way of thinking. Most Cherokees are Christians today. Perhaps this blending of religious systems is what must be called Cherokee religious tradition today. No surviving culture is ever static, cultural dynamics require change in order to survive. What survives in a culture is what the people accept and bring forward.

In spite of all this, we still have a unique religion. I believe that it is the elements of our tradition that still reflect our connection with the earth as a "living being" that have allowed us to survive as a unique people. We still honor the Sacred Fire, which is kept alive at our ceremonial grounds. Men, women, and children still dance with synchronized movements. Women still shake the turtle shells strapped to their legs as they step and caress the earth to create the rhythm and balance for our stomp dances. Our men still make the water drums and gourd rattles to lead our songs in a traditional way. Felt hats and baseball caps are beaded and tied with eagle feathers to be worn at the Green Corn Ceremony, and other special times of honor. We still play stickball and cook traditional foods as part of our ceremonial celebrations. Many still believe that as long as the Sacred Fire burns we will survive as Cherokee people. If the "reality" of these practices did not hold a deep sense of the sacred for us, and if this were not demonstrated in our experiential lives as meaningful, we would not still be doing them. We know these practices connect us with all that has gone before, our sacred earth, and the essence of what we are as human beings, in living relationship and harmony with a more than human world.

However, things *are* changing for us. Fewer people are telling the stories and going to the Stomp Grounds. We are struggling to keep our children interested in our traditional customs, and fewer of the next generation are learning our language, songs, and dances. Only 7 per cent of our tribe is full-blood, and we only have about 10,000 fluent speakers of our language today. We are the second largest Native American tribe in the United States with approximately 188,000 enrolled members. Perhaps the following recollection will give you a glimpse into our "living culture."

It was Labor Day weekend, 1996. I was back home for Cherokee Holidays in Tahlequah,

Oklahoma, the capital of the Cherokee Nation, at the Redbird Smith Ceremonial Grounds. Feeling heavy in my heart, I was sitting in my clan bed, the Wolf clan, with Pat and Julie Moss. I looked over at *Nakwisi usdi* (Little Star), Pat and Julie's son. He had been one of my students, a young man now, taller than me. His smile and demeanor hadn't changed, but I could tell by his tall, proud body that he had found his place. I wondered if I would recognize any of the other children? Had they all grown into such fine young adults? It made me feel my age, 52 that year.

Pat Moss used to be the Fire Keeper at the Four Mothers' Flint Grounds near Stillwell, where I used to dance when I was home in the summers of 1988, 1989 and 1990. These were the summers I worked for the Cherokee Nation teaching "Artmaking through Traditional Cherokee Mythology" to our children aged 5 to 12, so that future generations would know the manners and customs of our people through our stories, legends, and sacred images. Many of the children were hearing the story *Water Spider and the First Fire* for the very first time. I always worried about this, and wondered why no one had told them this story and the many others I told them.

I was so proud of the Cherokees who were here, still "Honoring" the passing on of a deeply loved elder, Gawexsky, in a traditional way. He was in his seventies, an important bridge-maker between our ancient traditions and our contemporary belief systems. I watched the earth sing as they walked the small box carrying his remains around the Sacred Fire for the last seven times and through the Fire Sticks in the West to begin the procession to the burial grounds in the woods close by. There were tears in my eyes as I watched his family. I knew what a great loss this would be, not only to his family, but to the entire community. Thunder spoke many times in the East while we listened to family and friends speak about Gawexsky. The yellow butterflies were weaving a special dance for him close to where the small box was placed in the East, the place where victory and success reside. He had passed through easily. The crows were flying in sacred formations in the West, the cardinal direction the spirit passes through when we pass on and join our ancestors. I saw the fours and sevens, our sacred numbers, being repeated. The white butterflies came to honor Gawexsky also; white is the color of the South, the place of peace and harmony.

When the remembering and prayers were finished (some were said in Cherokee and some in English) we got in our cars and formed a processional line. A gentle rain began as we drove through the wooded area to our destination. These gentle tears stopped as soon as we entered the burial grounds. This was a man with real power. When all of nature stands up to acknowledge a "passing through," you know this man had learned to speak to, and be heard by, the natural world. To me, that was real power and the sign of an enlightened human being. I was awed and humbled by such beauty in this "Honoring." Prayers were said by Medicine Men and family.

The men went first, as is our custom, gently picking up some of the recently lifted earth to scatter over the small box which had been placed in a shallow hole; the women went next. All of us paid our respect, some mourning loudly and having a difficult time, each of us offering what comfort we could in our own way. As the men began to shovel the earth into the shallow hole and pack it down, I walked by a headstone with the name Doris TeeHee on it. I felt her spirit with us. I didn't know at the time that Dave TeeHee would be the one to replace Gawexsky as Chief of the Redbird Smith Ceremonial Grounds, and the one to give his approval for me to tell this story.

I noticed a small round pod on the earth next to Doris's headstone. I knew to ask one of the Medicine Men if it was all right to take this with me to remember this day. He said, "yes," but to put it in the refrigerator over night. I did. Julie said some medicine had been made for those of us to take who wanted it. A hat was also there for donations to help the family in this time of need. I took medicine, small sips, and washed my hands and face with it before I left. I said a prayer in my heart

for the Medicine Men who had prepared this. I wanted to remember this day. I picked some of the tall Oklahoma grass that had wrapped itself around the sides of my car as I left. I tied the braided grass on the small beaded pouch I placed the brown pod in. I would always remember that it came from the burial place of a beloved Medicine Man, Chief of the Nighthawk Keetoowahs, Gawexsky Smith, Paint Clan, an honored Cheroke (see Plates T and U).

I wondered, had anyone documented his life. I hoped he or someone had written down his sense of wisdom, and in his own words.

How many of the 188,000 plus tribal members even knew who he was? Only forty to fifty people were at the Redbird Smith Grounds for the ceremony. The Cherokee Holiday celebration was going on all over town, arts and crafts booths, book signings, the State of the Nation address which would be given by our Principal Chief in the town square on Muskogee Avenue, the holiday parade, museum exhibitions and workshops, festivities everywhere. The whole town was bustling with people.

I guess we're just like any other people in the world in some ways, just trying to survive in a world that is moving too fast. There's not much time for reflection and "Honoring", and yet we still do.

Notes

1 Phyllis Windle, "The Ecology of Grief," in Theodore Roszak, Mary E. Gomes, and Allen D. Kanner, *Ecopsychology: Restoring the Earth, Healing the Mind* (San Francisco: Sierra Club Books, 1993), p. 138.

2 ibid., p. 139.

3 Evelyn Fox Keller, *A Feeling for the Organism* (San Francisco: W. H. Freeman, 1983), p. 198.

4 James Mooney, "The First Fire," *Ninteenth Annual Report of the Bureau of American Ethnology*, 1897–8 (Washington: Government Printing Office; republished: St Clair Shores, MI: Scholarly Press, 1970) pp. 240–2.

5 Ellen Dissanayake, *Homoaestheticus: Where Art Comes From and Why* (New York: The Free Press, 1992), p. 4.

6 ibid., p. 4.

7 ibid., p. 5.

8 ibid., p. 11.

9 ibid., pp. 11–12.

Index